Leonardo's Incessant *Last Supper*

Leonardo's Incessant *Last Supper*

LEO STEINBERG

ZONE BOOKS · NEW YORK

2001

Published with the assistance of the Getty Grant Program.

Printed in Canada.

Distributed by MIT Press
Cambridge, Massachusetts, and London, England

Cover: Billboard on Route 3, New Jersey, 1967 (Fig. 2), with the Tongerlo
copy (Fig. 154) replacing the billboard's *Last Supper* image.
Back cover: Leonardo, studies for Judas (Fig. 50), St. James (Fig. 46), and
St. Philip (Fig. 34).

Library of Congress Cataloging-in-Publication Data

Steinberg, Leo, 1920–
 Leonardo's incessant Last Supper / Leo Steinberg.
 p. cm.
 Includes bibliographical references and index.
 ISBN 1-890951-18-8
 1. Leonardo, da Vinci, 1452–1519. Last Supper. 2. Leonardo da Vinci,
1452–1519—Symbolism. 3. Last Supper in art. I. Title.

ND623.L5 A683 2001
759.5–dc21 00-028315
 CIP

CONTENTS

Dedicated to Sheila Schwartz
and to Paula and Herbert Molner

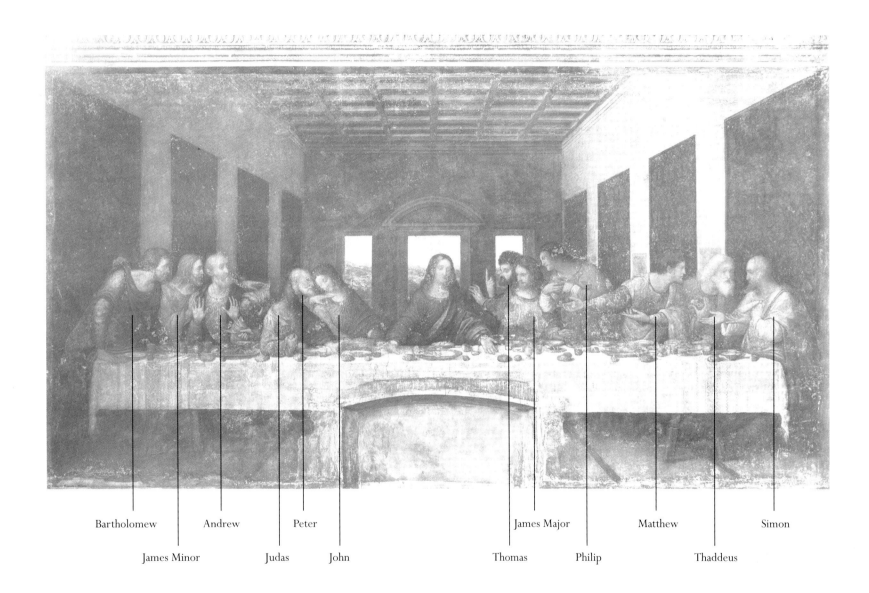

Bartholomew Andrew Peter James Major Matthew Simon

James Minor Judas John Thomas Philip Thaddeus

Last Supper with identification of the Apostles.

Introduction

TWO QUESTIONS ARISE at the mention of Leonardo's *Last Supper*: Is there anything left to see? and, Is there anything left to say? The answer to both questions is Yes.

The above seemed a fair opening for the essay I wrote on the subject in 1973, but you can see why it no longer works. Now, at the mention of the Last Supper, *the questions are "what do you think of the cleaning?"—or, "how about Andy Warhol's* Last Suppers?" *So the very start of that early opus proclaims obsolescence, hence my alarm when the editor of Zone Books suggested that this curiosity—it had filled one issue of a venerable quarterly journal which then promptly lost its old sponsor—when, to repeat, Jonathan Crary proposed (in August '97) that the essay finally take the shape of a book. Too late for that. Not only has the questionnaire changed, to say nothing of the painting itself (see gatefold, pp. 293–94). Some outlandish ideas that needed advocacy a generation ago have infected respectable scholarship and are bound for the commonplace. In view of this shifting scene, the present book, though it incorporates the original argument, had to become a new and a bulkier work. Except for the first twenty-odd pages, there wasn't much that could go unrevised. Here is the second paragraph of the original Introduction.*

Leonardo's picture is still where he painted it. Despite its physical devastation, despite the functional change of its setting from monastic refectory to public museum and from a fifteenth-century structure shattered in World War II to its bare modern replacement, the painting continues to stage a unique situation (Fig. 1). It transfigures the space it confronts, and there is in the painting no major feature that was not in one way or another determined by the given site. In this sense, as part of a close-knit collocation, Leonardo's invention—though it has been more than any narrative picture copied, adapted, abused, and lampooned—remains essentially unreproduceable. The image in situ is no kin to its clone on a New Jersey billboard (Fig. 2); and the uniqueness of the in situ experience forms one theme of the present essay.

I reprint the above partly because it's all true, but mostly for the sake of that billboard. (It's been pirated in subsequent literature, but Fig. 2 was its primordial avatar—a photograph taken by my late brother-in-law, the microbiologist Dr. William Charney.) And here's the next paragraph of the original Introduction.

1. Refectory, Santa Maria delle Grazie, Milan, with the *Last Supper*.

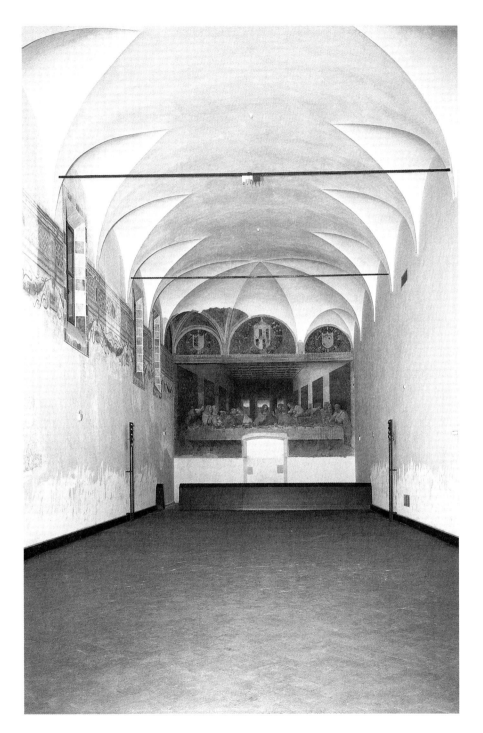

The answer to the second question [anything left to say?] is equally positive. What remains to be told about Leonardo's *Last Supper* is not some residual matter previously overlooked; the novelty of the subject is the whole of the work responding to different questions. In the present study, the picture emerges as both less secular and less simple; contrary to inherited notions, it is nowhere "unambiguous and clear," but consistently layered, double-functioning, polysemantic.

The above is no longer news; and what the following paragraph introduces as "the common view" is no longer pandemic.

The common view of Leonardo's *Last Supper* as a revelation of human nature and a feat of dramatic verisimilitude perpetuates two dominant attitudes of the nineteenth century—its secularism and its enthusiasm for scientific statement. The latter called for precise representation and demanded not only that a statement be consistent with what it means, but that it be inconsistent with alternative meanings. Hence the aversion to ambiguity, and the assurance that Leonardo's outstanding artistic creation must be as forthright in meaning as his anatomical drawing or his didactic prose.

Nineteenth-century secularism led to the same result. In the art of the Renaissance, the obscurantism imputed to religious preoccupations seemed happily superseded. Ideal art was believed to reveal humane truths which the service of religion could only divert and distort. And it was again Leonardo in whom these highest artistic goals, originally embodied in ancient Greece, seemed reaffirmed. In this projection of nineteenth-century values upon Renaissance art, the masterworks of the Renaissance were reduced to intelligible simplicity, and Leonardo's *Last Supper* became (nothing but) a behavioral study of twelve individuals responding to psychic shock.

At this point, I might as well reprint the rest, including the flourish about being no smarter than Goethe.

It is the wonder of great art to be so richly dowered that it works for successive ages even under restricting assumptions. Positivists who received Leonardo's picture as pure psychodrama felt fully rewarded. So do we who see the work steeped in exquisite ambiguity. But in differing from such earlier interpreters as Goethe, Burckhardt, and Wölfflin, we need not claim greater wisdom; we claim only to be writing out of this present time, as they did not. Our task is to declare how the work looks to an age that no longer insists on seeing the Renaissance as a movement of triumphant secularism; how it appears in a climate no longer averse to reading pictorial symbols as multiplex signs. The word "ambiguity," Cicero's Latin rendering of the Greek *amphibolia*, originally referred to a martial predicament; it meant being attacked from two sides at once. Modern consciousness has inverted the model to suggest effective action in several directions. Ambiguity becomes a species of power.[1]

That "martial predicament" was a nice touch. It encourages me to continue through to the end of this 1973 Introduction, which, incidentally, was written after nearly ten years of wrestling the subject. My thoughts on Leonardo's Last Supper *were first aired at the Metropolitan Museum, New York, in November 1966.*

The present [1973] account of Leonardo's work rests, first of all, on a reexamination of the actual mural and of its various connections—those internal to the composition and those from the picture out. The mural is considered in its relation to the given wall, to the refectory, even to the adjoining cloister and church. Secondly, the entirety of the depicted space—wall to wall and floor to ceiling—is seen as a single pictorial mesh, rather than as a *tableau vivant* staged against an expendable backdrop, or within a prestructured chamber.

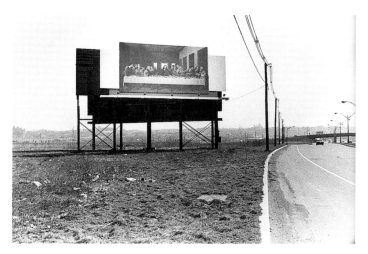

2. Billboard with the *Last Supper*, Route 3, New Jersey, 1967.

Meanwhile, two distinct bodies of interpretation have been enlisted: the observations of writers and scholars, and the responses of artists as expressed in copies and adaptations (see App. E). These twin modes of interpretation permit us to plot the working of Leonardo's creation in human experience. It is assumed that perceptions of the *Last Supper,* especially where they differ from one another, may become sources of insight into the work itself. Scholarly disagreements are not treated as occasions for taking sides, but as hints that Leonardo is doing more than one thing at a time. Similarly, if copyists—those who transpose Leonardo's refectory decoration to other settings— keep rejecting certain original features (e.g., the elusive margins or the truncated ceiling), we are led to suspect that these features may be unfit for transfer precisely because they once constituted a unique adaptation of image to site. Alterations in copies and divergent readings are thus not necessarily symptoms of misunderstanding. Offered by artists and scholars, they further the work's progressive self-revelation—in defiance of its material decay.

1. In ancient, medieval, and Renaissance usage, the word "ambiguity" invariably carries a negative connotation, as in Quintilian's precept: "Above all, ambiguity must be avoided" (*Institutio oratoria*, VIII, ii, 16).

THE BOOK RUNS TO NINE CHAPTERS. To facilitate scanning and skipping, I summarize.

Chapter I examines a notion which, beyond any other, has tyrannized the literature on Leonardo's *Last Supper*: that the picture freezes a single moment. To prove that this "moment" diffuses into successiveness and duration was the easiest part.

Chapter II questions the long-held belief that Leonardo confined his subject to Christ's announcement of the betrayal. It now appears that the subject is manifold—narrative, yes, but in equal measure symbolic, proleptic, and sacramental. A survey of the recent literature shows most of it still in denial and deeply perplexed.

Chapter III—"Of Hands and Feet"—discusses *(a)* the role of context in the creation of meaning; *(b)* the constricting effect of textual sources; and *(c)* the mechanics of ambiguity in Leonardo's contrivance.

Chapter IV introduces the disciples in their multiple competence: as individuals, as mixers, as portents. Their actions turn out to be archetypal no less than personal; resistant to easy reading.

Chapter V studies the depicted setting of the event and its unstable relation to the space of the refectory. Scholars disagree about what we are seeing, but their disagreements become heuristic when all are allowed to be partly right, mistaken only in wanting things one way and no other.

Chapter VI—"Coincident Opposites"—surveys more of Leonardo's double- and triple-dealing. The Apostles are found to act both in freedom and under constraint. They fuse where they disconnect; stand up without deforming the isocephaly they are part of. And as the matching halves of the composition become contrasting sides, so the depicted room appears both deep and collapsible, rigid and flexible in simultaneous contraction/expansion. The plotting of ambiguities in this chapter prepares the ground for the greater complexities of the Christ and the space he inhabits and shapes.

Chapter VII focuses on the protagonist, who commands the system in more than dramatic and compositional terms: the reigning principle of multiple function has here its origin and fulfillment.

(Back in 1973, this last argument raised an organizational problem. Since almost everything in the picture seemed to relate to the central character, how escape the tedium of continual back reference to the same figure? I decided to hold in reserve through three-quarters of the text whatever I thought needed saying about Leonardo's Christ, saving it all—his hands' seven functions—for what was then the penultimate chapter. Right or wrong thirty years ago, it didn't work this time around. Part of the sevenfold deal of the hands of Christ now preoccupies Chapter III, so that some of the matter adduced in this seventh chapter repeats. For this, and for repetitions elsewhere, I apologize.)

Chapter VIII reconsiders the chamber. The artist's imagination, the habit of mind that overdetermines the human gestures, is found to work as effectively in the design of the architectural structure, its geometric projection, its internal economy and outgoing reach. Operative throughout is the recourse to contradiction and the withholding of clues. The setting of Leonardo's main figure—a lone Christ threatened/befriended amidst perspectival as well as passionate motion—this housing is not a stage set whose actors may come and go, but the versatile ambience of drama and sacrament.

Chapter IX—"The Sanctification of Space"—honors once more the irreducible ambiguity of Leonardo's perspective, its consonance with the event staged in the foreground, its symbolic evocativeness as sacral space, and its metaphysics as divine emanation.

Today the painting is in a state of total ruin
—Paolo Lomazzo, 1584 [2]

ABOUT THE PICTURE'S DECAY and present condition I shall say very little. Following World War II and continuing intermittently from the late 1940s until 1954, there was a major restoration campaign—the fifth undertaken in the twentieth century. But this time the result was hailed as a "miracle." I still have my copy of the *Art News Annual*, 1955, with its enthusiastic report, entitled "The Last Supper Resurrected." The Introduction was written by Bernard Berenson, who was thrilled by what the restorer, Professor Mauro Pellicioli, had achieved.

> I felt that I was touching bottom, that the multiple restorations of centuries had been removed, and that I was looking at what Leonardo had painted, deteriorated by the centuries, but no longer . . . deformed by incompetent hands.

In the *Art News Annual*, Berenson's introduction was followed by a full statement from Fernanda Wittgens, the art historian who had supervised this "resurrection." Wittgens refers to the disastrous losses the mural had suffered behind the wall of protecting sandbags that saved it from Allied bombs—and to the injuries suffered again "during the rapid architectural reconstruction of the refectory in the winter of 1945–46. . . . Moldy by now, Leonardo's masterpiece, together with its underlying ground, seemed literally to dissolve into dust at the slightest touch."

Wittgens then describes the new techniques and materials that finally produced what she calls "the greatest miracle"—how Pellicioli's "daring, wisdom and science . . . distinguished the dead spots, where nothing existed between the repainting and the ground, from the zones where 17th-century colors concealed the brilliant treasure of Leonardo's authentic hand. . . ." "The painting," Wittgens concludes, "now appears vibrantly alive and luminous. . . . The restoration, by resuscitating a great measure of the pictorial actuality of the *Last Supper*, has given it voice so that it can speak to the 20th century in the living words of Leonardo."

Well, that was written at mid-century, prompted by wishful thinking and perhaps true at the time, but no longer. What Pellicioli had done would soon be undone by his one-time pupil Dr. Pinin Brambilla Barcilon.

To prevent further losses, Pellicioli had sealed in the surface, leaving it clogged with layer on layer of interpenetrant overpaint. Whatever of Leonardo survived in this brew was inapparently subject to continuing chemical and biological damage. And it was to rescue these authentic remnants that Carlo Bertelli ordered a radical cleansing, beginning in 1979 and not completed until 1999.

The campaign was well under way the first time I climbed the scaffolding in front of the picture (1983). Brambilla had me peer through a microscope while she aimed her scalpel at scattered flakes of original pigment. She would point to a chip, the size of your smallest fingernail, saying, "here's a bit of Leonardo." Then the scalpel would inch away to pinpoint another. It was these vestiges she was saving, using watercolor infill to join them. What we now see, if we look close, are aits of original pigment afloat in flat washes of pale, removable watercolor.

Brambilla had started at the right end of the mural, where more original paint survived, though intermixed with the dregs of nineteen previous repaintings, traceable back to the 1500s. Here the results gave some grounds for optimism, but Brambilla was anxious, knowing that the left half of the picture preserved even fewer remains. *Che pensa*—"what do you think?" she said in her sad, muted way.

2. Paolo Lomazzo, *Trattato dell'arte della pittura*, Milan, 1584, p. 50. Vasari, writing in 1568 (VI, p. 491), had already deplored the mural's condition as "nothing but a blurred stain." Armenini, having seen the work in the mid-1540s, remembered it as "half ruined" and yet *un miracolo molto grande* (G.B. Armenini, *De' veri precetti della pittura*, Ravenna, 1587, III, p. 172).

During the twenty-one years she spent on this toil, Brambilla has published periodic progress reports, all highly technical, but including some despairing asides, such as this:

> The other well-publicized restorations were far simpler, because they had an even, well-conserved surface. They weren't ruined, broken into scales and held together by glues and plasters like this one. Here I can clean an area one day and still not be finished, because when the solvent dries, it brings out more grime from beneath the surface. I often have to clean the same place a second time, or even a third or fourth. The top section of the painting is impregnated with glue. The middle is filled with wax. There are six different kinds of plaster and several varnishes, lacquers and gums. What worked on the top section doesn't work in the middle. And what worked in the middle won't work on the bottom. It's enough to make a person want to shoot herself.[3]

In May 1998, I was up there again, my third time. Dr. Brambilla, now past eighty and not in best health, was still working, assisted by three younger restorers, all huddling at lower left, scraping away. In many areas, having removed overpainting, they were facing bare wall. More filling-in needed—and it had to be done fast (a deadline had been imposed from on high), so that this must-see tourist attraction would show decent finish to the daily sightseers who queue for two hours to be admitted in groups of twenty for a leisurely viewing time of fifteen minutes.

A FEW WORDS about the illustrations. Some show the mural in photographs taken before the last (or the last but one) restoration, some in its present pallor. Some reproduce early sixteenth-century copies, or details from fastidious engravings. Since the work lives in no authentic definitive image, the choice in each case was dictated by the issue at hand. Whatever pictures exist are approximate sightings of a vision that has receded forever. Of Leonardo's *Last Supper*

we have only an after-image; sufficient nevertheless to feed thought for another five hundred years. But of the original surface—of its color and atmosphere, its breath of sfumato, its precision of nuance in still life and faces—almost nothing is left. If these Vincian delights are what you hope for as you enter the former refectory of Santa Maria delle Grazie, Milan, you'll find yourself in heartbreak house.

In Jonathan Swift's *A Tale of a Tub*, an argument for the superior virtues of Surface ends with this clincher: "Last week I saw a woman flayed, and you will hardly believe how much it altered her person for the worse."

AS I ABANDON THIS BOOK, it occurs to me that I may have neglected to mention some of the following:

> Leonardo da Vinci was born April 15, 1452, near the Tuscan hill town of Vinci, a fifteen-mile ride from Florence; the lovechild of a prosperous young notary and a peasant girl named Caterina, of whom we know nothing more, except that she later married a local unknown.

> Raised in his paternal grandfather's household, the boy was early apprenticed to the Florentine painter-sculptor-engineer Andrea Verrocchio.

> At age twenty, he paid membership dues to the Florentine painter's guild. From Vasari, his first biographer, we learn that Leonardo was still with Verrocchio in 1476, working soon after on a number of independent commissions.

> Sometime in 1482, he entered the service of the Duke of Milan, Lodovico il Moro of the house of Sforza.

> Commissioned to paint a *Last Supper* on the north wall of the refectory of the Dominican monastery of Santa Maria delle Grazie, Leonardo embarked on the work in 1495, completing it early in 1498.

> After many vicissitudes, changes of patron, and peregrinations, he settled at Amboise, France, where he died in 1519 with only commoners (and no king, *pace* Fig. 172) at his bedside.

3. Brambilla, quoted in Franck 1997, p. 181.

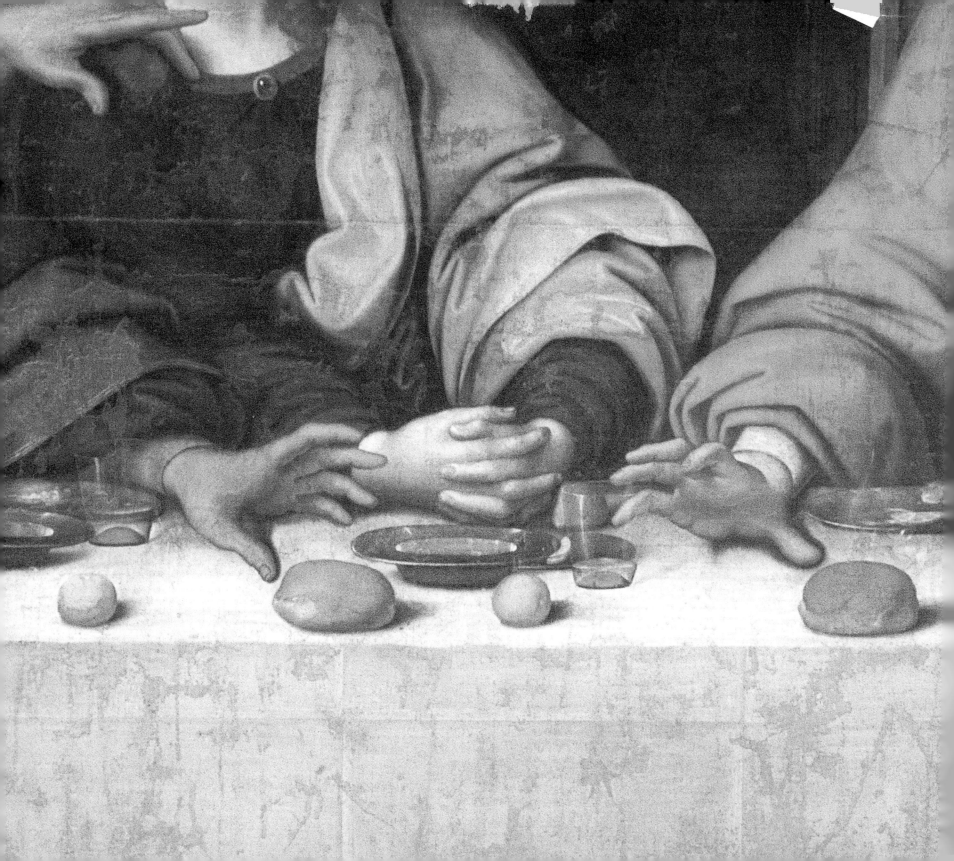

The Moment

OUR EARLIEST COPY of Leonardo's *Cenacolo* is an engraving of about 1500, attributed to the Milanese illuminator Giovanni Pietro da Birago (Fig. 4).[1] Judged as a replica, the work is inaccurate and naive, but as a comment on the original (Fig. 5), it marks the first recorded expression of a permanent critical need—to clarify and to simplify and even to rectify what Leonardo had done.

Conspicuous among Birago's improvements is the addition of a lettered *cartello* affixed to the tablecloth. The legend defines the occasion and removes all doubt about the moment depicted: Christ, speaking, says, "...one of you shall betray me" (Matt. 26:21). Or it may be that Christ *has* just spoken and that the caption explains the Apostles' reaction: "And they were exceeding sorrowful and began every one of them to say unto him, Lord, is it I?" The picture, then, represents a twelvefold reflex to a just-given signal.[2]

Except for one further adjustment. As Cardinal Federigo Borromeo described the *Cenacolo* in 1625, the action seemed rather to refer to yet a third moment. Asked to identify the betrayer, Christ "answered and said, he that dips his hand with me in the dish, the same shall betray me" (Matt. 26:23). Or, according to Luke (22:21): "The hand of him that betrays me is with me on the table." One glance at the left and right hands of Judas and Christ—apposed in symmetry and the platter midway (Figs. 3, 6)—convinces us that the cardinal had a point. He saw the whole company startled by the indictment: "The words passing among the Apostles seem to resound in our ears as Christ pronounces that terrible sentence...."[3]

But these close discrepancies—the steps from announcing the treason to designating its agent—caused no immediate concern. Before the emergence of systematic art

3. Anonymous, c. 1540, Abbey of Tongerlo, detail (App. E, no. 15).

1. Copies cited throughout this book are itemized in Appendix E, referenced as App. E, followed by a number.

 Thanks are due to The Metropolitan Museum of Art, New York, for celebrating the quincentenary of Leonardo's completion of the *Last Supper* (1498) by acquiring a splendid impression of the exceedingly rare "Birago" engraving—the first multiple reproduction ever made of a Renaissance painting.

2. Since Vasari (1568), the *Last Supper* as a study in emotional reactivity has remained the standard interpretation. Vasari writes: "Leonardo imagined,

and succeeded in expressing, the suspicion that seized the Apostles wanting to know who would betray their master." This vulgarizes the Gospel, wherein each Apostle worries about his own innocence—"Lord, is it I?" Vasari has every one of them sure that it's someone else.

3. Cardinal Federigo Borromeo, *Musaeum*, Milan, 1625; reprinted with Italian translation by Luigi Grasseli and notes by Luca Beltrami, *Il Museo del Cardinal Federico Borromeo*, Milan, 1909, p. 65. The passage is quoted in Bossi 1810, p. 46.

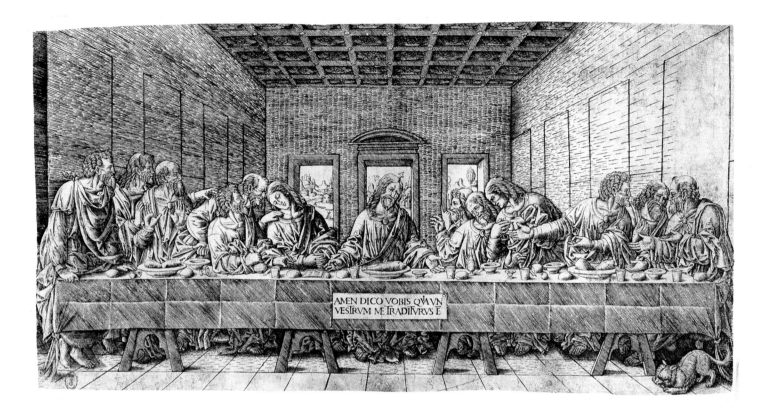

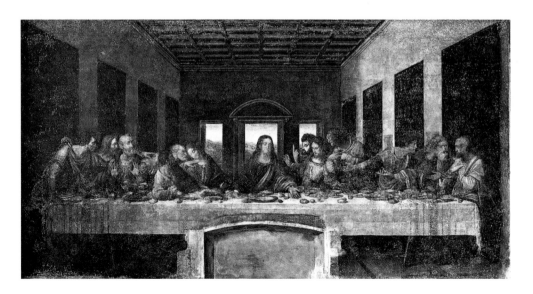

4. Giovanni Pietro da Birago (?), *Last Supper with a Spaniel*, c. 1500.

5. Leonardo, *Last Supper*, pre-World War I photograph.

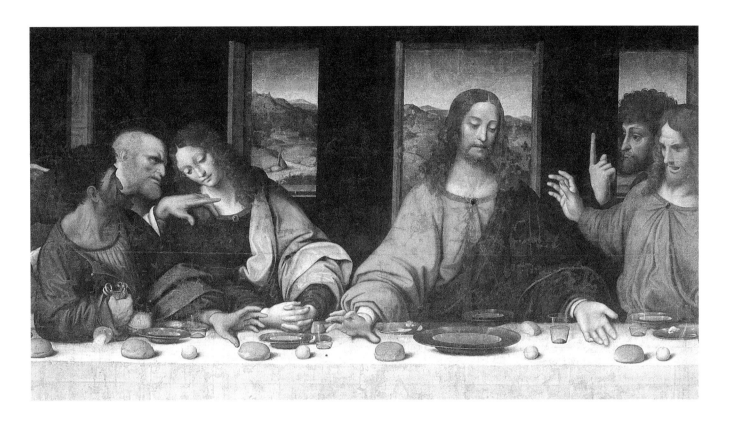

history, no one observed that the scene seemed referable to more than one moment. Leonardo's masterpiece continued to be admired as a perfect realization of instantaneity.

Toward the end of the nineteenth century, rigorous scholarship set out to define the dramatic moment with greater scientific precision. Since Leonardo's achievement seemed to reside above all in the rendering of human feelings, his success, it was felt, could not be accurately assessed without pinpointing the exact stimulus to those feelings. Whereas Goethe's famous essay on the *Cenacolo* (1817) had analyzed the entire action as a response to Christ's initial utterance—the "one of you," *unus vestrum*—Josef Strzygowski (1896) revived the alternative reading of Cardinal Borromeo. He argued that the chosen instant must be Christ's reference to the traitor's hand about to dip with him in the

dish (or being with him on the table) since this would explain not only the obvious coordination of hands flanking a plate, but also the defensive reflex of most of the other hands: they flutter up as if seeking an alibi, or point—as Strzygowski thought most of the glances did—to that same baleful opposition of hands.

An avalanche of positivist rationality descended upon Strzygowski to prove him wrong. It was sensed at once that his notion was dangerous. In Strzygowski's reading, the depicted moment was to be understood not as the Master's initial address to the Apostles, nor as his silent attention to their response, but as himself responding again. Had Strzygowski's suggestion required no more than a shift within the polarity of speech and answer, it would not have been greatly resisted. In scenes of disputation or colloquy (in

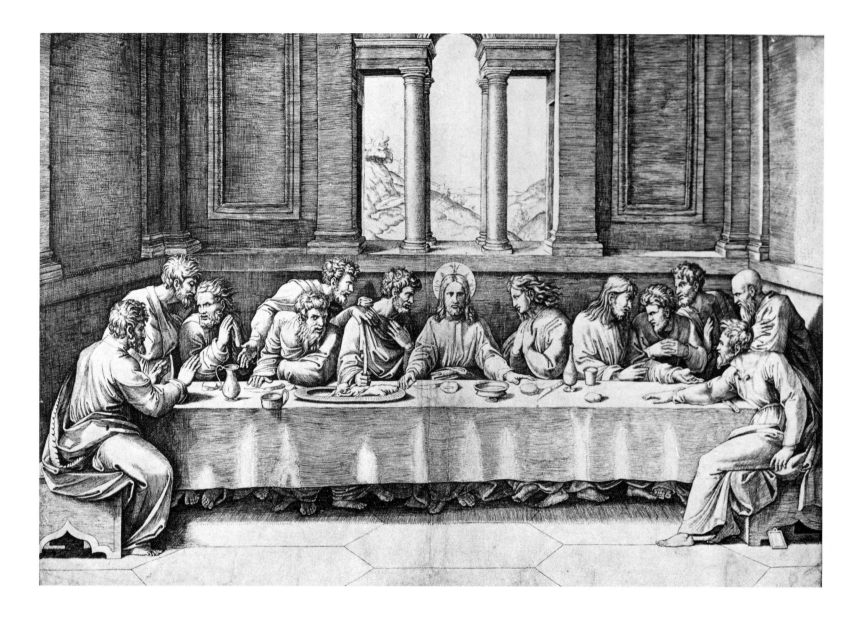

7. Marcantonio Raimondi after
Raphael, *Last Supper*, c. 1515–16.

Annunciations, for instance), the simultaneity of stimulus and response was a familiar convention, indicating that the two parties, rather than speaking at once, were reciprocally engaged.[4] But this novel reading of the occasion threatened to lengthen the interpretability chain so as to run from first signal, through reactive questioning, to counter-response. It implied a protagonist who could be conceived at either one of two moments—or who was able to act in both moments at once. Permissiveness on this score could not but imperil the temporal unity of the action. Accordingly, the Strzygowski argument was dismissed on the grounds that the plate between Christ and Judas is not a communal dish but the personal plate of St. John—and it would be unheard of for two diners to raid the private plate of a third. Otto Hoerth, in his imposing monograph of 1907, concludes that those two hands approaching the dish are "a chance optical constellation."[5]

It is worth observing that the earliest copyists of the work forestall the Borromeo-Strzygowski alternative. A sound preference for simplicity leads them to remove the source of the ambiguity by removing the dish and disengaging the hands of Christ and Judas. Subsequent copies (with rare exceptions) either omit the dish or shunt it aside, or diminish its size.[6] The effect throughout, whether so intended or not, is to reduce the multiplicity of possible readings. And since, in the normal course of events, a speaker cannot be making a statement and at the same time answer the question which that statement aroused, the gain in clarity is apparent.

A similar gain accrues from Raphael's drawing for Marcantonio's engraving of the *Last Supper* (Fig. 7).[7] The work is both a homage to Leonardo's *Cenacolo* and a critique of its equivocations. Is Leonardo's Christ initiating a sequence, or is he closing it by designating the traitor? Ever since Goethe, commentators have learned to insist that the picture does not show the Christ speaking, but his having spoken. The distinction serves to rationalize the commotion, which surely cannot be simultaneous with the pronouncement itself; the disciples must have let their Lord finish his nine-word sentence before starting up! Yet the visual evidence is perplexing, for the gesturing of Leonardo's Christ is not that of a man who has finished. These hands, reaching halfway across the table, indicate ongoing speech, and Raphael knew why he idled them, why he kept Christ's hands close to the chest. Making his Christ sit stern and unmoving, with both palms laid down, Raphael was silencing

4. Julius Held has observed that, in pictorial tradition prior to Rembrandt, all parties to a verbal discourse performed simultaneous speech gestures. Thus the apparent simultaneity of utterance and response in Leonardo's mural would be perfectly normal. See Julius S. Held, "Das gesprochene Wort bei Rembrandt," in Otto von Simson and Jan Kelch, eds., *Neue Beiträge zur Rembrandt-Forschung*, Berlin, 1973, p. 114 (subsequently published in English as "Rembrandt and the Spoken Word," in Held, *Rembrandt Studies*, Princeton, 1991, p. 167).

5. Hoerth 1907, p. 43. Möller agrees and comments (1952, p. 184 n. 54): "Strzygowski opines that the hands of Christ and Judas were about to meet over the dish, and that the other Apostles show their hands for this reason [!]. This oversubtle interpretation is wrong not only because the dish in question is merely John's plate, but because such nabbing of the betrayer, from whom the Savior averts his eyes, would resemble the trick of a detective, disturbing to the religious mood." More Strzygowski refuters, such as Jansen and Schubring, are cited in Seidlitz 1909, pp. 216 and 423 n. 14. Paul Schubring (*Kunstgeschichtliche Gesellschaft*, Berlin 1908, III) argues that

Christ's words designate no individual, but refer generically to the people he lives with, the *Hausgenossen* who daily dip with him in the dish. The distinction may be of philological interest, but it contradicts the millennial iconographic tradition which applies the words and the gesture to Judas alone. Konrad Escher concludes: "Strzygowski's assertion that the representation concerns the subsequent words of Christ has hardly met with approval" (annotation to the 7th [1924] ed. of Wölfflin 1898, p. 30 n. 1).

6. The treason dish is omitted in the Birago engraving (Fig. 4), in the Tommaso Aleni fresco (Fig. 142), in the small fresco copy at San Lorenzo, Milan (Fig. 143), in the large Bonsignori canvas of c. 1513–14 (Figs. 146, 147), in the San Barnaba copy (Fig. 149), in the Vespino copy (Fig. 171), etc. Among the scores of copies produced before the mid-sixteenth century, only four render the dish more or less accurately (Figs. 6, 144, 145, 150).

7. Raphael's "clarifications" are thoroughgoing: he rejects Leonardo's spatial arrangements; places the table within, instead of before, a deep space; and removes the ambiguity of Leonardo's figured frieze effect (discussed below, p. 135) by advancing the position of the terminal figures.

the protagonist and accomplishing what the literature imputes to Leonardo. The great clarifier understood that the gesticulation of Leonardo's Christ was out of sync with the rest of the action.[8]

Most of the copyists and adapters proceed similarly from a sure instinct for simplification, smoothing out simultaneities that complicate the original. Like the literature on the subject, the copyists will not tolerate double-dealing or equivocation, certainly not in a paradigm of high art. The preferred interpretation of the *Last Supper*, from 1500 to the mid-twentieth century, would have Leonardo's picture reflect the forthright clarity of his writings.

Even the revisionist art historian Johann Bołoz Antoniewicz (1904, of whom more below)—in the very process of arguing that the *Last Supper* has been steadfastly misunderstood—even he invokes passages from the *Trattato* (a posthumous compilation of Leonardo's notes on art) to plead for unambiguous clarity. The felt need is to assimilate the *Cenacolo* to the didactic lucidity of the master's notebooks, as if to dissociate it from the mysterial *Adoration*, the *Virgin of the Rocks*, the *St. Anne* groups, and the *St. John*.

IN 1905, the Berlin philosopher-sociologist Georg Simmel published a thoughtful paper on the *Last Supper*. As he contemplated the variety of the disciples' reaction, he saw the timing of the presentation shivering into "entirely different moments." What exactly Christ had just said he did not question, but found the hearers' behavior unsynchronized. Clearly, not all were reacting to a first impact. The words spoken seemed to reverberate and to resonate long enough to allow every man his own phased response.

The point is easily verified. One need only look at, say, Matthew, third from the right, to see him respond to something other than Christ's initial address. The literature has him assuring the incredulous Simon (at extreme right) that the threatened betrayal must indeed come to pass, for the Master himself has foretold it. But consider what such a reading, if taken literally, involves: that Matthew, hearing those fateful words, had at once turned away from the speaker to attend to Simon's expressed disbelief. So, then, for Matthew, Christ's utterance recedes to past tense—though not for Philip or Judas. Matthew and Philip would not be acting within the same instant.

8. Whether Leonardo's Christ was originally shown speaking, or hearing his speech responded to, is not deducible from the state of the lips, closed or half open. Until the mid-1990s, Christ's lips appeared closed, which Malaguzzi Valeri (1915, p. 546) took to be their original state, since "the numerous copies always represent Jesus with mouth closed." Yet Hoerth (1907, p. 22), studying the same copies, concluded that the mouth "was originally represented as open." The topic is first introduced by Bossi (1810, p. 77), who attributes to the Christ figure "the half-open mouth of one who had just finished speaking." This seems inconclusive, since half-open, as opposed to closed, lips may as well indicate speech. Perhaps this is why Goethe's précis of Bossi ignores the state of the lips, while insisting that the picture shows the after-effect of Christ's declaration: "The words are uttered, and the whole company is thrown into consternation; but *he*, with lowered glance, bends his head, while all his bearing, the arms' motion, the hands, all seem to repeat the dire words which the very silence confirms." (See John Gage, ed., *Goethe on Art*, London, 1980, p. 171. For Gage's use of a translation of 1820, here somewhat altered, see p. 35 n. 6; for Goethe's own words, see App. A.)

Goethe's muting of Christ became the standard interpretation. Thus Burckhardt (1855, p. 671): "Art hardly has a graver subject than this, the effect of a word on a seated assembly...." And so Wölfflin (1898, pp. 30–31): "Earlier painters fail to give the scene unity. They let disciples converse while Christ speaks.... It lies wholly outside the scope of the Quattrocento imagination to make the having-spoken [*das gesprochenen haben*] the motif of the main figure. Leonardo is the first to dare attempt it...." Heydenreich still concurs (1943, p. 60): "The moment depicted is when the words of Christ *have* been uttered." And so Philipp Fehl ("Veronese and the Inquisition," *Gazette des Beaux-Arts*, 58 [1961], p. 330): "Jesus *has* just announced that one among the company will betray him...." Likewise Helen Gardner (*Art Through the Ages*, 5th ed., 1970, p. 453; 4th ed., 1959, pp. 328–29): "Christ, with outstretched hands, *has* just said..." (all emphases added).

Yet some think they see Jesus speaking. So Popham (1945, p. 46): "The fresco, as is well known, represents the moment when Jesus exclaims, 'Verily I say unto you'...." Castelfranco (1965, p. 40) states with equal assurance that Christ is responding to the questioning of the disciples: "'the hand of him that betrays me is with me on the table.'" Though the sum of these readings implies a durational range, authors routinely locate Leonardo's essential innovation in the "precise temporal definition of the action." So Umberto Baldini (*Il Rinascimento nell'Italia Centrale*, Bergamo, 1962, p. 19) and many since.

Simmel's analysis is more penetrating. He quotes Lessing's remark that a man's first thoughts are everyman's thoughts. Therefore, says Simmel, any immediate reflex at a Last Supper should look the same as another. But, he continues, elaborating on Lessing, a soul suddenly overwhelmed needs time to unfold its unique mode of feeling, and in this unfolding dissimilar souls move at unequal pace. Thus Simmel finds Leonardo's *Last Supper* to be the first rendering of an assembly that reveals human personality in full inner freedom, including the freedom to take its own time. Temporal unity in the painting breaks down as each disciple attains self-expression.

But Simmel's reflections did not, in the end, subvert the picture's temporal unity in a historical sense. The differences he perceived among the disciples cancel out if Christ's own moment is assumed to be unitary. Though Simmel argued a breakup of "real time" in the picture, his "entirely different moments" referred only to inner clocks dispersed in separate psyches, not to the passage of narrative time. The instant of the presentation with respect to the story was not his problem. And as his reflections came from outside the art historical field, they hardly troubled the discipline, which was determined to keep this greatest of Western paintings decently unambiguous.

IT IS A TRIBUTE to Leonardo's success that every multivalency in the painting earns praise for being straightforward and clear—even though disagreements over what it is that is clearly presented never subside. Though there is no agreement as to the moment depicted, the *Last Supper* continues to be commended for its exactness in rendering it. The argument is passionate and defensive: surely a perfect painter guided by perfect intelligence would not have let ambiguity fuddle his message! Therefore, the *Cenacolo* must, like a snapshot, freeze a particular instant and avoid undefinition.

But what if Leonardo's perfect intelligence had addressed itself to the phenomenon of duration? How comes it that the scene is describable as a sequence of a half dozen moments? Each phase of the recorded event is in evidence. The action proceeds from the center, where Christ promulgates the announcement—"one of you shall betray me." General consternation ensues, everyone asking, "Lord, is it I?" Whereupon Peter leans over, prodding John to get more precise information. Not shown, but implied by what follows, is the next moment—John's question to Christ;[9] to which Christ responds, "He whose hand is with me on the table." Whereat Judas recoils. And it has been suggested that, in portraying the traitor, Leonardo may have had Matt. 26:25 in mind: "Then Judas, which betrayed him, answered and said, Master, is it I? He said unto him, Thou hast said"— and turns away. Since Leonardo characterizes interrelations no less than individual actors, it is at least thinkable that his Christ-Judas relation, too, is more richly programmed than first appears. And even if we hesitate to allow one or two of these phases, the scope of the narrative seems remarkably open. The story line coils and recoils, weaving duration into simultaneity.

The effect is "ambiguous," and the habit of placing ambiguity under a negative sign—as a symptom of indecisiveness or imprecision—has led scholars to disagree about what the painter was illustrating, each party discounting unwelcome clues as trivial or accidental. Respect for the master made them posit a single signification, lest Leonardo appear to have blurred the contours of his presentation. But blurring, blending, the diffusion of shadow and contour which painters came to know as sfumato, is a factor in the vision of continuity. As Leopold Ettlinger put it, "The *sfumato* . . . is as much a technical feature of Leonardo's art as it is

9. Since St. John learned the secrets of Christ's heart in direct communion, he has no need to ask: "This is St. John, who leaned upon the Lord's breast at the supper; a blessed Apostle unto whom were revealed heavenly secrets..." (Roman Breviary, December 27).

characteristic of his personality."[10] Leonardo's conception of narrative in the *Last Supper* applies the sfumato principle even to the gradations of time.

HE APPLIES IT AS WELL to the gradations of scale. The principle of continuous blending enables Leonardo to mix discrepant proportions as readily as discrete moments.

Begin with the table. It appears to occupy an ample place no less wide than the refectory (Fig. 1). But Emil Möller produced a diagram (Fig. 8) to demonstrate that the table—over-long for the width of this room—barely fits. Turn next to the Apostles—apparently seated at table. But Goethe observed (privately) that there is not room enough for them at the board; the standers had better not try to sit down again! They are indeed oversize, or, as Wölfflin puts it, *der Tisch Lionardos ist viel zu klein*—Leonardo's table is much too small.[11]

Lastly, the Christ. Giorgio Castelfranco has pointed out that Christ's figure exceeds the stature of the Apostles. The disproportion leaps to the eye when the figure is seen against the three at his right. Those on his left seem at first sight undiminished, but, in fact, Christ's feet (before their obliteration by the intrusion of a mid-seventeenth-century door) fell well below theirs. Thus Martin Kemp finds Leonardo's Christ "depicted on a larger scale than the other figures"

(1981, p. 194). The resultant archaism is readily overlooked, partly because we respect the justice of hieratic proportions and, more to the point, because Christ's immediate neighbors are so intertwined and fragmented that we barely notice how diminished they are. Yet not one of those flanking disciples measures up to the half-length at center. Though Christ is seated, his crown matches Matthew's, third from the right, and that of Bartholomew, at the far left, both standing nearly erect.[12]

The copies, of course, tend to right these discrepancies. In Birago's engraving (Fig. 4), the standing Apostles rise higher than their seated Lord. It is Birago, not Leonardo, who obeys the rational principle of consistent proportionality.

Putting these observations together—the testimonies of Möller, Goethe, and Castelfranco—we arrive at a panorama of escalating proportions. Leonardo's prolated table spans a too-narrow stage. The disciples, ostensibly seated at table, overwhelm their due places. And the protagonist, though he appears as one of their company, outscales them all. By dint of subtly graduated enlargements Leonardo builds up to a giant center. An imperceptible mix of proportions makes us accept as a human presence a Christ figure near half as large again as the already over-life-size Apostles.

10. Leopold Ettlinger, Introduction to *The Complete Paintings of Leonardo da Vinci*, New York, 1969, p. 6.

11. Wölfflin 1898, p. 27. Dvorak concurs (1927, p. 179): "[Leonardo] paints the table smaller than it should be." So also Heydenreich (1943, p. 64), and so Kemp (1981, pp. 194, 196), who finds the table too short for the figures, but taking up "so much of the width of the room that no one could be seated at its ends." A full statement of the case would describe the table as *too large* with respect to the set, *too small* with respect to the figures.

Goethe's comment on the outsize Apostles (anticipated by earlier critics; see Bossi 1810, p. 124) occurs in a manifesto-like letter that remained unaddressed, undated, unsent. It was probably written on February 11, 1818, meant for the young artist Louise Seidler (Goethe, *Briefe der Jahre 1814–1832*, Zurich and Stuttgart, 1965, no. 165). Of the figures, Goethe writes: "They enchant us by their morally passionate bearing, but these good folk had better not try to sit down again; two at least will land on another's

lap, no matter how close Christ and John huddle together." Goethe does not make this fault; on the contrary, he praises the imagination that overrides physical facts. Nevertheless, the observation here offered "in jest" was excluded from his *Cenacolo* essay. The above passage is too fine not to be cited in his own tongue (see App. A).

12. Castelfranco (1965, pp. 40–41) sees Leonardo's Christ—"by a slight increase in dimensions and spacing"—attain "a hieratic quality," for which he invokes both antique and medieval precedents, temple pediments as well as the tympana of cathedrals. Here Leonardo seems to revert to the hieratic proportionality of Trecento groupings, whose protagonists outscale their attendants (e.g., *The Triumph of St. Thomas Aquinas* in the Spanish Chapel at Santa Maria Novella, Florence). Leonardo differs from the Trecento painter not in suppressing discrepancies, but in disguising them under the appearance of plausibility. Such dissimulations, though long unacknowledged, remain common in later Renaissance painting.

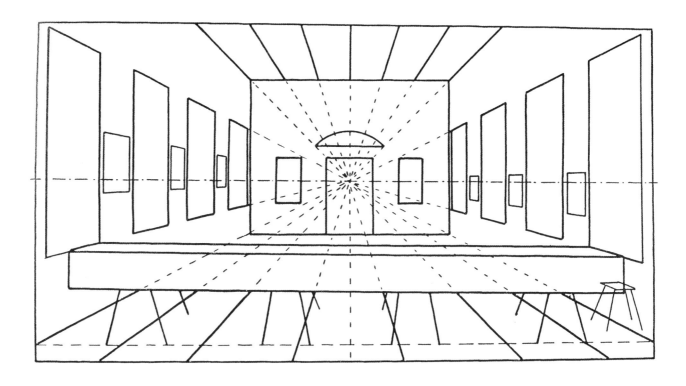

There is no denying that Leonardo's proportional system as here described challenges certain traditional concepts of Renaissance art. In Dagobert Frey's once-standard *Gotik und Renaissance* (1929), it is the medieval mode of representation that juxtaposes objects of diverse scale and events separated in time, whereas the Renaissance image attains unity through uniform scale and temporal freeze. Accordingly, the Renaissance conception of narrative time is assumed to mandate the depiction of a single arrested moment, one telling instant, so that successiveness is ruled out.[13]

But suppose we distinguish between kinds of successiveness. The sequential moments Frey noted in Gothic art are episodic and discontinuously spaced. The phases of

Leonardo's *istoria* coincide or flow through and past one another. His sequence intertangles in a pattern so tight that the durational terms of the narrative cannot be visually pried apart. Discursive narration converts to instant appearance. The choreography, the flux and reflux of mass and motion, is also a braiding of incidents, a storytelling.

Leonardo's own *paragone* discussion (introducing the above-mentioned *Trattato*) offers implicit support for the idea of history painting as duration made visible. His invidious comparison of the arts presents Poetry and Painting alike as committed to the representation of beauty—by which he means the imitation of optical data, the kind you take in at a glance. In this enterprise he finds poetic description inferior to depiction. Worse than inferior, for the versifier, as Leonardo presents him, "sins against nature in attempting to tell the ear what ought to be told to the eye." Poetry, writes Leonardo, proceeds "by mentioning the

13. Frey writes: "by grasping the picture spatially as a unit we also assume the depicted events to be simultaneous" (*Gotik und Renaissance*, Augsburg, 1929, pp. 54–55).

individual components of beauty, and these are separated from one another by time, so that time itself interposes a forgetting between them. . . ." Again: "The poet is unable to construct that harmonic total effect which is formed . . . through conjoint presence. And thus the beauty that is described cannot achieve the simultaneity which the viewing of painted beauty attains." And again: In the poet's art "one part proceeds out of the other successively; the succeeding one does not arise without its predecessor dying. . . . It is as though we wished to show a face part by part, continually covering up the parts already shown."[14]

The notion that spoken words (like music) perish at birth is not Leonardo's invention. We hear it from Savonarola: "A human word is formed . . . by a succession of syllables, and therefore when one part of a word is pronounced, the others cease to exist; when the whole word has been uttered, it too ceases to exist. But the Divine Word is not divided into parts; it issues united in its whole essence. . . ."[15] These lines were spoken about three years before Leonardo designed the *Cenacolo*. But where the friar compares the transience of human speech with the unperishing Word of God, Leonardo contrasts wording with painting and reserves lastingness for his own art.[16]

Of course, Leonardo travesties the poetic process, as if the poet's revelation of female beauty, for instance, could only be inventoried piecemeal—as in Mercutio's ironic blazon of Rosalind's charms (*Romeo and Juliet*, II, i). Such anatomical catalogues, itemized from "high forehead" to "fine foot," are admittedly inefficient, and, as Leonardo remarks in a related context, "Your tongue will be paralyzed with thirst and your body with sleep and hunger, before you depict with words what the painter will show you in a moment."[17]

Well, what *does* the painter show in a moment? Leonardo's *Trattato* speaks only of single figures, or of arrested tableaux such as battle scenes. It omits all reference to narration, whether in painting or poetry. Yet the *istoria*, or narrative, whose components are not body parts but phases of action, was the supreme task of Renaissance painting. And the *Last Supper* was Leonardo's definitive confrontation with it. Did he meet the challenge by fixating a moment to end up with a still? This would mean that the painter in his highest endeavor was confined to a slice, ceding the management of the whole to the wordsmith, the literary narrator. What, then, sustains Leonardo's claim that painting, in the fullness of information delivered, is the more potent art?

Leonardo's reasoning prompts us to infer that he would find the superiority of painting not in its confinement to a fixed instant, but in its power to present successive moments without the foregoing dying away. In short, painting is the

14. Richter 1883/1970, nos. 34a, 27, 30, 25. The translations are those of Wylie Sypher, *Art History: An Anthology of Modern Criticism*, New York, 1963, p. 164, except for the first, which I take from McMahon 1956, p. 29.

15. Sermon on the First Epistle of St. John (1491), trans. in Pasquale Villari, *Life and Times of Savonarola*, London, 1888, I, p. 137.

16. In his least giving vein, Leonardo writes: "That thing is noblest which has the longer duration. Therefore music, which passes away as soon as it is born, is of less account than Painting which, protected by glaze, lasts forever" (Richter 1883/1970, no. 78).

Magari; think of Leonardo's withered *Cenacolo* as you hear a Mass by Josquin or read Ariosto.

17. Richter 1883/1970, no. 18; the translation is that of McMahon 1956, p. 24. Needless to say, what Leonardo calls "poetry" applies only to the descriptive inventories called "blazons," a genre fairly annihilated in Lessing's *Laocoon*. But his larger meaning concerning the hopeless inadequacy of all verbal description remains valid. Cf. Wittgenstein: "My gaze ranges over [a landscape]. I see all sorts of distinct and indistinct movement; *this* impresses itself sharply on me, *that* is quite hazy. . . . And now look at all that can be meant by 'description of what is seen.' There is not one genuine proper case of such description" (Ludwig Wittgenstein, *Philosophical Investigations*, Oxford, 1965, p. 200).

more powerful art in that it can hold duration itself in a "harmonic total effect."

The *Cenacolo* is Leonardo's explicit text on the subject. Blending sequential actions, he brings the phases of the *istoria* together like members of an anatomical body. It is protracted time, timeflow rendered in "conjoint presence," that his painting makes instantaneous. Conversely, the perceived occasion—an appearance of instancy paced to sustained attention—expands into a temporal manifold. And even this many-phased sequence compressed in the seeming suddenness of the action is no more than half the story told in the picture.

〉

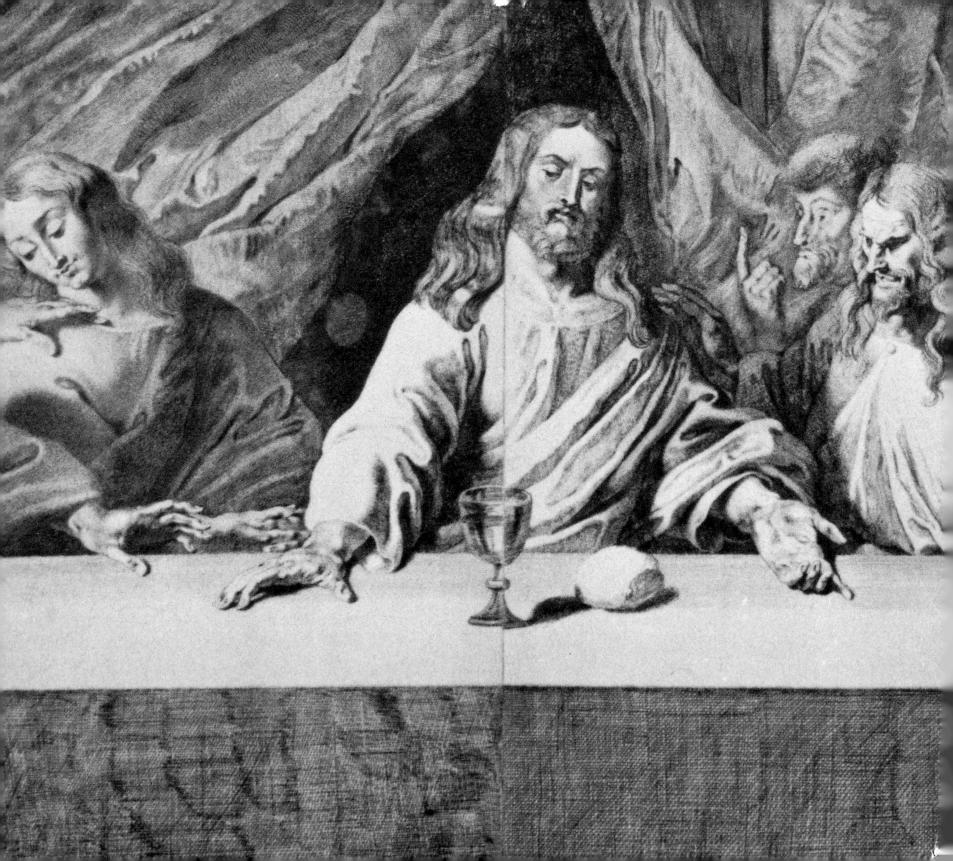

CHAPTER II

The Subject

WHAT MORE IS TOLD in Leonardo's *Last Supper*? The impoverishment of its content down to pure psychodrama is our legacy from the Age of Enlightenment. It comes to us from Giuseppe Bossi (Figs. 10, 11), whose large folio *Del Cenacolo di Leonardo daVinci* (1810) nourished both Stendhal and Goethe, and thus indirectly determined how the picture was to be seen and described. Bossi was a young Milanese painter (he died, knighted, aged thirty-eight, in 1815), a passionate Neoclassicist, friend of Canova, founder of the Brera Academy, and fervent admirer of Leonardo, in whom he recognized the perfection of his own cherished values.[1] His reading of the *Cenacolo* is revealing not only for what the picture is said to contain, but no less for what it is thought to exclude. Leonardo's conception of the event is praised for refusing to admit religious distraction. Bossi writes:

> The Gospel had revealed to all painters prior to Leonardo how Christ, assembled with his disciples, had said one of them would betray him. The effect of these terrible words, likewise described by the Gospel, offered a felicitous opportunity to unfold all those passions whose imitation constitutes the chief merit of art. Nevertheless, one [painter] would aim at representing the breaking of bread; another, the blessing of wine; still another, the distribution of the one or the other, situations all equally hallowed by history and religion, but hardly apt to arouse varied or powerful passions, and hence, by their very nature, weak and monotonous in effect.... Thus the high point, the most worthy of art, was still unattained when there arose...the divine Leonardo, who, unlike his predecessors, was not content to win the approval of religious souls, or of eyes that are satisfied by a beguiling superficial imitation; rather, he wished to engage the spirits of all men capable of feeling, men of all times and of every creed; to engage all those hearts to whom friendship and the horror of treason are not unknown. Guided by philosophy, he pondered how greatly those feelings would be enhanced when directed toward the Man God as the principal personage; but he so ordered his work that, even while abstracting the divinity of the protagonist, his subject retained such general import, that art here sacrificed nothing to private opinions or religious ceremonies, which are neither as eternal nor as universal as human feelings. (See App. A for the Italian text.)

Remarkable in this passage is the slighting of Christ's principal act at the Last Supper. In Bossi's persuasion, the

9. Pieter Soutman
after Rubens, c. 1620.
Reversed detail of Fig. 17.

1. For Giuseppe Bossi, see S. Samek Ludovici in the *Dizionario biografico degli italiani*, XIII, Rome, 1971, pp. 314ff.

institution of the eucharist would not have engaged Leonardo, being a topic unfit for the summits of art. The central sacrament of the Church is reduced to the performance of a "religious ceremony." What Bossi is saying here goes beyond defining the *Cenacolo*'s subject. Imbued with the fresh secular spirit of the Enlightenment, he asserts that the passions of loyalty and treachery, touching as they do our essential humanity, furnish a far greater artistic theme than the founding of a specific cult action, which only appeals to "religious souls" and leaves the emotions unstirred.

We can judge the novelty of Bossi's position by comparing earlier panegyrics that extol Leonardo's dramatic powers without being restrictive. Previous writers on the *Cenacolo* probably took its sacramental character so much

for granted that it seemed to require no comment. Their enthusiasm was not meant to deplete. It was the intensity of human experience in Leonardo's dramatization that struck them as new, not the shrinkage of its Christianity. Luca Pacioli, Leonardo's personal friend, could declare the subject to be the announcement of the betrayal, yet call the painting "a similitude of man's burning desire for salvation" (*de l'ardente desiderio de nostra salute simulacro*).[2] How, you may ask, is such burning symbolized by a revelation of treachery? Similarly, Bartolommeo da Siena: he exalts Leonardo's genius in conveying man's inner life through outward traits and expressions, yet calls this picture "the Mystic Supper."[3]

Most interesting is the case of Cardinal Federigo Borromeo (1564–1631). In a passage cited by Bossi, the cardi-

2. Fra Luca Pacioli's text (first quoted by Bossi 1810, p. 14) runs: *El che agli occhi nostri evidentemente appare nel prelibato simulacro de l'ardente desiderio de nostra salute, nel qual non è possibile con maggiore attentione vivi gli apostoli immaginare al suono de la voce de l'infallibil verità, quando disse: UNUS VESTRUM ME TRADITURUS EST. Dove con acti e gesti l'uno a l'altro, e l'altro a l'uno con viva e af-*

flicta admiratione par che parlino, sì degnamente con sua ligiadra mano el nostro Lionardo lo dispose (*De divina proportione*, cap. III, 1498, Venice, 1509).

3. Bartolommeo da Siena, *De vita et moribus beati Stephani Maconi Senensis Cartusiani...*, 1626, quoted in Bossi 1810, p. 250 n. 34.

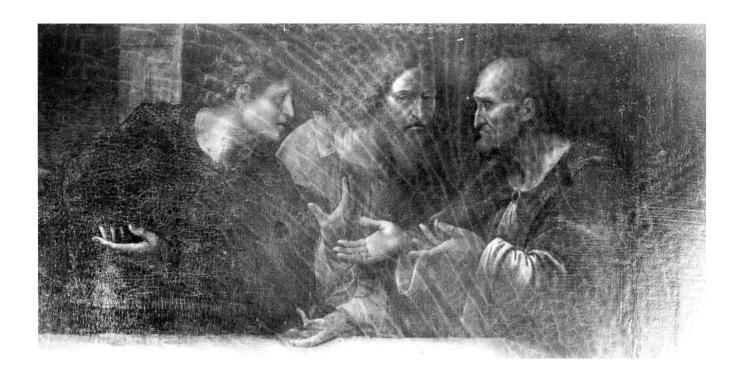

12. Andrea Bianchi, called Il Vespino, 1625, detail (App. E, no. 39), before cleaning.

nal defines Leonardo's theme as the identification of the betrayer, and he admires Leonardo's characterizations for their correspondence with the "laws of metoposcopy" (science of physiognomy, lit. watching foreheads). This sits so well with Bossi's own aesthetic criteria that, quoting the passage, he pronounces the cardinal's judgment superior to any and commends His Eminence for "seeing whatever is necessary to penetrate the secrets of art" (Bossi 1810, pp. 46–47). But Bossi was being devious, tendentious at best, for the cardinal's metoposcopic description does not refer to the original mural, then thought to be near extinction. It refers to the copy (still shown in the Ambrosiana, Milan), which Borromeo had commissioned from the reluctant local painter Andrea Bianchi, called Il Vespino (Figs. 12, 33, 171). The

purpose of the commission was to record whatever was still discernible of the original heads, and the copy, accordingly, takes in only the upper bodies. It is these half figures that earn praise in the cardinal's pamphlet of 1625, the "operetta," entitled *Musaeum*, which accompanied his donation of pictures to the newly founded Biblioteca Ambrosiana (see p. 19 n. 3). Meanwhile, in his weightier *Pictura sacra*, published in Milan in the same year as the pamphlet but not quoted by Bossi, Borromeo discusses the theological considerations proper to a rendering of the Last Supper.[4] In blessing the bread and wine, he writes, Christ should not make the sign of the cross, since, before the Passion occurred, the gesture of blessing followed a different rite. "Whence it is that Leonardo represents the Savior as almost

4. Federigo Borromeo, *De pictura sacra*, Milan, 1625, bk. II, cap. iv, "I misteri del Salvatore," ed. Sora, 1932, p. 35.

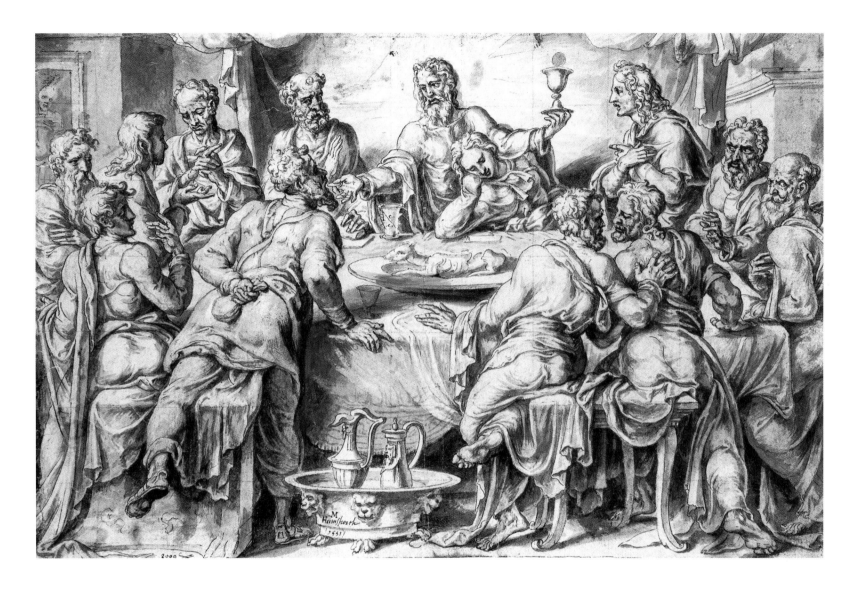

13. Maerten van Heemskerck, *Last Supper*, 1551, retouched by Rubens.

speaking or as having just finished the prayer…" (i.e., the Prayer of Consecration).

We are taken aback. The "prayer"? Isn't Leonardo's Christ supposed to have just said "one of you shall betray me"? Evidently, the cardinal, like Bartolommeo da Siena and Luca Pacioli, did not, on this point, fear inconsistency.

Nor was there reason to fear it, for the conjunction of the two themes of the Supper is embedded in Scripture and liturgy. Again and again, the narrative and the sacramental are syntactically intertwined. So in St. Paul's formulation that entered the Eastern Mass: "the Lord Jesus the same night in which he was betrayed took bread and said, Take, eat: this is my body" (I Cor. 11:23). Pictorial practice, both before and after Leonardo's *Cenacolo*, improves on the Pauline syntax by sounding both themes at once (Fig. 13). The two are born twins, and their iconographic coincidence is traditional. Thus the question is not whether an artist confuses two distinct moments, but whether he has demonstrably reduced the occasion to one alone; whether he has

so expunged eucharistic allusions that modern observers, unwitting heirs to Bossi's anticlericalism, may safely see the preeminent meaning of the Last Supper annulled.[5]

THE MODERN INTERPRETATION of the *Cenacolo* begins in the repudiation of its sacramental component. Goethe's celebrated review of Bossi's work on Leonardo's *Cenacolo*, "Joseph Bossi über Leonardo da Vincis Abendmahl zu Mailand" (1817), lent the charisma of Goethe's name and the splendor of his prose to a translation of the late Bossi's opinions.[6] Describing the depicted scene as a dramatic moment, Goethe, following Bossi, presents its content as ethical, not as religious; and finds no occasion to remember the eucharist. Authors of the next generation made the omission canonic, analyzing the Gospel account of the Last Supper into mutually incompatible themes. Anna B. Jameson, grandam of iconography, takes care to separate the *devotional* from the *historical* aspect of the event. "In the first," she writes (1848), "we have the spiritual origin of the Eucharist;

5. The simultaneity of the two themes in *Last Supper* representations—common since the ninth century both East and West—is discussed by von Einem (1961, pp. 27ff.), who wants Leonardo's work understood in the light of this venerable tradition. He reminds us that, theologically speaking, the betrayal announcement at the Last Supper is a subplot (*Nebenhandlung*). As an outstanding example of the combination of the two themes, he cites Taddeo Gaddi's *Cenacolo* at Santa Croce (Fig. 30), even though this fresco makes no overt reference to the eucharist. But, says von Einem, "the institution of the eucharistic meal requires no special index. As the intrinsic sense of the scene, it is sufficiently indicated by the solemnity of the presentation and by Christ's gesture of blessing."

Medieval and Renaissance *Cenacoli* may conflate the two themes in various ways, as when Judas dips in the dish even as Christ elevates Host and chalice. Sometimes the table appears twice in one picture—once for the *Hoc est corpus meum* and again for the *Unus vestrum*. Elsewhere the betrayal announcement is staged on clouds, *sub specie aeternitatis*. Occasionally, the image depicts one moment, while an inscribed banderole honors the other. The duality of the subject may be conveyed by the context—a betrayal scene decorating a monstrance or altar. For further examples of this thematic fusion, see now Eichholz 1998, pp. 510–12. A spectacular fusion appears in a drawing by Maerten van Heemskerck, which Rubens owned and retouched (Fig. 13): an ambidextrous Christ, passing the sop to Judas, lifts cup and wafer.

6. Near the end of his essay, Goethe writes: "Of the work of the Cavaliere Bossi we have hitherto given a general account, as well as particulars in translation and extract, have gratefully accepted his presentation, shared his conviction, respected his point of view, and if anything was interpolated, then in consonance with his discourse" (see App. A for the original text). Only in speaking of Bossi's full-scale copy of Leonardo's mural, his "reconstruction" of it (Fig. 26), does Goethe "depart somewhat" from his *cicerone*. Yet, despite these gracious acknowledgments, the Leonardo literature takes everything in the 1817 essay for unalloyed Goethe. For Goethe's indebtedness to what Gombrich calls (sight unseen) "an Italian pamphlet by one Bossi" (1993, p. 156), see Lavinia Mazzuchetti's *Goethe e il Cenacolo di Leonardo*, Milan, 1939.

English readers have long suffered a further distortion. Though our literature regularly cites Goethe's text, the only translation available until 1986 was a brochure printed in London in 1821. In this hackwork by G.H. Noehden, a phrase such as "we shared his conviction"—*theilten seine Überzeugung*—translates as "we participated in his actions." (Noehden's traducement reappears in John Gage, ed., *Goethe on Art*, London, 1980, and is still cited as the English version of Goethe in *The Dictionary of Art*, 1996, XIX, p. 199.) A closer, but somewhat pedestrian translation by Ellen and Ernest H. von Nardroff had appeared in 1986 (Goethe, *Essays on Art and Literature*, New York).

in the second, the highly dramatic detection of Judas. It is evident that the predominating motif in each must be widely different." And so Jacob Burckhardt (1855): "The Last Supper contains two entirely different moments, both traditionally treated by major artists. One is the institution of the sacrament. The other moment is the 'Unus vestrum' [the "one of you"]; Christ announces the certainty of the betrayal.... The latter in Leonardo." Thereafter it had to be one or the other, and knowing the difference became proof of professionalism, so that a modern scholar, writing in 1980, feels bound to repeat: "The Renaissance tradition which articulates human drama and underscores human evil is fundamentally different from the iconography of the Communion of the Apostles."[7]

Admittedly, some artists before Leonardo seemed not to have grasped the distinction between these two "widely different," "entirely different," "fundamentally different" moments; they might, for instance, have Judas reach for the dish even as they showed Christ elevating wafer and chalice. "It is open to question," wrote Wölfflin (1898, p. 30), "whether a distinction was always made between the announcement of the betrayal and the institution of the Lord's Supper" (it's like finding it open to question whether the fa-

mous antique *Hermaphrodite* makes due distinction between female and male). But if on this point traditional iconography seemed somewhat addled, it was thought to be Leonardo's achievement to have dispelled the confusion by suppressing the eucharistic motif in his *Last Supper*—exactly as Bossi and Goethe described it. Under the influence of the great playwright, the most admired of Quattrocento wall paintings became a drama at its emotional climax, its most fertile moment—a precocious anticipation of eighteenth-century dramatic theory.[8]

Inevitably, subsequent writers made Goethe their grand inhibitor, the means of foreclosing further thought on the picture. "[Its] spiritual content has been conclusively expounded by Goethe," Burckhardt had written (1855, p. 672), and was still echoed a century later: "Goethe's consummate account of the event renders every other description unnecessary" (Heydenreich 1943, p. 62, and 1958, p. 10). And so Kenneth Clark, who declared Leonardo's "dramatic inventions... analyzed once and for all by one of the few men who, by the scale of his genius, was in a position to judge Leonardo—by Goethe."[9] As Strzygowski lamented (1896, p. 139)—"Goethe's interpretation has so thoroughly passed into our flesh and blood that you will hardly find a

7. Sources of the foregoing quotations: Anna B. Jameson, *Sacred and Legendary Art* (1848), 3rd ed., Boston and New York, 1857, I, p. 272, s.v. "Last Supper"; Burckhardt 1855, p. 671; Polzer 1980, p. 245.

8. A chain reaction from Leonardo to Goethe is explicitly argued by Walter Paatz (*Die Kunst der Renaissance in Italien*, Stuttgart, 1954, p. 146): "The 'most fertile moment'—this concept derives from 17th- and 18th-century theory of literary drama; it was realized in poetry from Shakespeare to Goethe. Within Renaissance painting, the consummate achievement in this genre is the *Last Supper*...whose profoundest interpretation is Goethe's. This makes deep sense. The supreme master of German psychodrama [*Seelendrama*] was an admirer of Shakespeare, and Shakespeare was an heir of the Italian Renaissance; some of his finest plays adapt the fables of Matteo Bandello—the very novelist who, as a boy, had seen Leonardo's *Last Supper* come into being...."

Restate the above in reverse: young Bandello had watched Leonardo paint the *Last Supper*; some of Bandello's plots were used by Shakespeare, legatee of the Renaissance; and Shakespeare was famously revered by Goethe, whose admiration for the *Cenacolo*, accordingly, entails the filial

piety of a descendant. As Dvořák remarked of the *Last Supper* (1927, I, p. 183): "This is a hitherto unknown description of psychic processes.... Here, then, is the trail which, in literature, leads to the tragedy of character—to Shakespeare and on to Goethe and Schiller."

9. Clark 1958, p. 95. Cf. Wilhelm Lübcke (1860): "Following the exhaustive observations which we owe to Goethe, it would be superfluous and presumptuous to offer a detailed account of the work" (*Grundriss der Kunstgeschichte*, 3rd ed., Stuttgart, 1866, p. 530). Even where a Goethean misreading is being corrected—e.g., that Judas recoils from the hilt of Peter's knife in his side—Goethe prevails. "For the rest, Goethe has provided the only correct exposition grounded in Leonardo's art" (Escher in the 7th [1924] ed. of Wölfflin 1898, p. 30 n. 1).

Goethe's stranglehold on German (and English) writers is matched in France by that of Stendhal, whose account of the *Last Supper* is again Bossi-derived. (In 1973, I thanked Nancy Grove for this observation and announced as forthcoming her study of nineteenth-century literature on the *Last Supper*. The task was accomplished twenty years later by Richard Hüttel; see Bibliography.)

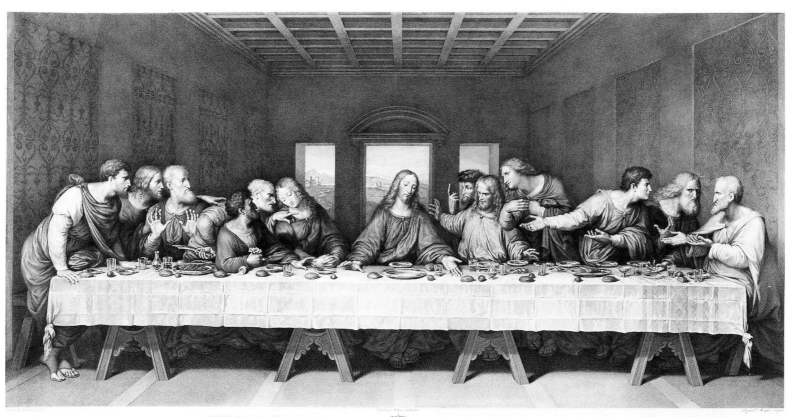

14. Raphael Morghen,
1800 (App. E, no. 48).

description of the picture, at least none in German, that fails to call his interpretation 'definitive' and 'unsurpassable.'" Strzygowski's own attempt to modify Goethe's reading, backed though it was by a seventeenth-century cardinal, found no support (see p. 21), and a counter-hypothesis, more radical and upsetting, fared even worse.

In 1904, Johann Bołoz Antoniewicz, a Polish scholar speaking in German, delivered an impassioned lecture on the *Last Supper* at the Academy of Sciences of Cracow, then part of the Austro-Hungarian Empire. To justify his departure from the Goethean reading, he offered an observation that ought to have devastated the authority of Goethe's essay. He pointed out that the essay did not describe the original mural, but Raphael Morghen's engraving of 1800 (Fig. 14). Goethe actually urges his readers to take up their Morghen print (which no properly furnished home would be without) in order to follow the argument. And Antoniewicz observed that the engraving perpetrates crucial omissions. Here is his text:[10]

> It was not in the Milan refectory, not before the original, that Goethe [formed] his opinion—he had, after all, seen it but once, very briefly, thirty years earlier on his return journey from Italy; no, it was in his Weimar study, looking at Raphael Morghen's engraving, which blurs whatever is fraught with meaning and indispensable to an interpretation. Yet Goethe's authority is so great, so seductive are his conclusions, that today almost everywhere only his interpretation is considered correct.

This said, Antoniewicz proposed that the betrayal theme in the painting could not fully account for the action, which, he felt, pertained more essentially to the institution of the holy sacrament (Fig. 15). He argued that Leonardo's Christ is not the spent force Goethe had made him—passive and silent in the aftermath of his speech. On the contrary: because everything in the picture strains toward him as the ac-

tive principle, and because Christ points to the loaf at his left, while his right hand leads to the wine (omitted in the Morghen engraving!), Antoniewicz concluded that Leonardo's Christ has just said, "One of you shall betray me"; is now saying, "Take, eat, this is my body"; and is about to say, "drink ye all of it, for this is my blood." The immediate occasion, then, "is nothing other, and can be nothing other, than the institution of the eucharist." Meanwhile, the Apostles, according to Antoniewicz, were responding to a twofold alert: those on our left hanging back in reaction to the foregone betrayal announcement still exerting its aftereffect; those on the right startled by the sacramental action in progress. A right/left contrast of present causation and aftershock: the twelvefold reflex was indeed momentary, but in reaction to asynchronous yet coefficient events.

Inevitably, Antoniewicz still clung to the postulate of one punctual moment—a blink between instant and aftereffect, i.e., midway between Christ's successive references first to the betrayal, then to his sacrifice; so that the incontrovertible presence of the betrayal theme in the left half of the picture was to be understood as a reflex delayed, as if Christ had grouped his slower-witted disciples off to one side. Whereas the disciples at right were responding to Christ's speech anent the bread of his body—moments before he would grasp and raise the cup of his blood. Such punctuality now seems needlessly literal, and it marred Antoniewicz's case, eliciting scorn and disregard of his observations, many of them keener than any before. His name and his insights found no place in Vinciana. The *Cenacolo* literature of the following fifty years cites Antoniewicz in just two stomping footnotes intended to seal his oblivion. But his intuition remains amazingly bold, a half century in advance of what art history in his day could digest.

Committed to positivism and objective criteria, scholarship before the world wars was not receptive to duplex

10. For Antoniewicz's complete original text, first English translation (and protracted oblivion), see App. B.

15. Leonardo, *Last Supper*, detail of Christ, before latest cleaning.

interpretations. Where seventeenth-century admirers of the *Cenacolo* had welcomed the picture's amplified vision, one that (for Cardinal Borromeo) *included* "the expression and variety of emotional states," the new methodology called for strict exclusivity. Since the *Cenacolo* was labeled pure psychodrama, its obvious exploration of character was assumed to be irreconcilable with mysteries of the Creed. From the mid-nineteenth century onward, standard descriptions of Leonardo's work become statutes of limitation, insisting that the artist's conception confines itself to one thing. Walter Pater (1869) hails the painting as "another effort to lift a given subject out of the range of its traditional associations. . . ." Max Dvorak likewise (1927, I, p. 181): "Leonardo restricts himself to the representation of a psychological moment." Karl Künstle (1928) sees Leonardo's *Cenacolo* concerned solely with "this subplot" (*dieser Nebenakt)* of the betrayal announcement—and regrets that the artist's preference for such distraction "prevented the realization of a true image of the Last Supper until well into the seventeenth century."[11] Maurice Vloberg's *L'eucharistie dans l'art* (1946) mentions Leonardo's *la Cène* only to declare it irrelevant, since the picture "confines itself to the episode of the denunciation."[12] If art appreciation ever aspired to unanimity, this was its happy hour.

Meanwhile, in America, a generation of readers of the

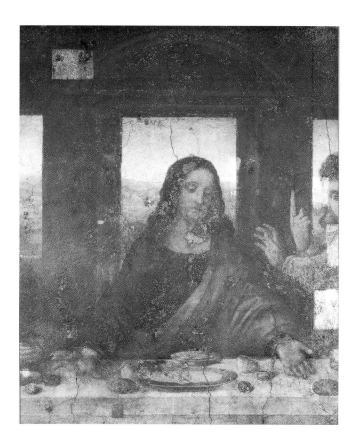

11. Karl Künstle, *Ikonographie der christlichen Kunst*, Freiburg im Breisgau, 1928, I, p. 418.
12. Vloberg 1946, I, p. 111. So also Joseph Destrée (*Les Heures de Notre-Dame dites de Hennessy*, Brussels, 1923, p. 76): *Il ne s'agit pas de la fondation du sacrament de l'Eucharistie.* Meyer Schapiro (1954, p. 330) finds in the fresco ". . . a new approach to the theme of the Last Supper—in spirit more dramatic than liturgical or theological. . . ." Ernst Gombrich's account of the Leonardo mentions the dispensing of the sacrament only by way of contrast. He allows that it occurs in *earlier* renderings of the subject, but "the new picture was very different" (*The Story of Art*, 3rd ed., London, 1950, p. 216). On this point, Gombrich remained adamant even to 1993 (p. 10): "it should be noted that in Leonardo's *Last Supper* there is no visual allusion to th[e] central scene [the Eucharist]: the apostles are all supplied with bread and wine; there is no loaf, no chalice."

Robb and Garrison textbook were learning that "this cele-brated religious painting is not fundamentally religious in character. It represents the psychological observations of the profoundest scientist of his century." Frederick Hartt's textbook, *History of Italian Renaissance Art* (in its 1st ed., 1969, p. 399), explained that Leonardo's chosen moment "enables [him] to bypass the traditional meaning of the Last Supper in Christian art. He is not in the least concerned with the institution of the Eucharist, . . . but with a single aspect of the narrative—the speculation regarding the iden-tity of the betrayer."[13]

TO THE SECULAR VIEW of the picture, which is neither wholly wrong nor exclusively modern, even Rembrandt subscribes. He, too—his interpretation embodied in three lively drawings (Figs. 16, 177, 178)—conceives Leonardo's *Cenacolo* as pure psychodrama.[14] But—and this is crucial—Rubens does the reverse. For him, the subject is sacramen-tal. A large etching (Fig. 17), based on a Rubens drawing and bearing Rubens' name and privilege, shows the table cleared of all but the elements of the Mass: only a breadroll and an ecclesiastical chalice abide before Christ. And while the gestures of the disciples remain unaltered throughout, the subjoined legends gloss the entire event as the moment of the institution, as though the scene represented nothing but the first call to Communion.[15]

What caused this most Catholic painter to go so far astray? Was Rubens too dull to grasp the distinction between the Last Supper's two moments?—unaware that the respec-tive responses to them are not interchangeable? And are they not indeed incompatible in view of the likely emotions aroused? Shock, horror, revulsion at the announcement of the betrayal; mute reverence in receiving the Host?

But Rubens' reading of Leonardo suggests that the churchly decorum associated with taking Communion need not be retrojected upon the instant of the Master's original utterance. At that first signal, when Jesus abruptly offered his flesh and blood, must we assume that the disciples kept their composure? "Whoso eateth my flesh, and drinketh my blood, hath eternal life," he had said at Capernaum—and incurred the affrighted response: "How can this man give us his flesh to eat?" (John 6:52). The Evangelist continues: "Many therefore of his disciples, . . . said, This is a hard say-ing." It must have been harder still when, at that "terrible and awesome table," in that "shuddering hour" (Chrysostom's wording), the pronouncement first heard at Capernaum re-sounded as a peremptory summons. No need to conceive the disciples in self-composure, each "alone with his thoughts"—the only deportment Kenneth Clark deemed appropriate to the proceedings. Why not in fervor and agi-tation? Rubens was not being perverse when he saw Leonardo's Apostles striving for understanding, or yielding undeferred faith. His own presentment of the Communion (Fig. 19) is all conflagration, red-roaring flame: Christ levels the Host at St. Peter, whose tilted head and heaved elbow show him translated from Leonardo's *Cenacolo*.

Granted that we normally associate Communion-taking with quietude—this is why Bossi (see p. 31) thought Christ's distribution of the bread and wine unlikely to stir strong or varied emotions, hence not a good subject for art. But the

13. Hartt changed his mind. Interviewed for *The New York Times Magazine* (Oc-tober 13, 1985, p. 43), he announced that he would alter this text in the book's next edition (1987) because "Leo Steinberg jumped on me and I guess he is right." Hartt forgot that Vasari, Goethe, etc. were included in that same "jump."
14. See App. E, nos. 44–46. Rembrandt knew Leonardo's *Last Supper* only in engraved and etched reproductions (Figs. 4, 17). The more remarkable to see his adaptations accelerate the event until, in the Berlin version, Christ's audi-tors start from their seats in what Kenneth Clark calls a "baroque free-for-all."

15. Reproductions of Pieter Soutman's etching after Rubens usually crop the eucharistic legends in the inscription space. Since these accord with the change in the tableware, they confirm Rubens' reading of the *Cenacolo*. (See also the Rubens School drawing, Fig. 41, and p. 82.) As for Rubens' verbal praise of the *Cenacolo*, it avoids saying anything that would restrict its subject. The text, written in Latin, was published in French translation by Roger de Piles (*Abrégé de la vie de peintres*, 1699; fully quoted in Bossi 1810, pp. 44–45, and in Brown 1983, pp. 24–25).

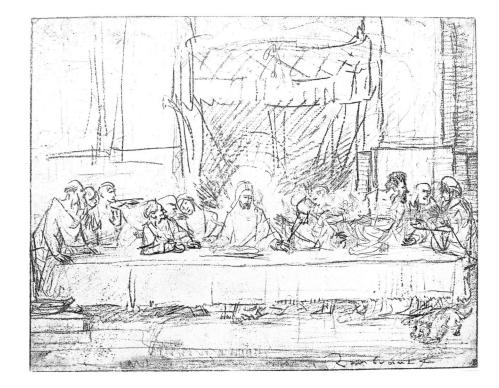

16. Rembrandt, c. 1634-35 (App. E, no. 44).

17. Pieter Soutman after Rubens, c. 1620 (App. E, no. 41). The
legends in the inscription space quote the four scriptural passages
that refer to the eucharist (Matt. 26; Mark 14; Luke 22; I Cor.
11:23). Below, left to right: *Lionardo da Vinci Pinxit: P.P. Rub.
Delin.; Cum Priuilegio; La caena stupenda di Leonardo d'Auinci chi
moriua nelle braccie di Re di francia*

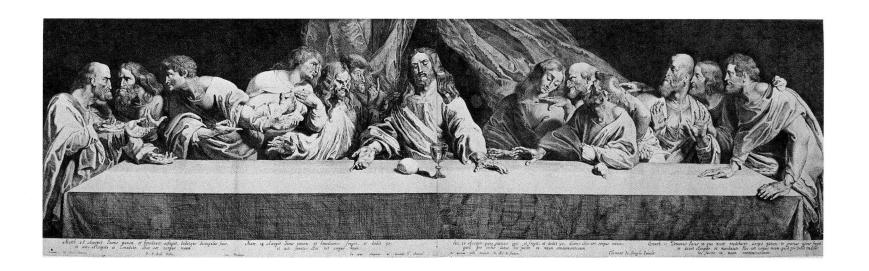

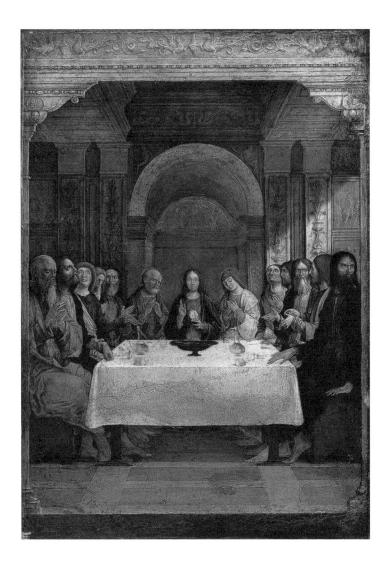

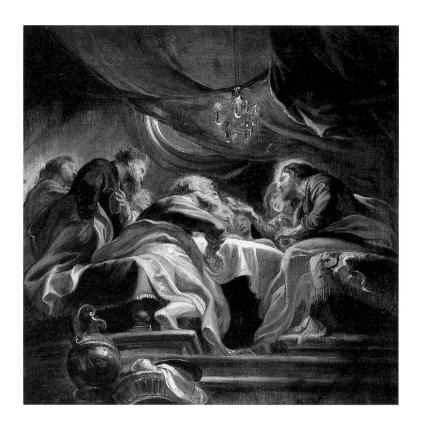

left
18. Ercole de' Roberti (attrib.), *Last Supper*.

above
19. Rubens, *Communion of the Apostles*, 1620.

Apostles' Communion imaged as a scene of extreme per-turbation (as in Tintoretto or Rubens) involves more than breach of decorum. The visualization depends on whether you conceive it ritually as a type of the Mass; or as a sudden irruption of grace; or as the promulgation of an inscrutable mystery; or as all three in one, none excluded. Numerous representations of the Communion of the Apostles (e.g., Ercole de'Roberti's *sportello* panel, Fig. 18) show some of the actors engrossed in disputation. In Leonardo's design, too, the appearance of quandary (as at the far right) could be taken proleptically—the nature of the eucharist as object of theological dispute among believers.

So then, if Leonardo's actors react to Christ's offer with troubled minds, or else (Judas excepted) with instant accord and belief, the image waives the boon of simplicity. Like an object of scriptural exegesis, it fans out into multiple meanings. The dilemma is not this or that—not who is right, Rubens or Rembrandt—but rather, what is it in Leonardo's staging that admits more than one reading?

THE ISSUE BECOMES MORE PRESSING when we discover that the picture lent itself to an alternative reading long be-fore Rubens. As early as 1508, the provincial Cremonese painter Tommaso Aleni, called Il Fadino, painted a *Last Supper* fresco for the refectory of San Sigismondo, Cremona (Fig. 142). The gestures of Christ's nearest neighbors derive closely from Leonardo, but Christ himself—one hand pointing to bread and wine while the other rises in bless-ing—leaves no doubt that the occasion is sacramental.

This is not a lone instance. In Simon Bening's Hennessy Hours (Fig. 20), the *Last Supper* predella under the minia-ture of the *Agony in the Garden* duly transcribes Leonardo's figures, except that Christ's left hand lifts the goblet, while his right blesses, anticipating Rubens' eucharistic interpre-tation. Neither Bening nor Aleni nor Rubens thought the responsive gestures of the disciples at odds with Christ's reinterpreted action.[16]

Yet another instance of such a reading is the early six-teenth-century copy of the *Last Supper* at St. Germain l'Aux-errois, Paris—not as it now appears (Fig. 156), but as it would have appeared in its original state, with the table bare except for the elements of the Mass. This large panel, now in the sacristy, was overpainted in the 1830s to conform with the full-scale copy from the Certosa di Pavia, then

16. Destrée, who published and attributed the Hennessy Hours, comments as follows (see p. 39 n. 12): "The predella displays a copy of Leonardo's *Last Supper*. The use of a chalice in a subject whose significance is wholly dramatic proves that the Flemish artist had mistaken the meaning of the work of the Italian master."

Rethink Leonardo, and Master Bening's "mistake" shifts to Destrée.

newly acquired by the Royal Academy, London (Fig. 145). The original state of the St. Germain copy is recorded in a print of 1768 (Fig. 22), engraved after a (damaged) sixteenth-century black chalk drawing at Windsor (Fig. 21). Both drawing and print show Leonardo's composition punctiliously reproduced, except for two striking changes: an architectural set copied from the St. Germain panel; and a table, as in Rubens' version, cleared of all but breadloaf and chalice.

In short, the tradition we are pursuing—the perception of Leonardo's actors in reaction to the institution—reverts to Leonardo's own day. The Rubens School etching with its sacramental inscriptions either rediscovers the alternative interpretation by rethinking the work, or else spells out an interpretation that had been always around.

Even Raphael may have understood Leonardo's creation in more than one sense. His design for Marcantonio's engraving of the *Last Supper* (Fig. 7) depicts the announcement of the betrayal, but the lone wafer in front of Christ renders the subject "ambiguous." Some will argue that the inclusion of this one feature does not suffice to ambiguate; that bread and wine placed before the protagonist in scenes of the betrayal announcement serve allusively, parenthetically, i.e., as a reminder of what more the occasion entails. This is not incorrect, but I think it misses the point: that the artist found the depicted conduct of the disciples compatible with eucharistic "allusion." On the scale of the Raphael composition, one wafer is indeed a small token. But with the cumulative evidence furnished by Simon Bening, Aleni, and the St. Germain copy (before overpainting), it confirms that the interpretability of Leonardo's *Cenacolo* as the sacramental moment was recognized early in the Cinquecento. That this recognition continued beyond Cardinal Borromeo and Rubens into the eighteenth century emerges from a letter written by the sagacious Charles de Brosses from Milan in 1739: "In the refectory of the Graces, the institution of the eucharist, painted in fresco by Leonardo da Vinci; I have seen nothing more beautiful here. . . ."[17]

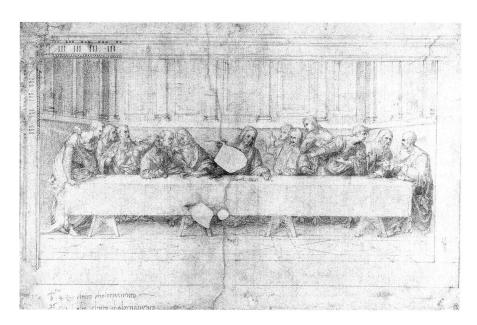

21. Anonymous, after the St. Germain copy, sixteenth century (see App. E, no. 18).

22. W.W. Ryland, 1768, after Fig. 21.

WHAT WAS NOT ALWAYS AVAILABLE was a temper that could tolerate ambiguity in a paradigm of Renaissance art. Not until 1952 was the note sounded by Antoniewicz in 1904 struck again. Then, in a brief radio talk on the BBC, Edgar Wind presented the whole pictorial drama of Leonardo's *Last Supper* as an "opposition of loss and offering, of the great gift and the great sacrifice, which are embodied in the Eucharist." According to Wind, "[Christ's] two hands perform opposite and contradictory actions. The hand on the side of those who understand His announcement mystically and pragmatically, is opened as in an offering. The other hand . . . is in a gesture of prehension or apprehension, as if Christ were saying, on the one side: 'I am offered to you; I am given to you as the food of salvation'; and with the other hand: 'I am taken away from you, one is among you that will betray me.' There is, as it were, a negative and a positive side, as there is actually, in the sacrifice of Christ. . . ." Like Antoniewicz, Wind contrasts the two sides of the picture: "On the negative side a melancholy and a violent reaction…on the positive side an enthusiastic, that is to say, ecstatic and accepting reaction." But Wind's grasp of the subject was still premature. A recognition of the religious cast of the picture began to take hold only during the 1960s.[18]

In 1961 Herbert von Einem decided that the motion of Christ's hands toward bread and wine (Fig. 15) could not be fortuitous (or, in Otto Hoerth's precious formula, another "chance optical constellation"). Sensing that the depicted event surpassed both simple meaning and temporal unity, von Einem wrote (1961, p. 63):

In the biblical text [in Luke only], the institution of the sacrament precedes the betrayal announcement. Thus (if the unity of time were to be strictly respected) it must have already occurred. Leonardo lifts it out of the temporal sequence and gives it permanence. Christ's gesture must not be referred only to the announcement of the betrayal (as Goethe and his followers have done). While the disciples are disturbed only by the threatened calamity, Christ, by his gesture, seals his divine mission. Only when we consider the double sense of his gesture do we understand it in full.

This goes some way, but not far enough. In von Einem's reading, the disciples (without the Antoniewicz-Wind differentiation of left and right) are "disturbed only by the threatened calamity," missing the full sense of Christ's gesture. The gesture, then, "seals [Christ's] divine mission" in a manner intelligible to the interpreter, but not to the company, including the Evangelists Matthew and John. We are asked to believe that Leonardo, lifting the institution "out of temporal sequence," froze the disciples at a point just prior to their Communion, so as to dramatize apostolic incomprehension (a notion previously sounded by Heydenreich, see p. 48). This, to me, seems unlikely, but I can see how it profits the interpretation. It acknowledges a mystical action at the epicenter, without need to rethink the rest. The response of the Twelve remains uncomprehending and unambiguously simple: anxiety over the betrayal announcement has darkened their wits. As Luisa Vertova would echo soon after:

17. *Au réfectoire des Grâces, l'institution de l'Eucharistie peinte à fresque par Léonard de Vinci; je n'ai rien vu de plus beau ici…* (Charles de Brosses, letter of July 17, 1739, in *Lettres d'Italie du Président de Brosses*, Paris, 1750).

18. Wind's radio talk, published in *The Listener*, 47 (May 8, 1952), included one final extravagance: that the four groups of Apostles symbolize the four modes of scriptural exegesis and the four Temperaments. Not surprisingly, the one-sentence summary of the talk in the *Répertoire d'Art et d'Archéologie, 1952* (Paris, 1956, no. 8758) bypasses Wind's central eucharistic theme, to cite instead only his coda, which conformed better to the received notion of

Leonardo as scientist: *Les personnages de la Cène incarnent des types psychologiques et peut-être des "temperaments" au sens médical.*

Leonardo's jubilee year made one other eminent scholar try to amplify the *Cenacolo*'s meaning: "the depth of the room with the view of far away hills and sky…seems to point to the worldwide, universal significance of the institution of the Most Holy Sacrament" (Wilhelm Suida, "Leonardo's Activity as a Painter—A Sketch," in *Leonardo: Saggi e ricerche*, ed. A. Marazza, Rome, 1954, p. 320). But can eucharistic significance be conveyed by room size and panorama? The author was eager to find, but at a loss where to look.

The drama unfolds before us with utmost clarity. Christ has announced his imminent destiny, and an abyss sunders his suffering, loving divinity from the grief-stricken amazement of his disciples. All believe in Christ, but as a man—unable to separate from the man the Truth which he represents (Vertova 1965, p. 55).

It is a convenient solution, this stupefying of the Apostles. To the central action it concedes complex meaning—on condition that ambiguity contaminate nothing else. But von Einem, writing in 1961, at least reopened the question.

Four years after von Einem's paper, the theologian Karl Th. Schäfer caused a further disturbance. He reasoned that if Christ's gesture did indeed have a "double sense," then its other sense must be somewhere reflected in the reactions of the Apostles; they could not every one of them misunderstand. Unaware of the larger framework long since proposed by Antoniewicz and Wind, Schäfer found his hunch confirmed in two figures: in the St. Philip (third on Christ's left), who offers himself in response to the self-offering of the Master; and in St. James Major (with outflung arms), whose alarm, Schäfer thought, expresses a sudden wonder over the *mysterium tremendum* unfolding before his eyes (1965, p. 217).

To these two, Schäfer granted enlightenment above the rest. The emphatic St. James, a character who had long been safely aghast at the revelation of treachery, was to be newly perceived—by assuming a different stimulus—as a man awed by the miracle of the Mass.[19] The proposed conversion marks a new approach to the painting. After 150 years of confident secularism, the work was being scanned for signs of ulterior meaning. The method employed is still scattershot: one or another figure, this or that telltale feature,

is singled out. Still lacking is the perception that the entirety of the *Cenacolo* imparts dual meaning.

The change of intellectual climate shows up in the decade's textbooks. Suddenly, in 1962, H. W. Janson's brand-new *History of Art* (p. 350) credited the *Cenacolo* with "many levels of meaning at once." How so? Because the Christ's gesture of "submission to the divine will" hints at his "main act at the Last Supper, the Institution of the Eucharist." Janson, who would have read von Einem's paper of the previous year, elaborated no further. Nor do we know what student users of his best-seller made of those unspecified "many levels." But we do have a record of rival textbooks quickly falling in line. Compare the fourth and fifth editions of Helen Gardner's *Art Through the Ages* (1959, p. 328, and 1970, p. 453, respectively). In the earlier edition, the *Cenacolo* displays only a "highly dramatic action." The fifth edition interpolates this one sentence: "Leonardo has made a brilliant conjunction of the dramatic 'One of you will betray me' with the initiation of the ancient liturgical ceremony of the Eucharist." A slotted insert backed by no new observation and unexplained; but by 1970, "brilliant conjunction" had begun to sound right. High time to rethink the contrasting interpretations of Rubens and Rembrandt, and to ask how Leonardo contrived to make the uproar over the treason announcement interpretable as also a reflex to the words "Take, eat, this is my body."

Recent Writing About the Cenacolo

Down to the mid-1960s, nearly all of the literature on Leonardo's *Last Supper* rested on four reassuring assumptions: that the action unfolds in a rectangular chamber; that

19. The interpretation of James' gesture as a response to a mystery (Antoniewicz, App. B, p. 207, restated by Schäfer in 1965) finds support in paintings that reenact the gesture in open reference to Leonardo, but transposed to a mystic moment. So Caravaggio's *Supper at Emmaus* (London) assigns James' outflung arms to a disciple at the blessing of bread. Yet Horst Lozynski (in

Enthüllte Geheimnisse vom Abendmahl des Leonardo da Vinci, Überlingen, 1987, I, p. 26) declares it "unthinkable" that James be concerned with the sacrament, since his attitude expresses shock and revulsion.

Well then, let's think again: surely, that which has been repeatedly thought cannot be other than thinkable.

the subject of the betrayal announcement is subject enough; that the commotion at table admits no sacramental digression; that the most scientifically minded of Renaissance masters would not have lapsed into equivocation. As one redoubtable scholar put it, Leonardo created the *Last Supper* "by the simplest means" and "had no wish to bewilder by means of secondary effects."[20]

Now every one of these certainties totters. Above all, the eucharistic presence in the picture has become difficult to deny. Yet some holdouts still do; they are scholars who see Leonardo as a philosophical proto-scientist, a secular skeptic who might exploit a narrative furnished by Scripture, but would not encumber it with more doctrine than the story line needed. Within recent *Cenacolo* literature, the disagreements are waged in the open, the contenders differing about what seems to be simply there. Why, then, the dispute?

Because every *simply there* gets unsimpled as it expands into context, and the context spreads wide. The right hand of Christ, for instance: it becomes controversial as soon as you ask what it intends, what it targets, threatens, repels, or engages; what it correlates with—even to floor and rafters. And the relevance of alleged context is always deniable, always open to question. Is it significant that an orthogonal of the perspectival construction finds its concretion in the right arm of Christ?—that this arm (as Antoniewicz was the first to observe) aligns with a beam of the ceiling (Fig. 117), and probably with a stripe in the floor? An anatomical member, an arm advancing its hand—and a spacewide web: should their mutual integration register as part of a system wherein that hand's reach grows illimitable? Is Christ's right-hand gesture relative only to Judas, or, forget Judas, correlative only with Christ's other hand?

An Italian psychologist, Dr. Gino Modigliani, writing in 1913, looked at Christ's two hands together (Fig. 15) and read the contrast of their respective attitudes as the revelation of ultimate incarnational mystery. In the open *left* hand, he thought, we were to see Christ's offer of his redemptive self-sacrifice. But the divine nature revealed in this offer has not yet fully subdued Jesus' vulnerable humanity, so that, death approaching, his "nervous" *right* hand convulses in "a movement of instinctive rebellion."[21] That all-too-human right hand, according to Modigliani, recoils from the threat of death, anticipating Jesus' subsequent plea on the Mount of Olives—"Father, if it be possible, let this cup pass from me."

It is this sort of reading that most modern readers deplore. One scholar of the mid-1970s would not have Christ's right hand linked to his destiny, nor to the wineglass before it, nor to any object in reach. That hand, wrote Hans Ost, is not pointing, since pointing is done with the index finger. Nor is it positioned to pick the glass up. Rather, he says, this hand "commands '*calma*!,' 'silence!' [Christ] is subduing…the tumult with the same gesture by which even today Herbert von Karajan [the conductor of the Berlin Philharmonic in 1975] restrains his *Philharmoniker*."[22] Ost is serious; he is gravely concerned not to let Leonardo's art be "returned to the framework of Christian iconography." His Leonardo is to remain anticlerical, the *Last Supper* as far as possible aloof from religion, and Christ's right hand innocent of complicit christology.

The most recent German monograph on Leonardo's *Cenacolo* (1998)—Georg Eichholz's 550 pages of text plus backmatter and generous illustrations—surveys vast deposits of previous writing; puts Christ's right hand through meticulous digit-by-digit examination; compares and contrasts other right hands in fifteen other *Last Supper* Christs (including Holbein's, Titian's, El Greco's, and Tiepolo's;

20. Max Gronau, *Leonardo da Vinci*, London, 1903.

21. Gino Modigliani, *Psicologia vinciana*, Milan, 1913, quoted in Malaguzzi Valeri 1915, p. 526.

22. Hans Ost, *Leonardo-Studien*, Berlin, 1975, pp. 88–93.

pp. 460–62); and concludes that the dexter work of Leonardo's protagonist is too ambiguous to be psychologically decipherable—yet lucid enough to exclude sacramental distraction. Eichholz, still following Bossi and Goethe, is anxious to retain Leonardo for secularism. Accordingly, he spurns all attempts to sacralize any part of the action, preferring at each point a "profane interpretation," or none (pp. 180–81). In his view, "an independent-minded artist and investigator such as Leonardo would more probably let himself be guided by the insights of natural philosophy than by dogmatic theology."

It must be a very different motive (abhorrence of ambiguity?) that led Father Angelo M. Caccin, O.P.—a Leonardo scholar and former prior of the Dominican monastery which hosts the *Cenacolo*—to deny the picture a sacramental component. "It's ridiculous to say this is the institution of the eucharist; the Apostles wouldn't be so alarmed and angry if Christ was initiating the eucharist." But the good father's argument spins in a circle. He thinks he sees anger because that would be the fitting reaction to the betrayal announcement. Where the subject is seen as complex, alarm yes, but no anger.[23]

THOSE WHO ALLOW a eucharistic factor to the *Cenacolo* are, at this writing, ascendant. As Jack Wasserman put it in 1983 (pp. 23f.): "Most authorities now concede that [the picture] is an amalgam of two consecutive situations. . . . However, despite the general agreement regarding the dual interpretation of the painting, there remains still a residual ripple of doubt, which, if left to languish, is potentially unrewarding. . . ."

Most authorities now concede . . .; but their concessions are variously hedged. Discounting the authors of textbooks (who squeeze in the sacrament to stay in the swim) one observes indecision even among eminent *Leonardisti*. Some vacillate between what they see and what must now be professed—not, I think, from personal instability, but because the predicament offers no easy way out. For an older scholar, any symptom of ambiguity in the *Last Supper* could be traumatic.

Consider the case of the renowned Ludwig Heydenreich. His full-scale *Leonardo* (1943; English ed. 1954) had allowed the picture no hint of the sacrament. Nor did his brief *Abendmahl* of 1958. Here Christ is understood to be saying "One of you shall betray me," while the disciples, Judas excepted, respond in troubled incomprehension. Sixteen years later, in a 1974 monograph on the *Last Supper*, the author seems to be eyeing a different picture. It is now introduced as "an ideal pictorial representation of the most important event in the Christian doctrine of salvation—the institution of the eucharist..." (p. 12). On the other hand, "what we see in the painting is . . . [Christ's] first and to the disciples still mysterious reference to the treachery" (p. 46). So then, in Heydenreich's reading, the disciples are doubly baffled—oblivious as yet to the eucharist and bewildered as well by the treason announcement. Yet this bewilderment, though it constitutes *what we see in the painting*, turns out to be marginal, since, as we learn a few pages on, the depicted episode of the betrayal announcement is "only the framework designed to direct our thoughts to the essential meaning of the sacred scene, the institution of the eucharistic sacrifice" (p. 61).

Does this make sense? Whose thought is directed to the *essential* eucharistic meaning of the picture by the consternation of the disciples? Not Father Caccin's; nor the author's own earlier thought; nor that of Goethe, whose "masterly" interpretation, Heydenreich tells us (1974, p. 55), renders any other description superfluous. In fact, from 1800 to past

23. Father Caccin is quoted in Curtis Bill Pepper, "Saving 'The Last Supper,' " *The New York Times Magazine*, October 13, 1985, p. 44. In a responding letter I pointed out that the matter was open to interpretation. Citing the contrasting opinions of Rembrandt and Rubens, I warned Father Caccin that

he was associating himself with a Dutch heretic "against a loyal son of the Church." The *Times* ran the letter (November 24, 1985, p. 162), but wisely docked the terminal provocation.

1950, all commentators (save Antoniewicz and Wind) insisted that the dramatic sweep of the action forbids eucharistic associations.

Think what Leonardo's formerly "clear" presentation has now become. Heydenreich cites both Wind and von Einem. But the concession these authors wring from him gives us a strangely indirect picture. While Heydenreich's Christ, saying "one of you shall betray me," causes *what we see in the painting*, Christ's hands secretly mime a weightier message unnoticed by the disciples. Such a reading, which makes only the stealth at center "essential," renders inessential most of what we are given to see. A link seems to be missing; is the picture psychodrama or sacrament? For a scholar of Heydenreich's generation, it was difficult to get these acts together.

DIFFICULT IT STILL IS, hence the felt need to keep the sacramental intrusion in check. Of course, we are told, bread and wine at Christ's fingertips hint at the elements of the Mass, but hinting is all they do. Within the economy of the picture, these elements are not assertive enough to determine the subject. The eucharistic moment in Leonardo's *Cenacolo* is at best present by intimation, not actually represented. Creighton Gilbert, like Anna Maria Brizio on the same refutational errand, grants Leonardo's picture its sacramental strain only to the extent that the eucharistic idea inheres in the mere concept of the Last Supper (Gilbert 1974, p. 393; Brizio 1983, p. 21). Gilbert sees Leonardo "alluding to it by subtle hints." Joseph Polzer admits it by subtle reference only.[24] Martin Kemp's fine Leonardo monograph of 1981 (p. 191) finds "many aspects of the Gospel narratives . . . explicitly or implicitly apparent," and observes that Christ's hands "suggest his institution of the eucharist." Fifteen years later, in his Leonardo entry for *The Dictionary of Art*, Kemp (p. 189) closes a brilliant paragraph on the *Last Supper* with a eucharistic codetta: "The dominant intention is to convey the varieties of reaction to the central charge of Christ's impending betrayal. The theme of the institution of the eucharist, signaled by Christ's gestures towards the wine and bread, would also have been readily understood"—leaving unclear by whom, by how few or many, and at what point in time this also-ran theme would have been "readily understood." And so, most recently, Eichholz, in a sentence of exquisite convolution, wherein—to preserve temporal unity—the symbolic allusion to bread and wine is said to be not unambiguous, but, on the other hand, "not explicitly excluded."[25] Here again, Christ's *overt* act in the painting contracts to the betrayal announcement. Though the eucharistic theme is no longer deniable, one can at least quarantine it, contain its centrifugal force, lest the contagion of ambiguity infect the whole picture.

THIS SEEMS TO ME too half-hearted to do the *Cenacolo* justice. The twin themes under discussion, the narrative and the mystic, do not come rank-ordered, one dominant, the other subdued, unless so graded by interpretation. In the alternative reading proposed in this book, the two—the submission to death and the grant of redemption—come partnered into very coincidence, like the two natures of Christ.

Not surprisingly, modern viewers normally find Leonardo's overriding concern in the expression of character and emotion, to which all else in the painting defers. But such ranking may be due to a prejudice carried over from social experience, i.e., from our habit of consorting with

24. Polzer (1973–74, p. 68) finds "the poses of [Christ's] hands…clearly ambivalent. They generally lead toward bread and wine…and hence refer subtly to the Eucharist and the Communion of the Apostles."

25. Eichholz (1998, p. 512): *Den symbolischen Hinweis auf Brot und Wein schliesst er zwar ausdrücklich nicht aus, unterlässt mit Bedacht aber auch einen entsprechend unzweideutigen Hinweis, um nicht die zeitliche Einheit des Bildes, der er soviel Mühe zugewandt hat, am Ende doch noch wieder zu sprengen.*

our own kind. Depicted characters, no matter how deceptively realistic, are of a kind somewhat different. They don't entertain us like a roomful of people. Their society, their connectedness with the rest of pigmented matter, is of another order, an order that allows the most asocial redistribution of status. When we approach a buffet at a party, we tend to see fellow foragers before discerning the canapés; but suppose the approach is to a painting. In 1520, a French cleric (Pasquier Le Moine) who had accompanied Francis I on a visit to the *Cenacolo* five years before, described his experience of the picture as follows:

> The Supper of Our Lord with his Apostles, painted flat on the wall at the entrance of the refectory on the side of the entrance door, which is a thing of extraordinary excellence, because as one sees the bread on the table one would say that it is actual bread, not simulated. The same can be said of the wine, the glasses, the vessels, the table and tablecloth, of the food, and of the personages themselves.[26]

Observe the precession: first bread, wine, and still life—then human trailers tacked on as if afterthought. I doubt that a modern explicator or tourist would itemize in that order.

But even a twentieth-century scholar may invert the normal priorities. In 1938, Max Raphael wrote a remarkable paper (not published until fifty years later).[27] Its theme was the structure of space in Leonardo's *Last Supper*, a structure found to be so *semantic* that the author declared it to be the picture's dominant vehicle of signification, subserved by the figures. On this view, the spiritual content of the *Cenacolo* was "visualized and made immediately visible" in the effect of the perspectival projection. Of course the author overstated his case. His attentiveness to the eloquence of the fabric made him belittle the relative import of the *dramatis personae*. In copies that reproduce the figures alone, Raphael

wrote, the effectiveness of the work is almost entirely lost—which is manifestly untrue. But the argument demonstrates that the temptation to grade the parts of Leonardo's organic totality on a scale of importance is hard to resist.

It depends on one's preoccupations. A devotee of perspective, caught up in the inexhaustible fascination of Leonardo's spatial construction (see chap. VIII), hardly cares that the room is inhabited—so impregnated with thought is this housing. Perverse, perhaps, but (in a limited way) we can share such perversity by turning a reproduction of the *Cenacolo* on its side, discovering that the thirteen half-length figures fill less than one-fourth of a field whose other three-quarters are all energy and no slack.

To privilege one thing over another—this is, of course, what we do we scan and change focus. But the selections made are our choosing, whereas the painter's imagination repletes the whole. As Leonardo produced the *Cenacolo*, he lent as much verve to a sleeve as he did to the faces; gave the most ardent gesture equal attention with tableware; lavished no less precision on the tiny hooks that hold up the tapestries than on men's eyes. Leveling of this sort may not reflect the values that sustain our social life, but we are talking about a painting—a picture in which (as both Antoniewicz and Simmel observed) there are no bystanders; every one of the Twelve counts alike. Simmel, concerned with the actors only, remarked that there is no comparable egalitarianism in earlier group pictures (p. 25). This is true of the figures. But the distribution of equal emphasis in this painting is all-pervasive; and it springs from a habit of mind. For us to assert which pictorial feature, which moment of the Gospel account, or which evangelical text was uppermost in that mind is to say more than we rightly know.[28] As I see it (excepting only the Christ), Leonardo posits no hierarchy of

26. Pasquier's recollections were printed in Paris in 1525. Published by Luca Beltrami in 1890, the text was reprinted in Hoerth 1907, p. 15, and again in Pedretti 1983, p. 39.

27. Raphael 1938, pp. 84–96. It is one of the merits of Eichholz's overview of the literature to have restored Max Raphael's thinking about Leonardo to modern attention (Eichholz 1998, p. 93).

effects, no underprivileged portion, no theme ancillary, admissible only as intimation, hint, or allusion. Whatever is, is there in full presence. Gronau in 1903 thought Leonardo unwilling to bewilder with "secondary effects." Now, almost a century later, scholars assert that the theme of the eucharist in the painting must be exactly that, a secondary effect.

AN INTERESTING CASE is the work of the American scholar Jack Wasserman, whose commentary on the *Last Supper* comes in three steps. In the introductory essay of his 1975 monograph, *Leonardo da Vinci* (p. 30), we read that Leonardo "set out to represent the biblical story of the final supper before the betrayal and crucifixion." The text proceeds:

> Never before Leonardo's fresco had this narrative been portrayed with such clarity, with such concern for the unity of time, place, and action, and with such attention to the precise representation of the very moment of the revelation of the betrayal to come.

This seems straightforward in the conventional mode; call it phase I. But in the commentaries on the plates (p. 94), we learn that "the episode was also the occasion for a symbolic revelation…establishing the sacrament of the Eucharist…. Leonardo represented this aspect of the event also."

What, then, becomes of that unity of time and action praised in the text? Is this impatient Christ instituting the eucharist in a split-second sequel before his foot-dragging friends have recovered from his previous speech? Recognizing the problem, Wasserman resorts to the Heydenreich-von Einem notion of apostolic incomprehension. "Oddly enough," he writes, "the doctrinal lesson is lost to the apostles, who instead react solely to Christ's pronouncement of the impending betrayal." But then comes this further step; call it phase II:

> One has to assume from this, and from Christ's strongly frontal position in the painting, that Leonardo meant for Christ, in his didactic role, to address another audience—the monks assembled before Him in the dining hall. His outstretched arms serve to emphasize the elements of the Eucharist, and at the same time to appeal poignantly to the congregation partaking of their own meal before Him.[29]

This suggestion, though briefly stated, is big with consequences—which Wasserman did not pursue. When he retackled the problem in 1983, the eucharist in the *Cenacolo* was again marginalized. Since it seemed "odd" for the Apostles to be unaware of Christ's ongoing action, Wasserman now ventured a "highly speculative" proposal (phase III): that the picture may have been structured at first without any regard to the eucharist; that it was planned to illustrate the single theme of the betrayal announcement; and that it was so carried forward until the death in childbirth of the ducal patron's young wife, Beatrice d'Este, on January 3, 1497—when the painting must have been far advanced. "It would not be unreasonable to propose," Wasserman writes, "that the death of Beatrice was the circumstance that suddenly had caused Leonardo to change the theme of the painting to include the institution of the Eucharist" (1983, p. 29).

Such a scenario could only be offered in the belief that the eucharistic factor in the *Cenacolo* depends exclusively on the negligible near-nothing of a plain drinking glass and an undistinguished breadroll. These, on the scale of the composition, are indeed modest, and we have seen copyists (including the painter of the excellent Hermitage copy, Fig. 27,

28. Since the Gospels of Matthew and Luke disagree as to the sequence of Communion and betrayal announcement, scholars have wondered which version Leonardo rejected in embracing the other. Leonardo's rendering—opting for atemporal simultaneity—falsifies neither Gospel.

29. Literalists might object that Wasserman's reading disengages the eucharistic rite from the Communion of the (as yet uncomprehending) Apostles, whereas it is precisely in the Apostles' Communion that the rite is established.

and Goethe's informant Raphael Morghen, Fig. 14) leave one or both of them out. If you think the sacramental element in the picture confined to these items, and nothing else in the picture confirming, then, to be sure, the eucharist in Leonardo's *Last Supper* becomes thinkable as a last-minute addendum—in Gilbert's wording (1974, p. 390), "the minute modification of adding the wafer and chalice." But was Christ's frontal address to the flock in the refectory (Wasserman in phase II) also part of that afterthought?

It seems to me that Wasserman in his middle phase may have been on to something, and that he dropped a good idea too soon. The suggestion that Leonardo intended those on the refectory floor to behold something other than what the characters in the picture can see carries huge implications. Where Antoniewicz and Wind had made the picture's twofold subject divide left from right, Wasserman's motion has the dichotomy pivot through 90 degrees, perpendicular to the field. The betrayal announcement would be the cause of whatever happens within the representation; the institution of the sacrament would be directed to us.

This formulation is immediately helpful in preserving unity of time and action—for the staged characters. They react to a fleeting, just-given signal, whereas we, stationed outside, face the Celebrant out of time. The distinction, then, is not between now and next, but between momentary and evermore. And one further advantage accrues: since no gesture Christ makes can be inconsequential, and since Christ's present action indicates bread and wine, it is better to give that action a cognizant audience (albeit outside the picture) than to have it performed only to pass unrecognized by the Apostles.

BUT THERE IS MORE—so much more that we may be approaching a major Leonardo invention. Put the question this way: when did painters of narrative pictures begin to exploit the difference between what we see and what appears to the characters in the drama? As fifteenth-century naturalism gained ground, did this distinction register and acquire semantic value?

Of course, there is always a difference. Sighting from diverse positions, no two viewers, whether in- or outside a picture, get the same view of an object at any one moment. A bystander to a couple of gossips sees them seeing each other full face, while he sees their profiles; so what—such aspectual diversity is not, need not be, meaningful.

Significance may come in where a story is told. In narrative pictures, a covert action off center, a furtive entrance upstage—unobserved by the foreground characters—may be leaked to us to further the plot. But such byplays are anecdotal details; they do not suffuse field and structure, actors and setting. A radical difference between our overview and the glimpsing allowed to the *dramatis personae* is not intended.

It is precisely what Leonardo's *Last Supper* intends. To the beholder outside the picture, more is given than a privileged aspect of Christ's face and hands, while the tabled Twelve see only his right or left side. The frontality blatant to us also gives us Christ's upper body as an equilateral triangle; shows that sign figured before triune fenestration and under the curve of a gable subtended by the centric point of the perspective, which lies in the right temple of Christ. These felicities of design are revelations of godhead, vouchsafed only to us. Above all, we alone see every orthogonal homing in on that temple and issuant from that same hub (Fig. 115). All this we receive because we are neither inside the picture's space nor participant in its narrative. What we do see as we watch the protagonist irradiating his ambience is a hieratic/dramatic presence, at once cipher and narrative, the two more than conjoint—inherent in one another.

Such mutual inherence poses a problem, and it explains why any one exegesis is refutable by another. Where one reading posits the picture's protagonist as sacred icon, almost a logogram, a counter-interpretation points to the man's overwhelming humility. Behold Christ's vailed glance and the cast of his head: such admission of personal sorrow

bespeaks a temper foreign to hieratic icons. True; and I see the resultant dilemma deliberately engineered. An equilateral triangle that gentles its apex and grieves: it is Leonardo's way of sustaining duality by an antithetical touch designed to disqualify any unilateral reading. As a player in a historical episode, Christ companions his fellows and, unlike earlier hieratic Christs that surpass their narrative moments (e.g., in Piero della Francesca's *Resurrection*), he glances aside, not at us. But, beholding Christ's grief, do we suppose him aware that his head centers the curvature of that overdoor gable; that his arms spread in line with two beams of the ceiling; that the whole system radiates from his brow? Imagine this Christ (for a moment) unaccompanied by anything but the perspectival construction. As the bestower of the instruments of salvation, he presides at the heart of his aura—an almost medievalizing presentment, as close in structure to, say, Andrea da Firenze's *Via Veritatis* fresco (c. 1365) in the Spanish Chapel at Santa Maria Novella, Florence, as to any Quattrocento *Cenacolo*. In Andrea's *Maestas Domini*, an immense, centered, insular Christ thrones within a mandorla, approached on each side and in multiplied anonymity by files of angels. Leonardo creates a very different image, but the orientation from center out is the same. We are shown a theophany, and we will find the elements of the eucharist to be crucially part of that showing.

As for the widely alleged incomprehension of the Apostles, I see no reason to declare them oblivious to the institutional moment. The argument for their unawareness is circular. Where an interpretation restricts the depicted event to the betrayal announcement, the disciples are condemned (by that interpretation!) to overlook any fidgeting of the speaker's hands; it becomes irrelevant, seeing that Christ has just uttered the accusative *one of you*. The perturbation caused by his speech—each man's instant anxiety, "Lord, is it I?"—prohibits attention to what Christ's hands may be

doing. But we have this alternative. Where the betrayal announcement and the institution are perceived in coincidence, the apostolic response becomes correspondingly many-layered. And why should the Apostles, moments before their Communion, not understand? Insofar as Christ's gesture leads to both bread and wine, they would be hearing his summons, *Take, eat…,* and hear the word *This*: This is my body, this wine, this bread. This much they can see. What they miss is the context of a transfiguring blaze that issues to us, and to us alone, from the speaker's frontality.

Did earlier *Cenacolo* painters empower the difference between our visual field and that of the diners? I think not, if only because they seat Judas on our side of the table. Had Gaddi, Castagno, Ghirlandaio, or Perugino (Figs. 30, 86, 121, 122, 124) conceived Christ's full face as semantically distinct from the profile visible to his friends, they would not have reserved the privileged aspect for the betrayer. Here, perhaps, lies one reason why Leonardo placed Judas in line with the others. His conception of the *Cenacolo* as simultaneously narrative and hieratic admits no impediment on the longitudinal axis. The theophany must proceed undisturbed.

WHAT, THEN, IS THE PICTURE ABOUT? To quote Leonardo again, as was done in the foregoing chapter: "Your tongue will be paralyzed…before you depict with words what the painter shows in a moment." With this caution in mind, let's just say that the painting tells laterally, and tells something else longitudinally; that it conflates the ritual and the episodic; conflates as well the two natures of Christ, whose earthly peril aggrieves the disciples, while his divinity manifests itself in his shape, in his gift, in their faith, in the responsiveness of the perspective, in the beholder's perception. I take this bounty to be the subject of Leonardo's *Cenacolo*, and will try not to trim it—at least not knowingly—in the following chapters.

·212·

CHAPTER III

Of Hands and Feet

NO ONE SEEING THE PICTURE misses the show of hands at the center, but what are these hands seen to be doing? The question is put in the passive to urge this next question: *Seen to be doing* by whom, and at what stage of the picture's reception? Simply to ask what the hands of Leonardo's Christ engage or address (Fig. 24) is an interrogation of history as much as an invitation to look.

Let me review the right hand. Would its enterprise change if the table were cleared? Some thoughtful copies of the *Cenacolo* do indeed strip the board of what is felt to be needless clutter—every vessel within reach of that hand is removed (Figs. 33, 149, 175). The effect is to leave it aimless, gesticulant without direct object, yet, in the copyists' judgment, without significant loss.

Then, at one historical moment, that right hand became suddenly *transitive*, literally "passing over"—a hand in transit to bond with some other thing, some object close by that would motivate its operation. So far as the record tells, no such bonding was noticed until 1625, when Cardinal Borromeo conjugated Christ's gesture with the dish at his right, and thence, moving on, with the extended (or recoiling) forehand of Judas. The result, in this reading, was a triple sequence—hand-dish-counterhand—a connection which the

cardinal took to be the mainspring of the overall action (p. 19).

Of course, you were not compelled to agree. What with Christ's face averted, and Judas two seats away, and the plate between them pertaining to John, you didn't *have* to attach Christ's right side to that sequence. The mirage of a dish beset by inexplicable hands could be dismissed—in the felicitous phrase I keep quoting—as "a chance optical constellation," so that Christ's hands, both of them, would remain self-sufficient, *intransitive*. In this isolationist spirit, Hans Ost argued (as already mentioned, p. 47) that Christ's *dextera* must be pleading for silence, bidding the Apostles to cool it, calm down. If Ost is right, then all further meaning derived from that "chance constellation" is wrong.

The disagreements are not easily settled. Wanting external proof, arguments for probability must be wrung from the visual data, and that is hard work, because, as Tom Hess used to say, it takes years to look at a painting. He should have said centuries.

It took until 1904 to discover another connection. Not till then was the wineglass brought into the picture, i.e., made relevant to the proceedings. This feat Antoniewicz accomplished by seeing Christ perform one compound gesture: he noticed both hands in concert reaching halfway across the

23. Leonardo, study for the hands of St. John, Windsor 12543.

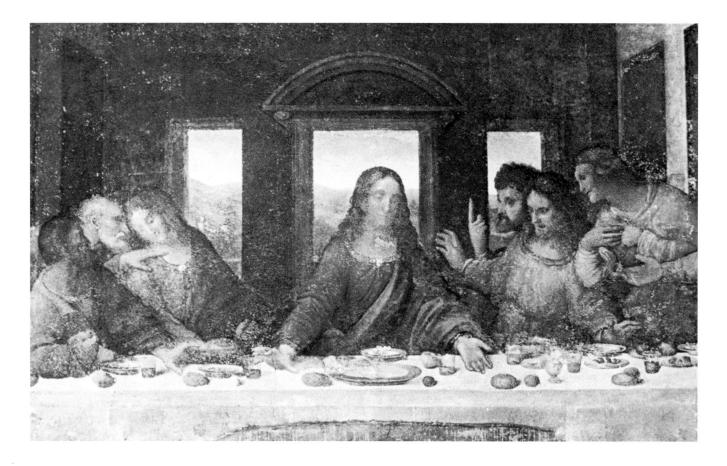

table to find bread and wine in their paths. In this new perception, which redirects Christ's right hand, Borromeo's hand-haunted dish has no place, since normally a hand does not aim two ways at once, not even where virtuosity is in play; a pianist cannot, in one gesture, strike a chord and reach for a drink. Therefore, it would have to be one or the other. Christ's right hand must target either the Judas dish, according to Borromeo, or, according to Antoniewicz, the wine.

But suppose we honor both authors. Begin by asking whether a Renaissance painting is read as an arrangement mapped on the picture plane or, following its illusionistic directives, in depth. If we let both readings stand, we may find Christ's right hand doubly transitive, claiming both the

dish and the glass: the dish, if we scan astream with the table, parallel to the picture plane; the glass, when we see Christ's action launched hitherward from shoulder out (Fig. 25).

Simple seeing becomes more discerning, more taxed—like listening to musical counterpoint. This right-handed act now wants to be seen as a nodal point, the intersection of an orthogonal and a transversal. Our redoubled perception reveals that the artist was here thinking in two and in three dimensions at once, across the field and right through.

Should Leonardo be charged with such double-dealing? Yes, by all means, for this sort of duplicity, or better, *duplexity*, lies at the heart of Renaissance painting and of its love of perspective, wherein every point, line, and plane

24. Leonardo, *Last Supper*, detail, pre-World War I photograph.

25. Christ's hands
as the intersections
of orthogonal and
transversal directives.

double-functions in flatness and seeming depth; which doubling Leonardo here charges with narrative purpose. As the picture's protagonist at his last meal accepts the mortal consequence of his humanity—and makes this same supper the occasion for bestowing on humankind the greater consequence of his divinity—so his right hand, doubly transitive, targets both treason dish and eucharistic wine. And if skeptics object that one hand cannot simultaneously perform two disparate acts, the artist replies that his narration empowers this hand beyond normal manual capabilities. It's a depicted hand we are shown, an anatomical member whose larger membership in pictorial syntax admits moments of paronomasia, as language and music do.

The hand pinpoints an intersection. A leftward motion, collineate with the table, runs past John's hyphening clasp—to the *sinistra* of Judas. And this transversal intersects the orthogonal that descends from the centric point of the picture (at Christ's right temple) through shoulder and arm down to the wine. We are bidden to look at the image the way we hear the polyphony of Leonardo's contemporary Josquin des Prez—as when two melodic strains meet in transitional unison. Christ's right hand, or rather its action in place, is exactly such unison. Surcharged by the context, it forms the pivot wherein the twofold event of this supper coincides with the given duplexity of perspective.

What follows? Must wine glass and treason dish still be competing for primacy? I see no sufficient reason to demote either one to the status of "afterthought" or "allusion"; just as in Quattrocento perspective neither surface nor depth need be seen as predominant. A Renaissance painting is not in essence 3-D, nor essentially flat; it is both, because the system describes an interrelation. And it is this interrelatedness which Leonardo weaves into his gospel.

I conclude that the readings of Borromeo and Antoniewicz are equally valid, and that the contested hand is the crux where the dramatic and the sacramental converge, and whence they diverge. The artist is storytelling in two

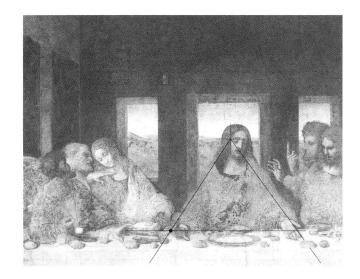

and in three dimensions at once, charging coincidence to define one versatile action. Repeat: as the person of Christ unites man and God, so his right hand summons the agent of his human death even as it offers the means of salvation. This two-natured hand in its congruent godhood and frailty is the profoundest pun in all art.

Such a reading may not please simplicity lovers, but it is consonant with what is visually given—provided that the "given" is understood as a gift that may be declined. In this sense, the case of Antoniewicz is paradigm. Undaunted by Goethe, who described Leonardo's Christ as one who had had his say and was now resigned to inaction, Antoniewicz saw the Christ figure as agent—both hands actively molding his speech, and both directed at bread and wine previously overlooked. But this was seeing too much; the academicians whom Antoniewicz addressed in 1904 balked at his observations. The full text of his talk never got published, and a half century of further resistance ensued.

The resistance has gradually slackened. For most modern commentators, Christ's hands are now transitive—for

most, but not all. The literature on the *Last Supper* remains disputatious. Some argue that neither breadroll nor glass looks transubstantiable enough to warrant thoughts of the eucharist. Some question whether Christ's right hand with its heel grounded is properly positioned to grasp; whether the fingers are fairly described as pointing (unless it be "passive pointing"); whether the adjunction of these hands to these items was intended or random, and if intended, whether it should be seen as an actual occurrence or as allusive byplay, or, on the contrary, as the main event flanked by subsidiary action. All this because someone in 1904 (others following two world wars later) registered a visual signal to comprehend two hands in one glimpse, and both together with two homely objects. Why with these, sitting so undistinguished near the fore-edge of the table? Because their location distinguishes them; they align with and they forward Christ's oncoming gesture.

THAT GESTURE'S TRANSITIVE CHARACTER was further amplified in 1973, in the essay form of the present book. The question there asked ran as follows: if alignment is the criterion of relevance, then why stop at the bread and wine? What if these objects were seen not as terminals, but as points of transmission? In Leonardo's implausible table setting, most of the breadrolls, including the one which Christ's left hand addresses, verge close to the brink. So, too, the wine-glass at Christ's right hand stands as if placed for partakers this side of the table, both items distinguished only by being elected, urged on by one forwarding gesture. Now suppose we behold these twinned items in continuity with the vectors released from the centric point of the composition (Christ's temple); see them trued with the arms, in arrival

and streaming forth, trued with the stripes in the floor. Then the twin course laid down by Christ's gesture would flow open-ended to the pictorial threshold, spreading out toward us. The containment intended in the grudging term "passive pointing" flares into active bestowal as we let the context expand. Christ's hands indeed terminate at the fingertips; their effectiveness doesn't.

Unfortunately, their larger outreach is no longer apparent because Leonardo's pavement is lost. The design must be reconstructed and reimagined, with uncertainties still remaining. Only this much is certain: Leonardo had conceived a rose-colored floor, articulated by stripes of another color. Obedient to the perspective, these stripes formed converging orthogonals. (For the positioning of these floor lines I follow—as did Morghen and Bossi, Figs. 14 and 26—the pattern formerly displayed in the fresco copy from Castellazzo. My reasons for taking this controversial stand are set forth below, pp. 65–66, and in App. D.)[1]

Now our immediate concern is with the pair of floor bands flanking the median, the pair in line with the dispensing arms. As these bands lean inward, Christ becomes the capstone of a great central pyramid. But as Christ initiates, these same stripes, now seen as divergent, unload toward us. And midway between the decurrent slopes of Christ's arms and the floor lines that transmit their momentum, exactly halfway, there lies the bread, and there stands the wine. These elements bring the thrust of Christ's gesture to the fore-edge of the table—below which the bands of the pavement proceed again, hithering to the threshold where the picture spills over. An alignment, then, of outreaching arms, eucharistic species, and striated floor—too exact to attribute to chance. The placement of

1. Since the following paragraphs favor the floor design as it appeared in the copy at the monastery at Castellazzo, just outside Milan, let me preview what App. D discusses more fully. The fresco, part of the refectory decoration completed by 1514, is tentatively attributed to Andrea Solario. Destroyed in World War II, it now survives only as a black-and-white photograph

(Fig. 136). Probably executed c. 1510, if not earlier, the work was in progress during Leonardo's second Milanese period (1506/08–13). A certain authority thus invests the Castellazzo copy, long widely regarded as the most accurate. I shall do likewise, provisionally—even though this puts me at odds with friends in Milan.

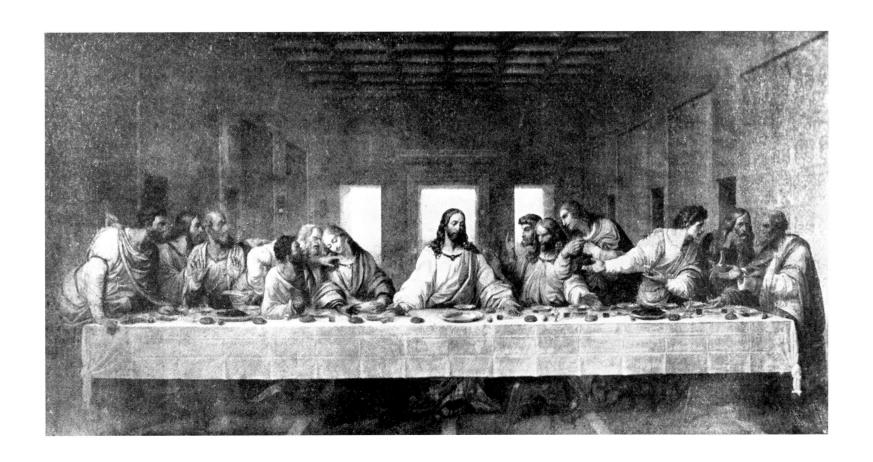

26. Giuseppe Bossi, 1807,
destroyed in 1943 (App. E, no. 49).

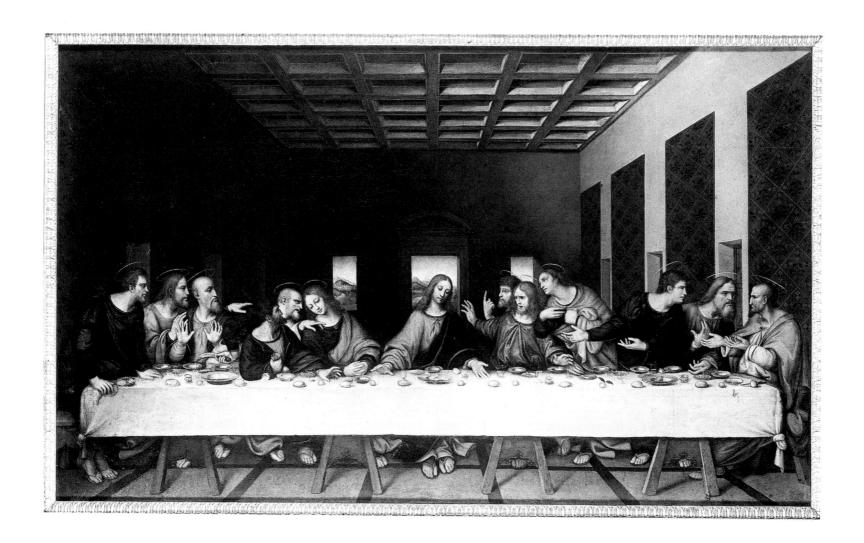

27. Anonymous, mid-sixteenth century,
Hermitage (App. E, no. 21).

wineglass and loaf comes too close to defining the work of the sacrament to be dismissed as fortuitous.

There is more. Projecting the course of Christ's arms down to the floor lines, and these same diagonals upward into the ceiling, we rediscover (bowing to Antoniewicz) a coordination with two of the ceiling's long beams (Fig. 115); and at once the general radiation effect, always observed in the picture, is tracked to its source, found in one giving gesture.[2]

I think we see—or would have seen had the mural survived intact—a willed visual metaphor. Within the geometry of the picture, the elements of the eucharist, placed in extension of Christ's earthly presence, serve as conveyors: from the centrality of the Incarnate toward the faithful this side of the picture.

SO MUCH FOR CHRIST'S UPPER BODY. What of the feet which, alas, only the copies record? By the mid-seventeenth century, the lower zone of the painting was so nearly effaced that the brothers of Santa Maria delle Grazie saw nothing to grieve at when, to supplant their modest fifteenth-century access, a huge Baroque doorway ("far larger than necessary," says Goethe) was rammed through the wall of the mural. Whatever vestige of floor and feet survived to 1652 was not considered worth saving.

Goethe scorns the barbarity of these monks, but is somewhat ambivalent about the loss. Too Olympian to peer under the table, and disdaining to single out even one pair of feet, he expresses a sentiment that reflects what well-bred Teutons used to call *Tischzucht*—good table manners: "All

ethical expression," he writes, "pertains only to the upper part of the body, and the feet in such situations are everywhere in the way. . . ." Accordingly, Goethe commends Leonardo for wrapping all the footwork in shadow, out of sight, or barely discernible.

How right Antoniewicz was to point out that Goethe's essay describes not the original, but the Raphael Morghen engraving of 1800. In the print (Fig. 14), the undertow is all tenebrosity. In the mural (as the early copies attest), the feet appeared blatant enough to prompt at least one reflection: this very night, each of these feet is washed and wiped dry by the Master. In view of the Gospel (John 13:4–5), how negligible can these feet be; surely, this is their hour! The thought seems not to have crossed Morghen's or Goethe's mind, but it may have occurred to Leonardo, in which case a glance at the goings-on under the table should be *Tischzucht*-compatible.[3]

Apart from the fact that every foot in the painting consummates a full body motion, the feet in synoptic view form a quasi-architectural pattern: those of the terminal figures drop on the picture plane below all others—except for the feet of Christ, more prominent than the rest (Fig. 27). The arrangement recalls the ground plan of a palace facade with emphasized central corps and projecting corner pavilions. Leonardo evidently bethought the disciples' feet and their relation to Christ's.

Let us pretend that we still see the protagonist whole. The reach of his feet confirms the body's subtly overscaled stature (Figs. 144, 145, 150). But just as remarkable is their

2. It was Antoniewicz (App. B, p. 206) who first observed how the surface web of Leonardo's design coordinates with orthogonals, as in the alignment of Christ's arms with two ceiling beams. To the floor lines he did not refer. Though he projected the slant of Christ's arms ceilingward in "natural continuation," he saw the downward course of the left arm suddenly break off at the bread (*Hier bricht sie plötzlich ab*).

3. In a rare reference to the disciples' feet, Erich Frantz (1885, p. 37) seconds Goethe's praise of Leonardo for keeping the feet out of sight. More perceptively, Edmondo Solmi (1900) finds them abetting the general

expression of consternation. Few other *Leonardisti* peek under the table—except the irrepressible Emil Möller (1952, p. 68), who regrets that almost no one heeds these appendages, which he characterizes with adjectival aplomb: Judas' affrighted foot is evasive (*erschreckt ausweichend*); Peter's feet are "aggressive"; those of John, "all but paralyzed"; Bartholomew's, "placed with courtly decorum"; Matthew's, "free and secure," etc. To which Eichholz (1998, p. 281) adds only this: that the pertinence of specific feet to their respective physiques "is not always unambiguous."

into "unconstrained calm" (Hoerth 1907, p. 223), "fine-tuned repose" (Möller 1952, p. 60), or "quiet composure to contrast with the restless feet of the Apostles" (Heydenreich 1943, p. 113). The precise positioning of Christ's tangent feet at point center was attributed only to the character's presumed state of mind, belying the formality of the pose.

More critical commentary appears in the copies. Discounting documentary replicas, a surprising number of early copyists and *all* later adapters of the *Cenacolo* show the feet of Christ parted.[4] What made these Leonardo enthusiasts do it? They admired the composition, yet they disparaged these feet. Did they think the posture too prim, or too ceremonious—appropriate, perhaps, to a pharaoh posing for a granite colossus, but out of place in a narrative? If so, they did have a point: neither in common experience nor in the conventions of Western art do the feet of male sitters so cling together.[5] What then (re-imagining the original) keeps Christ's feet in the *Cenacolo* cleaving on the field's central axis? Certainly, they were not conceived without being pondered, for who does not know that Christian tradition makes the body of Christ a hierarchical system, wherein the lower extremities, ranked as the "menial members," symbolize the deity's incarnate nature? "The head means the godhood of Christ; the feet his manhood"—so runs the old motto.[6]

As Leonardo disposed them (the left foot slightly retracted), these adjoined members perform—seem to me to perform—two coincident roles, reflecting once again the

28. School of Coppo di Marcovaldo, *Last Judgment Christ*, c. 1270–75, cupola, Florence Baptistery.

pose—concentered and conspicuously isolated. At this crisis, when Jesus, spreading his arms, announces the onset of the Passion, his feet press close together.

Earlier scholars saw nothing interesting here. If they mentioned these lowly members, it was to tranquilize them

4. Early copies and adaptations that give a manlier stance to Christ's feet are abundant (e.g., Figs. 4, 7, 142, 146, 147, 152, 161). Some, like the relief copy in the choir of the Certosa di Pavia, use a central trestle to hide Christ's feet altogether. Evidently, the original disposition was widely disliked. When Eichholz (1998, p. 280) refers to the tall seventeenth-century door that finally destroyed the *Cenacolo*'s lower center, he remains undecided whether to attribute the mayhem to indifference or to "latent aggression."
5. "…the two feet, flat on the ground, demurely side by side" (Samuel Beckett, *Malone Dies*, New York, 1956, p. 53). Beckett's sitter in this posture is doomed. That a normal male is not expected to assume such a pose may be further illustrated as follows: in Cézanne's huge portrait of his friend Achille

Emperaire—described as "a dwarf whose musketeer's head dominates a fragile body with spindly limbs"—the sitter keeps both feet evenly side by side. Rejected by the Salon jury in 1870, the painting was soon after lampooned in a caricature, in which the original's tangent feet separate—as do the feet of Leonardo's Christ in the copies cited in the foregoing note. Cézanne's mocker could not conceptualize what was plainly there to be seen (see John Rewald, *The History of Impressionism*, New York, 1961, pp. 246–47).
6. For the diffusion and persistence of this christological trope from Early Christian times to late medieval, see Steinberg 1983/96, p. 28, and Excursus XVII, "The Body as Hierarchy," pp. 149–51.

29. Milanese Gospel
Book Cover, *Crucified
Christ*, detail, 1018–45.

At the same time, obedient to the sitter's mortality, the positioning of the feet foreshows—seems to me to foreshow—the duress of the cross: the feet not equitant, overlapping, but side by side, the way they rest on the suppedaneum in pre-Gothic four-nail *Crucifixions* (Fig. 29). The message, readiness for imminent martyrdom, seems clear enough, and to my mind more plausible than the attempt to make this pointed footwork denote only emotional calm. Like so much else in the painting, the feet of Leonardo's Christ double-function: as they rejoin the rest of the body, they foreshadow it glorified; and they foreshadow it crucified.[8]

But why refer to the cross at this stage of the narrative? If the depicted moment is the betrayal announcement simultaneous with the disciples' response (with "allusion," perhaps, to the sacrament), then, in linear time, the deadly consequence of the betrayal would be premature. Yet the forward reference on this occasion is both timely and customary. Traditionally, in Florence, *Last Supper* frescoes in monastic refectories shared their walls with representations of the Crucifixion (Fig. 30). How Leonardo viewed these venerable precedents is not recorded; nor do we have his opinion of Ghirlandaio, whose recent *Last Supper* frescoes (Figs. 121, 122) dispense with concomitant *Crucifixions*.[9] But as Leonardo confronts the alternatives of Ghirlandaio's up-to-date

protagonist's dual nature. Seen at one with the head and hands, the feet finish a regular figure; they diamond the sitter's outline, give shape to the aspect of one inhabiting a mandorla, the dwelling of the Pantocrator (as in Fig. 28).[7] No common physique falls into such geometric perfection.

7. The mandorla effect of the figure's rhomboid contour reappears in Pontormo's *Supper at Emmaus* (Uffizi). Luciano Berti's description of Pontormo's Christ as *idealizzato come in una mezza mandorla* (*L'opera completa di Pontormo*, Milan, 1972, p. 100) is a half-truth, overlooking the piercingly beautiful foot under the table. The implied mandorla—as in Leonardo's *Last Supper*—engages the whole.

8. Concerning the position of Christ's feet on the cross—whether superposed or adjoined: after 1300 it became common to show overlapping feet transfixed by a single nail, a novelty thought at first to be disrespectful and rebuked at the time. The feet of Leonardo's Christ, ranked side by side, would foreshadow the Crucifixion in its more ancient form. Fig. 29 illustrates an eleventh-century Milanese four-nail *Crucifixion* in the Milan Cathedral Treasury, probably known to Leonardo. There are thousands of similar instances. The type, with both feet displayed, remains an ever-available alternative, from the Prado Velázquez and Rembrandt's *Three Crosses* etching

to Julian Schnabel's *Vita* (1984; reprod. in Arthur C. Danto, *The State of the Art*, New York, 1987, opp. p. 100).

9. At Santa Croce, the first monastic refectory in Florence to receive a *Last Supper*, Taddeo Gaddi rendered the scene as a kind of predella to a symbolic, full-wall *Crucifixion*—illustrating St. Bonaventura's *Lignum vitae* (Fig. 30). The vestigial *Last Supper* fresco at Santo Spirito appeared again under a *Crucifixion* (for attribution, see R. Offner, *Corpus of Florentine Painting*, IV/1, New York, 1962, pp. 68ff.). In Castagno's *Cenacolo* at Sant'Apollonia, the "enshrined" *Last Supper* (Fig. 82) underlies a superior *Crucifixion* flanked by scenes of *Entombment* and *Resurrection*. Ghirlandaio's Crucifixion-less Ognissanti *Cenacolo* of 1480 (Fig. 121) thus constitutes a depletion of content, remedied soon after by the insertion of small background incidents from the Passion (e.g., Perugino in the Foligno monastery in Florence, Fig. 124; Cosimo Rosselli in the Sistine Chapel; and several of Leonardo's copyists, such as the Ponte Capriasca painter, Fig. 153).

30. Taddeo Gaddi, *Last Supper*
and *Tree of Life*, c. 1335.

naturalism and the older atemporal symbolism, he again re-conciles. In his *Cenacolo*, the presentiment of Crucifixion, though reserved as a moment unborn, retained beneath the threshold of overt action, is literally central to the whole argument, as central to the pictorial fabric as it is to the Mass. The eucharist, a meal in its outward form, entails Christ's death on the cross. "In the Mass," writes Jungmann, citing St. Thomas Aquinas, "the sacrifice of the cross is made present sacramentally."[10] Of that sacrifice, the feet of Christ as the tokens of his mortal nature are the appropriate heralds. The design of the *Cenacolo* transfigured them into a sign.[11]

Unfortunately, since these feet evanesced long ago, whatever is said about them relies on those early copies which seek to reproduce the original figures as closely as possible. Their combined witness assures us that Christ's feet in the mural met on (or near enough) the picture's main axis. Yet they differ about the retraction of the left foot: little of it in the Castellazzo (or the later Hermitage) copy; emphatically more in the Tongerlo and Certosa copies; almost none in the later Ponte Capriasca fresco or the Dutertre drawing (Figs. 27, 144, 145, 153, 154, 180). I suspect that Leonardo had made the stance of these feet another occasion for equivocation. In the mural, the feet evenly side by side would surely have stood for the Crucifixion. One foot withdrawn, the other pointing the nadir of an overall diamond, contours the body eschatological. Leonardo conveyed both at once, exercising that effortless simultaneity which resists imitation.

I RETURN TO THE RIDDLE of Leonardo's design for the pavement. How exactly did its median engage the protagonist's feet, whose sign character would have been more apparent if these feet rested on a central floor band. But all original paint across the lower zone of the mural wore away centuries ago, and what little evidence for Leonardo's pavement survives is inconclusive. Here more than anywhere else, the earliest copies show contradictory patterns. Accordingly, we are not certain whether Leonardo's striped floor mirrored the ceiling, i.e., with a central stripe on the median, or whether the center was open, flanked by converging orthogonals. The latter variant (as in the Certosa and the Tongerlo copies, Figs. 145, 154, further discussed in App. D) plants Christ's feet on a blank. The alternative (as in the Castellazzo fresco of c. 1510, followed by Dutertre, Morghen, and Bossi, Figs. 14, 26, 180, 185) shows the feet finding the central band of the pavement. This conjunction of tangent feet and axial midline encourages association with the stem of the cross. The sight of Christ's feet joined on an upright stave makes it difficult to unthink the Passion.

So then, since the early copies diverge (and since the recent cleaning yields no conclusive determination), we face two alternatives:

1. Leonardo may have devised a scheme in which pavement and ceiling contrasted, leaving a blank bottom center, so that no axial midline supported the symbolism of Christ's adjoined feet. In this case, the Castellazzo copyist, posting Christ's feet on the median, would have intensified the

10. Jungmann 1951, II, p. 144 and n. 33. In the doctrine dominant since the twelfth century, the substance of the eucharist is not the risen Christ's glorified body, but the flesh of the Crucified. Thereafter, the eucharistic moment of the Last Supper must be associated with the Crucifixion. (For the iconographic effects of the doctrine, see Adolf Katzenellenbogen, *The Sculptural Programs of Chartres Cathedral*, Baltimore, 1959, pp. 13f.) The same doctrinal shift mandated the placing of a cross on the altar (see Joseph Braun, *Das christliche Altargerät*, Munich, 1932, p. 467).

11. The notion that Leonardo positioned Christ's feet to prefigure their constraint on the cross has been gradually gaining acceptance. For Pedretti (1983, p. 80), the feet on the mural's vertical axis "seem to stress the suggestion of . . . Crucifixion." Rossi and Rovetta (1988, p. 17) write: *Steinberg ha dimostrato . . . che il Cristo leonardesco aveva probabilmente i piedi uniti, alludendo in tal modo . . . al Crocefisso.* Yet one skeptic, who would sooner see an infinitive split than that table, objects: "It would have been astonishing to suddenly recognize the crucified Christ, rising 'through' the table itself . . ." (James Elkins, *Why Are Our Pictures Puzzles?* New York and London, 1998, p. 115).

passional symbolism beyond Leonardo's intention.[12]

2. Leonardo may have contrived a symbol-fraught nexus, which the Certosa and the Tongerlo copies dispel.

Despite the view taken by the last restoration, I think the second alternative the more probable. It accords with the copyists' need to attenuate wherever they found connotation too clotted. Since Leonardo's *Cenacolo* was widely believed to represent only the betrayal announcement, the Certosa and Tongerlo painters may have thought the Passion association inappropriate to the moment depicted. As some copyists omitted the wineglass at Christ's right hand to keep the eucharist out of the picture, so, to keep the future out of the present, they would have removed the centerline from under Christ's feet.

More than that. Consider what the proposed Passion association makes of that central stripe—a triple play. As a mark on the wall, the stripe rises vertical on the plane of the mural; perspectively, it reads as horizontal recession (cf. the road's shoulder in Fig. 2); and it re-erects allusively by virtue of contact with one pair of feet. The floor's midline in threefold manifestation: literally perpendicular, leveled in spatial illusion, uprighted in symbolic prolepsis, anticipating the shaft of the cross. Thus if the evidence of Castellazzo prevails—and it may not. But whatever the feet of Christ touched upon, whether midline or blank, in the context of the *Last Supper* their posture alone was semantic.

The context of the Last Supper. What exactly does this catchall "context" refer to? Given Christ's feet in this unique image, the word would have to entail at least all of the following:

—the context of Christ's body entire; up to the head, out to the hands, and down to the toes to configure a perfect rhomb;

—the context of the contrasting feet of the disciples;

—the context of the geometry of the field, centered by Christ's lower limbs;

—the comparative context of old *Crucifixion* icons, with tangent feet side by side;

—the context of traditional refectory decoration, where Crucifixion imagery surmounts a depicted *Last Supper*;

—the context of the Mass itself, which offers the body as a whole sacrifice.

All of the above but, above all, the context of the picture's own narrative mode, which makes collocation no less pregnant than gesture. We have learned at long last that neither the dish between Christ and Judas nor the elements at Christ's fingertips were to be scanted; and just so the settlement of the feet. Though no longer apparent, the lost feet of Christ continue to signify.

They signify contextually with the dispensing hands. As the feet seem drawn inward, inactive, prepared to take *from* the world, so the hands, by way of the wine and bread, release beams of energy that pass from the picture outward as things bestowed. The sum of Christ's converse with man—Crucifixion received, sacrament given—inheres in the pattern.

THERE ARE SEVERAL POSITIONS from which the interpretation here offered may be attacked. The most confident, because armed with texts, argues that Leonardo's writings betray a mentality very different from what my reading of the picture implies. Certain passages in the *Trattato*—nearly always cited by commentators and held to be especially relevant to the *Last Supper*—suggest that the master's idea of narrative painting was fairly straightforward; no hinting at dogmatic theology, no proleptic mystique, and not a word about multiple function, simultaneity, ambiguity,

12. Pietro Marani agrees that Christ's adjoined feet in the mural evoke the Crucifixion, but feels that an upright stem under these feet would have made the reference too obvious (in conversation, May 1998). How obvious would

it have been to non-painters? Though a floor band leading up to Christ's feet showed prominently in the Castellazzo copy and in the Morghen engraving, no writer before 1973 saw the effect as an omen of the Crucifixion.

ominous collocation, or peekaboo clues under the table. None of that, but rather the simple imperative to make bodily motions reveal emotional states, and this with the utmost directness and clarity. Leonardo writes: "Make figures with such action as may be sufficient to show what the figure has in mind. . . ."[13] Again: "A picture or representation of human figures ought to be done in such a way that the spectator may easily recognize, by means of their attitudes, the intent in their minds" (Richter 1883/1970, no. 593). Do we need more than this to tell us what Leonardo's characters were designed to express? So the admirable Edmondo Solmi (1900, p. 121) quotes the above to confirm that, in the *Last Supper*, we "clearly recognize" the characters' feelings. Half a century later, Kenneth Clark (1958, pp. 95, 97) calls the disciples at the *Last Supper* "embodiments of emotional states." Even for Martin Kemp (1996, p. 189), "The *Last Supper* is the supreme demonstration of Leonardo's belief that poses, gestures and facial expressions should reflect the 'notions of the mind' in a specific emotional context." All of which is reasonable and correct; it is also inadequate and obstructive when the texts are conscripted to keep this most complex of paintings simple and manageable for the convenience of its discussants.

Specifically: texts such as the above put any twofold reading of, say, Christ's right-handed gesture at odds with the artist's declared intention. Since the precepts set forth what it is that Leonardo wants depicted figures to show, the conviction that the *Cenacolo* characters will show just that much and no more becomes an article of faith and stiffens

resistance to readings which no period text seems to support. The commentator's task is staked out: name and describe the emotion that stirs this or that figure. As Clark put it in one astonishing sentence, "[The *Last Supper*] is the most literary of all great pictures, one of the few of which the effect may be largely conveyed—can even be enhanced—by description" (1958, p. 95). Onward, then, to enhance Leonardo, as best we can. But as few art writers attain Goethe's eloquence in description, it follows for Clark that Goethe had done the enhancing "once and for all." It follows further that Christ's right-hand gesture, for instance, must not be referred to a sacramental cup, because a gesture that illustrates an emotion-charged speech ("one of you shall betray me" or "he that dips his hand with me in the dish") would be putting the speaker's mind on a different track. Exegetes of such persuasion want each datum reduced to a one-to-one fit between a moment's affect and its somatic expression. And they quote Leonardo's notations because there one has something reliably black on white, more trustworthy than anything conjured in color.[14]

It is not that Leonardo's notes should be slighted. On the contrary: matched to the picture, they teach us to measure the distance between the master's pedagogics and his creative imagination. Getting that measure and seeing that distance dilate is rewarding enough. Therefore, I would cede authority to no text above the authority of the picture, which alone judges how apt a text is, even though it come from the artist.

What Leonardo's precepts enjoin on would-be practitioners of narrative painting is a professional minimum—

13. *Farai le figure in tale atto il quale sia soffitie[n]te a dimostrare quel che la figura à nell'animo altrime[n]te la tua arte no[n] sia laudabile* (Richter 1883/1970, no. 600).

14. A classic statement of the belief that the mental states of Leonardo's figures must be instantly readable appears in Hoerth 1907, p. 29. From Leonardo's manuscripts, Hoerth has learned how diligently the master pursued his studies, that such studies preceded all his slowly maturing works and would surely have preceded a work of the *Last Supper*'s importance. The insight thus gained from the writings assures the author that nothing arbi-

trary occurs in the *Last Supper*. Therefore, every expressive value in the picture will be so unambiguous and clear that no doubt as to its cause may arise (*...daß daher, als Wirkung einer bestimmten Ursache, die Stufenleiter der mimischen Ausdruckswerte so klar und eindeutig gefaßt sein dürfte, daß über die Natur dieser Ursache ein Zweifel nicht wird bestehen können*).

Similar assurances run through the literature, from Tikkanen (1913, p. 45), to Castelfranco (1965, p. 40), and even to the excellent Martin Kemp (1996, p. 189), informing readers of *The Dictionary of Art* that the expressions in the *Last Supper* clearly exemplify the precept quoted from the *Trattato*.

to keep every action in tune with the actor's character and the provocation: don't let old men skip about, but have them "sit with their fingers clasped holding their weary knees" (Richter 1883/1970, no. 594); don't let muscles in action go slack, persons amazed look uncaring, a young woman strike an immodest pose, an angry crone wave her legs instead of her arms (Richter 1883/1970, no. 583), and so on. The do's and the don'ts are always sensible and realistic. They demand minimal compatibility, lest a depicted gesture contradict character or occasion. Whether or not more can be done with it—by dint of context—the rules do not say.

CONSIDER THE CONTEXT of Christ's other hand. To most scholars, the emotion displayed by that open palm seems self-evident. Christ is accepting the Passion at hand, or—in the enhancing words of one nineteenth-century author (Frantz 1885, p. 33)—he gestures "as though he wished to show his wounded heart on his hand's surface." Thus if you focus on the gesture alone, assuming it to be intransitive. Yet, as we have seen, the fingers unfurling before a breadroll bespeak more than mute resignation. As this hand polarizes the other, it becomes equally potent, initiatory. And even this is not all, for in its transitive competence, Christ's left hand underlies the portentous finger raised by St. Thomas, who now demands close attention.

His is the window-framed nutcracker profile and the erected forefinger. No other disciple here comes nearer to Christ—and with so little body to show. As for his lofted hand, see it in isolation and it looks disembodied, wanting its proper launch, a finial levitating without carnal support.

Now suppose we see Thomas' finger and Christ's open palm in one single-plane configuration (Fig. 31). They are indeed jointly empaneled against the wall pier behind, and they link on one perpendicular, much as Christ's other hand falls in horizontally with that of Judas. Thomas' hand is not unsupported if we recognize Christ's stable palm directly under.

31. Leonardo, *Last Supper*, left hand of Christ, right hands of James Major and Thomas, after latest cleaning.

32. *Savonarola Preaching*, 1496.

But before addressing what this coordination might mean, let us see what is accomplished when that apostolic finger is referred only to Thomas' person and to his own likely feelings. How in fact has this gesture been glossed by commentators who know for sure what it is that gives rise to that finger? And let this be a test case.

Mindful of Leonardo's injunction to make gesture reveal a specific affect or thought, and confident that the master's practice would not belie his own rules, most interpreters from the eighteenth century to the present speak out as from certain knowledge. They read their St. Thomas like an open page. Yet Goethe declared that Thomas' gesture had been misunderstood: it was not threatening Judas, or swearing revenge (Bossi 1810, p. 102). Rather, the finger was brought up to the forehead in order "to intimate thoughtfulness" (*um Nachdenken anzudeuten*; Goethe 1817, p. 82). For the rest of the nineteenth century, both readings, the menacing and the pensive, remained on the books. Until we get this third reading: "He, the philosophical skeptic among the Apostles, wants to express by means of his raised index finger that, heaven knows, he himself could not be the traitor." Thus Seidlitz (1909, p. 165). On this view, Thomas is neither threatening nor urging reflection, but, like a good *Philosoph*, proclaiming himself free of guilt.

A fourth reading of Thomas' gesture comes to us from Gino Modigliani (1913), whose St. Thomas "thrusts himself toward Christ with finger extended as if to prod the speaker to explain himself more clearly."[15] A fifth occurs in a sometime-authoritative Leonardo monograph, with introduction by Heinrich Bodmer (1931). According to Bodmer, "the Apostle is invoking the aid of the heavenly powers as the last hope in this moment of extreme peril."[16] Yet another inter-

32. *Savonarola Preaching*, 1496.

pretation (your sixth) comes from the American Leonardo scholar Jack Wasserman (1975/84). The finger, he writes, is "raised in doubt."[17] (Since doubt is what doubting Thomas is best at, what else would his finger be raised in?) But can we pin doubt on this of all gestures? Watch Savonarola perform it in the pulpit of the Florence Duomo (Fig. 32). An index so hoist and haught spells inflexible certitude.

A seventh reading is offered by Msgr. Pietro Amato (1985), professor of iconography at the Pontifical Oriental Institute in Rome. To prove that Leonardo's *Last Supper* contains no hint of the eucharist, the Right Reverend points to Thomas' evidentiary finger: "The gestures of the Apostles conform to the impending betrayal. St. Thomas raises his finger, for example, as if to say, 'You think it's me?' an impossible gesture if this was the moment of the eucharist."[18] No question in the monsignor's mind that Thomas' gesture

15. Gino Modigliani, *Psicologia vinciana*, Milan, 1913, quoted in Malaguzzi Valeri 1915, p. 526.
16. *Der Apostel ruft die Hilfe der himmlischen Mächte an, als letzte Rettung in dem Augenblicke höchster Not* (Heinrich Bodmer, *Leonardo: Des Meisters Gemälde und*

Zeichnungen [Klassiker der Kunst], Stuttgart and Berlin, 1931, p. xxiii).
17. Wasserman 1975, p. 31, and 1984, p. 15.
18. Quoted in Curtis Bill Pepper, "Saving 'The Last Supper,'" *The New York Times Magazine*, October 13, 1985, p. 46.

(read by now in seven different ways) is as intelligible as plain Latin.

Eight: a two-volume study unveiling the "Secrets of Leonardo's *Last Supper*" (1987) explains Thomas' input in complement with the knife-toting Peter, to whom Thomas seems to be saying: "If we want to defend Jesus, we must proceed with care and due circumspection."[19] Note the change of address: over the past couple of centuries, Thomas' focus has shifted from threatening Judas to soliciting Christ to cautioning Peter.[20]

A ninth interpretation of the commotion at table, including the action of Thomas, comes from the blithest spirit that ever dispuzzled a riddle. It occurs in a recent book on St. Jude (alias Thaddeus) by Liz Trotta, described on the jacket as an "Emmy Award-winning journalist." Trotta devotes a paragraph to "Leonardo da Vinci's sublimely artistic and psychological study of *The Last Supper*." She remembers that, according to Luke 22:24, the disciples disputed among themselves which of them should be accounted the greatest. This rivalry for first place is what Trotta sees represented in the *Last Supper*: "Da Vinci," she writes, "plumbs the essence of each man . . . capturing it for an arrested and eternal moment. As the Apostles wrangle over their places at the table, . . . Christ gives them a lesson in humility."[21] Thomas' forwardness, then—his jostling to get nearer the center—shows him jockeying for position. And the reared finger Leonardo gave him to plumb his essence would signify: Now don't forget, I'm numero uno!

Thus far, the historical record. For two hundred years, the purport of Thomas' gesture has been anyone's guess, as if delivered in an idiom unknown or imperfectly understood. The finger, said to urge cerebration, may be rising in doubt; then again, it might be minatory or cautionary, interrogatory or imploratory of heaven. It could petition the speaker for clarification, or try to ward off suspicion, or hustle for a privileged place. If gestures in Leonardo's *Cenacolo* were meant to reveal a particular state of mind at a particular moment, then, in this instance, the painter has failed. Success would have pulled in more unanimity.

The nine worthies quoted above were paraded for the distinctiveness of their responses. Each contributes a personal insight, and with a sincerity that perhaps ought not to be mocked. But I cannot help noticing that their opinions rest on a common mistaken assumption. Every one of them—from the laureate bard to the award-winning journalist—perceives this St. Thomas, or interprets his present momentum, as though he were a *dramatis persona* in an interpersonal situation, a live human being, whose behavior, like an actor's, should be transparent to fellow men. Yet we do know that depicted men are not exactly our fellows, having one capability which we lack. Whereas we come in the round, bundled in sacks of skin, the apparent embodiment of painted figures is only part of their competence. In addition to their feigned moving mass, they readily disconnect or make areal connections which our compact physiques cannot match. The anatomy of depicted figures—that of Leonardo's St. Thomas especially—may be distributive; unstopped by integument, it disperses to remoter adjacencies.

Look again at that sundered hand—its heraldic detachment, parted even from the man's head. The thing separates like a sign, like the sort of directional marker formerly used in public places—a male hand with straightened digit to indigitate THIS WAY OUT; except that Thomas' finger points up. But this upright forefinger occurs in

19. Horst Lozynski, *Enthüllte Geheimnisse vom Abendmahl des Leonardo da Vinci*, Überlingen, 1987, I, p. 26.

20. Monstadt (1995, p. 272 n. 91) observes that Thomas' "richly significant hand," apart from its heavenward focus, "also points to the Sforza coat of arms" in the central lunette above the mural. Whether or not this was intended by Leonardo, no such intention is imputable to St. Thomas.

21. Liz Trotta, *Jude: A Pilgrimage to the Saint of Last Resort*, San Francisco, 1998, p. 219.

Leonardo's rare paintings no less than four times, invariably pointing to heaven.[22] Like the raised index Leonardo had previously assigned to an angel at the *Adoration*—and would assign again to the London *St. Anne* and the Louvre *St. John*—Thomas' finger soars like a miniature spire. The steeple finger is Leonardo's trusted sign of transcendence.[23]

In the *Last Supper*, it rises on one perpendicular over the pad of Christ's open hand, a vertical elevation crossed by the outflung arm of a friend, so that we could be hallucinating a phantom cross (Fig. 31). To my eye, the complex formed by Christ's founding gesture intercrossed by another's arm and culminant in Thomas' finger expresses a mystery—the eucharist expounded as in a rebus: "This is the bread which comes down from heaven, that a man may eat thereof and not die" (John 6:50).

Question: was this "rebus" assembled by Leonardo, or cobbled by interpretation? If it's modern handiwork we are asked to look at, why then, away with it. I can only reply that I see the picture make certain connections, and that they who will not have these items connect may be inflicting dismemberment. In the St. Thomas, they may be seeing only the person where they should be seeing the painting. But of course, it's Leonardo's own fault for impersonating so well.

And now for the weightier question: with twenty-two apostolic forefingers available, why would Leonardo privilege that of St. Thomas? Surely because his is the finger destined to verify the Resurrection, the Christian hope. Three days hence, at the rumor that Christ's entombed body has

risen, Thomas will demand that his finger be permitted to test, steep itself in the wound; to which Christ consents, unexpectedly. To Mary Magdalen, the first to behold him risen, Jesus had said, "Do not touch me, for I am not yet ascended" (John 20:17). To Thomas he says: "Put in thy finger hither,…and bring hither thy hand" (John 20:27). As St. Bernard would summarize a thousand years later: "Thomas, by first doubting the truth and then proving it by the testimony of his touch, became the firmest witness of the Resurrection.…"[24] How could this association have eluded the painter when he appointed that hand, quartered it like a vatic sign over Christ's open palm?

THOMAS IS NOT ALONE in casting doubt on the intelligibility of what Leonardo's actors express. St. Philip, for instance (third on Christ's left): what is it that makes him hurl himself Christward? Seventeenth-century viewers saw him undoing his uppermost button, and so the gesture is interpreted in the Vespino copy (Fig. 33) for which Cardinal Borromeo had such high praise. Viewers of a less practical turn saw Philip enacting the words of the Gospel. Having heard the Master's terrible "one of you shall betray me," he wonders, as do the others, "Lord, is it I?" Whereas Goethe saw Philip not questioning but rather asserting his innocence. For those of us who also see the eucharist instituted, Philip's ardent response to the Master, the pressing of hands to breast, bears a more richly fraught message.

Much the same may be said of the open-armed figure

22. Edgar Wind (1952) thought both Thomas' finger and Matthew's "gesture of reception" quoted in Raphael's *Disputa* (Vatican Stanze), the two together indicating "the contrast between ritual and mystical theology;…the body of Christ as a sacrament is on the altar, but in reality it is in Heaven."

Meanwhile, in the Morghen engraving on which Goethe relied (Fig. 14), Thomas' heraldic forefinger, rigid, outsize, and apeak, is downsized and flexed. But one tiny detail in the engraving (too small to show up in reproductions) suggests that even in 1800 Leonardo's *Last Supper* could be allowed a secret symbolic charge. On the neckline of the tunic worn by the figure

Morghen mistook for Thomas (the actual James Major), he inscribed in tiny gold majuscules the resurrected Christ's words to Thomas: *Quia Vidisti Thoma Credisti* ("because thou hast seen [me], Thomas, thou hast believed"; John 20:29).

23. Of the Louvre *St. John*, Picasso remarked (mistaking only the promiser): "Yes, da Vinci promises heaven: look at this raised finger" (*Picasso on Art*, ed. Dore Ashton, New York, 1972, p. 168).

24. St. Bernard, *Homiliae Quatuor, De laudibus Virginis matris*, Hom. II, *Patrologia latina*, 183, col. 67.

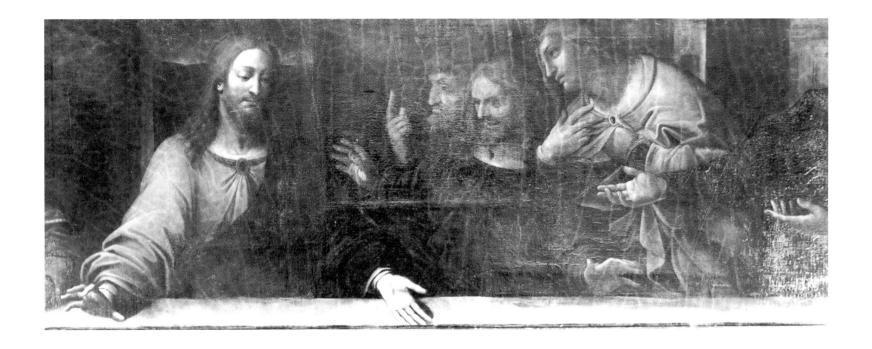

33. Andrea Bianchi, called Il Vespino, 1625,
detail (App. E, no. 39), before cleaning.

between Philip and Thomas—again, a mental state hard to pin down. In the literature, from Goethe onward, the man "draws back in terror"; "shrinks back with horror"; expresses "disgust"; foresees the fateful outcome of the hands of Judas and Christ approaching each other; recoils "horrified . . . as from a blow."[25] All this might properly follow the announcement that one at this table will prove a traitor. But Antoniewicz (App. B, p. 207) and Schäfer (1965, p. 217) insisted that the man's bearing—seeing Christ at this moment indicate bread and wine—expresses speechless awe at the mystery unfolding before his eyes.

Well, then, since each interpreter allows James just one nameable reflex, which shall it be, repugnance or holy wonder? Or are both perhaps too exact? At least one scholar (Hüttel 1994, p. 123 n. 18) is content to see James' gesture express only "profound astonishment"—no hint as to what might have caused it. Such reticence seems sound and safe until we reflect that astonishment is not what an astonished man has in mind (unless it's an actor faking it). If surprise

without content, generic astonishment, is all we are meant to infer, we are no longer, in Leonardo's sense, seeing a gesture "sufficient to show what the figure has in mind." For Leonardo would have the tenor of a man's gesture shaped not only by a present emotion, but as well by the kind of message that aroused the emotion. His advice: "The painter ought to consider the manners of men who talk with one another, coldly or warmly, and attend to the matter of which they speak, and see if their actions are appropriate to their [subject] matter."[26]

I RECALL A CARTOON PARODY of the *Last Supper* in which the protagonist, addressing a waiter, says, "Separate checks"— whereat his invited guests start in profound pseudo-Vincian astonishment. The effect, venially blasphemous, is mildly funny—and cautionary: we are reminded that the interpretation of facial expression or gesture, in the *Cenacolo* as anywhere else, depends on what we think is the occasion, the prior signal, the widening context.

25. Sources of the foregoing, in order of citation: Goethe 1817; Jameson 1848, as on p. 36 n. 7; Dvorak 1927, p. 182; Heydenreich 1965, p. 228 n. 39; Hartt 1969, p. 399.

26. *Trattato*, McMahon 1956, p. 59, the translation here modified to match the original (fols. 33r, 33v): *Il pittore debbe considerare li modi di quelli homini, che parlano in sieme freda ò caldamente et intendere la materia di che parlano, e vedere se li atti sono appropriati alla materia loro.*

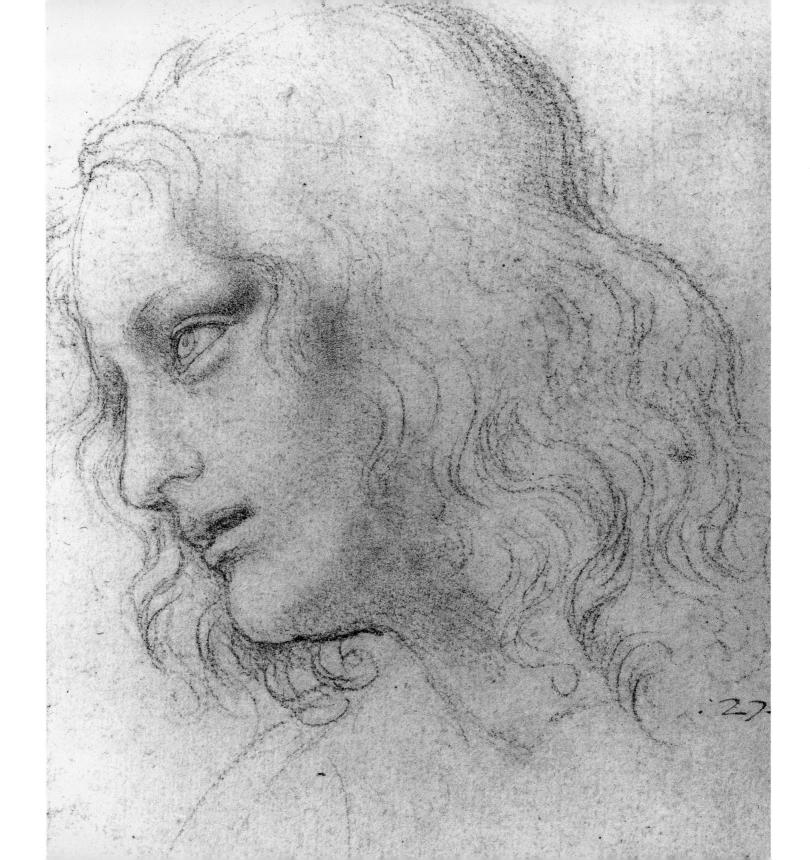

The Twelve

HOW DO WE KNOW WHO IS WHO? Leonardo individualized his *dramatis personae*, but neglected to label them. Accordingly, by the end of the eighteenth century, when the mural had fallen into irreversible ruin, the traditional appellations that must once have been common knowledge were no longer remembered.[1] With the revival of interest in the *Cenacolo*, two variant roll calls emerged—to be swept aside by one of Giuseppe Bossi's discoveries. In the parish church of Ponte Capriasca near Lake Lugano, Bossi examined an unsigned, mid-sixteenth-century fresco copy of Leonardo's *Cenacolo* (Fig. 153). On that fresco, fallibly attributed to Pietro Luini, Bossi found the twelve names inscribed on a frieze beneath the table, and he confirmed the identifications by a descriptive analysis of each figure. From his presentation, by way of Goethe and Stendhal, the Ponte Capriasca

nomenclature attained general currency. (Modern attempts to reshuffle remain unpersuasive; they are laid to rest in App. C.)

Well then, quickly from left to right.

At the short end of the table stands St. Bartholomew. He has leapt to his feet too fast to uncross his ankles, or so Bossi explained (see p. 108). Now, with both hands on the board, he cranes head and shoulders—either from eagerness to hear more, or else, being part of a painting, to keep his head isocephalous with those sitting down. Why the painter chose him for this outpost position is not apparent, at least not yet.[2]

Seated next is St. James Minor (or James the Less, so named, according to one hypothesis, because the other James was called first). St. Paul refers to him as the Lord's "brother" (Gal. 1:19), a term which Catholics interpret as

34. Leonardo, study for St. Philip, Windsor 12551.

1. When the painting was three hundred years old, most of the apostolic identities had to be reinvented by the then prior of Santa Maria delle Grazie, Domenico Pino (1796, pp. 22ff.). Alternative appellations were published soon after by Abbé Guillon de Montléon (1811). The abbé's methodology was ingenious. He would, for example, calculate a given Apostle's age at the time of the Supper, then scan the depicted crew for one who looked about sixty-six, whom he then confidently identified. The nomenclatorial chaos left behind by Guillon and Pino is discussed in Hoerth 1907, p. 127. Hoerth's n. 76 includes a comparative chart.

2. Because of supposed facial likeness, a Leonardo drawing at Windsor (12548) is often adduced as a study for Bartholomew's head. But the Windsor profile lacks the thrust of Bartholomew's pose. The alleged correlation would have Leonardo fix the man's facial type before inventing his action. Such practice is not borne out by the drawings that survive for the heads of Judas, James Major, and Philip. (Another bearded profile [Windsor 12553], formerly called a study for St. Bartholomew, has long ceased to be a viable candidate.)

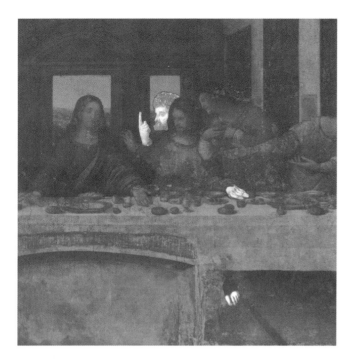

kinsman or cousin. Later legend made his likeness to Jesus so close that the Blessed Virgin herself could barely tell them apart.[3] In iconographic tradition, this resemblance is usually honored, and was apparently honored by Leonardo. The faces in their present condition are unreliable, but Leonardo gave to both James and Jesus blond, shoulder-length hair.

Sufficient for Goethe to remark on their "unmistakable" family likeness.

Next in line is St. Andrew, the earliest called of the Apostles, hence aged (and bald). He is followed by Peter, Judas, and John, the three whose identity in the mural was never doubted. Drawings survive for the heads of Philip and Judas (Figs. 34, 50) and the hands of St. John (Fig. 23)—and for the startled James Major, first on Christ's left (Fig. 46); which brings us to the auspicious side.

Next to James sat St. Thomas—now out of sequence, thanks to his impetuosity. To keep up with his index finger, Thomas has quit his seat and outflanked his neighbor, by whom he is now expansively overlapped. When the painting was fresh, you would have spotted two more installments of him at and under the table. Thomas came head, hands, and foot in four dispersed rations—a man of parts and a *tour de force* (Fig. 35).[4]

Welcome next young St. Philip—hands on chest, ardent, and open-lipped. So the artist conceived him in the great drawing preserved at Windsor. The type accords with Florentine usage: Philip appears young, ardent, and open-lipped in Nanni di Banco's statue at Or San Michele (Fig. 36) and in the statuette topping the late fifteenth-century reliquary of St. Philip's arm bone in Florence (Fig. 37).[5]

The triad at the far right comprises Matthew, Thaddeus,

35. Thomas' head, hands, and left foot, composite from Figs. 49 and 154.

3. See Jameson, I, p. 259 (as on p. 36 n. 7): "According to an early tradition, he so nearly resembled our Lord in person, in features, and deportment, that it was difficult to distinguish them. 'The Holy Virgin herself,' says the legend, 'had she been *capable* of error, might have mistaken one for the other': and this exact resemblance rendered necessary the kiss of the traitor Judas, in order to point out his victim to the soldiers." All this, except for the Virgin's near fallibility, Jameson takes from the *Golden Legend*. But how did Judas, who surely was "capable of error," distinguish between these look-alikes? Moreover, James Minor was not present at the arrest.

4. The St. Thomas archipelago: right hand separated from head, a disjected left marking his place at table, and a remote foot—all under one government. (Some copies attempt to reconnect Thomas' pointing hand to a body, as in the plaquette of 1824 [Hüttel 1994, fig. 70] by the once-famous Berlin medalist Leonhard Posch [1750–1831].)

Fig. 49 reproduces a red chalk drawing at Windsor, often claimed to be autograph. It is (in my view) a copy of a Leonardo study for Thomas' left hand, which shows clearly enough in most sixteenth-century copies, e.g., Figs. 144, 145, 151, 154. In the mural, this hand was, by the eighteenth century, so eroded that its one leftover digit was assimilated to the adjacent hand of St. James, causing wonder why Leonardo would have given the latter six fingers. It was Bossi (1810, p. 99) who produced the correct explanation. Soon after, the unsightly dead spot was plugged with a painted morsel of bread. In Dutertre's copy (1789–94; Fig. 180), the gap is screened by a fruit dish. In the now-restored mural, Thomas' long-lost hand has mysteriously reappeared.

5. The reliquary, formerly in the Florence Baptistery, now resides in the Cathedral museum; see Luisa Becherucci and Giulia Brunetti, *Il Museo dell'Opera del Duomo a Firenze*, Florence, 1971, II, p. 242, no. 11, pls. 124–26.

and Simon, of whom more in a moment. So much for the disciples as singletons.

SINGLENESS AND DIFFERENTIATION were a small part of the enterprise. Though Leonardo knew his characters one by one, they were not to be lined up seriatim. The task, never before attempted, was to collect in "conjoint presence" a superdozen male sitters strung across nearly 29 feet of wall; to convert the drag of enumeration into what he called a "harmonic total effect."

The way Leonardo mastered the problem is an untiring marvel. Given the company's irreducible number, he suffused the gross with the restlessness of ever-shifting alternative tallies. His individualized actors come four times three or twice six, or if you will, six in the middle with threesomes manning the flanks. Of course, you don't count—you just see them constantly re-arrive at their recombinant total. To put it another way: the figures are mustered in sixes—that many on either side if you take the spread wall to wall. But look upward: as these same figures underlie the lunettes overhead, you find a grouping of six (Christ exempted) canopied by the central lunette, so that the bisected assembly—coaxing you now to keep glancing up and across—yields six on the left, as many at right, plus one sixsome at center; three overlapping half-dozen for a total of twelve. At the same time, these twelve, who divide variously into sixes or four-times-three, keep regrouping by twos, so that each duodecimal self pairs, trines, and half-dozens—in sum, a refluent flux in "harmonic total effect." I am reminded of the Balanchine-Stravinsky collaboration on the ballet *Agon* (1954), of which Robert Craft writes: "*Agon* is about twelve dancers and twelve tones. Balanchine himself recalled that . . . 'we constructed every possibility of dividing twelve,' meaning dance solos, duos, trios, quartets."[6]

6. Robert Craft, "Stravinsky and Balanchine," *The New York Review of Books*, October 8, 1998, p. 43.

The *Cenacolo* is, among other things, that kind of dancing—the principle of vicissitating division is similar. But in the painting the recombinations are so fluently intertwined that it seems almost perverse to sunder what the artist has joined. Better to watch how the figures associate.[7]

Pairing and Seating

Within and despite the obvious triadic arrangement, the picture involves at least ten of the figures in significant pairs.

Andrew and Peter, fishermen both, were the first-called; and they are brothers. Behold them even now side-by-side.

Peter and John, habitual companions as well as personifications, respectively, of the active and the contemplative life—here shown putting their heads together.[8]

Jesus and John, presently farthest apart. But they are soulmates, hence mirror images, matched in outline, in (original) hue of garment and tilt of head.

7. A perceptive analysis of the *Cenacolo* in relation to the wall system was published in 1932 by Werner Müller. His diagram superimposed the wall's three heraldic lunettes on the composition, showing how the span from Peter to Philip corresponds to the central lunette.

Müller's insight—that the figures relative to the lunettes yield one central mass flanked by triadic groups—was anticipated by several sixteenth-century copyists and adapters of the *Cenacolo*. Two instances: the ruinous refectory fresco in the Augustinian monastery at Crema, dated 1507 (Fig. 141), and the Leonardo-derived fresco by the Ferrarese Garofalo, dated 1544.

8. "The Passover is prepared for Christ by Peter and John—that is, by action and contemplation" (Thomas Aquinas quoting Theophylactus on Mark 14:13–15 in *Catena aurea in Quatuor Evangelia*, Expositio in Marcum, 4, ed. P. Angelici Guarienti, Turin and Rome, 1953, I, p. 541). The respective characters of these Apostles became common knowledge. "Peter," explained the Pseudo-Bonaventure, "symbolizes the active and John the contemplative, as Augustine himself says in the homily on the Gospel that is read for the feast of St. John" (Isa Ragusa and Rosalie B. Green, eds., *Meditations on the Life of Christ*, Princeton, 1961, p. 312).

In the Grazie mural, Peter's recourse to John (John 13:24)—the hothead consulting his imperturbable friend—may be construed beyond its denotive sense as the active man's plea for the quietist's illumination.

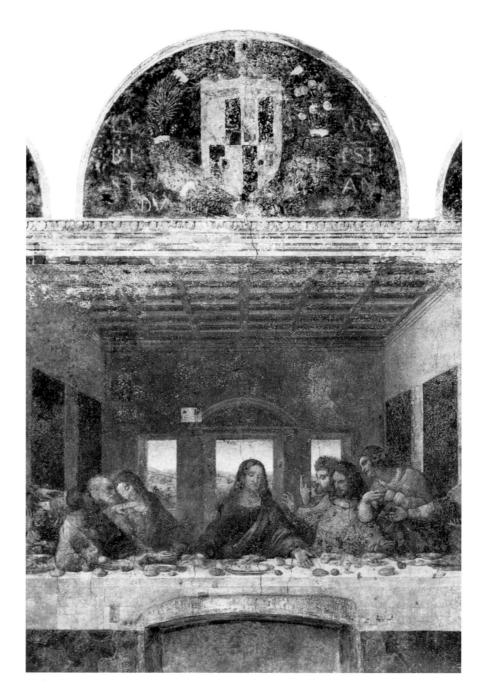

38. Leonardo, *Last Supper*, detail, before latest cleaning.

Judas and Christ, linked by the dish between their opposing hands.

The sons of Zebedee, John and James, whom Jesus nicknamed the "sons of thunder," here flanking his seat, as though in proleptic fulfillment of their mother's hope. "Grant," she had pleaded, "that these my two sons may sit, the one on thy right hand, and the other on the left, in thy Kingdom" (Matt. 20:21; Mark 10:37 ascribes the request to the brothers themselves).

Thomas and Christ: one horizon threading their eyes; their heads, theirs alone, silhouetted against clear sky—heads jointly framing a christological finger (see p. 71).

(Why Thomas, before leaving his seat, sat next to Philip is not evident. Their names are linked in Acts 1:13, but this does not seem sufficiently pressing.)

Most remarkable is the remote coupling of Peter and Philip (Fig. 38). Both men start up and lean inward, like the springing of a great arch, an inchoate arch to be capped by the (no longer visible) gable over the central window. As Peter and Philip in symmetry overlap two distant wall corners, the concentering heave of their bodies prepares to enclose, to concamerate Christ under a giant parabola; Peter darting forward in concern for Christ's human person; Philip—his head higher than any—perhaps yearning for the mystical body. Unless we believe with Goethe that Philip, responding only to the betrayal announcement, protests his personal innocence; or believe with Bodmer (see p. 69 n. 19) that this youngest among the disciples is least able to "control his indignation." A eucharistic interpretation of Philip's posture, one that sees him and Peter in complementarity, reflecting the dual theme of this Supper, may seem extravagant, but it is better to air it than to leave the effect of their correspondence unnoticed.

The neighboring of the graybeards at the right end, Thaddeus and Simon, is more certainly motivated. According to one tradition, they were brothers (they appear as young siblings with labeled halos in, e.g., Perugino's *Family of the Virgin*, 1500–02, Musée des Beaux-Arts, Marseilles). Moreover, they traveled and preached together, were martyred together in Persia, and share a common feast day (October 28).

But that's not all. One pious legend identifies them with the shepherds of the Adoration. The story may have arisen because Scripture gives Simon and Thaddeus neither parentage nor hint of an earlier career. Then why not equate them with the shepherds who genuflected at the Nativity? The Evangelist makes no more mention of them, but consider: these shepherds were grown men when they hailed the birth of the Savior. Is it likely that, having adored, they returned to their flocks, giving the incident no further thought? God forbid; through thirty-odd years they would have kept council together, then, recognizing the Savior when he reentered Judea, followed forthwith, and became his Apostles. Thus the nameless, too-soon-abandoned shepherds of the Nativity story are given a glorious future; Simon and Thaddeus, a pious past. And as from old habit, they still keep council together at the Last Supper.[9]

While we need not imagine Leonardo diligently researching his characters, we should, I think, grant him an intelligent interest in his subject. He surely read up on the Apostles in the *Golden Legend*, the common sourcebook used by Renaissance artists for the lives of the saints, printed in

9. The legend concerning Simon and Thaddeus is cited by Jameson, I, p. 261 (as on p. 36 n. 7). Émile Mâle repeats the story, again without source, using the convenient neutral: *On racontait … qu'ils étaient du nombre de ces pâtres à qui l'ange apparut la nuit de Noël* (*Les Saints Compagnons du Christ*, Paris, 1958, p. 210). In Friedrich Gottlieb Klopstock's *Der Messias* (canto III [1751], lines 244–56), Simon alone is so designated: "Come, follow me Simon,/ said [Jesus] to him, and leave the flock to your mates./ For I am he of whom you, when yet a youth,/ Heard the heavenly hosts sing near Bethlehem's spring." Bossi, too (1810, p. 109), cites the legend that identifies Simon as one of the Bethlehem shepherds.

F. VINCENTIVS BANDELLVS,
de Castro nouo, Elect. Romæ
1501. Rex. Ord. an. 6. Ob. Mon-
tisalti in Calabria 27. Aug. 1506.

Italian translation since 1475.[10] As need arose, Leonardo may have consulted a learned adviser, such as Prior Vincenzo Bandello (Fig. 39)—visualizing from the information received.[11] The alliances formed in the picture suggest that arbitrariness was never an option. Leonardo made certain to know them all, whether singly, as brethren, or as companions.

A WORD ON THE TRINES. The group at Christ's right, John, Judas, and Peter, clusters the three who are destined for roles in the Passion. And they cannot wait to regroup, so that the disciples whom Jesus especially loved—Peter, John, James—become his close neighbors.

On Christ's left, the triumviration of James-Thomas-Philip seems harder to justify; it unites nearest to Christ, and as the most zealous, three saints cherished in Florence, Leonardo's hometown. If this was fortuitous (we are, after all, in Milan), it does not dispel the impression that Leonardo gave informed thought to the seating arrangement.[12]

39. Posthumous sixteenth-century portrait, *Vincenzo Bandello, Prior of Santa Maria delle Grazie.*

10. Jacopo da Voragine's *Legenda aurea* was englished by William Caxton in 1483. A deplorable modern English edition by Helmut Ripperger and Granger Ryan (New York and London, 1941) was widely used for half a century, despite mistranslations and unacknowledged abridgments (see Steinberg 1983/96, p. 57 n. 62). A full and reliable retranslation was finally published by William Granger Ryan, Princeton, 1993.

Leonardo's sourcebook is repeatedly mentioned by Bossi (1810, pp. 94, 96–97), but never its title or its thirteenth-century author. Bossi cites the *Legenda aurea* only as a work translated by Niccolò Malermi, a substitution which led even the *Enciclopedia Cattolica* (Rome, 1951, s.v. "Malermi") to appoint Malermi the author of a compendium of saints' lives. Bossi may have suppressed Voragine's name and book title because the *Golden Legend*, rife with tall tales and rank superstition, had long fallen into disrepute, so that any dependence on it would have done the sagacious Leonardo no credit.

11. Vasari's anecdote about Bandello sours the man's reputation forever. Vasari has the prior complain that Leonardo is dawdling. Questioned by the duke, Leonardo replies that the picture is all but finished, except for the features of Judas, for which a sufficiently odious model is yet to be found, but,

come to think of it, the prior's face would probably serve; whereupon Leonardo portrays Bandello in the figure of Judas (laughter). So writes Vasari. It was Emil Möller (1952, p. 11) who discovered an engraved portrait of the hapless baldpate Bandello, proving the anecdote to be sheer fabrication. Not to worry; the story will be retold as long as the *Last Supper* is spoken of. For a similar figment involving Michelangelo's *Last Judgment* fresco, see L. Steinberg, "A Corner of the *Last Judgment*," *Daedalus*, 109 (Spring 1980), pp. 211–16.

Leonardo's encounter with his model for Judas is the subject of a modern novel: Leo Perutz, *Leonardo's Judas* (1957), trans. from the German by Eric Mosbacher, New York, 1989. The book entered the Leonardo literature in Hüttel (1994, p. 130 n. 252). Professor John Simons of Colorado College kindly presented me with a copy.

12. Concerning the Florentine connection: relics of St. James were brought to Florence in 1334, whereupon the Furriers Guild made him their patron. Philip, whose arm relic was revered in the Baptistery, was Florence's patron of tanners. Thomas, a "Medicean saint," is designated Magistrato dei Sei della Mercanzia (see George Kaftal, *Iconography of the Saints in Tuscan Painting*, Florence, 1952, p. 969).

40. Leonardo, *Last Supper*, detail, after latest cleaning.

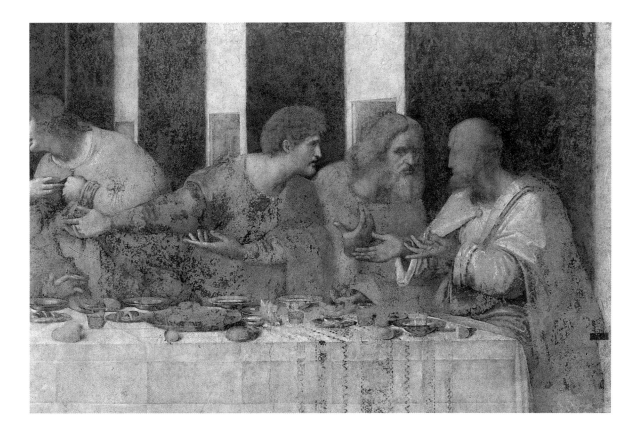

"What a pack of vehement, gesticulating, noisy foreigners they are" [13]

Knowing their names and affiliations, we proceed to the next question: what agitates them, and do their reactions sustain the dual subject of the Last Supper? If Rubens' grasp of their motives was not capricious, then—since he conceived the whole company in reaction to the institution of the eucharist—every one of the Twelve should be interpretable on a level beyond the familiar, the literal. We shall have to ask whether each actor's response lends itself plausibly to an alternative reading. A positive answer will not guarantee that the proposed alternatives are exactly the ones that would have occurred to Rubens (or to Simon Bening, or Antoniewicz or Wind). But we will have established that explanations other than the usual psychodramatic ones are at least tenable.

The following inquiry finds the Apostles on the dark side of the picture doubly defined: in their response to the present moment and in anticipation of their personal destinies. Whereas on the lighted side, gestures famous for dramatic expressiveness may be read, in the spirit of Rubens, as gestures that refer to Communion.

Begin with the figure of Simon at the far right (Fig. 40). He puts forth both hands, palms up, as if to accent a spoken

13. Bernard Berenson, "An Attempt at Revaluation," in *The Study and Criticism of Italian Art*, London, 1916, reprinted in Morris Philipson, ed., *Leonardo da Vinci: Aspects of the Renaissance Genius*, New York, 1966, p. 112.

expostulation. So, at any rate, the action (unglossed by Goethe) was understood by nineteenth-century writers. "Simon, with his hands stretched out, [expresses] a painful anxiety" (Jameson). J. J. Tikkanen looked deeper; he thought this old man too good-natured to suspect anyone of so vile a deed as had just been foretold. "He puts forth his open hands as who should say: 'How is this possible?'" Neither author observed that the gesture pays homage to Taddeo Gaddi's *Cenacolo* at Santa Croce in Florence, where the hands of the endmost figure are similarly extended (Fig. 30).[14]

Is Simon's action, then (in Leonardo's phrase), "sufficient to show what the figure has in mind"? Rubens read Simon's mind very differently. He had seen the mural sometime before 1608, i.e., before another four centuries of wastage and overpainting. And he had made a painstaking study of the ensemble. From one of his drawings—one probably drawn from the copy at Tongerlo (App. E, no. 15)—derives the double-folio etching by Pieter Soutman (Fig. 17), with its eucharistic legends applied to the whole, Simon included.[15]

There is further evidence that Rubens took the sacramental import of Simon's gesture for granted. From his shop issued a large drawing which reduces the *Cenacolo* to an epitome (Fig. 41). Two actors are singled out: the protagonist, with bread and chalice before him, and our Simon, unchanged in gesture, extending both hands to the celebrant.[16] Does this make Leonardo's depicted moment exclusively eucharistic? Or, better put: is Simon's response interpretable as eucharistic reception? In this formulation, the question has ceased to be speculative, for we have learned that it was so understood in Rubens' circle. And one reason for this understanding was surely the recognition that Simon's hands anticipate, or rehearse, a ritual performance common in traditional iconography—the gesture of the disciples receiving the wine from Christ's hands in representations of the Communion of the Apostles (Fig. 42).[17]

In the *Cenacolo*, the gesture is sufficiently similar—with this difference: the communicants approaching the high priest at the altar know what they do, whereas Leonardo's Simon, as a *dramatis persona*, need not be conscious of what his action foreshadows; he is, after all, engaged in talk with his neighbor. Just as Peter and Philip cannot see how the protagonist is enarched by their inclinations; just as Thomas cannot foresee his forefinger's vocation, so Simon's impulsive gesture is subjectively innocent of its outcome. But for the beholder familiar with ceremony, or with iconographic tradition, Simon is shaping a cultic form in its nascency.

If Simon's case stood alone—and despite Rubens' perception of it—one might dismiss it as idiosyncratic. But Simon is not alone. His gesticulation intertwines with that

14. Tikkanen (1913, p. 47) further explained that old Simon's doubt yields to the persuasiveness of young Matthew, third from the right: "It is doubtless true, says the young Apostle, for the master himself has said it."
 In 1924, Hermann Kranichfeld (as on p. 84 n. 18), made what Eichholz (1998, p. 466) calls an "astonishing observation": that Simon's left thumb seems to be touching the minimus (pinky), so that Simon must have been counting, checking off possible suspects for the betrayal on the fingers of his left hand. Four unlikely candidates being discounted, Simon would now be saying, "I give up; can't imagine who it might be." (The observation is repeated in the revised 1928 edition of von Seidlitz's 1909 Leonardo monograph.) But the alleged fingerwork is illusory. If the thumb flexed all the way to the minimus, we would see it foreshortened, not in extension as here.
15. The impact of Leonardo's *Last Supper* on Rubens is further discussed in App. E, nos. 40–43.

16. See App. E, no. 40. In the Rubens School drawing, as in Soutman's etching, the bare table displays only chalice and bread, a stripping down which elicits this profound understatement from the Desmonts-Lugt *Inventaire* of Flemish drawings at the Louvre: *La table est moins garnie que dans la fresque et la verre a changé de forme.*
17. The reception of the eucharist with hands outstretched, as in Fig. 42, right, is a common motif. (Examples from the eleventh and twelfth centuries, from Greek and Russian Orthodox as well as Roman Catholic sites, are reproduced in the *Propyläen Kunstgeschichte*, III, pls. 306 and 19, and V, pl. XIX.) The earliest occurrence of the motif may be the *Communion of the Apostles* on a sixth-century silver paten in the Archaeological Museum, Istanbul. Cf. Jungmann 1951, II, p. 378: "According to Theodore of Mopsuestia the communicant should draw near with lowered eyes, both hands extended, . . . since he is to receive the Body of the King."

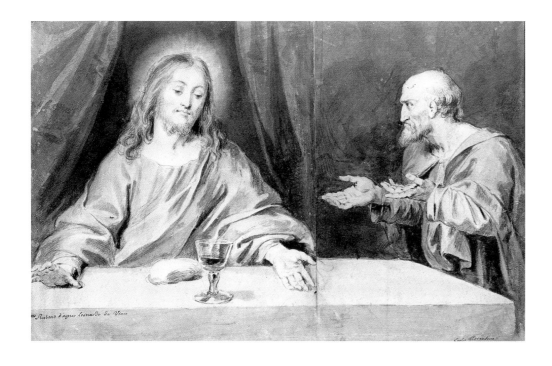

41. Rubens School, *Christ and Simon*.

42. Byzantine, *Communion of the Apostles*,
after 1354. Left: Christ dispensing the bread;
right: dispensing the wine.

of Thaddeus, whose gesturing is more complex than Simon's, yet, I believe, similarly ordained. His is surely the oddest gesture of all: a left hand, stretched forth like Matthew's, but backed on the table; a raised right (supinated)—atwist to extrude the thumb—hovers wide open, insistent and urgent (Fig. 43). To this stressful hand the artist must have given attention. Was he inattentive to the lay of the other? The question before us is this: do Thaddeus' hands act in concert, or may the tabled one be ignored?

Unfortunately, this Thaddeus (a.k.a. Jude) has not had a good press. During the past two hundred years, his maneuver attracted scant comment, inspired no "enhancing" description. Strzygowski (1896, p. 153) took note of both hands, one pending over the other, but, he observed, these members want wiggle room. Being so tightly cramped, they must have been jammed anyhow into that leftover slot; the left hand laid down simply to have it show, and the whole man a mere *Lückenbüsser* (stopgap).

Hoerth (1907, p. 76) thought otherwise. Finding four fingers of Thaddeus' right hand self-addressed and the thumb Christ-directed, he concluded that the intent of the gesture was not hard to divine (*unschwer zu erraten*), and proceeded to give the depicted miming its speech: "I [pointing to his own breast] will assuredly not betray Him [i.e., Jesus, to whom the thumb points]." Meanwhile, the left hand, aimed toward Christ, merely corroborates what the other thumb said.

Strangely enough, that thumb's message—what exactly it targets—is still in dispute. Some think that Thaddeus is telling Simon to trust the report relayed to them by St. Matthew, to whom, accordingly, the thumb points. But as long ago as 1913, the clear-sighted J.J. Tikkanen saw Thaddeus "pointing his thumb surreptitiously at Judas," as if to say,

I bet it's him (the left hand now out of service). Eleven years later, this reading was seconded (without credit) by Kranichfeld, so that, by the mid-1920s, Thaddeus' plainspoken thumb was clearly indicating either Matthew, or Jesus, or Judas.[18]

Reading these authors, one suspects that someone went wrong—they did, or the painter of the *Cenacolo*. Leonardo's *Trattato* demands that "the motions and attitudes of figures should display the true mental state of the moving figure, in so true a way that they cannot signify anything else" (McMahon 1956, no. 401). If the pantomimic approach which such Leonardo injunctions encourage in modern scholars is the correct approach, then our lack of agreement in assessing the mental state of a figure becomes Leonardo's delinquency. Instead of legible clarity, the painter will have sown utter confusion, even unto this day. Or say that the artist in Leonardo has failed to keep faith with the author of the *Trattato*.

In 1998, Liz Trotta (see p. 70) briefly described the trio at the right end of the picture. She sees Matthew with back-stretched arms asking his seniors, "Do you hear what He says?" Whereat "the aged Simon displays his bewilderment, while [Thaddeus] . . . reflects the same question, but temperately, his right hand raised in unspoken entreaty to Simon." No left hand is noticed, and no centripetal thumb. Thaddeus' drift, formerly leftward, is now all to the right.

The most recent work on the *Last Supper*, Georg Eichholz's monograph of 1998, examines Thaddeus' gesture at length (pp. 418–20), leaves no digit unturned, and ends up nonplussed. After fifty more pages of other matter, we are suddenly told *en passant* (p. 468) that nothing definite can be said about Thaddeus' inner life (*Über sein Innenleben ist keine sichere Aussage möglich*). His gesturing, Eichholz thinks, is no clue.

18. Tikkanen 1913, p. 47; Hermann Kranichfeld, "Ist eine Rekonstruktion des Abendmahls von Leonardo da Vinci möglich?" *Velhagens und Klasings Monatshefte*, 4 (1924), p. 9. Anticipating the above scholars by almost a century, A. Bouquet, the French satirist who first politicized Leonardo's design, interpreted Thaddeus' right-hand gesture as a back-pointing thumb (Fig. 140). The left hand he omitted.

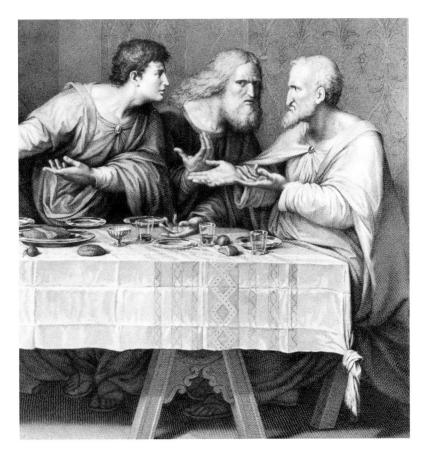

43. Raphael Morghen, 1800, detail (App. E, no. 48).

cient, more likely to stir at a solemn pace. Suppose the motion of his upper hand not prompt, rapid, assertive, but reverential—a right gently descending to be cupped in the waiting left? Thus consummated, not as a slap but as a coming to nest, the gesture, like Simon's, anticipates another ritual form of Communion-taking: the hollow right hand "resting upon the left as on a throne to receive Christ the King" (Figs. 42, left, 44).[19] In Byzantine art, from the sixth to the fifteenth century, it is such double-cupped hands that receive the Host.

But there is no need to revert to Byzantium. The two gestures produced at the right end of the table had long been absorbed into Florentine art. In Castagno's *Vision of St. Jerome* (Fig. 45), the women attending the eponymous saint look up at the crucifix, and both enact eucharistic reception: at left, St. Eustochium opens her hands toward the corpus; the abbess St. Paula cushions one hand in the other, performing that same lasting ritual which Thaddeus' hands are about to define.[20]

We are given yet another case of duplexity. Within the narrative, Thaddeus is clearly trading words with his mate, their hands intergesticulant, gears interlocking, one speaker's gesture inside the other's personal space so as to visualize colloquy. (The motif may be Castagno's invention, as in Fig. 86, leftmost pair, and it recurs in Mantegna's so-called *Sibyl and Prophet* in Cincinnati.) But Leonardo has contextualized the

Goethe would not have agreed, partly perhaps because he alone saw a purpose in Thaddeus' ambidexterity.

> . . . [Thaddeus] has laid his open left hand on the table, his right hand raised as though to slap its back down on the other; a movement such as may still be observed among simple folk [*Naturmenschen*] when, in response to some unexpected event, they exclaim with emphatic hand slap—"What did I tell you! Didn't I suspect all along!" (see App. A, p. 199)

Goethe rightly perceived that Thaddeus' hands produce one compound gesture—which no one before had considered, and which would not be reconsidered until 1973. But the speed of that gesture I think he misjudged. What if we slow it down, think of it *ritardando*? This Thaddeus is an-

19. The formulation is of the fourth century. "Make the left hand into a throne for the right which shall receive the King, and then cup your open hand and take the Body of Christ" (Cyril of Jerusalem, *Catech. myst.*, V, 21f.; quoted in Jungmann 1951, II, p. 378). For further citations, see Hans Aurenhammer, *Lexikon der christlichen Ikonographie*, Vienna, 1959–67, I, p. 222.
20. We are probably meant to recognize the eucharistic allusion wherever the Christ Child—as priest and as sacrifice—holds the symbolic goldfinch in double-cupped hands, as on a Florentine plaquette of the late fifteenth century (Bange 323; Ricci 18).

For the imaging of an action "in process of being assembled," see L. Steinberg, "Pontormo's Capponi Chapel," *The Art Bulletin*, 56 (September 1974), pp. 396–98. In the present interpretation of Thaddeus' gesture, Leonardo would be anticipating both Raphael and Pontormo.

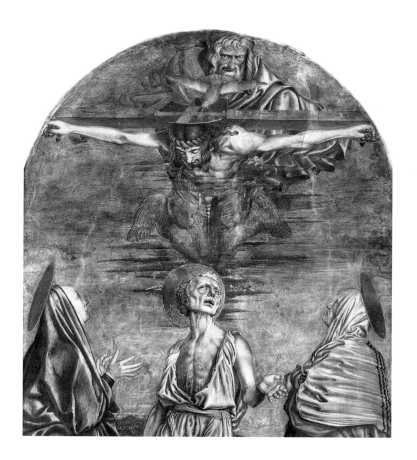

motif into double function. Depicting reciprocal speech, it entwines the ritual gestures that prepare to receive the sanctified bread and wine, interinvolved as flesh and blood are.

So then, on the narrative plane, Thaddeus communes with his old-time companion. What his action prefigures is a different sort of communion. No wonder that such a two-natured gesture defeats every attempt at unilateral interpretation.[21]

Before bidding Thaddeus adieu, I note that his left hand rests on its back—as does only one other hand among the twenty-six on display: it is Christ's, addressing the bread.

The affinity of these two left hands leaps to the eye in copies such as Figs. 21, 171, 175, where all intervening fare is omitted. We now see these hands differing chiefly in their orientation: Thaddeus' hand toward Christ; Christ's toward us. It is missing a lot to dismiss the correspondence as accidental.

Matthew-Thaddeus-Simon—the whole group in concerted gesticulation. A flotilla of six open hands in formation strains toward Christ, as if in immediate response to the word "Take!" Whatever psychological motives we ascribe to this manual play at the shock of the betrayal announcement, the eucharistic interpretation attends to a second voice, a con-

44. Byzantine, *Communion of the Apostles*, c. 1415.

45. Andrea del Castagno, *The Vision of St. Jerome*, 1454–55, detail.

opposite
46. Leonardo, study for St. James Major, Windsor 12552.

21. Thaddeus' gesture, faithfully reproduced, turns up in the Venice Accademia drawing for a *Last Supper*, discussed in App. F (Fig. 201). I attribute this baffling document to a very young pupil who, in the Thaddeus figure, would have copied an early Leonardo study. If the present interpretation of

Thaddeus' gesture is valid, then its occurrence in the Accademia drawing at a presumably early stage of the *Cenacolo* project indicates that the expressibility of eucharistic reception had occupied Leonardo's mind from the beginning.

comitant meaning. It is the meaning Rubens took from the picture. Nor is it far-fetched, seeing that the Communion of the Apostles is imminent.

The Triad Closest to Christ

Here the case for a twofold interpretation gains urgency. James Major, next on Christ's left (Fig. 24), has been often described as aghast. Yet it was his reflex, his open mouth and his stare that prompted Antoniewicz's eucharistic reading. And Schäfer in 1965 reread James' alarm as instant assent to the mystery of transubstantiation (see p. 46). If the Windsor drawing for this Apostle is any guide (Fig. 46), then surely he was not conceived to express a state of revulsion.[22]

And what of Philip, third in the group, arriving with both hands on his breast? Is he, as Goethe thought, deflecting suspicion, protesting the purity of his heart? His generically devotional gesture has incurred the usual mix of interpretations: avowal of innocence; a tearing of the garments in grief (Gallarati, quoted in Bossi 1810, p. 104); an unbuttoning of the cloak to symbolize the opening of the heart (so in Fig. 33); instant offer of faith. In the literature, the pose is often (inaccurately) described as arms crossed over the chest.[23] As such, it would take its place in the iconography of Communion. Repeatedly, in early fifteenth-century Tuscan

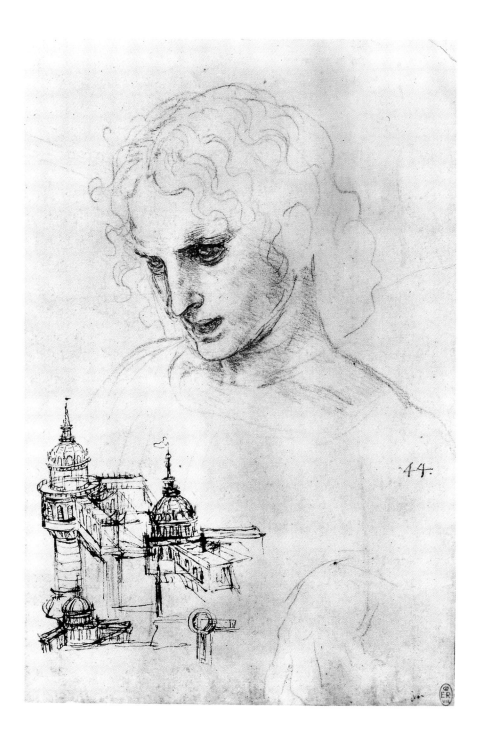

22. A regretful aside concerning St. James' dress. His tunic originally displayed an imperative feature: folds of fabric gathered up to converge in the clasp at his throat. Given the man's back-reeling posture, the effect, rather than of folds falling, was a sudden uprush, helping to drive the tilt, the recoil of the body; a striking instance of the visual imagination that enlists even a sartorial stitch to advance the dramatic moment. For three hundred years, this feature was carried over successively in each restoration—until the most recent. Now, instead of the ruffled olive of James' garment, we find only thin watercolor, nothing beneath, and smooth as a bubble's skin.

23. Jonathan Richardson the Younger, who had examined the mural in 1720, i.e., before Bellotti's extensive repainting in 1726, described Philip's figure as "the Apostle who crosses his arms over his breast" (French edition, 1728; see Brambilla 1984, p. 70). So also Hildebrandt (1927; see Eichholz 1998, p. 426), and so Bodmer (as on p. 69 n. 16), p. xxiii, and many since.

paintings of the Communion of the Apostles, the disciple receiving the wafer from Christ *crosses* his hands (Figs. 47, 48, and cf. Fig. 13!). Philip's are not crossed, or not yet; but, like Simon and Thaddeus, he readies his body for obligation. Whatever else this Christward posture suggests, it is interpretable as a communicant's.

Of course, none of this is prescriptive or exclusionary. We do not cease to see the motions of the Apostles on the radiant side of the picture in psychodramatic terms. What is asked is recognition of amplitude—and tolerance of those who, like Rubens, discern the ever-present alternative.

St. Thomas

More than the spur of the moment determined Leonardo's rendering of St. Thomas (p. 71). To establish his character, the painter had little to go on—not much is said about Thomas in Scripture. St. John's gospel (11:6) gives him a speech that suggests an impulsive nature: at Christ's decision to return to Jerusalem, he exclaims, "Let us go that we may die with him!" But Thomas is best remembered for his moment of doubtfulness when, once again, he speaks out while his companions are silent. That the dead Christ has risen he will not believe unless this, his own finger, bear witness.

Such was the sum of Leonardo's St. Thomas material: an eager temper, a finger appealed to, and eventual appointment as verifier. How should these *disparata* splice into action at Christ's last supper?

They did. Leonardo's Thomas has leapt from his seat, from between beetling Philip and reeling James, dodging their squeeze to leave only a handhold at the table's edge as he sallies (Figs. 35, 49). Jinks of such nimbleness call for quick thinking and muscle tone. And that ready forefinger (here I let myself fantasize) must be a personal mannerism; it's as if the man's normal ebullience discharged itself irrepressibly in a wagged index, a finger ever monishing while he talked, pointing or probing. And so even now, at the Master's speech, up it goes.

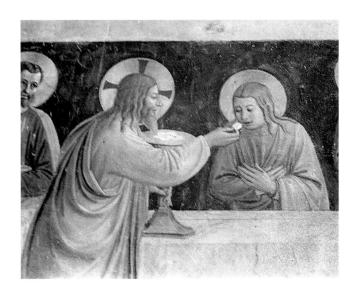

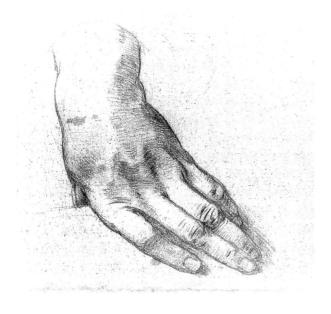

49. After Leonardo, hand of St. Thomas, Windsor 12545.

As a player in the dramatic plot, Thomas can have no inkling that his brandished finger will soon be summoned to confirm the mystery of death overruled. But we know, and the painter knows that we do. Having attributed the alerted pointer to habit, he now, and at the same time, renders its action proleptic. The context it enters transubstantiates Thomas' gesture, so that what had been a harmless personality quirk now speaks to the Resurrection.

What, then, do we make of Thomas' finger? Reconnected to the rest of his body, it is the van of his forwardness; seen at one with Christ's open palm, it steadies into a spire (Fig. 31). The gesture accords with the man's nature and accords with a yet unwritten script, a Gospel wherein his role in the scheme of salvation will be commemorated. In this reading, Thomas' finger bodes as if foreordained, much as the table he clings to portends the altar.

The Side of Death

Against a backdrop of shadow and declining diagonals, six troubled diners start at one signal. To a cursory glance, they are men in the grip of an instant. Keep looking, and that same gripping instant tends into consequence, even to personal martyrdom. The inner triad refers to the imminent Crucifixion. It contains the dark force that sets the Passion in motion, then, behind Judas, St. Peter. Peter's right hand points the knife he will ply a few hours hence at the arrest. And the interlocked hands of the beloved disciple are prepositioned for their grieving on Calvary (Fig. 23).

Christ's dreamy neighbor, sitting at his right side, seems at first sight inactive. A recent American textbook has him "slump toward St. Peter in a faint." In fact, for a contemplative, this St. John is remarkably active, and his clasped hands are as functional as Thomas' finger (Fig. 3).

The first call on them is to retreat. Retreat from what? Why, from the very items which *Cenacolo* scholarship makes bones of contention. Remember how skeptics refused eucharistic symbolism to the wineglass at Christ's right hand; or denied a dramatic role to the dish between that hand and the left hand of Judas, arguing that both glass and dish are there for John's personal use. Thus if you tally the totals of guests and plate. But who looks that way at this picture— are we butlers suspicious of larcenous guests that we should be counting the tableware? Better to notice that John's "personal" glass and platter approach our side of the table, while his hands withdraw and recede. These hands advance no possessive claims; they disown. Active in manumission, they free wineglass and dish for engagement with Christ's spreading fingers; the dish serving dramatically in Christ's confrontation with Judas, the glass about to be hallowed.

John's physical bearing does more. Psychologically, with respect to his person, the locked hands shield his tranquillity. Visually, on the plane of the picture and in line with the narrative, they hyphenate the confrontation of Judas and Christ. Proleptically, these same peaceable hands foretell John's familiar stand at the Crucifixion. The interfolding of fingers, shown here as a quaint personal habit, becomes, in the context of the *Last Supper*, the quotidian norm of a

gesture which the agony of compassion under the cross will intensify to a wringing of hands. The motif unites an acquired habit (past tense) with present function (withdrawal and hyphenation) and foreboded future. Not unlike St. Thomas' versatile finger.[24]

Judas

A stupendous drawing, Windsor 12547, preserves Leonardo's thought for the features of Judas (Fig. 50). The face is averted. But more ominous than the lost profile is the snarl of vein, muscle, and sinew that excoriates the neck like an *écorché*'s, as if already postmortem, anatomized. The neck of a man who will hang before the night's end.

Judas' recoiling grasp is not reducible to a single narrative present. Though he seems stopped at the moment of accusation, he does not actually dip in the dish, and his forward hand cannot—and did not for Rubens—exclude the transgression of unworthily receiving the eucharist. St. Paul writes: "Whosoever shall eat of this bread and drink this cup of the Lord unworthily shall be guilty of the body and blood of the Lord" (I Cor. 11:27–29). In Rubens' reading of the *Cenacolo*, the terms of the equation reverse: he who is guilty of the Lord's blood is partaking unworthily.[25]

There is more, and the overplus accords with the

24. Writing in 1885, Erich Frantz (p. 40) related John's interlocked hands at the Supper to his familiar grieving on Calvary. Examples of the latter are common. Among those possibly known to Leonardo, I cite: Giovanni da Milano's Oratorio di Mocchirolo, reconstructed in Room II of the Brera; Gentile da Fabriano's *Crucifixion* (Brera); Masaccio's *Crucifixion* panel from the Pisa polyptych (Naples); Luca della Robbia's altar at the Basilica di Santa Maria dell'Impruneta.

25. Whether Judas partook of the sacrament or departed into the night before the distribution is a question left open by the divergence of the Gospel accounts. Polzer (1973–74, pp. 62–63) points to the "obvious analogy" between Judas receiving the sop from Christ and the Communion of the Apostles. "Clearly," he writes, "the feeding of the sop [John 13:26] is the Communion of Evil and Damnation—just as, conversely, the ritual of Holy Communion . . . is the sacramental gateway to salvation."

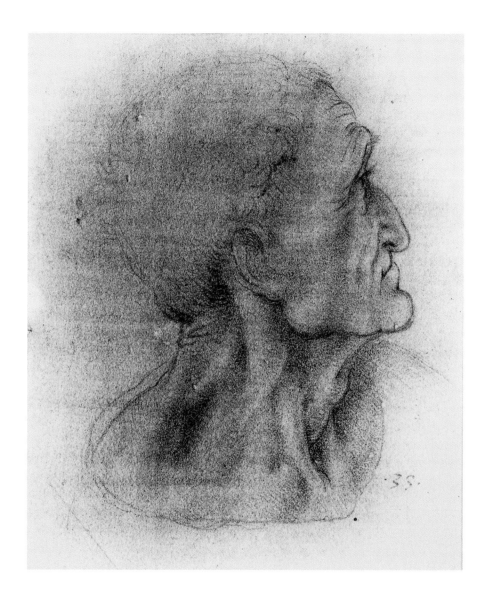

50. Leonardo, study for Judas, Windsor 12547.

51. The diagonal that targets Judas' elbow.

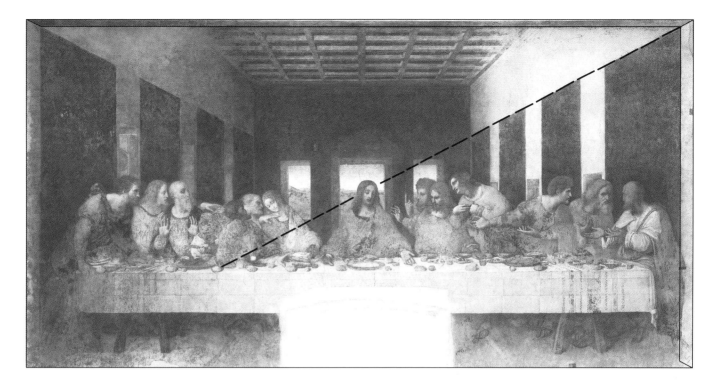

Cenacolo's twofold subject. It is probably not accidental that Judas' elbow (ask yourself how it arrived so near the fore-edge of the table) grazes a roll of bread—bread elbowed out of the way. Leonardo makes the rejection seem inadvertent but emphasized nonetheless, for the object spurned falls on a major compositional vector: the strong diagonal formed by the tops of the right-hand tapestries runs straight-edge to that anconal collision (Fig. 51). The plane geometry of the field colludes with the narrative and exerts topical stress.[26]

One more turn of Leonardo's thought may perhaps be recovered. In the mural, Judas' right forearm originally overturned a saltcellar. No such *saliera* is visible now, but it occurs in the early copies, it is mentioned in writing by 1648, and recent cleaning revealed traces of white in the right place, resolving all former doubts about the authenticity of the motif.[27] But perhaps, in the artist's mind, it was not always salt that Judas upset. A Leonardo notation that jots down possible actions for the persons at a Last Supper (see p. 284) includes: "Another, as if turning around, while holding a knife in his hand, upsets with his hand a glass on the table." Such overturning of glassware during the sacred Supper would be a novelty, and it prompts this reflection: if the motif of spilled wine (rather than salt) had once been thought of, and thought of for Judas, it would have meant more than stage business. In the context of the Last Supper, wine spilled by Judas would have symbolized shed-

26. The first scholar to see what some of us in the latter twentieth century were rediscovering—the picture's linear web participant in the narration—was Antoniewicz (App. B, pp. 205–06). This strain in Leonardo's thought was lost on the early copyists, such as the Tongerlo painter (Fig. 154).

27. The earliest reference to Leonardo's Judas upsetting the salt occurs in Ilario Mazzolari's *Le reali grandezze dell'Escuriale di Spagna* of 1648; quoted by Bossi 1810, p. 50.

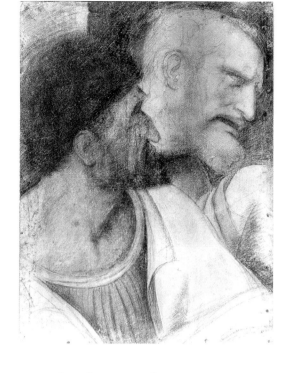

52. Leonardo follower, Judas, c. 1510–20, Strasbourg.

53. Anonymous copyist, subsequent to Fig. 52, Judas and St. Peter, Chapel Hill.

ding Christ's blood. And if Leonardo visualized the betrayer's left hand at the dish and the other arm in single reflex accidentally overturning the wine and spurning the bread, then Judas' action—like the protagonist's but under a negative sign—would have expressed the duality of Passion and Eucharist embodied in the Lord's Supper.

A remote possibility; in the mural as executed, the spilled-wine motif that had once crossed Leonardo's mind found no place. Furthermore, the above *appunto* assigns the spilling to one holding a knife, and the only held knife now in sight is St. Peter's, an instrument about which more will have to be said.

OF JUDAS, one reads in the *Cenacolo* literature that his face alone lours in shadow. And so it may have appeared in the original state of the mural—on this point, the early copies concur, though the depth of applied shadow varies with the copyist's disapproval of villainy. But Leonardo's initial thought was more subtly intentioned: the Windsor drawing 12547 (Fig. 50) shows Judas' features receiving reflected light. The light could fall from the illumined wall opposite, but more probably comes from Christ, the object of the betrayer's wide-open gaze.

What this gaze signifies, what the face in the drawing was meant to express . . . (I leave the questionnaire open).[28]

28. Responses to Leonardo's Judas in Windsor 12547 yield the usual mix. One scholar (Odoardo Giglioli, quoted in Pedretti 1983, p. 110) found the muscles of face and neck showing "excessive tension," along with an "almost caricature-like aspect" and "insignificant expression," which seems incoherent. For some, such as Möller, the face expressed viciousness only. More recent writers see "intelligent features, not lacking nobility" (Feddersen 1975, p. 137) and no symptoms of turpitude (Eichholz 1998, p. 464). Pedretti sees in the "clearly Semitic type" of the model "nothing of the sinister look that it was to acquire as it came to be translated into [Leonardo's original?] painting" (1983, p. 110).

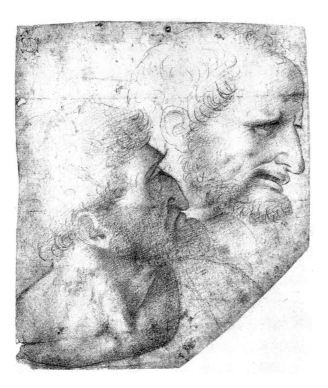

54. Leonardo School, Judas and St. Peter, 1510–20, Ambrosiana.

What the Judas face *in the mural* was believed to express was consensually predetermined. The older *Cenacolo* literature finds the face Leonardo would have given to the betrayer expressive of bottomless evil, a compound of slyness, hypocrisy, thievish greed, ungodly defiance. All this to describe the aspect of Judas on a patch of wall where no vestige of Leonardo's brush has survived. The restoration by Giuseppe Mazza in 1770 is known to have produced a new Judas, and the cleansing of the 1990s, though it claims to reveal authentic Vincian underpaint at the other faces, admits that the betrayer's head had to be done up from scratch, led on by the best early copies.

How closely these copies reflect Leonardo's final conception of Judas we'll never know. Some scholars presume that the master himself must have given Judas' face a pejorative turn, deforming the head in Windsor 12547 into an icon of sheer malignity. But suppose that the face in the mural conformed to the drawing. In that case, the copies record a consensus that Leonardo's portrait of the betrayer was not damning enough (Figs. 52–54, et al.). They express odium rooted in Judeophobia, for it is common lore that this Passover feast admitted only one Jew, the very type of his race.[29]

29. It is the copies and the altered original that conspired to produce late nineteenth-century descriptions of Leonardo's Judas such as the following from Erich Frantz (1885, p. 42): "On a sinuous neck rests the head which, in coarse and hard features of Jewish type, expresses the character of the traitor and miser with terrifying veracity. The low, wrinkled brow...."

A classic example of Judas treated as anti-Semitic stereotype is the novella *Judas Iscariot and Others* (c. 1909) by Leonid Andreyev: "None of the disciples had noticed when it was that this ugly, foxy-haired Jew first appeared in the company of Christ: but he had for a long time haunted their path ... irritating them as something abnormally ugly, treacherous and disgusting." In giving Judas red hair, Andreyev was following a venerable tradition, which holds that red hair "attests abundance of heat, and signifies a natural leaning to unbelief" (see C.G. Coulton, *Five Centuries of Religion*, Cambridge, 1923, I, p. 159. The iconography of the "foxy-haired" caitiff is studied in Ruth Mellinkoff, *Outcasts: Signs of Otherness in Northern European Art of the Late Middle Ages*, Berkeley and Los Angeles, 1993, chap. 7).

Eichholz (1998, p. 465) discusses the gradual darkening of the image of Judas in Christian tradition, and the early identification of his person with Jewry, citing the assertion of Pope Gelasius I (492–96) that the Jews were named after Judas. In the copies of Leonardo's *Cenacolo*, most of which derive from earlier copies, Eichholz observes the Judas figure undergoing increasing vilification.

The Judas=Jewry equation in Christian tradition is impressively documented in Monstadt 1995, passim. Analyzing Italian *Cenacoli*—from the Trecento to 1525, and against a background of both theology and folk culture—the author finds Judas generally interpreted as the only non-Christian at the Supper, and as the exponent of Jewry *tout court*. See especially Monstadt's pp. 2, 3, 5, and 257 n. 45, on the tendency of Leonardo's copyists to debase the Judas image into caricature. I translate from the summary of Monstadt's book on the back cover:

In the institution of the sacrament, the Last Supper signifies for Christianity the beginning of a New Covenant between God and man. Concomitantly, representations of the Last Supper frequently contrast a Judas, conceived as emphatically Semitic, with the non-Semitically rendered fellow diners, so as to visualize a clear demarcation from Judaism, which, according to Christian teaching, remains erringly in the 'Old Covenant'.... Judas, reinterpreted by various pictorial means to be the only Jew at the Last Supper table, becomes, as the betrayer of Christ, representative of the whole Jewish people.

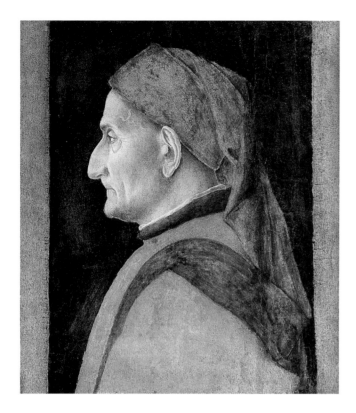

Descriptions of the *Cenacolo*'s Judas make a point of his villainously low brow. The Windsor drawing gives Judas a forehead high enough for an extravagant stratification of ruts. Of degrading caricature it shows not a trace. One need only pair it with a portrait of an unknown patrician ascribed to Mantegna (Fig. 55) to recognize Leonardo's original Judas as good Italian. Feature by feature (including lost upper teeth), the two profiles exhibit family likeness.[30] What

chiefly distinguishes Iscariot in the drawing is the emotional stress, the held breath, the clenched mouth under pried-open eyes—upper and lower face in astonishing contrapposto.

As for the brow, it does indeed look abnormally stunted in the most esteemed early copies. Consider the drawing of Judas' head at Strasbourg (Fig. 52), a rare survival of the sort of preparatory cartoon used by the copyists.[31] It is one in a set of six (originally thirteen?) full-size cartoons attributed to a Leonardo pupil. But would you call it reliable? Is the master's structural thinking recognizable in the passage from throat to jaw, in that upper lip, at the overhang of the forehead, the planed timber effect of honed bone ridge and brow? No feature anywhere among Leonardo's drawings, not in the most grotesque of his invented heads, shows such reduction of organic fluency to hard edge. Yet this same keen-cut jut reappears in the copies over and over, as in the (disputed) drawing in Chapel Hill (Fig. 53; Brown 1983, no. 6), in the Certosa and Tongerlo copies (Figs. 145, 154), and now in the assisted remains of the mural. The same schematism, gross and simplistic, stiffens the Ambrosiana sketch (Fig. 54), said to reflect a more advanced stage in Leonardo's conception. How so? Would Leonardo's naturalism and sense of stylistic unity tolerate—in the very figure he boldly integrated with the rest of the twelve—an abrupt lapse into caricature? Comparing Windsor 12547 with the work of the copyists, I am led to suspect that they failed, here as elsewhere, before some inimitable complexity.

See how they flattened that neck. Leonardo's drawing peers into an anatomical thicket and uncovers a wilderness which all but one of the copyists shirk. Only the Écouen

55. Andrea Mantegna (attrib.), *Portrait of a Man*, c. 1448–50.

30. Ludwig Goldscheider (*Leonardo da Vinci*, London and New York, 1943, p. 9, figs. 10, 11) compares the Judas drawing to an anonymous portrait of Amerigo Vespucci, whom, according to Vasari, Leonardo had drawn as an old man. Italian painters around 1500 evidently regarded this hawk-nosed, chinful type as the mark of strong character. Cf., among many others, the head at far right in Bramantino's *Adoration of the Magi*, c. 1503–05, in the National Gallery, London.

31. The Strasbourg cartoons were introduced into the literature by Georg Dehio as the earliest and faithfullest copies of Leonardo's *Cenacolo* ("Zu den Kopien nach Lionardos Abendmahl," *Jahrbuch der königlich preussischen Kunst-sammlungen*, 17 (1896), pp. 181–85). They were closely studied by Hoerth (1907, pp. 182–91) and by Möller (1952, pp. 93–103). Both authors review the complex and uncertain provenance of the set. Documented in England before 1800, the cartoons were purchased in 1892 by Wilhelm Bode, who allocated them to the Strasbourg museum.

56. Marco d'Oggiono
(attrib.), detail
(App. E, no. 12)

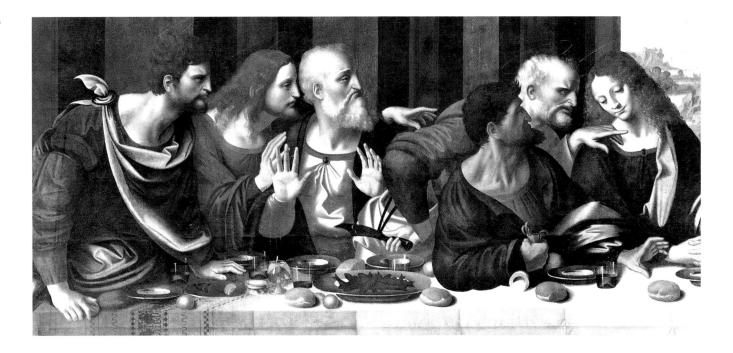

copy attributed to Marco d'Oggiono (Fig. 56) tries to emulate the strains of this neck, with its jugular crossing a disturbed sternomastoid muscle. The Écouen painter (missing the tilt of Peter's head and botching the left hand of Judas) is not entirely trustworthy. Yet he labored to get that neck right. What was his model for it? Since he would not have seen the Windsor drawing when he executed his copy sometime after 1520, we may speculate that the mural he knew displayed (at least with regard to the neck) a Judas figure somewhat closer to what Windsor 12547 still shows.

This hunch is not likely to be well received. An alleged anatomic inaccuracy in the musculature of the neck—to my eye an explosion of pathos which, if wrong, I would hate to see righted—has led some modern *Leonardisti* to disattribute

the Windsor drawing, or to denigrate it as a thing heavily overworked. Not all agree, and I'm not alone in finding the drawing essentially incorrupt, though the contours of jaw line and Adam's apple may have been reinforced.[32] Nor can I bring myself to regard the Ambrosiana sketch (Fig. 54) as reflecting a more advanced stage in Leonardo's evolving conception of Judas. In the Ambrosiana drawing, the "corrected" sternomastoid forms a fat slug, incapable of inflection (and Peter's head, as in the version at Écouen, has lost its adventurous bias). This crudely hacked sketch is a betrayal of Leonardo. It is more likely a twice-removed copy than, as Pedretti suggests (1983, pp. 49, 110), a pupil's faithful rendering of a lost intermediary stage between Windsor 12547 and the definitive execution. I cannot imagine a

32. After long hours at Windsor (April 12, 1973), I wrote to the first dedicatee of this book: "Today in Windsor I got to see Leonardo's dwg for the Judas, persuaded myself that it was not overworked and got a sense of the

gesture of that face. Try to recoil as Judas does, then raise your eyebrows all the way while keeping your mouth clamped shut. Very hard to do. Which way do you breathe? How do you feel?"

Leonardo character "evolving" from the subtle, light-sensitive articulation of the Judas at Windsor to the crudity of the copyist's image.

Leonardo's initial rendering of the betrayer tracks inner conflict; lips clenched under enchanted eyes that gaze on their gift of light, and the brows upped almost beyond a forehead's endurance. This brow takes its shape from a spasm—which the copies read as a structural malformation, a misshapen crag. On the face of the ultimate sinner Leonardo's drawing did not stamp ready-made execration, as one might on the devil's snout. To the agon, the wretchedness of a man who had once been chosen by Jesus—whom Satan entered on cue (John 13:27), but whose nature, having experienced devotion, retains its capacity for remorse—Leonardo brought a tragic vision far in advance of what his contemporaries could fathom. The subjective experience of abjection never received more humane understanding.

THE ABOVE INTERPRETATION, drawn from my response to the Windsor head, is hardly idiosyncratic. In its treatment of Judas, the *Cenacolo* literature of the past hundred years has sought, intermittently, to shift from routine demonizing to humanization. Hoerth (1907, p. 157) compared the Gospels of Matthew and John as they diverge in telling the Judas story (notice that Leonardo's *Cenacolo* has John and Matthew move in opposing directions). He concluded that Leonardo favors John's narrative, wherein Judas (in Hoerth's reading) finds himself "predestined" to perform the requisite task of betrayal, urged to it by Christ himself—"that the Scripture may be fulfilled" (John 13:18); which, as Hoerth reads the Gospel, "makes Judas a tragic figure."

This notion, rejected with indignation by Möller and others, resurfaced in Hans Feddersen's brief *Cenacolo* mono-graph (1975), an ardent book, which the author did not live to complete. Feddersen expatiates on the person of Judas, tracing the newly humanized "Judas psyche" to the German Enlightenment of the latter eighteenth century. In the Enlightened perception, Judas believes in Jesus, but as the promised "King of the Jews" (Matthew 2:2), the awaited liberator from Roman oppression—and commits the betrayal either to force his Lord to take action or from disillusionment. In Judas, Feddersen writes (p. 135), we encounter not fundamental evil, but a tragic misprision of the messianic message. Feddersen credited this revision of Judas to Friedrich Gottlieb Klopstock (1724–1803)—"the German Milton"; but here he strayed. Klopstock's cloying hexameter epic, *Der Messias* (1748–73)—which Feddersen's book, alas, made me read—produces a Judas figure predictably odious, a petty miscreant driven only by private envy and greed.[33]

Goethe is something else. His autobiographical *Dichtung und Wahrheit* (part III, book 15, composed in 1812–14) outlines an epic he had planned to write, sometime before 1775, on the Wandering Jew, the Ahasver of Christian legend. This Ahasver was to be an affable cobbler, befriended by Jesus, whom he continually warns to stop making trouble, since nothing good will come of it. Following Christ's arrest and conviction, a despairing Judas enters Ahasver's shop and, amid tears, recounts the miscarriage of his recent deed. In common with the wisest of the other disciples (presumably Peter), he, Judas, had been convinced that Jesus meant to declare himself chief of his nation, but that a crisis was needed to overcome Jesus' tendency to procrastinate. And all would have gone well had Jesus not unexpectedly surrendered himself, whereby the plan was miserably aborted, so that now "there was nothing for the poor ex-Apostle to do but go hang himself."

33. Unaccountably, Klopstock's Judas is initially given a noble physique: his sable locks fall about stately shoulders; his grave visage is "full of manly beauty" (*voll von männlicher Schöne*). A head soaring above the heads of the other disciples "completes his manly aspect" (*vollendet sein männliches Ansehn*).

This blazon is quickly expunged as Judas, though still loved by the Master, is found to be nursing a secret hatred of John and of the Redeemer himself. He is dogged by Satan; "deep in his soul lurks a craving for riches," etc. (canto III, lines 372–424).

57. Raphael Morghen, 1800, detail (App. E, no. 48).

Feddersen refers to Goethe's unrealized project, and to later nineteenth-century poets who again cast Judas as a misguided, this-worldly patriot. But if latter-day poets and thinkers produced this "long overdue" revision in the interpretation of Judas' motive and character, they were, according to Feddersen, doing what had been accomplished in painting 250 years earlier by Leonardo, without whose achievement the later revisionism would be unthinkable.

Of course, this is a somewhat excentric position. The more recent work of Brigitte Monstadt (1995, pp. 265–66) approximates Feddersen's view only insofar as St. Peter, too, could be, like Judas, uncomprehending of Christ's divine mission (Matt. 16:22–23, Mark 8:32–33). Seeking to ward off the Passion, Peter "rebukes" Jesus, and is in turn rebuked by the Master: "Get thee behind me, Satan: for thou savorest not the things that be of God, but the things that be of men." Peter is saved by Christ's prayer (Luke 22:31–32), but the Judas of Leonardo's *Last Supper* is, in Monstadt's wording (p. 272), "abandoned to darkness, condemned to damnation by Christ."

The Triad of Andrew, James Minor, Bartholomew

The figure of Andrew, third from the left, is doubly afflicted—by loss of paint surface and by a text. I refer again to Leonardo's notation of gestures performable by persons at table, or in a *Last Supper* (quoted in full and discussed on pp. 284–85). In two brief paragraphs, nine actions are itemized, including the following, supposed to describe our St. Andrew (Fig. 57): "Another with his hands spread open shows his palms, and shrugs his shoulders up to his ears, making a mouth of astonishment."

Does this description fit—shoulders to ears, mouth of astonishment? How is such a mouth made, this *bocca della maraviglia*, and do they make it in Italy? In a private poll conducted over this past quarter century, I have asked a round number of natives to show me a mouth of astonishment. Not one failed to open wide. Which confirms the following from Charles Darwin:

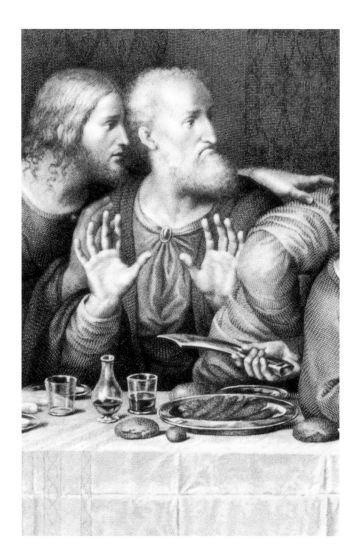

With mankind hardly any expression is more general than a widely open mouth under the sense of astonishment.[34]

Nevertheless, ever since Jean Paul Richter in 1883 published that Leonardo notation, it has been taken to refer to the picture's St. Andrew, whose lips are sealed. For Richter himself the figure "coincided" with the notation. Half a century later, Fumagalli's compendium of Leonardo's writings has the Andrew figure express astonishment in "the precise attitude indicated" in the painter's "hasty note" (*nota frettolosa*).[35] And so Kenneth Clark (1958, pp. 95–96): "With unusual good fortune we have in one of [Leonardo's] pocketbooks a note of the gestures suitable to the Last Supper." The above *appunto* is then glossed as follows: "There is no difficulty in recognizing in St. Andrew the man who shrugs his shoulders and makes the *bocca della maraviglia*"—a phrase Clark translates not as *mouth* but as *grimace* of astonishment, as if Leonardo had written *boccaccia*. Clark's "grimace," displacing astonished mouth, suppresses the notion of a slack jaw, which would have distanced the *bocca* of Leonardo's notation from the tight-lipped mouth of the depicted Apostle.[36] Nor is the picture's St. Andrew caught shrugging. His head rises high and free over squared shoulders—stately shoulders that should not be beshrugged to convenience a text.

Of course, Clark (like Fumagalli) did notice that most of the gestures Leonardo had jotted down never entered the painting. "Leonardo's note," he remarks, "was made from observation, and as the conception of the Last Supper grew more heroic, these everyday gestures became too trivial." But Leonardo's conception did not only grow more heroic; it became more evasive of simple meaning. Of the three motions proposed to convey amazement—open mouth, shoulder shrug, and raised palms—only the last survived,

58. Fra Angelico, *Coronation of the Virgin*, c. 1445–50.

but survived in a gesture too archetypal to mime mere surprise. Clearly, this text will not do. And yet, being gifted to us by "good fortune," it is given a gift-horse reception and stabled in the *Cenacolo* literature.

Andrew's hands resonate with ulterior meanings, which the genre character of that jotting puts out of reach. The gesture is familiar from earlier *Last Supper* representations; some Quattrocento *Cenacoli* use it two or three times. What may this gesture import? In reaction to the betrayal announcement, it could mean "Heaven forfend!" But in the context of this primitive Mass, other connotations accrue. Is it impertinent to observe that the action resembles—prefigures—

34. Charles Darwin, *The Expression of the Emotions in Man and Animals* (1872), chap. 5, ed. London, 1904, p. 146. Cf. Shakespeare, *King John,* IV, ii, 193–95: "I saw a smith…with open mouth swallowing a tailor's news."

35. Giuseppina Fumagalli, *Leonardo: Omo sanza lettere* (1939), ed. Florence, 1970, pp. 269 n. 3 and 270 n. 1.

36. The open *bocca della maraviglia* refers to a startled reflex; it expresses sudden surprise, unlike the state of sustained attention which Leonardo describes in another note (Richter 1883/1970, no. 594).

59. Giotto (?), *Canonization of St. Francis*, c. 1300, detail.

60. Giovanni Antonio Sogliani, *St. Dominic at Table, Served by Angels*, 1536.

the priest's "basic attitude" during the Preface and Canon? That attitude is "the traditional stance of the *orantes* . . . an evident reference to the Crucified."[37]

Furthermore, Andrew's hands rise like those of St. Francis in his stigmatization, and again at his canonization (Figs. 58, 59). They rise like those of the mourner in Perugino's *Lamentation* (1495, Pitti Palace), or like St. Dominic's hands in Sogliani's later fresco at San Marco, Florence (Fig. 60). God the Father himself will show just such uplifted palms in Lotto's *Trinity* of 1522 (Sant'Alessandro della

37. Jungmann 1951, II, p. 141. Cf. Honorius of Autun (twelfth century) on the office of the Mass: "When [the bishop] recites the canon . . . he represents Christ nailed on the Cross."

Discussing the martyr saint figured with lifted palms in the apse of Sant' Apollinare in Classe, Ravenna, Otto von Simson writes (*Sacred Fortress*, Chicago, 1948, p. 45): "The term *Orans* does not explain this attitude sufficiently. . . . The meaning of the *Orans* gesture is 'representative': [it] identifies the martyr as an imitator of Christ."

Further on the meaning of the gesture and its various interpretations as a symbol of faith, of prayer, or of the Church—see Walter Lowrie, *Art in the Early Church*, New York, 1947, pp. 64–68. See also Meyer Schapiro, *Words and Pictures: On the Literal and the Symbolic in the Illustration of a Text* (Approaches to Semiotics, 11), The Hague and Paris, 1973, chap. 2. Schapiro comments

(p. 19): "It has been asked whether simply prayer is represented by the raised arms, or the sign of the cross. But for the early Christians there was no ambiguity here since that posture of prayer . . . was regarded as a sign of the cross."

The literature on the *orans* gesture (the term is modern) begins with Tertullian's tract on Christian prayer, *De oratione*, chap. 14 (c. 200 C.E.; trans. Ernest Evans, London, 1953, p. 19): "Though Israel wash every day, in all his members, yet is he never clean. His hands at all events are always unclean, crusted over for ever with the blood of the prophets and of the Lord himself: and therefore being, through consciousness of their fathers' guilt, criminals by inheritance, they dare not lift them up to the Lord. . . . We however not only lift them up, but also spread them out, and modulate them by the Lord's passion. . . ."

Croce, Bergamo). As in these—and as in a thousand more that rehearse the gesture unaccompanied by open mouth or shrugged shoulders—Andrew's hands (whatever else they may be reacting to) reenact that representative gesture whose symbolic reference is to the cross. And since Leonardo did not differentiate the Twelve at random, we must ask why he would have assigned these raised palms to this first called of the Apostles.

St. Andrew is best known for his martyrdom on the X-shaped cross that still bears his name. But Andrew did not merely undergo crucifixion; he is said to have craved it to seal his communion with Christ. Whoever, during the Renaissance, sought to establish his character would have drawn directly or indirectly (by way of the *Golden Legend*) on the Early Christian *Acts and Martyrdom of the Apostle Andrew*, only to find that the book is not so much a historical narrative as a sustained exaltation of the cross—the *Acts of Andrew* have been called "a liturgical hymn to the cross."[38] Threatened with crucifixion, Andrew professes himself a "slave of the cross of Christ" and intones: "O good cross, . . . fervently sought, and already prepared for my soul longing for thee" Throughout his ministry, Andrew knows himself cast for the imitation of Christ. And so Leonardo depicts him, twofold in competence. For those who want no more from the picture than a psychophysical response to the announcement of the betrayal, he is the one with astonished hands. For those who have seen a priest at the altar, who recall the corresponding pose of St. Francis stigmatized and, finally, Andrew's own story, he is the Apostle whose lodestar is crucifixion.[39]

Even the two-handed gesture of St. James the Less (second from left) may be interpreted beyond its immediate formal or dramatic value. James, without leaving his seat, has turned sideways to impose hands successively on the shoulders of the brothers Andrew and Peter. Leonardo here reinvents an ancient device by which a terminal figure in an overlong frieze composition is drawn into the proceedings at center.[40] What James' far-reaching hand signifies in emotional terms is not clear. But—I say this with hesitation—the gesture may again be proleptic, anticipatory. Performed by the Apostle who, as the "brother of Jesus," was to become the first Christian bishop, James' transaction seems to be surely aimed: his reach, passing Andrew, settles on Peter, who will succeed him as head of the Church. Now both James and Peter extend a left hand to fall on another's shoulder. Likeness of gesture associates the future first bishops of Rome and Jerusalem. It could be coincidence.[41]

38. So von Simson, *Sacred Fortress* (as on p. 99 n. 37), p. 46. For the complete *Acts of Andrew*, see *The Ante-Nicene Fathers*, ed. A. Roberts and J. Donaldson, Grand Rapids, Michigan, 1951, VIII, pp. 511–16. Cf. *The Apocryphal New Testament*, ed. M.R. James, Oxford, 1924, pp. 337–63. This early text became the chief source for the life of the Apostle in the *Golden Legend*.

39. I have not succeeded in locating a passage said to occur in the *Vita Christi* (first printed 1474) of Ludolf of Saxony (1300–1378). At the moment of Christ's announcing his Passion, each Apostle, according to Ludolf, foresaw his own martyrdom.

40. As an index of eager participation, the motif of hands laid on successive shoulders occurs on a sixth-century B.C.E. relief of the Syphnian Treasury, Delphi. Leonardo must have conceived it anew. It reappears in the *Last Suppers* of Marcantonio (after Raphael, Fig. 7); Andrea del Sarto, San Salvi, Florence; Dürer's drawing of 1523 in the Albertina (Lippmann 579); Giovanni da Asola, Querini Stampalia Gallery, Venice; Suor Plautilla Nelli's fresco in the Antico Refettorio in Santa Maria Novella, Florence; Alessandro Allori, Santa Maria del Carmine, Florence; etc.

41. Though the leadership of the Apostles following the Ascension is now generally assigned to Peter, the Early Christian tradition bestows that title on James the Less. Thus Eusebius (*History of the Church* I, 1): "This James, whom the early Christians surnamed the Righteous . . . , was the first, as the records tell us, to be elected to the episcopal throne of the Jerusalem church. Clement [of Alexandria] in his [lost] *Hypotyposes*, book VI, puts it thus: 'Peter, James, and John, after the Ascension of the Savior, did not claim pre-eminence because the Savior had specially honored them, but chose James the Righteous as Bishop of Jerusalem.'" James is still "first bishop of Jerusalem" to St. Isidore of Seville (*Patrologia latina*, 83, col. 153) and others.

The similarity of gesture Leonardo gave James Minor and Peter is mentioned in a different context on p. 139.

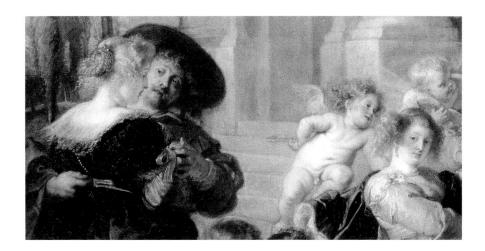

61. Peter Paul Rubens, *Garden of Love*, early 1630s, detail.

Bartholomew Top to Toe

At the far end of the table, Bartholomew stands exposed to the knife leveled at him by Peter's right hand. Peter's akimbo threat is reckless, not aimed. His blade falls into position by fluke, or perhaps to predestinate, seeing that Bartholomew will die by flaying. To me—as it did to Rubens—the apposition looks like an omen. (Rubens is mentioned here because, having internalized the motif, he gave it an upbeat inversion. In his *Garden of Love* [Fig. 61], an arrow—held by a distracted cupid in the elbow-out posture of Leonardo's St. Peter—targets the newlyweds. Rubens diverts to the prospect of married love a configuration invented for the prospect of martyrdom.) In the *Cenacolo,* the premature tryst of a martyr with the instrument of his passion must be either an oddly apt accident or else staged with intent.

Suppose it other than accidental. A question posed twenty-five pages ago may now be answered: why Leonardo dispatched this upright Apostle to the end of the table. If, at the tiding of the Passion at hand, Bartholomew was to be targeted by a knife and shown receptive to the knife's promise—like Andrew, eager for martyrdom in imitation of Christ—then he had to be stationed at 90 degrees to his fellows, i.e., against the table's short end.

But the way Bartholomew stands on confusing feet poses a problem harder to answer. Bossi thought that this erstwhile sitter had shot up too fast to uncross his ankles. Yet, though such action is feasible, it is not what ankle-crossers normally do when they spring up. They uncross as they rise, which Leonardo would surely have noticed; it is the kind of thing he watched out for.

How strangely nonchalant these feet look, and how at odds with the gravity of the man, or the occasion. Though Bossi praised the pose as exactly right, no writer since has thought well of it. It suggests a relaxed ease which, at this pass, would be out of character.

The question that instantly comes to mind is whether to entertain the question at all—who cares about the happenstance of two feet somewhere under the table. But I have four reasons for stooping.

First, because many copyists, faithful to every other attitude in the picture, unravel Bartholomew's feet; and I have learned that whatever in Leonardo's design the copyists alter deserves close attention.[42]

Secondly, writers on the *Cenacolo* rarely take notice. Goethe mentions Bartholomew's stance only to withhold further comment. And where comments are made, they find fault. So the once-famous Anton Springer (1876) took the Apostle's feet, as rendered in the Castellazzo fresco and the Morghen engraving, to be incontrovertible proof that these copies were "falsifications." He thought it immediately evident "that this end figure cannot properly stand as the copies pretend (feet crossed . . . so that the whole body rests only on the two hands)."[43] It is rare to find a High Renaissance figure

42. To de-emphasize St. Bartholomew's feet, some of the copies lower the knotted tassel of the tablecloth. Others reposition the feet side by side (e.g., Figs. 21, 147, 167A) or deepen the enveloping darkness. Implied is a

derogation that did not get into print until the late nineteenth century.
43. Anton Springer, "Leonardos Abendmahl und Morghens Stich," *Repertorium für Kunstwissenschaft* (1876), p. 209.

one here whose contour runs continuous from head to heel. Moreover, of the twenty-six feet brought to this session, only his show as a pair and reach farthest down—matched only by Christ's, coupled again and falling nearly as low (see p. 61). So that, before Christ's fated feet were destroyed, they and Bartholomew's would have co-registered at a glance across half the floor. I sense a remote correspondence, but before airing my hunch, a few grounding considerations.

62. Leonardo, studies for an *Adoration*.

THE STANCE AS SUCH, the crossed-ankles posture, commands a respectable literature. Disregarding an (unread) paper by one Stephani, published by the Academy of Sciences of St. Petersburg in 1854, there is J. J. Tikkanen's important essay of 1912, concerning leg positions in art.[44] Five are discussed, including our motif, whose proliferation is traced from Archaic and Classical Greece, through Hellenistic and medieval art, to early modern. Tikkanen finds the pose originally associated with mature, masculine dignity, but, by Hellenistic times, commonplace and applicable to every age and condition, irrespective of sex. Occasionally, the pose assorts with mortuary symbolism—it is given to the defunct on antique grave stelae; to the infant Genius of Death with inverted torch on Early Christian sarcophagi (and so again on the twelfth-century Modena Duomo facade, and on a tomb relief of 1518 in San Satiro, Milan). Yet the posture typically suggests relaxation. It is elegantly assumed by a young martyr saint in Castagno's Berlin *Assumption* (1449–50); and by the life-size bronze Levite over the north door of the Florence Baptistery, part of a group on which Leonardo is believed to have collaborated with Rustici. Among Leonardo's drawings, crossed ankles (other than sitting with knee on knee or in Spinario position) occur

criticized for bad posture, but Bartholomew's stance seems to ask for it. Erich Frantz (1885, p. 47, following Bossi and followed by Seidlitz 1909, p. 218) thinks Leonardo intended Bartholomew's still-crossed ankles to convey the suddenness of his start, then adds undertone in a footnote: "It cannot be denied that the posture seems forced"—and blames the restorers. Thereafter (until Eichholz 1998), Bartholomew's feet get no further mention, which should give the attention they are about to receive a certain rarity value.

Third, as a general principle, I assume that nothing in Leonardo's *Last Supper* is trivial. Its lowest-priority features seem to me no less interesting than minutiae in Leonardo's mechanical or anatomical drawings, which scholars peruse without fear of bogging down in detail. Think of Bartholomew's body as some kind of engine, and you know at once that this disposition of feet must be reasoned.

Fourth and last, I attend to these lowly members because Leonardo gave them distinction. His Bartholomew is the only

44. Tikkanen, *Die Beinstellungen in der Kunstgeschichte: Ein Beitrag zur Geschichte der künstlerischen Motive* (Acta Societatis Scientiarum Fennicae, 42, 1 [1912]).
45. Later examples of cross-ankled standing are common—a right-middleground figure in Raphael's *School of Athens*; a chatting lancer in Lotto's *Stoning of St. Stephen* (1516, Bergamo), etc. Invariably, the pose suggests a

sustained state of rest and, most of the time, untroubled well-being. Future treatises on the subject will distinguish the self-supporting variety from the stance that relies on external props, and decide whether the investigation should stop at Caravaggio's *Madonna di Loreto* in Sant'Agostino, Rome, or proceed through Nicholas Hilliard even to Gainsborough and beyond.

63. German School, *The Credo*, c. 1450–70, detail.

64. Northern German, *Christ on the Cross*, c. 1500–30.

65. Hans Burgkmair, *Christ on the Cross*, 1515.

at least twice: once on a Windsor sketch of a talkative sitter (12703r; reprod. Pedretti 1983, p. 60), and again on a young stand-up shepherd leaning casually on a friend (Fig. 62); comfortable in both cases. Clearly the crossed-ankles posture is no pathos formula with fixed connotation.[45] The most we may safely conclude is that Renaissance artists took it to be not inappropriate to honored figures in solemn settings. If the pose is to mean anything in a particular instance, only the context tells.

Let me ask first whether crossed feet might be symbolic in Renaissance pictures of the dead Christ. In some Northern images of the *Crucifixion*, the legs cross at or below the knee, so that each foot shows entire (Figs. 63–65). Such instances are infrequent. What is surprisingly common is the crossing of ankles by the recumbent corpse—a posture which in Dürer's *Lamentations* (Munich and Nuremberg) and in Raphael's drawings for a *Lamentation* (engraved by Marcantonio, Fig. 66) surely harks back to the Crucifixion. And it is this motif of crossed feet which recurs with insistence in North Italian paintings of the deposed Christ. I cite Vincenzo Foppa's *Lamentation* altarpiece of c. 1480; Andrea Solario's *Lamentation* of 1504–07 (Fig. 67); Bramantino's of c. 1513 (Fig. 68).[46] Think of Veronese's *Dead Christ Supported by the Virgin and an Angel* of 1581 (Fig. 69), or of Rosso's *Dead*

45. Foppa's altarpiece (reprod. in David Alan Brown, *Andrea Solario*, Milan, 1987, fig. 96) had been painted for a family chapel in the Milanese church of San Pietro in Gessate. In 1821, it entered the collections of the Prussian State, Berlin; it perished at the end of World War II. For Solario's Louvre *Lamentation*, the British Museum preserves a fine preparatory drawing. A Solario drawing at Windsor for another *Pietà* composition (Brown, fig. 93) again shows the feet crossed. Most interesting is a radically foreshortened *Dead Christ* (Brera) attributed to Bramantino: the picture adapts Mantegna's famous *Cristo in scurto*, but modifies it by crossing the feet (reprod. in Gian

Alberto Dell'Acqua, *L'opera completa di Bramantino*, Milan, 1978, no. 48). In Bramantino's great *Crucifixion* altarpiece (Brera), all three victims are crucified with crossed ankles.

The motif of the deposed Christ's crossed ankles remains powerfully present throughout the sixteenth century. It is especially poignant in a lost *Entombment* by Dirck Barendsz (1534–1592), who had trained in Titian's studio. The composition is preserved in two Barendsz drawings and in an engraving by Jan Sadeler (reprod. in J. Richard Judson, *Dirck Barendsz*, Amsterdam, 1970, pls. 26, 27, 33).

66. Marcantonio after Raphael,
Lamentation, 1515–17.

67. Andrea Solario, *Lamentation*,
1504–07.

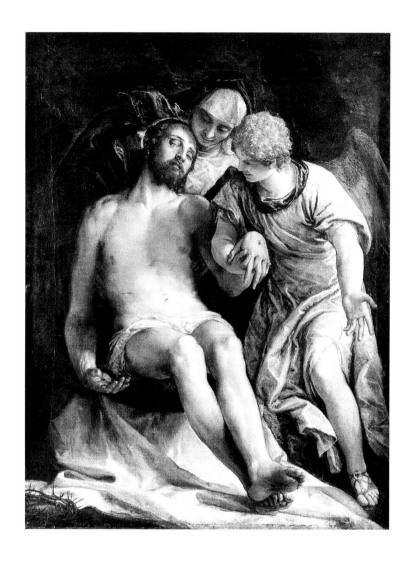

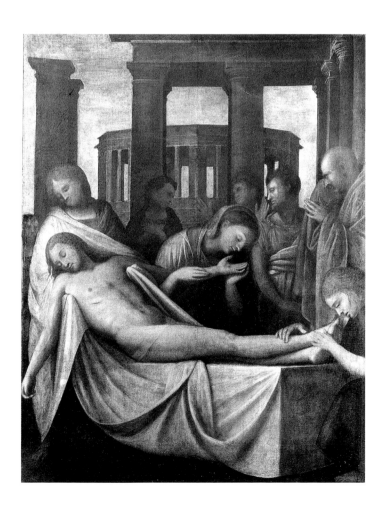

left
68. Bramantino, *Lamentation*, c. 1513.

above
69. Paolo Veronese, *Dead Christ Supported
by the Virgin and an Angel*, 1581.

70. Rosso Fiorentino, *Dead Christ Attended by Angels*, c. 1525.

pose, a young Christ looming over his altar in the crown of the Church and contemporaneous with the *Last Supper* being painted in the adjoining refectory.

Now the question to ask is this: could allusion to Crucifixion be intended by association where a stander with ankles crossed is not Christ, but a person whose thought is of none other—such as the young Baptist in Andrea del Sarto's *Holy Family* (Munich, c. 1514) or Correggio's penitent *Magdalen* of 1517–19 (Fig. 72), or the pensive St. John with his back to the Crucified, again bending over to lean on his arms (Fig. 73)—much like Leonardo's Bartholomew. And this further question: whether a Crucifixion association would be pertinent for the leftmost Apostle in the *Cenacolo*.

HERE IT MAY HELP to read St. Bartholomew's story. His martyrdom, as told in the *Golden Legend*, was a duplex affair. Exactly how did he die? Everyone knows he was flayed alive (witness Ribera). But in fact this version of his execution supplanted an earlier tradition, according to which he was crucified—a relief on the eleventh-century bronze door of San Paolo fuori le mura, Rome, augments the traditional iconography with an executioner nailing Bartholomew's feet to the cross.[47] In Western art, it was not until the twelfth century that Bartholomew's excoriation ousted his martyrdom by crucifixion. And by the thirteenth century, the author of the *Golden Legend*, Jacopo da Voragine, needed to reconcile the conflicting accounts. Following is the English translation by William Caxton (1483):

> There be divers opinions of the manner of his passion. For the blessed Dorotheus saith that he was crucified. . . . St. Theoderus saith that he was flayed. . . . And this contrariety may be assoiled [resolved] in this manner, that some say that he was crucified and was taken down ere he died, and for to have greater torment he was flayed.

Christ of c. 1525 in Boston (Fig. 70)—a naked corpse about to awaken, seated with ankles crossed. Imagine these feet in a genre setting, and they would seem comfortably at ease. In every one of these pictures, the footwork alone, if all else could be disregarded, appears merely insouciant. But as these feet are the dead Christ's, it is difficult to resist the thought that these *caviglie in croce*, or *incrociate*, memorize their foregoing ordeal.

Could such christological ankle-crossing intimate the ordeal to come? Leonardo would have known the *Madonna and Child* tondo capping the choir vault of Santa Maria delle Grazie (Fig. 71)—the nude boy standing up in crossed-ankled

47. See Aurenhammer (as on p. 85 n. 19), I, pp. 300–03.

71. Milanese, *Virgin and Child*, c. 1495.

72. Correggio, *The Magdalen*, c. 1517–19.

right
73. Pellegrino Tibaldi (?), *Cruxifixion,* c. 1550.

Suppose this text read by a painter so determined to demonstrate what painting can "show in a moment" that he might want the saint's future martyrdom *under both forms* expressed in the man's present posture. Leonardo has Bartholomew's torso strain forward, breasting a knife's point 20 inches away. And the feet? They would, in my proposed reading, chart the man's double death, the painter exploiting the body's full length to honor a twofold martyrdom. When the painting was fresh, the visual effect would have compassed another of Leonardo's far-flung correspondences. As the left hand of Thaddeus, far off to the right, accords with Christ's life-giving hand at a distance of half the table (p. 86), so the feet of Bartholomew across the left half of the floor would make common cause with Christ's feet.

It seems to me at least thinkable that Leonardo intended these chiastic ankles to foretell the durance to come. Christ at this table prophesies martyrdom for his chosen (John 15:20; 16:33). And so I see these men rendered: responsive to the betrayal announcement and enfutured by Christ.

OVER-INTERPRETATION? Let me review the four choices before us. The easiest course is to unsee Bartholomew's posture, ignore the stance of the one character in the picture whom the painter displays in full view, uninterrupted down to the toes. If we happen to notice, our first option is *guarda e passa*—see and move on.

A second option is Bossi's naturalism.[48] He has tried the pose, he says, and has made his friends try it repeatedly; if you sit with crossed ankles and get up real fast, the ankles stay crossed. (A Leonardo notation [McMahon 1956, no. 410] might be used to corroborate: at a sudden summons

to one's attention, says Leonardo, the first to respond are the eyes; the feet "remain in place.") Bossi's confirming "experiment" may be the earliest recorded case of a scholar seeking to understand a depicted figure by direct imitation, proprioceptively. But many of us, unaware of Bossi's priority, have been doing this all along; and in the present instance have found the opposite to be true: in brisk elevation, crossed ankles uncross! It depends on the given command. If Bossi instructed his volunteers to check whether Bartholomew's posture as a sudden upstart was likely, he got what he wanted, a positive answer. Where the command comes without reference to the *Cenacolo* figure— "now sit this way and start up"—the persistence of chiastic ankles is improbable.

Which brings us to option three. Modern eyes find Bartholomew's pose in the painting too debonair— "courtly" is one scholar's description. Noticing the Apostle's feet, we regret to see them strike a false note. Thus Anton Springer and Erich Frantz, who hypothesized a restorer to exonerate Leonardo (pp. 101–02).

A fourth option is to explain psychologically; so Georg Eichholz, whose *Last Supper* monograph (1998) surpasses all earlier studies in bulk, detail, and citation of previous literature. Yet, at the picture's lower left corner, Eichholz is stumped. He adverts to "the somewhat forced-twisted, yet unconscious pay-attention-attitude of Bartholomew's legs" (*die schon etwas gezwungen-verdrehte, wiewohl unbewusste Hab-Acht-Stellung von Bartholomäus' Beinen*; p. 471). Page turned, and the posture becomes the "anxiously furtive sign language of the legs." Whence the author's surmise that at Christ's "One of you shall betray me," Bartholomew does

48. Bossi writes (1810, p. 97): *...quasi dubitando di quel che* [Bartholomew] *ha udito, si alza appoggiandosi delle due mani alla mensa, onde accostarsi ad udir meglio ciò che Cristo è per soggiungere. Egli sedeva da prima colle gambe incrociate* [does he mean legs, knees, or ankles?]: *Leonardo studioso di accrescere per mezzo del contrasto l'istantaneità e prontezza dell'atto, conservolle nella stessa posizione: e facendo piegare le ginocchia alla sua figura, e sopra entrambi i piedi sostenendola*

mediante l'appoggio delle mani, le diede sì giusta espressione che non saprei come meglio si possa figurare un uomo perturbato dal dubbio di aver male udito, e desideroso di ascoltare cose di alta importanza. On p. 175, describing his own reconstruction of Leonardo's *Cenacolo*, Bossi reiterates: *I piedi li feci sollevati entrambi alquanto, perchè così dimanda l'attitudine momentanea di questa figura, che provai io stesso più volte e feci da molti provare.*

not feel himself to be above suspicion. What Eichholz here finds especially helpful is Darwin's observation of what dogs do when they listen. From Darwin's *The Expression of the Emotions in Man and Animals* (1872), he quotes:

> Dogs, when their attention is in any way aroused, whilst watching some object, or attending to some sound, often lift up one paw and keep it doubled up, as if to make a slow and stealthy approach.[49]

Eichholz omits Darwin's illustration of a small terrier dangling one paw in midair, but Darwin's text gives him "an almost comic but plausible explanation" for the Apostle's otherwise inexplicable stance.

These, then, given St. Bartholomew's footwork, are the four options now on the books: ignore or deplore it, naturalize or psychologize it. A fifth option is to read it as symbol. If you know a sixth that is more persuasive, I will gladly retire my fifth—which would have Bartholomew participate head to foot in the overall movement of figured thought.

WE HAVE RUN THE COURSE—both ways; and this chapter is already on the long side. But if the task was to describe the *dramatis personae*, it is not enough to have distinguished them one by one. Each of these twelve reveals himself in ways that emerge only from the ensemble. For instance: Leonardo has been at pains to make all the disciples' hands show. And he has made all but three pairs of hands deliver one single-minded, two-handed gesture. Scanning from left to right: Bartholomew rests his weight on both hands; James Minor lays both on neighboring shoulders; Andrew's hands rise on one impulse; John's interdigitate. On the opposite side, James Major's arms spread like paired wings, Philip's meet on his chest, Matthew's fly toward Christ. And we have seen what coherent actions the seniors at the far right accomplish.

This leaves just three disciples with hands at odds, to wit, Thomas, Peter, and Judas. Impulsive Thomas, his right pointing upward, lets a few left-hand fingers mark his vacated place at the table (Figs. 35, 49; see p. 76); we are not to believe that the lagging hand knows what the other is up to. Peter's hands obey contrary calls—he is tapping John's shoulder without letting go of the knife in his right. And so Judas' hands divaricate—one advancing, the other retracted, clutching the purse. It is as if disjunctive maneuver, hands variously driven, were the symptom of internal conflict, Leonardo's outward sign of inward division. Would this have been consciously engineered? Hard to tell; but whether intended or not, the painting ascribes inner disharmony to exactly three of the Twelve: to the one who doubts, the one who denies, and the one who betrays. The central figure in whom disparate natures unite operates to a different standard.

LITTLE IN THIS CHAPTER touches directly on the protagonist, a figure routinely hymned for its seeming simplicity. But it is surely remarkable that Leonardo's Christ performs not one of the actions which normally focus the subject of a *Last Supper*. As he is not passing the sop to Judas, nor obviously using the dish to dip into, so his hands do not rise in blessing, or in elevating the Host. All such forthright indicators of moment and meaning are banished to preserve, or to attain, undefinition.

No wonder that Eichholz at the end of his rope—having perused all that's been written about Christ's right hand alone and citing for comparison a score of other *Cenacolo* Christs down to Tiepolo's (1998, pp. 461–62)—settles at last for von Einem's capitulation: "a gesture that must remain incomprehensible and which has caused interpreters to crack their brains" (p. 455, quoting von Einem 1961, pp. 61–62). Eichholz echoes: "art historical investigation to this day has

49. Darwin, *The Expression of the Emotions in Man and Animals*, chap. 5. Darwin's accompanying fig. 4 shows a "small dog," with left forepaw uplifted, "watching a cat on a table."

vainly cracked its head over the original (unambiguous?) sense of this gesture" (p. 461).

Now I think we know why: what this gesture (and much else in the picture) puts forth defeats any interpretation that looks for a single motive and resists multiplicity.

THERE IS A DRAWING for a *Last Supper* from the school of Michael Wolgemut (which the young Dürer attended; Fig. 74). The drawing predates Leonardo's mural by a decade or so. It shows John asleep and Jesus feeding the sop to the betrayer, whose ringent mouth gapes for a swart insect-fiend. A banderole over Judas' head spells out the Latin of Matthew 26:25: "Master, is it I?" More scripted banderoles festoon the top, explicating what else has been, or what else is being, or is about to be said: "This is my body"; "One of you shall betray me"; "This is my blood"; "I am the Lord." We are told in so many words that the Lord's Supper holds more than one still image can show.

To hold this moreness in the solution of "conjoint presence" is what Leonardo demands of his art. Therefore, to sustain maximum ampliation, whatever is too delimiting must be ruled out. At the same time, all intimations, so far from being marginal to a main story line, become the constituent stuff of duplexity. The symbolic contrast of the two sides—proneness to martyrdom/receptivity to the eucharist—is both stated and resubmerged in the passing shudder. If the motions of the right-hand Apostles can read as faith offerings, they remain readable also as reactions to the betrayal announcement. On the other hand, the actions on the dark side, referable to the identification of the betrayer, are also interpretable as faith yearning for understanding. In short, within the balanced asymmetry of the grouping, the themes of the Supper suffuse one another. As Leonardo did not confine the scene to a single scale, nor to one temporal moment, so the gestures ambiguate.

Subsequent chapters will show just how pervasive ambiguity in the *Cenacolo* is; how it determines and at once undetermines even the perspective, the simulated architectural structure, the relation of the figures to their surround, and the relation of the spatial illusion to the actual refectory. One spirit at work, whether addressed to the hard data of masonry or the flow of emotion.

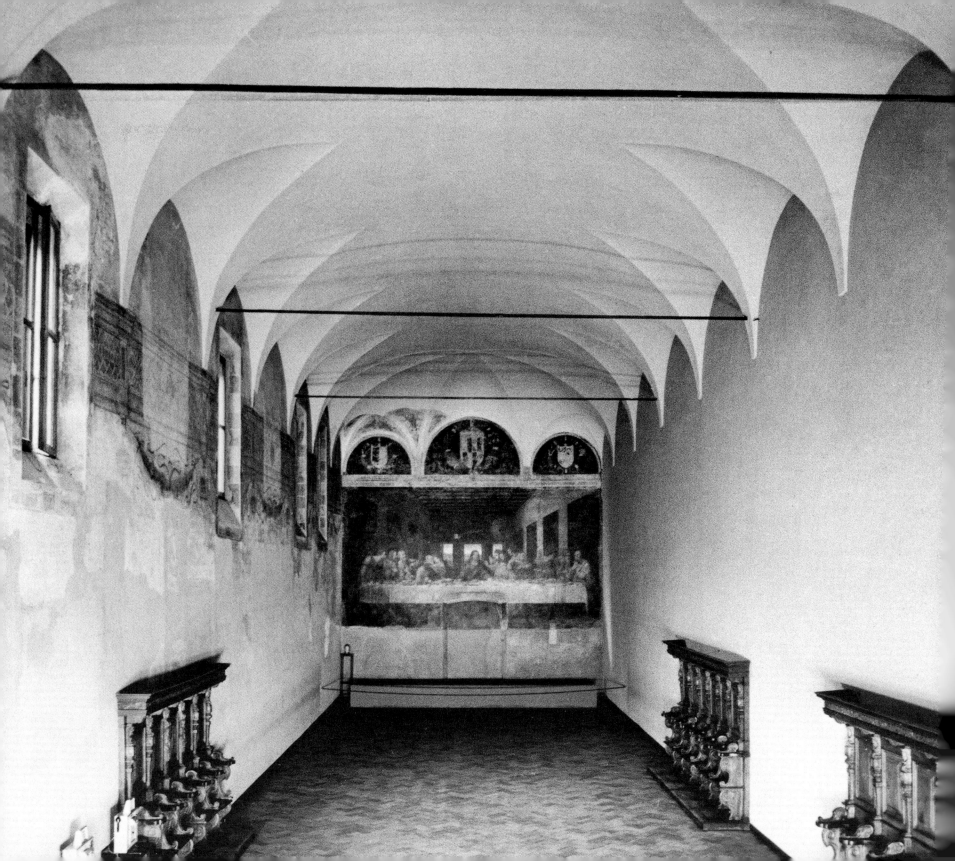

CHAPTER V

The Connection

Self-addressed memo: Explain why the bare stage Leonardo gave to his actors claims so much of this chapter, as well as the finale of chapter VII, and most of the rest. Because—as Leonardo meant his protagonist to be more than a man, and the action more than an episode, he charged that bare setting to make up the difference.

SUPPOSE LEONARDO WONDERING how the union of God and man in the Incarnate would actually look—to the Twelve, then to subsequent Christendom. What sort of features, what bearing, would reconcile in one figure heaven's omnipotence and meek human submission? This utmost polarity is the Creed, but can it be visualized? Goethe's answer was No. Here, he thought, was a task to defeat even the most spirited brush (see p. 149). In his conception of narrative painting, the duality of the Incarnate's nature must necessarily show in Christ's person, or else remain unexpressed, inexpressible.

So said the poet. But the picture says otherwise. You non-painters!—this now is the picture taunting its most illustrious admirer—you would have our resources confined to what faces and gestures can show. You imagine a figured

Christ so dependent on typecasting and miming to supply want of speech that he cannot but fail your bill of particulars. You itemize what you think a depicted Christ ought to demonstrate: commanding presence and manly grace to convey at once compassion and puissance, plus mercy and justice along with humility, imperturbable calm and straight nose, not to mention tall stature, omniscience, majesty, and so on. Piling virtue on virtue, word upon word, you drain your thesaurus to shame the meagerness of mere visualization. But bear in mind that the very Gospels allow Jesus' physical presence no apparent divinity.[1] His godhead is manifest in its effect, its influence on all around, including even inanimate matter, solid or air.

Such is the argument of the picture, and I couldn't agree more. I reflect: when Jesus walks on the waves, it is not to show what a weightless God looks like (in just a moment Peter will do the same). It is not that "the waters hardened . . . and the surface of the deep congealed" (Job 38:30), but that each step taken makes the water's unaltered substance accede to his faith and his will. And so when he calms a tempest, or passes through a closed door. The divinity that puts

75. Refectory, Santa Maria delle Grazie. The mural seen from middle distance, 4.5 meters above ground, 1973 photograph.

1. On the inapparency of Christ's divine nature during the Ministry, cf. Steinberg 1983/96, pp. 233–34.

nature under obedience shows in its operation. And so again in the *Cenacolo*. This Christ's nature is not circumscribed by physique, nor even by the consequence of his speech. If the picture exhibits his instant impact on fellow men, visibly stirring their passions, what of it?—this much any rabble-rouser can do. But here Christ's effectiveness is of another order; it is a potency that implicates the response of the physical set, so that nothing remains unaffected. And that's what makes this bare stage, this perspective, indispensable to the gospel told by this painting.

THE COMMON MISAPPREHENSION of the *Cenacolo*'s chamber as an inert receptacle tells us a lot. It explains why, in the excitement of watching the drama, so many copies, all adaptations, and most verbal descriptions concede this *proponitore* nothing of his other nature; the applause goes to his humanness, to which the behavior of ceiling and walls is irrelevant. Where the painter's spatial construction is taken literally as the representation of an actual (or conceivably actual) room, a room unmoved by the event, you may as well resettle the company, stage the affair without architectural interference—and deprive the protagonist of half his power.

In the present chapter, I examine the contradictory attitudes brought to Leonardo's construction; later on, search the structure itself. Unexpected problems arise, not all of which are resolvable, at least not by me. But it's worth trying, because only detailed analysis reveals Leonardo's construct to be more than a feat of perspective. This chamber is an enigma; it embodies a reactivity wherein the godhood of the protagonist reigns with spectacular subtlety.

ALMOST FOUR-FIFTHS of the painted surface depicts uninhabited space, too capacious to be overlooked, but (for most viewers) too empty to matter. The winning foreground takes all. All eyes on the men at table; the vacancy at their back is no competition.

One expects painters to have known better, and perhaps some of them did, but not when they put pen to paper. In artists' descriptions of the *Last Supper*, from Vasari (and Rubens) to Bossi and Fuseli, the housing of the sacred company is passed over in silence. For professional writers, it hardly exists. Two great literary inhibitors, Stendhal in France and Goethe in the land of *Dichter und Denker*, ignore it, and bequeath their exemplary disregard to posterity. Down to the 1880s, the place where Leonardo's Christ broaches his Passion gets no more attention than philosophers spare for the layout of Socrates' prison cell.

When scholars did begin to take notice, their effort was still to justify the earlier inattention. Until about 1960, commentators on the *Last Supper* declared Leonardo's spatial arrangement to be a foil for the figures, usually with the assurance that the structure is "unambiguous and clear." Confidence on this point was arrived at by syllogism. Clarity without ambiguity is admirable; the *Last Supper* is admirable; therefore, it had better be unambiguous and clear.

To the unconcern of the literary, we must add what the painters contribute: outright rejection of the original set by professionals whose work on replicas or adaptations must have led them to see, if not to approve, Leonardo's perspective. Most copyists change it.[2] Others, including the strongest, quarry the mural for groupings and gestures, sloughing the rest. The common practice, in copies as in

2. Radical alterations of the background occur in all but eight of the fifty-odd copies surviving from the sixteenth and early seventeenth centuries (see App. E). The following leave Leonardo's design largely intact: the Castellazzo fresco (Fig. 144); probably the full-scale Royal Academy canvas from the Certosa di Pavia, but its upper portion, if it ever existed, is lost (Fig. 145); the Louvre drawing no. 2551 (Fig. 163); the large canvas at Tongerlo (Fig. 154);

the small anonymous panel in the Soprintendenza, Milan (Fig. 155); the Hermitage copy (Fig. 27); and the Birago engraving (Fig. 4), though the prints that derive from Birago again alter the background (Alberici/De Biasi 1984, nos. 37, 39, 40). The small Cesare Magni panel (Fig. 150), faithful to the original in many respects, invents a new checkerboard ceiling and modifies the proportional system.

verbal ekphrasis, is to rehouse the figures, arguing, in effect, that Leonardo's *dramatis personae* would have been better off dining elsewhere. Not a success story so far.[3]

But the negative record can be turned to advantage by directing attention to fundamental anomalies in the work, precisely those which painters and writers sought to suppress. In the *Last Supper*, the body-space ratio exhibits two principles, each in itself implausible and hard to reconcile with the other. On the one hand, viewing the event as a drama staged on a three-dimensional set, we get disconnectedness, an irrelation between setting and figures that borders on the absurd. Leonardo so downstaged the table that the vacated chamber is left with nothing to house. A spacious hall on which the diners have turned their backs and from which, poised at the brink of the forestage, they are nearly ejected—hardly a reasonable representation of a table inside a room. This anomaly may explain the departure from Leonardo's arrangement in copies and adaptations that survive from the sixteenth and seventeenth centuries. Unlike the writers, the men who produced these works faced all of the mural, fore- and background alike, whereupon they pared their task down to one or the other: either inhabited quarters with the table inside, or a table against neutral ground, such as a curtain or paneled wall.[4] Few condoned Leonardo's fantasy of a table divorced from a plunging backspace, with mess hall and diners in mutual repulsion, the company wanting no part of the room, the room all set to be left alone.

On the other hand, scanning the picture as painting rather than as *tableau vivant*, we discover the opposite of divorce—foreground and depth in close symbiosis, webbed on one screen. Change focus from illusionism to picture plane, and the meshing of set and figures becomes surprisingly tight (see chap. VI).

WÖLFFLIN WAS THE FIRST SCHOLAR to give the depicted chamber attention, and he offered a rationale for Leonardo's figure-space ratio. As he perceived it (reversing the view of the copyists), the background construction, though lacking intrinsic meaning, enhances the drama by setting off the heroic scale of the men.

> The perspective of the room [and] the shape and decoration of the walls are made to reinforce the effect of the figures. [Leonardo's] chief preoccupation is to make the bodies appear voluminous and imposing, hence the depth of the room and the partitioning of the walls with tapestried panels. . . . It will be noticed that they present nothing but small surfaces and lines, which in no way seriously distract the eye from the figures.[5]

This is well seen. But Wölfflin left unconsidered the anomalies that troubled Leonardo's professional colleagues: the abrupt dissociation of hall and table and, on the other hand, the close surface mesh. If, as Wölfflin points out, the background effectively magnifies the comparative size of the figures, then why did Rubens, who understood heroic scale and knew how to think three-dimensionally—why did he,

3. Until the 1980s and '90s, most authors allowed Leonardo only one purpose in designing the setting of his *Last Supper*. One scholar saw the depicted chamber making sense *only* as a receptacle for the crepuscular light (Strzygowski 1896, p. 146). Another perceived "a plain, unadorned room, . . . having *no other function* than to create a harmonious frame for the event" (Dvorak 1927, p. 179). Kenneth Clark (1958, p. 93) sees in the picture "*nothing to distract* the eye from the main theme. . . . The scene of Leonardo's *Last Supper* is so bare that most copyists felt bound to invent a more attractive setting." (Clark failed to note that half of these "more attractive" inventions produce settings far barer than Leonardo's.) Even the open-eyed Brigitte

Monstadt (1995, p. 248) grants Leonardo's spatial construction only a "purely subservient function."
4. Especially telling are copies that recess the table. The effect may be achieved either by advancing the foreground pavement, or by loading the downstage with repoussoirs such as a dog or washbasin, or by stationing columns or other paraphernalia in front (Figs. 4, 16, 146, 176).
5. Wölfflin's functional explanation (1898, p. 27) is adopted by most subsequent exegetes, including Hoerth (1907, pp. 223f.), Heydenreich (1943, 1958), and von Einem (1961, p. 49).

in copying the design, jettison Leonardo's background and substitute curtains (Figs. 17, 175)? If the mincing perspective behind the figures makes Wölfflinian sense, why was it so rarely respected? How does one reconcile the persistent disuse of Leonardo's deep space with Wölfflin's accurate observation that this spatial background is functional?

I propose two possible answers. The ambiguities in Leonardo's perspective—more insistent the closer you look—may have prompted the copyists to resist, as many scholars do even now. Where ideal clarity is presupposed, any source of perplexity is an irritant.

My other explanation is the more charitable. Bearing in mind that Leonardo's raiders were lifting the composition out of its context in the Grazie refectory, their dismissal of the perspectival construction need entail neither criticism nor incomprehension of its success *in situ*. Their alterations tell us only that they found such construction encumbering whenever the design was translated to some other locale. Whence we are led to suspect that the function Wölfflin ascribed to the depth of the chamber is not sufficiently understood without taking account of the refectory.

WHEN THE PICTURE WAS PLANNED, there was a wall to be frescoed, a wall four times the height of a man, the fourth side of an unusually long and spacious mess hall. It was the scale of this hall that the mural was challenged to match, and the need to magnify the foreground figures without monstering them to inhuman scale arose from the exigency of the site. Suppose Leonardo had placed his actors against flat-ter ground: thirteen half-figures ribboned across a tall wall, leaving a steep drop underfoot, top-heavy clearance above, and, facing them, the actual refectory, unmatchably large and inadequately confronted. How could thirteen figures of human measure rise to the task of dominating both their own wall and the long fetch in front—unless by some wizardry of design?[6] The situation called for an *ad hoc* solution.

Leonardo's solution meets opposing requirements. While the perspective parcels up walls and ceiling to aggrandize the foreground figures (as Wölfflin saw), this same perspective simulates a great hall, so that the tabled figures are not only enlarged, but enlarged against a receding space commensurate with the refectory. The perspective thus double-functions: read on the picture plane, it contracts, for the figures' sake, into diminishing lots; read in depth, it distends itself hugely. And this double-functioning is just the beginning.

Leonardo's bolder idea was to transfigure the semicircular cusps of the refectory vaulting above the mural. Under his hands, the cusps turned into lunettes that ostensibly rest on a (depicted) stone architrave. The lunettes displayed—along with coats of arms and heraldic letters—traceries of entwined branches that screened (and may have shown a glimmer of) the hidden forepart of the ceiling.[7] Of this square-coffered ceiling we see only its minishing half. But the feigned latticework made the viewer believe that the ceiling in full forward projection would overtop the crest of the central lunette (Fig. 106).[8] The implicit result was a room in parity with the refectory—in breadth and depth

6. Turning a reproduction of Leonardo's *Last Supper* on its side, so that the table runs straight up and down (as already proposed on p. 50), one is astonished to find the figures claiming so little space.

7. See Pinin Brambilla Barcilon and Pietro C. Marani, *Le lunette di Leonardo nel refettorio delle Grazie* (Quaderni del Restauro, 7), Milan, 1990.

8. Primitive anticipations of such a ceiling—implied forward spread concealed by a lintel or upper frame element —occur in Ghirlandaio's *Death of*

Santa Fina (Fig. 76), in Verrocchio's *Madonna and Child* in Frankfurt, and in Antoniazzo Romano's *Death of Santa Francesca Romana* (Fig. 77). Monstadt (1995, p. 246n. and fig. 99) cites a less similar precedent in Filippo Lippi's *Obsequies of St. Stephen* fresco in the Prato Duomo.

9. Fig. 2 demonstrates the irrelevance of the original background in translocation. Any competent Renaissance or Baroque painter would have advised the billboard's self-effacing sponsor to efface the background as well.

and as well in its hidden upsweep; the very room whose visible portion appears sufficiently small-partitioned to monumentalize the actors up front.

Thus Leonardo's perspectival construction justifies itself *in situ*. It prevents a high wall from dwarfing the figures, while its apparent depth and inapparent height match the enormity of the hall from which it is viewed. But whenever the image is copied for use in alternative situations, nothing necessitates a backspace of such irrelevant scope. To put it another way: within the Grazie refectory, the disposition makes sense by analogy—with a stage set facing an orchestra, or, more to the point, with an altar table screening an apse and confronting a nave. Never, unless drastically revised, would Leonardo's contrivance, pried from its context, perform persuasively as a table inside a room.[9]

Such is the discerning conclusion I ascribe to those many artists who adopted Leonardo's figures and scuttled the rest of the picture. Their "rejection" of the master's perspective is reasonable. Except for the few whose charge was to produce a faithful documentary record, all copies destined for a different setting modified the original system, and they did so either by foreclosing Leonardo's illusionism or by curtailing its reach. Taking note of these alterations, we need not assume disrespect for Leonardo's achievement. Instead, we can credit the copyists with an intelligent recognition that these thirteen actors in another locale—or reduced to a bas-relief, easel picture, or print—deserved more congenial accommodation. The persistent change or cancellation of Leonardo's perspective in copies and adaptations becomes negative proof that the image alone shows but half—that the design of the mural, in its totality, was site-specific.

76. Domenico Ghirlandaio, *Santa Fina Receiving Word of Her Approaching Death from St. Gregory,* c. 1475.

77. Antoniazzo Romano, *Death of Santa Francesca Romana,* 1468.

TURN NOW TO MORE POSITIVE EVIDENCE, beginning with the height of the pictorial threshold. The base of the mural lies well above that of the *Crucifixion* fresco on the facing south wall of the refectory (Figs. 1, 95), and this oddity was remarked upon at the time. Matteo Bandello's memoir of seeing Leonardo at work in 1497 (not published until 1554) makes special mention of the mural's unusual elevation.[10]

Why this exorbitant altitude? There was a low entrance door in the north wall, the monks' and the kitchen help's normal access to the refectory. But though that access could easily have been rerouted, Leonardo accepted its interference. For this decision, several reasons suggest themselves, foremost among them, respect for the Gospels. Both Mark and Luke locate Christ's Passover meal in the "guestchamber" of a Jerusalem dwelling house, "a large upper room furnished" (see p. 171). Since other *Last Suppers* normally disregarded this upper-story specification, there is no need to assume that it constrained Leonardo. Yet he preserved the door as subjacent to the event, so that his staging of the Last Supper became true to the letter: a large *upper* room, situated well above the monks' entrance.[11]

But as Leonardo's decisions are usually overdetermined, so here. Though his depicted "guestchamber" is interpretable according to Mark and Luke, it is not necessarily so experienced. Goethe, for instance, experienced it otherwise—not where he pores over the Morghen engraving, but in the postscript recalling his visit to the site in 1788. Here Goethe ignores the iconographic dictate of an "upper room" and records instead his sense that the sacred assembly is immediately present. He visualizes the monks and their prior seated at tables along three sides of the hall; then, on the fourth wall—or rather, *as* a fourth wall—the mural. Christ and the disciples occupy, Goethe writes (1817, p. 54), "the fourth table . . . as though they belonged to the company. At suppertime, it must have been an impressive sight when the tables of Christ and the prior faced each other as counterparts, . . . the sacred company was to be brought into the present, Christ was to take his evening meal with the Dominicans in Milan." As Goethe describes it, the created illusion is immanent. Nothing, certainly no perspectival distraction, disturbs his sensation of real presence at the "fourth table."

Nor would the height of that table have caused him to reconsider, seeing that it rose by degree: down the long walls of the refectory ran the boards of the monks; against the south wall, the prior's table rose on a dais; finally, higher still, at the apogee of a gradual lift, the mensa of Christ.

If on this point Goethe was right—and his impression is not easily contradicted—then the *Last Supper* is situated to be readable in two ways: literally, on an upper floor; existentially, in condescension to our level.

ABOUT THE CHAMBER behind the depicted diners Goethe says not a word. He responds to what he finds sufficiently marvelous: Christ's proximity, the companionship of the "fourth table" on the refectory's actual fourth wall. What Goethe elides is the longitudinal axis that couples the depicted recession with the refectory—and their shared light, and the difficulty of defining the correlation of the two adjoined spaces.

Here again we run into ambiguity, witness the disagreement of later scholars. Just how is the joining of the actual with the fictional space to be understood? How is their junction experienced from the refectory floor? Predictably, we hear more than one answer, but let me begin with the common intuition.

10. Matteo Bandello, *Le novelle*, Laterza ed., Bari, 1910, II, p. 283. The mural would have loomed even higher before the refectory floor was raised in the nineteenth century.

11. More than one consideration may have determined the mural's high threshold: to level the pictorial horizon midway on the fresco wall; to enhance visibility from a distance; to ensure against damage by floods (suggested by Francis Naumann); to rise clear of the given door rather than paint around the intrusion (as was done by Mantegna, Raphael, Titian, and others).

Leonardo's spatial illusion impinges directly on the hall we are in. It reveals an interior on a raised level, opening wide like a deepened exedra or extended alcove: "The spatial setting seems like an annex to the real interior of the refectory," writes textbook Janson. And so Ludwig Heydenreich, in his day a leading *Leonardista*: "The pictorial space is the perspectival continuation of the real space; it is the illusionistic prolongation of the refectory." Creighton Gilbert elaborates: "Leonardo's single perspectival space, continuing steadily from our room far into the painted room, supports the demand of the period that painting at its best is at its most realistic, in the sense that reality in a painting is undifferentiated from reality outside it." And so Anna Maria Brizio, who taught generations of Milan's university students: "The painted space and real space interpenetrate and continue in each other."[12]

This fusion of real and fictive space is indeed one's initial impression —precisely why soberbrows will not trust it. As they scrutinize the orthogonals of the depicted perspective—most conspicuously those formed by the tapestry tops—they find them not in smooth continuity with the refectory walls, but breaking abruptly inward. No matter where in the refectory you take up position, the painter's orthogonals fail to align with the convergence of the real perspective (Figs. 78, 79). Accordingly, the scruplers conclude that Leonardo's illusionism was conceived as a self-contained system. The blatant discontinuity at the joints leads them to reject, as a mere misreading of evidence, both Goethe's vision of the "fourth table" and the "annex" interpretation of Janson, Heydenreich, Brizio, et al. For them, the depicted scene looms otherwhere, disconnected from the site occupied by the spectator. Thus Sydney Freedberg:

Space within the wall is not illusionistic; it is not readable from any point within the actual hall as an extension in perspective of our space.[13]

And more expansively, Frederick Hartt (1969, p. 401):

Leonardo has broken with the Quattrocento tradition culminating in the illusionistic systems of Mantegna and Melozzo, which decreed that represented space must be an inward extension of the room in which the spectator stands. Although Leonardo's perspective is consistent, there is no place in the refectory of Santa Maria delle Grazie where the spectator can stand to make the picture "come right." Never can the represented walls of the upper chamber in Jerusalem be seen as continuations of the real walls of the refectory on the other side of the picture plane.... The painting is now a projection on an ideal plane of experience in which lower realities are subdued and synthesized. This is a perfect perspective, which could be seen by no pair of human eyes, and within it are set forth larger-than-life human beings who exist and act and move on a grander plane than we. Ideal volumes inhabit ideal space. The joy of the Quattrocento in visual reality has been replaced by a wholly different satisfaction, that to be obtained from imagined grandeur.

Voice of the disciplinarian. The speaker wants "imagined grandeur" to be satisfaction enough and will not indulge such naive joys as finding our space continuous with Christ's, or having Christ join us at supper. The discontinuity of the perspectives forbids.

What about this discontinuity? Was Freedberg right to deny the "space within the wall" a conjunctive effect, because it appears discontinuous from any available viewpoint? Was Hartt right to conclude that Leonardo's depicted walls are not receivable (from any place in the refectory

12. Sources cited in the foregoing paragraph: Janson 1962, p. 350; Heydenreich 1943, p. 59 (cf. 1958, p. 12, and again, 1974, p. 25); Anna Maria Brizio, "The Painter," in Ladislao Reti, ed., *The Unknown Leonardo*, New York, 1974, p. 29; Gilbert 1974, p. 372. Wolfgang Braunfels sees Leonardo's per-

spective spread so wide that "one imagines Christ and the Twelve actually present" (*Abendländische Klosterbaukunst*, Cologne, 1969, p. 16).

13. S. J. Freedberg, *Painting of the High Renaissance in Rome and Florence*, Cambridge, Massachusetts, 1961, p. 21.

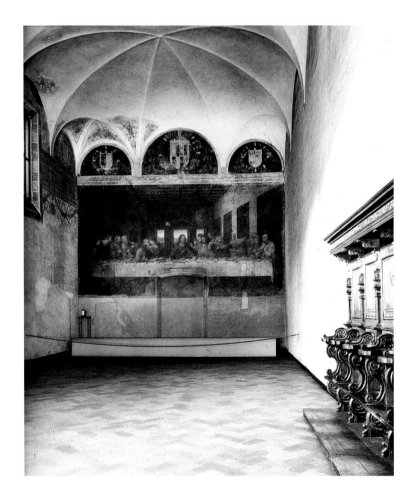

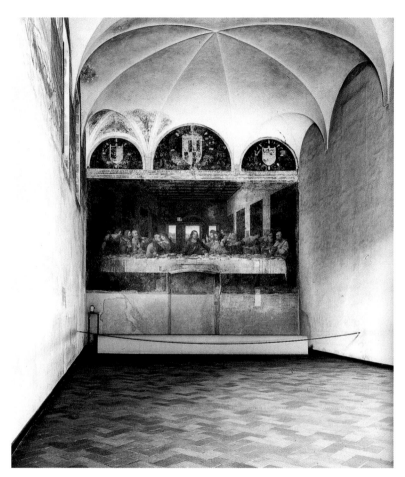

78. Refectory, Santa Maria delle Grazie. The mural as seen from near the east wall, 1973 photograph.

79. Refectory, Santa Maria delle Grazie. The mural as seen from near the west wall, 1973 photograph.

"where the spectator can stand") as "continuations" of the refectory's real walls? And were those other scholars—to say nothing of the million unpublishing tourists who rejoice precisely in this now-proscribed continuity—simply misled?

Let us first agree about the given conditions. Within the picture, the strongest orthogonals are formed by the tapestries, which are hung to align with the frieze decoration that ran along the side walls of the refectory under the lateral vaulting (Fig. 1). Theoretically, the two systems, two sets of isoclinic orthogonals—the refectory's frieze and the decor of the painted chamber—should smoothly join; but they don't. They refract like a stick dunked in water, so that the perspectives of the real and the depicted walls disagree. (The felicitous implications of this disagreement will occupy chap. IX.) But they do align when seen from the altitude to which the depicted perspective refers, that is to say, from a height of approximately 4.5 meters, or about 15 feet, and from directly opposite the head of Christ.

To convince myself of these truths (in 1970, when truth seemed an easier quarry), I rigged up a three-dimensional model of the refectory situation, using whatever scrap was around: a postcard reproduction in lieu of the mural, and, for the side walls, two oblong cardboards, courtesy of the laundry. On these cardboards and at 90 degrees to the painting, the contours of Leonardo's feigned architrave were produced at their proper height, so as to run along the "refectory" walls (Figs. 80, 81). The interior of this stately pile was photographed through two peepholes on the median of an improvised opposite wall—one at normal eye level (Fig. 81, cf. Fig. 1), the other at the height of the depicted horizon where the eyes of Christ are (Fig. 80). The simulation confirmed the existence of an ideal ray, perpendicular to the picture plane; one central beam from point of sight to the centric point of the projection. On this central beam, the depicted perspective "comes right."

Early in 1973, I was able to confirm these predictable findings at Santa Maria delle Grazie. Fig. 75 reproduces a

80. Cardboard model with postcard of the *Last Supper* viewed from Christ's eye level.

81. The same viewed from normal eye level.

photograph taken from a scaffolding erected on axis halfway down the refectory (unfortunately, at slightly inadequate height). Seen from approximately 15 feet (4.5 meters) above ground, the tapestry tops in the mural register in continuity with the friezes on the refectory walls, confirming the common intuition that the space of the mural prolongs that of the refectory.[14] (Since 1973, these findings have been verified with sophisticated precision; see chap. VIII.)

But if that high-pitched, axial viewing position is physically out of reach, as correctly observed by Freedberg and Hartt, must we accept their conclusion that a perspective projected from this position alienates the depicted scene from our own space? In fifteenth-century narrative painting, a high vantage point for elevated wall frescoes was perfectly normal. So far from inducing estrangement, it produced precisely what Hartt called the "joy of the Quattrocento in visual reality." The alternative—a frog's-eye perspective adjusted to the viewer's physical station *dal di sotto in su*—had been tested by Mantegna half a century before the *Last Supper*, only to be quickly abandoned. In one lofty fresco of the Eremitani Chapel (after 1448), Mantegna sought to beam the spatial illusion to the groundlings below, addressing the projection to where they stood in the pit. He did it once, to show that he could; thereafter refrained, because perspectives from a groveling vantage do not so much engage as exclude the spectator—they withhold a view of the floor on which the action unfolds. And where viewers cannot imagine themselves pacing the floor of the action as

potential participants, they are debarred from participation and the scene becomes inaccessible. Such inaccessibility is appropriate for pictures that represent the interiors of sacred shrines (Masaccio's *Trinity*) or depicted effigies (Uccello's *Hawkwood Monument*) or visions of open sky (Mantegna's Camera degli Sposi); it is fitting for images of iconic saints, honored heroes, or simulated statues ensconced in high niches. But for narrative scenes, high-pitched stations rendered as if seen from below were understood to be inappropriate.

Inappropriate and unnecessary, as all fifteenth-century mural painting in Italy demonstrates: we readily "look in" on scenes whose horizons float above ours. Whatever else Leonardo may say in his notebooks, on this point he followed convention.[15] Project yourself back to the Grazie refectory in its original function, your gaze raking the tables along the side walls: the sight of the tabletop in the mural then becomes another means of incorporating the image with the actual environment. Whereas a low horizon, addressed to a viewer's eye level on the refectory floor, would have alienated the sacred board. If its kinship with the monks' tables was to be manifest, only an elevated eye level, with the depicted tabletop showing, would do.

Thus the visual evidence leads three parties of energetic observers to as many opinions. One reading finds the sacred company at a companionable fourth table (discounting the space behind). Another opts for the semblance of an adjoined annex (ignoring the discontinuity at the seams). A third

14. The 15-foot altitude to which Leonardo's perspective refers is neither that of the far higher Christ figure in the *Crucifixion* fresco on the opposite wall (Figs. 92, 95), nor, in a literal sense, the painter's own point of sight. The painter's eye travels every inch of the field. To the extent that his focus is felt to coincide with the centric point, this focus is also ours. As for the working painter's actual position on a scaffolding in front of the mural, it cannot at a glance take in the refectory and the depicted space. Comprehension of the two spaces together is the artist's imaginative invention. He does not possess it while painting, and, having finished, he shares it with us.
15. Leonardo writes (Richter 1883/1970, no. 537): "When the painter has

to paint a story on a wall he has always to take into account the height at which he wishes to arrange his figures...and he must place himself with his eye as much below the object he is drawing as, in the picture, it will have to be above the eye of the spectator. Otherwise the work will look wrong." That Leonardo's *Cenacolo* flouts his own precept was pointed out by Pedretti (1973, p. 71): "In his *Treatise on Painting* Leonardo states that the vanishing point in a mural ought to be placed 'opposite the eye of the observer of the composition'; but whoever looks at the *Last Supper* is far below the axis perpendicular to the vanishing point...." Cf. Kemp 1981, pp. 195–96. The subject receives full treatment in Kubovy 1986, pp. 140–49.

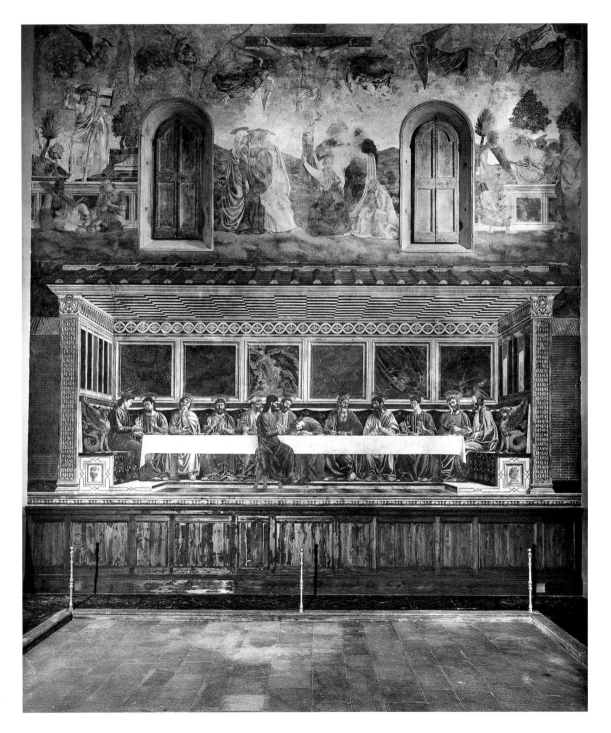

82. Andrea del Castagno, *Last Supper* with superior frescoes of the *Resurrection, Crucifixion,* and *Deposition*, 1447.

(dismissing the convention of heightened horizons and the unifying effect of the light) sees an ideal projection of inaccessible grandeur. Selectively registered, the data of Leonardo's luminous presentation lead to differing conclusions.

But—as in the odds between Rubens and Rembrandt—the question is not who is right, whose faction to join, but rather: what arcane machination in Leonardo's design fosters such contrariety? To me it appears that these diverse ways of describing the relation between the painting and the refectory are one and all justifiable. They fail only where they preclude.

Consider Goethe's account. His *Cenacolo* essay celebrates Leonardo's rendering of the passions. But his postscript, cited above (p. 118), is the first to record how the picture's *dramatis personae* may be directly experienced, near enough to be consorting with us. This perception is more than a fantasy. Its credibility rests on a venerable tradition in the design of *Cenacoli*, which Leonardo revived. He has bypassed the more modern precedents of his Florentine Quattrocento, those of Castagno (Fig. 82), Ghirlandaio (Figs. 121, 122), Rosselli, and Perugino (Fig. 124), whose *Cenacoli* cabin the sacred company in snug enclosure. Careless of the risk of anachronism, Leonardo reverts to the primitive mode of Taddeo Gaddi's *Last Supper* at Santa Croce, where—under a huge representation of the cross as the Tree of Life—table and diners, fronting their frescoed wall, protrude make-believe into actual space (Fig. 30).[16]

Leonardo, of course, is more artful. Unlike Gaddi, he allows just enough floor in front of the table to meet the minimum requirement of an ulterior space. But he keeps this stage apron so shallow that Goethe, had he been questioned, could have declared it the ledge of a podium on which the refectory's preeminent table is raised. What Goethe correctly saw is the Gaddi-like foreground character of the event. For him, the seeming coincidence of Christ's table with the wall plane of the fresco is the overwhelming reality. Here he made no mistake.

Equally cogent is the prevalent "annex" interpretation; we are right to find the depicted chamber continuous with the refectory. Had Leonardo wished to forestall the illusion that our space flows on in the recess of the picture, he could have lined the seams with insulating dividers, such as pilasters, instead of inducing the sense of reciprocal prolongation. But he did more, using incoming light as the unitive agent *par excellence*.[17]

In the picture, light entering from the left bleaches the east wall of the chamber. As the westering sun passes through real windows high in the west wall of the refectory, both spaces together are suffused by its radiance. Before the mural decayed, this vision of real light irradiating a painted space must have been the most magical feature of Leonardo's illusionism—the assembled friars shared one glow with the sacred assembly. Even today, the effect sometimes returns at the hour of dusk. In their common reception of the evening light, the two spaces cannot but be experienced in continuity. If for no other reason, the "annex" interpretation, like Goethe's "fourth table," must stand.

What, then, of that highest bid, the picture as "ideal projection"? This too is valid, since it involves an incontrovertible fact: the depicted eye level is not ours, but that

16. To the fifteenth-century *Cenacoli* mentioned above, all of which house the table within a containing space, we may add the frescoes of Bonifacio Bembo (c. 1457, Monticelli d'Ongina, Piacenza; Eichholz 1998, pl. 20) and Stefano di Antonio di Vanni (1465, Refectory, Spedale di San Matteo, Florence; Vertova 1965, fig. 18). In contrast, both Hoerth (1907) and Heydenreich (1943) remark that Leonardo's table appears to intrude into real space—the "Gaddi effect."

17. One fine detail now shows up only under the most favorable lighting conditions: the differentiated color of the outer jambs of the two flanking windows. The jamb at the left, averted from the sun's rays, is a cool olive; that on the right is rose, facing the evening light. The colors are convincingly representational and complementary in terms of the spectrum. Faint, scattered traces are still discernible.

of the painted figures. With them, but from an eminence far above our carnal station, we contemplate the mystic table.

The result is protean. Leonardo's "clear and unambiguous" system—a formula long intoned like a charm—is receivable either as a felt presence, as semidetached, or as wholly removed. Some receive the depicted scene in its immanence. Most viewers experience it optically as the extension of a split-level hall. A few see a self-contained upper room presented only to the imagination (like a stage interior with its front wall removed). And each of these temperament-driven responses has merit, being grounded in what is given. It is a characteristic Leonardo situation in which partisan certainty in the long run yields to the press of possibilities offered.

But if the visual evidence, all things considered, seems slippery, why not resort to the hard data of Leonardo's writing, where the artist has much to say about perspective and point of view? Of course we read him. But we shall see his practice in the *Cenacolo* contradict what he writes. For the management of ambiguity Leonardo laid down no rules.

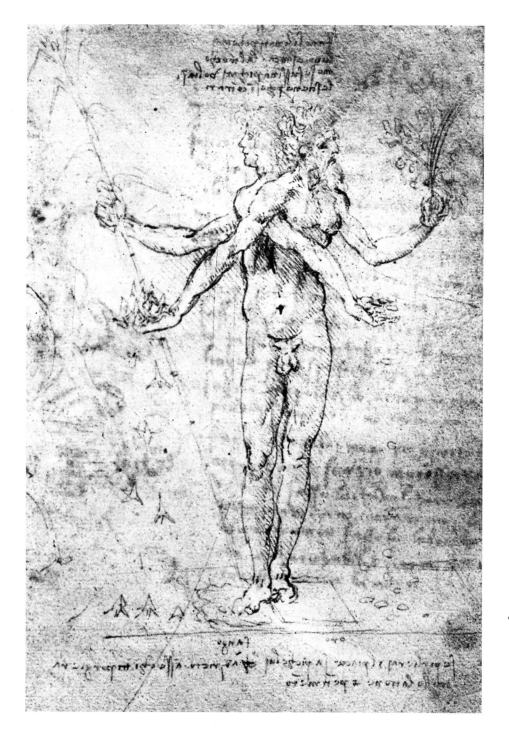

"Pleasure and Pain are represented as twins,
 as though they were joined together,
 for there is never the one without the other;
 and they turn their backs because they are
 contrary to each other. . . ."
 —*Leonardo's explanatory inscription*

Coincident Opposites

ONCE MORE GEORG SIMMEL, a thinker more respectful of art than most of his tribe. In a six-page paper on Leonardo's *Last Supper* (1905), he hailed the mural as a turning point in the evolution of Western man.[1] There had been earlier pictures that staged the amazement of crowds or bystanders. But, says Simmel, the figures there represented (he cites frescoes by Giotto and Duccio) were "anonymous, the selfless bearers of an affect, exempla merely of a general conception of mood or passion." Whereas every tremor in Leonardo's *Last Supper* betrays the personal, the unique. "Here is achieved, for the first time, the inner freedom of personality which gives the new age its cue, that freedom for which the world and its events are but a means and a stimulus, and through which the ego arrives at its self."

Interesting; perhaps even persuasive in the light of 1905 optimism about the new century ushering in the liberation of man. But discounting that dispiriting century, let's reconsider Leonardo's free spirits with Simmel's paean in mind. How quit, in fact, are the actions of Simmel's free agents?—as free as, say, Oedipus in his choice of a wife?

Almost any proposition about this intractable painting seems reversible. Opposites, if not equally true, are at least true enough to expose some of the tensions that make the work live. Simmel admires the motions of Leonardo's actors as unconstrained self-expression. Yet these are characters in a story whose outcome is known, a story told four times over in Holy Writ, as foreknown as the catastrophe in Greek drama. Let them seem to be acting in freedom, but, "branded and fettered by time" (as Stephen Dedalus brands all historical characters), "they are lodged in the room of the infinite possibilities they have ousted" (*Ulysses*, episode 2). Unfree, then, being held in a web of necessity spun by the Gospel account; a necessity which the picture makes visible through the constraints of pictorial structure, stage and actors at one—as if these agents were grouped and steered into place by remote control. Simmel's admirable salute to freedom addresses only a *tableau vivant*, a file of twelve agile performers on neutral ground.

Preframed Spontaneity
In the painting, actions performed in spectacular freedom turn out to be subject to far-off determinants. Four triads of troubled disciples convene, but convene in strict correspondence

83. Leonardo, *Allegory*, c. 1483–85, detail.

1. What Simmel (1905, pp. 55–60) claimed for Leonardo would be claimed for a hyperborean straggler in Harold Bloom's *Shakespeare: The Invention of the Human*, New York, 1998.

with the lunettes over the architrave (Fig. 38). Looking up to acknowledge the larger context, we see the men take prepared places, ostentatiously self-directed, yet controlled from on high.

Consider the freest of all the gestures displayed at this table, that of St. James, thrusting out with both arms. What could be more inly motivated? But there is a scarce-hidden secret in that gesture's alignment with the diagonal descending from upper left. I refer, of course, to the fourfold recession of the wall hangings. Within the deep-space illusion, the slope formed by these tapestries travels inward to the far reach of a wall. But on the plane of the surface geometry, this same slope targets the centric point at the temple of Christ, and does not stop even there. Apply a straightedge to prolong this diagonal, and you find James' arms riding it like a chute (Fig. 117). A receding gradient, a vanishing line driven by the perspective, tips the wingspread of the man's arms.

What now determines this stalwart's pose? Of course, it's a burst of emotion finding its widest outlet. And the special amplitude of the gesture may have been assigned to James Major to flag him as man of action, the warlike, far-ranging Santiago. Yet this same gesture reenacts immemorial custom—a preformed expression of mourning seen on Roman sarcophagi at the death of a hero; seen again in *Lamentations* over the body of the deposed Christ (as in Fig. 67); and most recently in a *New York Times* photo of an anile Serb mother keening at the grave of her daughter (July 4, 1999, p. A4). Is our St. James, then, hearing Christ announce the onset of his Passion, rehearsing a mudra of grief?

And what of the influence of his neighbors? James' recoil serves to give clearance to Christ, yet, like a crowd-control officer, he seems to apply his heft to contain two importunates pressing up from behind. Or else, he careens at that precise tilt because bilateral symmetry requires him to correspond with the group at Christ's right. Then again, the painter may have guided James' right arm to intersect with the perpendicular established by Christ's left hand and Thomas' finger (thereby incidentally intimating a cross, Fig. 31). Or was James' gesture designed after all to haul a diagonal down from the upper left corner and relay it to bottom right, so as to clinch the picture's surface organization in counterpoint with its depth? In short, is this bravest of gestures impulsive, or in service to symmetry, or interactive with fellow disciples? Is it primarily passionate, or symbolific, or under geometric control? As the context of these valiant arms widens, the magnificence of their throw remains undiminished and, in the drama, still self-determined, yet intricate in a network of extraneous influence.

The background keeps butting in. If we formerly saw the persons of Philip and Matthew (fourth and third from the right) unfurl as from a common stem, we now see that stem supplied by a slenderized tapestry at their back. Look at Matthew alone: his right arm, propelled in spontaneous agitation, obeys other needs—Leonardo has pitched it to mediate between the horizontality of the table and the obliquity of the right-hand tapestry tops (the diagonal that nails Judas' elbow, Fig. 51). Even the passionate Philip, even he, heaving inward, inadvertently overlaps a distant wall corner, and he gestures so feelingly that the meeting of hands on his bosom replicates with precision the obtuse angle projected behind him by the junction of side and rear wall. You might ask what on earth Philip's fervor has to do with that remote nook. But that's like asking what a voice in the treble has to do with the bass. If Leonardo's characters conform with his observations of human behavior, they also perform like themes in grand opera, buoyed up or counterpointed, always accompanied.

The longer one contemplates back- and foreground together, the more entangled the actors. Conversely, the rigging of the perspective conspires with human impulse. The depicted room forgoes its autonomy, while the disciples, for all their verve, come to seem closely empaneled—free will in connivance with complicit necessities. And this may be

another reason why the setting in which Leonardo entangles his cast is so often refused. The copies and knockoffs would have those fine gestures emancipated from the commands of the system to become the more persuasively free, closer to Simmel's ideal of self-expression.

Weird Symmetry

Leonardo's *Last Supper* is probably the only great painting that earns praise for being symmetrical, but why should that be an issue? Is it because narrative pictures that pretend to give the passions free rein do not normally call on arithmetic to sort and station their actors? Is the orderliness of the staging admired for prevailing against threatening disarray? Perhaps one senses that the tides of emotion sweeping across the board should have produced a less calculated arrangement. Hence the recurring surprise in the literature. One scholar writes: "In severe symmetry the Apostles exhibit every conceivable emotional reflex." Another sees "strict law in command, the most consummate symmetry." A third likens the isocephaly of apostolic heads to the beam of a balance, with Christ's head at the fulcrum. Wölfflin observed that Leonardo's bold innovations—keeping John up and awake and Judas in line—enabled him to "lend the scene a superior homogeneity, and the disciples could be symmetrically disposed on either side of the Lord."[2]

All this is true; the evenhanded allotments to left and right are there to see. But the quickening comes from sub-

versions of symmetry stirring in the picture's deep structure, where symmetry is enforced and simultaneously disobeyed. To these subversive phenomena, since they are often missed even by copyists—and because they are tiresome to describe and tedious to read about—writers on the *Last Supper* pay scant attention. It is more profitable to praise the work's equilibrium and win instant assent. Moreover, the picture feeds a craving for symmetry that wants to think every deviation away. It coaxes the viewer to find more symmetry than there is, to subordinate even major disparities to the regimen of the obvious. Accordingly, generations of wishful commentators and copyists emphasize the work's balance, while departures from parity are played down. Yet we are surely the richer for seeing how the symmetry of the design beats out two counterforces: sharp contrast of side against side, and an irrepressible trend left to right.[3]

IT WAS A MODERN ART EDITOR'S GAFFE that first led me to recognize the rightward momentum of the composition. A reproduction of the *Last Supper*, accidentally flopped, revealed that Leonardo's arrangement does not work in reverse— it lists to one side. In reversal (Fig. 84a), the excentricity of the image leaps to the eye, and we notice how troubled that famous symmetry is. But the means Leonardo used to disturb the apparent stability remain hidden, though in plain sight.

The effect of a sideward drift derives, to begin with,

2. Authors quoted in the above paragraph in order of appearance: Max Semrau, *Die Kunst der Renaissance in Italien und im Norden*, Esslingen a. N., 1912, p. 270; Möller 1952, p. 52; A. J. Anderson, *The Admirable Painter: A Study of Leonardo da Vinci*, London, 1915, p. 226; Wölfflin 1898, p. 26. The harping on symmetry continues through subsequent literature, which is curious, since bilateral symmetry in *Cenacolo* compositions was commonplace (cf. Figs. 30, 189). So Panofsky comments on Leonardo's "symmetrical composition with the figure of Christ as an axis" (*Albrecht Dürer*, Princeton, 1948, I, p. 221). Schapiro (1954, p. 330) sees the movements of the Apostles contrasting with "the central Christ, the symmetrical table and architecture in a converging perspective rhythm." Even Pedretti (1973a, p. 39), discussing

the mirror image recommended by Leonardo to reveal what we don't normally see, remarks that the mirror "cannot do anything with the perfectly symmetrical *Last Supper*."

3. Leonardo's asymmetries, and the resistance to seeing them, may be demonstrated in the central figure alone. Though the Christ appears centered and stable, his head, shoulders, and hands, even the small plate before him, shift sideward with respect to the fenestration. These fine displacements are adjusted not only in the Birago print of c. 1500 (Fig. 4), but as well in the punctilious Morghen engraving of 1800 (Fig. 14), as if to correct an inadvertent imbalance. Morghen also suppresses the side walls' opposition of shadow and light.

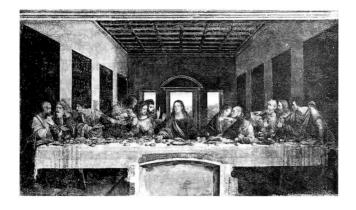

by a sideward motion across the flat of the field. It is possible—though not compelling—to see the tapestried wall on the left tipping down, the corresponding slope on the right in ascent. Along with the funnel contraction forged by the perspective, we then see a graph traced on the plane of the wall—down to and at once up from the protagonist's temple.[6] In such perception, the orthogonals that produce the apparent depth of the chamber double-function to travel the picture plane like the trough of a wave.

What causes this rightward trend, of which the naked geometry of the projection is obviously innocent? A one-point perspective alone, diagrammed without incident light or inhabiting bodies, allows no such effect (cf. Fig. 8). So then, what appears to me as a catenary momentum driving the scene from

84a. Leonardo, *Last Supper*, pre-World War I photograph. Reproduced in reverse.

84b. Leonardo, *Last Supper*, pre-World War I photograph.

from the barely perceptible shift of the table; it inches toward the right, diners abetting. Against the fixity of the chamber, the whole assembly, Christ and his plate included, displace to one side, so that board and diners assume a minutely excentric relation to the architectural set. Tending toward the bright-lit east wall, the table shifts like the cursor of a slide rule. The resultant asymmetry is more than a modifier in the interest of animation. Though the metric displacement is minimal, it is as crucial to the physical system as to its symbolic drift.[4]

Even the centered perspective of the depicted room comes under pressure. Of course, the contours of the (presumably parallel) side walls close in on their centric, or vanishing point.[5] But (to my eye) this convergence is overlaid

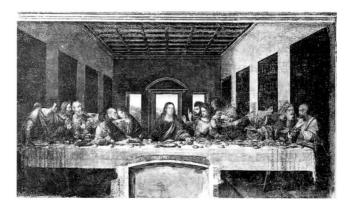

4. The excentricity of the foreground table, verifiable at the site, is best observed in the photograph of the *Last Supper* with a modular grid superimposed, here reproduced as Fig. 130 from Brachert 1971. More on this diagram on p. 185.

5. The term "vanishing point" is modern, not used in the Renaissance. It implies that a perspectival construction inevitably leads the viewer's eye into the depth of the picture, whereas "centric point" allows the alternative, which I have elsewhere called "the hithering spill." On this subject, see especially Alexander Perrig, "Masaccios 'Trinità' und der Sinn der Zentralperspektive," *Marburger Jahrbuch für Kunstwissenschaft*, 21 (1986), pp. 18–24.

6. The sense of rising or falling induced by diagonals (in cultures whose script reads left to right) is discussed by Wölfflin: "That which runs in the direction of a left-right diagonal is experienced as rising, the opposite as

falling; "Über das Rechts und Links im Bilde," in *Gedanken zur Kunstgeschichte*, Basel, 1941, p. 83. Cordial thanks to Rudolf Arnheim, whose letter of September 20, 1974, pointed me to this text.

7. Despite Wölfflin's corroborating perception (see the foregoing note), my sense of a left-to-right movement seems to be largely subjective. One thoughtful observer, Max Raphael (1938, p. 90), saw *both* side walls strain upward and hitherward against the downward press of the ceiling. This is interesting. Apparently, the system allows (encourages?) three diverse readings: (*a*) the tapestries conduct their respective walls rearward in decurrent recession; (*b*) both side walls come advancing, ascendant; (*c*) they dip and rise, left to right. Without denying the validity of the first two, I would hold on to the third as most in harmony with the humanity in the foreground.

one side to the other must be due to the light and to the walls' compliance with the figures placed directly in front. The company, as Leonardo disposed them, are intimate with the parts of the chamber, and the chamber responds.[7]

The Bipartite Triptych

A composition in counterpoint: one theme, set out at the foreground table, presents a bilateral grouping, with six figures (or doubled trines) flanking the axis. But the picture is co-articulate as a triptych, precisely trisected by the depicted walls. And it is with respect to this tripartition that the stability of equivalent halves yields to the counter-theme of directed progression. To put it another way: each of the walls that trisects the field is screened by a different count of figures, and with this difference comes a gradual loosening, an opening up on the sunlit side. Suppose we enumerate: fully five figures bunch before the dark wall on the left; only three loosely spaced heads dot the right wall. The inequality of these crews affects their respective backdrops. As the five on the left (Judas included) stare or strain centerward, their focus confirms the centripetal tilt of the shadowed wall. But of the three Apostles silhouetted against the wall opposite, two (Matthew and Thaddeus) throw their weight to the right, confirming the eastwardness initiated at center.

The key figure here is St. Matthew. Measured from forehead to fingertips, his reach exceeds even the spread of Christ's arms. But though his hands fly to Christ, the brunt of his body, like that of a man pulling a rope, strains to the right. Matthew's right arm is unique: it is the sole active limb in the picture that is both outstretched and unforeshortened. And as the track of this arm parallels the incline of the rightward tapestry tops, their slope takes up his motion. The élan of Matthew's trajectory engages the wall behind, aligning the tapestries (he fronts three of them) with his personal upsweep, his gesture.[8] Once again, reciprocity: as the actors deploy with respect to the inanimate set, so the set follows their lead.

Thus both lateral walls, from the left margin inward and hitherward from the opposite corner, bear east. Perspectival recession is overruled by currents of feeling. It is the rightward thrust of seven figures—of Bartholomew, James Minor, Peter, and Christ, and again of James Major, Matthew, and Thaddeus—that prods the entire system.[9] We behold a spectacular interdependence of foreground and background, of the nervous and the inert. Walls facing each other in symmetric convergence participate in an asymmetric cross-rhythm.

SO MUCH FOR THE COMPOSITION AS TRIPTYCH. Yet the picture comes in two halves, and its bipartition opposes sinister darkness to spread of brightness. The contrast reflects the duality of the subject. A constrained side at left bundles the three whom the Gospel associates with Christ's imminent death: Judas, Peter, and John. The auspicious side starts at Thomas' finger, the finger appointed to testify—*et resurrexit!* Contrasted too are the respective densities of the

8. Matthew's right arm, equal to the module that governs the quadrature of the field (see p. 185), may be Leonardo's modular *braccio*—Italian for "arm" and the basic Renaissance unit of length. The reason for appointing Matthew to exhibit the picture's module may lie in a secondary iconographic tradition that makes Matthew's attribute not the beheading axe, but a set square (a builder's attribute more commonly assigned to James Minor). The pertinent Matthean examples all seem to be Northern. They include the Matthew page from the Hours of Catherine of Cleves, c. 1440, The Morgan Library, New York; Lucas Cranach's woodcut, Geisberg 575; a Master S engraving of 1519, Hollstein 301; Nicolaes Ryckemans' engraving after a

Rubens painting, 1619–20, inscribed "S. Matthaevs," in the Pallavicini collection, Rome. By the late sixteenth century, the set square may designate other Apostles, St. Jude (Thaddeus) as well as James Minor. For a discussion of this confusion of attributes, see Hans Vlieghe, *Corpus Rubenianum Ludwig Burchard: Saints*, I, London and New York, 1972, p. 36.

9. Four of the thirteen figures offset the dominant surge to the right. But the effect of the penchant of John and Judas is checked by their triangularity and reduced size. And the centerward plunge of St. Thomas is merely inferred, not an optical datum. This leaves only Philip's strong counterthrust, which the forceful recoil of James Major keeps in check.

groupings: a stringent half under stress of compression, the other free-flowing. Finally, at the congested end, ten hands out of twelve (excepting only those of St. Andrew) bear down, weighing on table or shoulders; whereas on the right, ten out of twelve hands are aloft. No wonder the synergetic walls shrink and resurge, driven from dark to light.

The left/right antithesis was originally sustained by the distribution of color. This is now hard to experience, given the near-total effacement the mural has suffered. It is certain, however, that the hues of the left-hand Apostles showed deeper chiaroscuro. We can still contrast Bartholomew's blues to the laundered robes worn by Simon.[10] Assume these differentiations attributable to Leonardo: then the apposition climaxed in the figure of Christ, whose garment, tunic and mantle, formed the binate core of the system, the centrality where alone primary colors met in full saturation, red against blue.

Thus the system remains emphatically bilateral. Against the still center, whence all outflowing energy derives its first cause, the picture divides into differing halves, and from this complementarity exempts almost nothing, not even the apparently stabilizing rear wall. On this inert feature Leonardo lavished no less attention than on every other participant in the action. The rear wall keeps still only when disregarded; it stirs into motion as we take note of the slender sections bracketed by the gable. Normally, such twin piers flanking a central light are paradigms of bilateral symmetry. But the "pier" on our left sinks like a driven pile into the cleft formed by the meeting of John's arm with Christ's (as Antoniewicz observed); the other, of which only the mounting top shows, is buoyed by the lift of three superposed hands—Christ's open palm, James' right hand on the wing, Thomas' steeple finger. This rear wall incorporates an implicit rotation whose impetus derives from the protagonist's gesture and dress: the sky-blue mantle triangulated to peak at a shoulder, the passion-red of the tunic tapering to descend. Thus the twin piers under their crowning gable receive from Christ a bilateral differentiation which they share with the waning and waxing sides of the room; and with the dual subject of the Last Supper.[11]

"LEONARDO IS AS DELIBERATELY SYMMETRICAL as his predecessors had been, but surpasses them in the superior articulation he gives to the whole," Burckhardt had written (1855, p. 672). We can go further now. The symmetry of Leonardo's *Cenacolo* surpasses that of, say, Ghirlandaio, in more than dynamic articulation. More is achieved than the substitution of threesomes for the monotony of serial figures. Challenged by left-right contrast as well as by sideward drift, the picture's abiding symmetry becomes a conciliation. It becomes, as it were, iconographic. What the balance equilibrates is not just matching walls, or six against half a

10. In 1792, Leonardo's color was discussed with remarkable insight by Luigi Lanzi: "He had two manners, one full of dark tones which makes the light tones stand out; and another quieter manner in half tones . . ." (*Storia pittorica della Italia*, 1792, 4th ed., 1822, I, p. 101). The *Cenacolo* applied and contrasted both manners. For further discussions of Leonardo's color (preceding the latest cleaning), see Fernanda Wittgens, "Il restauro del Cenacolo di Leonardo," *Atti del Convegno di Studi Vinciani*, Florence, 1953, p. 39; and Arturo Bovi, "La visione del colore e della luce nella *Cena*," *Raccolta Vinciana*, 17 (1954), p. 315. Heydenreich (1958, pp. 13–14) observed a centrifugal drift from two saturated colors in Christ to "increasingly subtle mixtures." The outward trends are not, however, equivalent; the color heightens steadily from the dark to the lighted side. See also John Shearman, "Leonardo's Color and Chiaroscuro," *Zeitschrift für Kunstgeschichte*, 25

(1962), p. 32: "Leonardo has compensated…by a greater strength of color on the left than on the right, and by stronger contrasts of color and modelling within the shadow;…the color is much softer on the right, with many of the draperies approaching a silver-grey. This increase of plasticity and color in the more weakly-lit part is a device which [Leonardo] seems to have learnt from Masaccio." More on the subject of the *Cenacolo*'s color in Eichholz 1998, chap. 5, "Kolorit und Zeichnung."

11. Suppose Christ's colors to symbolize his dual nature. Equal in area, the two color fields take distinct shapes. The red tends downward. The rising blue—in sync with Christ's palm and the lift of James' right arm and Thomas' finger—imparts upward momentum. Thus the protagonist's colors (originally full-blown) contributed to the beat of the whole—down on the shadow side, up on the other. The system *in nuce*.

dozen, but oppositional principles—declension and lift, contraction-release, shade versus brightness, grief-to-come giving on the promise of life—while an irresistible trend orients the system toward the positive pole. These polarities refute any reading of Leonardo's subject that confines it to the betrayal announcement. And they beggar the kind of interpretation that treats the symmetry of the composition as if it exemplified textbook simplicity.

Fused Disconnections

Textbooks invariably cite Leonardo's brilliant disposition of the figures in groups of three. This is correct and instantly verified. But take the next step. Having seen the twelve-strong assembly divide, look to see the divisions connect. How is it that Peter, so quick to turn his back on the left-most group, contrives to implicate each member within it? Close behind Peter sits brother Andrew, and both brothers have a shoulder tapped by James Minor, while Peter's own careless knife targets Bartholomew. Surely Peter's continued engagement with each of the three he has left behind is a virtuoso performance. It makes one curious to see how Leonardo will handle the two other intertriadic breaks.

At the corresponding point opposite, the break seems at first sight accentuated. Here Matthew and Philip, to clench their respective sets, pull apart in opposing directions; yet remain close-connected. Philip and Matthew, each self-expressive—together, a *pas de deux*. They sunder as no others here do, but, as we have seen, they do it in likeness, in the style of unfurling fronds. And Matthew's flung arm more than reclaims his abandoned ground, so that this triadic division, too, becomes an occasion for linkage.

And what of the inner triads, the two most disconnected? Being farthest apart, these middle groups will have to be closest affiliated, and so they are. Those flanking the center seem at first prized apart by the figure of Christ; but these are the sons of Zebedee, along with Peter the Master's best-loved disciples. Fraternally bonded and nigh enough, they insulate the protagonist, while Peter and Philip, the outermost of these triads, arch inward, at one with the gable and the lunette overhead. The partitioning of the Twelve into four clusters of three was a splendid idea. It took more art to heal the divisions, to split and mend in one operation.

I am reminded of the drawing at the head of this chapter, an allegorical figure wherein Leonardo visualizes a fantastic anatomy, the physique of contrary principles (Fig. 83).

(Before citing further instances of double function in the *Cenacolo*, let me reflect on the thanklessness of the task. That reconciled contrariety pervades the design, confirming ever again the duality of the subject—simultaneously psychodramatic and sacramental—is apparent to me. But there are unitarians who suspect my attention to paradox in the *Cenacolo* to be clinically obsessive. A recent polemic against complex interpretation in general and this present blight in particular concludes that I show "all the signs of a patient who can articulate, but not control, his neurosis."[12] Whether the observations presented agree with the picture is not the author's concern. He has his hands full diagnosing a case.)

The Door / Window Enigma

More complications—the lights at the back, for instance: we can leave them unquestioned, or mystify them by asking whether they are windows, or one door between narrow windows, or even three doors. The problem is trivial, but the record of copies and glosses is surprisingly controversial.[13]

12. Elkins (as on p. 65 n. 11), p. 154.
13. The actual mural, along with the evidence of some early copies, partly dismisses the problem, since it shows the left-hand window with a limiting sill, which, incidentally, aligns itself elegantly with the neckline of St. John's tunic. The Tongerlo copy (Fig. 154) raises the sill and invents another such for the right-hand window. Birago's engraving (Fig. 4) records no window sill anywhere. The lower limits of the outer openings were evidently felt to be variable and unclear.

Some early replicas, to demonstrate how a doubt-proof door should be proportioned, enlarge the main opening (Figs. 143, 150, 163). Others, equally dedicated to clarity, slim down the middle and widen the laterals to suggest serial fenestration (Figs. 4, 26, 151, 157).

The will to have things one way inspires the commentators as well, though they are, in fact, of two or three minds. Some declare for a window-flanked door, others speak confidently of three windows, while Pedretti and Naumann diagram three doors in a row, like a church entrance (Figs. 85, 101). What is visually given divides opinion, and will so continue, until the inadequacy of the clues is credited with intelligent purpose. Here, at the shining middle, the painter has lodged an item just clueless enough to yield a small mystery. As understood by some early copyists, the central opening is interpretable as a portal; interpretable also as symbol, for did not Christ, shortly before his last meal, say, "I am the door" (John 10:9)?

On the other hand, insofar as these openings configure a trilight behind a nascent Communion table, they intimate the Trinity's presence, like the windows of a church apse. So then the deliberate un-definition makes useful sense. The door/window conundrum emerges as a structured dilemma. Seeing how it is done can be intriguing—or irritating, depending on temperament.[14]

COINCIDENT OPPOSITES abound in the picture. Some may seem insignificant. But in the *Last Supper* no detail is waste, and close observation confirms over and over how intricately Leonardo elaborates to bring opposites into states of union. To take note of such states is not anachronistic. We

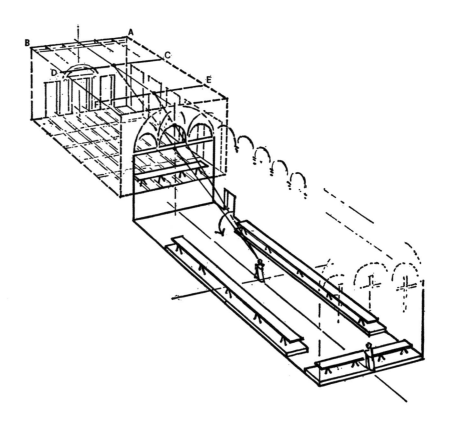

85. Projection of the *Last Supper*'s illusionistic space in relation to the refectory. Pedretti 1973, p. 70.

are reminded of Leonardo's contemporaneity with Machiavelli, who writes of a certain Magnifico that "in him were united two different natures in inexplicable manner"; with Castiglione, who explains that a chaste kiss gives each partner two souls and the two of them one; with Pico della Mirandola, who formed a "collection of incompatibles," and proclaimed that "the mind can compose all contradictions"; and with Nicholas of Cusa (d. 1464), whose phrase *coincidentia oppositorum* titles this chapter.[15]

14. In a paper on Leonardo's *Last Supper*, read at the College Art Association conference, 1972, Roy H. Brown offered conclusions similar to some I presented at the same session. From the published abstract of his paper, I quote: "The isolation of Christ strongly suggests an epiphany. 'Word-made-flesh' seems more palpable within an equilateral triangle, against a door ('I am the door') and before three openings of brilliant blue light that imply the

Trinity." For the trinitarian symbolism of apsidal windows, see Panofsky, *Early Netherlandish Painting*, Cambridge, Massachusetts, 1953, p. 132 n. 1.

The door-or-window dilemma has never been frankly acknowledged. Writers on the *Cenacolo* make their choice casually, sometimes vacillate without notice. Only one scholar (Horst 1930–34) confessed uncertainty by writing "door" in scare quotes or question-marked.

Flat Frieze or Three-Sided Seating?

For the form of the table and the consequent arrangement of figures Leonardo had several traditions to draw on. We may discount the round table or the segment-curve horse-shoe design. The latter, Early Christian in origin, reappears in Cosimo Rosselli's fresco in the Sistine Chapel (c. 1481), but the type was generally considered unsuited to monumental works in architectural settings. Better adapted to a wide, wall-sized stretch was the frieze composition: thirteen men all in line facing either the nave of a church (e.g., Fig. 189) or a fraternity at their meal, as in Taddeo Gaddi's fresco at Santa Croce, Florence (Fig. 30).

To Leonardo's immediate predecessors in the Florentine Quattrocento, the medieval frieze compositions must have looked stale and flat, and the want of an enveloping ambience, unnatural. To avoid such archaic planarity, the *Cenacoli* produced from the mid- to the close of the fifteenth century erect a three-dimensional set. Their tables are designed to give marginal figures a palpable salience, seating one or two at each end in a forward plane.

These two traditions—the figured frieze and the inset within adequate three-dimensional housing—diverge irreconcilably. Anyone could have told Leonardo that you can't have it both ways. Still, somehow he does. He obviously opted for spatiality; no earlier *Last Supper* representation had made quite so much of it. And he did adopt three-sided seating, with one diner at each end turning the corner. Yet, at the outer trines, the visual effect is exactly contrarious, suggesting that the figures here come single file.

At these terminals, where earlier *Cenacolisti* stressed forward projection, Leonardo re-flattens the system, reverts allusively to the primitive order of Taddeo Gaddi, and restores the long-repudiated effect of a running frieze. It is as if Leonardo's St. Simon (far right) sat simultaneously flush with his neighbors and at a right angle.

To discover just how Leonardo equivocates, it is instructive to compare his outermost sitters—Simon polarized by Bartholomew at extreme left—with the corresponding figures in, say, Castagno's *Cenacolo* (Fig. 86). There, the end figures sit against their own backing walls, plainly at 90 degrees to their neighbors; they show profile shoulders and superior heads. Such spatial clues Leonardo rejects.[16]

He does more. Each of his far-out Apostles, taken in isolation (as in Fig. 41), clearly occupies the short side of the table; each sits fronting his nearest neighbor, the recessed Thaddeus upstaged at right, James Minor at left. But we do not register the terminal figures in pairs; at both ends, it's a triad we see. And no sooner is Simon grouped with the third in his party than he surrenders his salience. As he and Matthew (both overlapping the man between) communicate in a shared plane; and as their four hands in procession join in one Christward sweep, Simon reenters the "frieze." Matthew's forwardness in leaning over brings Simon back into line. It is by such stratagems that Leonardo invests this terminal sitter with both co-planarity and 90-degree deviation, depending on whether we read him in relation to shrinking Thaddeus or to bold Matthew.[17]

I leave it to the interested reader to figure out how

15. References: Machiavelli, in Edmond Barincou, ed., *Machiavelli in Selbstzeugnissen und Bilddokumenten*, Hamburg, 1958, p. 101; Castiglione, *The Courtier*, IV, 64; Pico della Mirandola, in Rosalie L. Colie, *Paradoxia Epidemica: The Renaissance Tradition of Paradox*, Hamden, Connecticut, 1976, p. 29; Nicholas of Cusa, quoted in Ernst Cassirer, *The Individual and the Cosmos in Renaissance Philosophy*, Oxford, 1958, p. 50f. Cassirer's work discusses Cusanus' influence on Leonardo.

16. Anxious to render the seating more clearly three-sided, some adapters of Leonardo's *Cenacolo* widen or accent the short ends of the table. Thus

Raphael (Fig. 7), Franciabigio (Fig. 197), and Andrea del Sarto (San Salvi, Florence), to say nothing of painters who stage the event without reference to Leonardo.

17. Leonardo's purpose in meeting these divergent demands might be stated as follows: he was satisfying the scriptural requirement to house the sacred company in its own "large upper room." At the same time, he presented the scene (Goethe's intuition) as a meal taken at a "fourth table" in the Grazie refectory. Hence the flat-frieze effect that approximates the depicted scene to the refectory wall.

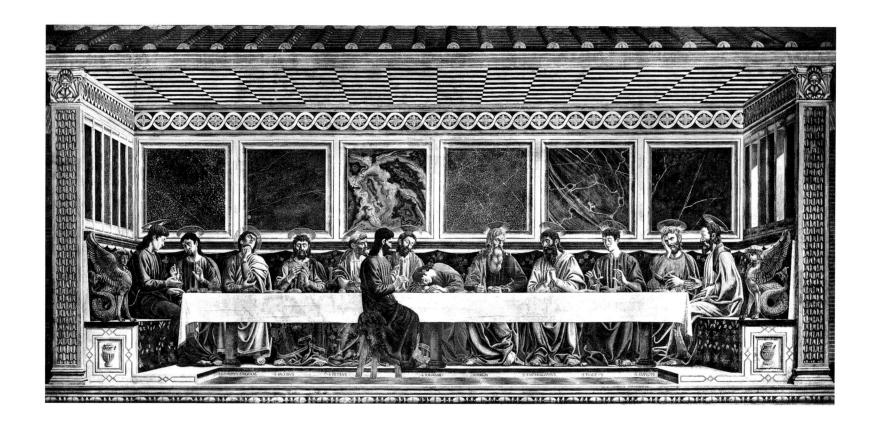

86. Andrea del Castagno, *Last Supper*, 1447.

Leonardo resolves the paradox of corner turning and staying in line at the far left, where Bartholomew takes on these further tasks—to give the rightward drift of the table its initial propulsion, and to give Matthew a model for the rightward projection of head and neck.

The Riddle of Matthew's Pose

I return at last to the complexities of Matthew's figure, third from the right. That he moves nimbly hither and thither is plain enough. But he double-functions as well on a vertical scale, for he seems to be equally seated and on his feet, depending on whether we read him to right or left. I have just referred to his doubling the craned-head effect of the upstanding Bartholomew. Is Matthew, then, a stand-up sitter sidling two ways? To keep his poll level with those of his fellows, he must have stayed half seated at least, twisting his torso toward them without lifting his fundament. Yet stand he must in relation to Philip, since the two of them, seen as a pair, exfoliate from one axis. I am forced to conclude that Matthew stands with respect to Philip, while still in session with his seated neighbors. Both he and Simon display spatial aptitudes "united in inexplicable manner."

But why dwell on such trivia? Surely, the *Last Supper* wants homage paid rather to the spirituality of its subject, the urgency of the drama, the grandeur of its artistic conception, its penetrating psychology, irresistible influence, and so on. Because, to say it once more, I am trying to track in the painting a mode of thought pervasive and all-embracing—an intellectual style that continually weds incompatibles, visualizes duration in one seeming flash, opposites in marvelous unison. Again and again, whether in choice of subject or formal arrangement, whether addressed to a part or the whole, Leonardo converts *either-or* into *both*. The interpreter, meanwhile, must take the cue: where something in the picture seems disarmingly obvious, look for its opposite. The rewards are immense.

SUMMARIZING THE ARGUMENT of this and the previous chapters: the *Cenacolo* composition is steady-state symmetry as well as sideward progression and contrast of sides. It is bi- and trisected, backed by a window which is also a door. The spatial illusion connects with and disconnects from the refectory. And the timing is instant duration. The protagonist is scaled both to his human companionship and to a superhuman dimension, and the action of his right hand signifies both in parallel with the table and hitherward. The Apostles act both on the spur of the moment and in pre-framed futurity, miming impulsive gestures that presage ritual norms. Two of them, Bartholomew and Matthew, are simultaneously on their feet and isocephalous with their seated companions. Matthew himself, straining two ways at once, pairs with the Philip he separates from, while his arm's contour runs both parallel and at 90 degrees to the crests of the tapestries, depending on whether we read on the picture plane or in depth. It is in keeping with such counterpoint thinking that the wineglass in front of St. John is both his to use and the cup of the sacrament; that two Gospels at variance with each other are harmonized (p. 51 n. 28) and that the general subject is both the announcement of the betrayal and the institution of the Lord's Supper. The picture is—as Sir Thomas Browne puts it in another connection— "complexionally propense" to ambiguity.

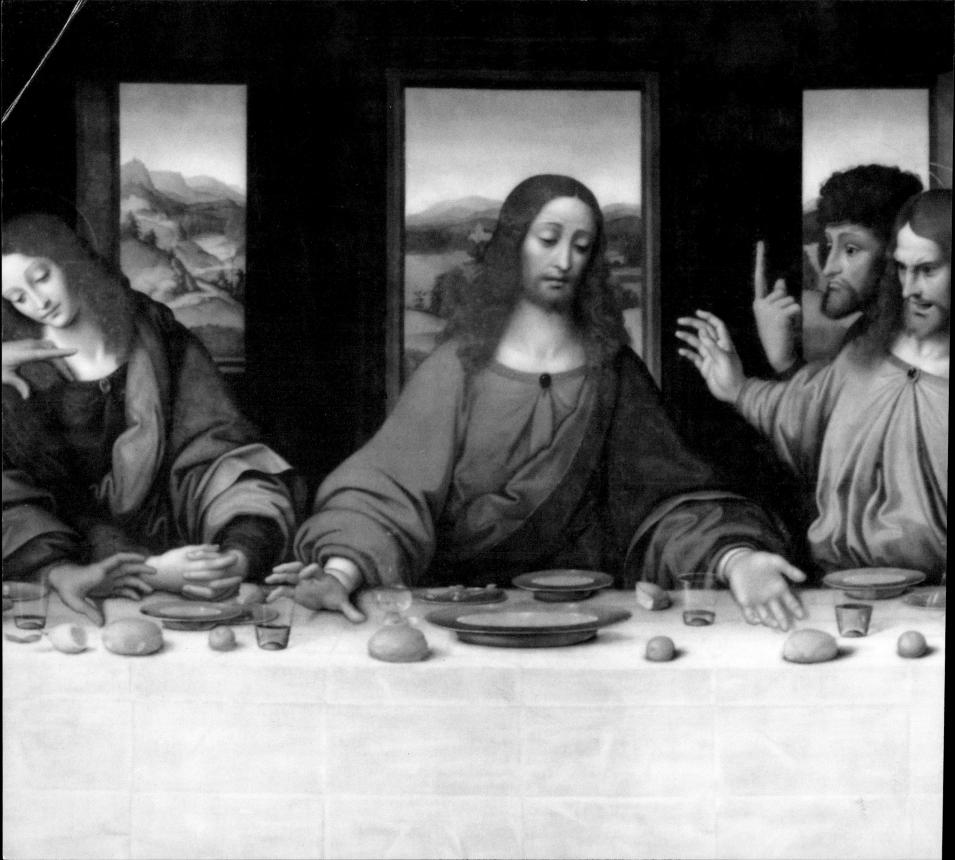

CHAPTER VII

Seven Functions
of the Hands of Christ

1. CHRIST LOWERS HIS ARMS in resignation; done with the ministry, he is about to submit to the Passion. Ever since the late eighteenth century, the pathetic humanity of the gesture has won admiration. Leonardo's Christ is described in the sufficiency of an aggrieved human nature. Thus the prior of the Grazie monastery, Domenico Pino (1796, p. 17): "The countenance gently majestic, the eyes downcast as of one who is saying what it pains him to say." Bossi (1810) rejoiced to see the divinity of the protagonist "abstracted," his human pathos intensified. Stendhal (1816, p. 196) imagined Leonardo's Christ "sickened of life" (*il se dégoûte de vivre*), having mistakenly judged men by his own heart: "Such is his emotion, that in telling the disciples, 'One of you shall betray me,' he dares not look upon any of them." For Goethe (1817, p. 84), the figure embodied our notion of a magnanimous man "whose heart is oppressed by a painful sorrow, whereof he would ease himself with a friendly word, only to make matters not better, but worse." Walter Pater (1869,

p. 99) was pleased to recognize in the picture "... not the pale Host of the altar, but one taking leave of his friends." And a hundred years later, Herbert von Einem (1961, p. 58): "Gone is the formal gesture of blessing. . . . The sorrowful inclination of the head converts the sublimity of the divine into gentle humanity."

We almost see how it is done—how the cadence of resignation is conveyed by the droop of the shoulders. The morphology of acquiescence was never more closely observed, never more accurately defined as the obverse of resistance. Squared shoulders assert themselves; they withstand. Those of the Christ signal surrender. Insistently Leonardo's choreography drives the point home: from left to center, in one figure after another, redoubled stress falls upon sturdy shoulders—three hands in succession settling like epaulets. Then, backlit, a steep incline at St. John's Christward side; and, finally, brought down by a lowered hand, the responding slope of Christ's body, figure and hieroglyph of submission.[1]

87. Giampietrino (?), c. 1520, from the Certosa di Pavia, detail (App. E, no. 6).

1. The skimpy shoulders of John and Jesus used to worry commentators and copyists. One scholar (Guillon 1811, p. 22 n. 10) attributed the deficit at John's shoulder to the restorers. Hoerth, writing almost a hundred years later, agreed (1907, p. 22): "Justly does Guillon de Montléon blame the overpainters for the unnatural scrimp of John's left shoulder, which seems to be wanting the collarbone." As for the Christ, Frantz (1885, p. 72) complained that the Castellazzo copy (Fig. 144) shows the Redeemer "wanting shoulders." No wonder that they swell in most early copies, broaden manfully under Rubens' care (Fig. 17). They grow immense in Bossi's "reconstruction" (Fig. 26) because, as Bossi explained (pp. 181ff.), the virtues of gentleness, resignation, and love are "secondary" to Christ's principal virtue of "la potenza."

2. STRANGELY ENOUGH, it is this shrinking of shoulders that also serves to triangulate the body's shape. Christ's arms, aligned with the falling hair, form a nearly regular, three-sided figure—a Jesus geometrized. The effect must have been instantly noticed and was evidently disapproved: every one of the copyists, from Birago to Bossi, sought to undo the straightness of those banking sides, inventing bulkier shoulders and concaves for the crook of the elbow. Four centuries had to pass before, in the heyday of formalism, the original shaping of Leonardo's Christ figure could be approved. Hoerth (1907, p. 223) cites the "harmonic effect of the main figure's triangular contour." Malaguzzi Valeri (1915, p. 520) commends an observation made in 1901 by C. Steinweg: "The figure is disposed as a triangle, Leonardo wanting it so because, as a good mathematician, he regarded the triangle as a symbol of strength and immobility." Eichholz's recent monograph (1998, pp. 214–15) discusses the Christ-triangle as an instance of Leonardo's "secret geometry."

The secret will out. Some of us can't help suspecting that the observed geometry hints at a Christian symbol of some reputation, to wit, the sign of the Trinity. Leonardo, it seems, would have the incarnation of godhead reign at the table—or address us from the table—under the aspect of an equilateral triangle. So then, the sloping banks of the central figure propound nothing less than a paradox. Symmetrical contours, the very ones that reduce Christ's manhood to meekness, evoke his divinity in emblematic abstraction. We are given a twofold value: in one reading, a full-bodied presence, a man in a fugitive moment swayed by a personal sorrow; in another, a stable pyramidal shape—

discrete, midmost, immovable. A single posture meets contradictory/complementary ends, projecting a figure worthy of the dual nature of Christ.[2]

3. WE HAVE BARELY BEGUN, for we need to recall two earlier observations concerning Christ's action (pp. 55–58). Granted that his lowered arms shape both affect and emblem; does not the effortless simultaneity of the gesture also promote the dramatic plot by designating the traitor? "He that dips his hand with me in the dish" (Fig. 24). Coincident with these imminent or just-spoken words is a motion which the context renders accusatory. Christ's right hand stays the recoiling left hand of Judas—the two, in the symmetry of their mutual approach, suddenly similar, almost identical. The hands are antagonists, summoned and sundered by that ill-boding dish.[3]

So if we scan along the table from hand to hand. But reading Christ's action from shoulder out, we have seen the arm advance more than halfway across the table and the hand forming a fulcrum, an intersection of linear directives orthogonal as well as transversal (Fig. 25). And as intersecting lines do not stop where they cross, we press on.

4. IN RELATION TO THE BETRAYER ALONE, Christ's right hand performs the third of its tasks. And we remember this other: the reach for the wine by fingers splayed for the widest span, like a pianist's striking an octave. Wineglass as well as treason dish enters the scope of that hand. The two hands together, teamed now in one action, respectively engage bread and wine. Such manifest exposition of the eucharistic species, however disguised as still life, may not be

2. The Christian symbol of godhead in anthropomorphic triangulation usually refers to the Father. (Examples: Carpaccio's *Padre Eterno*, c. 1495, at Grumello, near Bergamo; Dürer's enskied God the Father in the *Virgin and Child with St. Anne* engraving, c. 1500, Meder 43.) Leonardo's recourse to the emblem could allude to Christ's words spoken after the Supper—"He that has seen me has seen the Father" (John 14:9). For the Leonardo-derived

symbol in Pontormo's *Supper at Emmaus* (Uffizi), see p. 63 n. 7.

3. Roy H. Brown (1972) sees a "magnetic confrontation of hands." It was Cardinal Borromeo (1625) who first suggested (p. 19 above) that Christ's right hand refers to the imminent dipping (Matthew 26:23). Bossi agreed (1810, p. 185). Both authors assumed that this one action necessarily excludes any other.

88. Cassino School,
Last Judgment,
eleventh century, detail.

89. Maso di Banco,
Last Judgment,
c. 1335–45, detail.

discounted. We are bidden to read Christ's right hand, like his left, sacramentally.[4]

Thus the meanings proliferate. But as they come into focus, so grows the resistance, a resistance to ambiguity expressed in a normal preference for simplistic descriptions and apparent as well in the numerous sixteenth-century replicas of Leonardo's *Last Supper*. Many copyists banish the wineglass.[5] Some let the dish go. Not one preserves the pluralities of the original. Even Raphael, in the very act of paying homage to Leonardo's *Cenacolo*, feels the need to pare down. His drawing for Marcantonio's famous engraving

(Fig. 7) allows the protagonist only one gesture: planting both palms on the table. Implicitly, the surcharged complexity of the original is rebuked.

5. BUT LEONARDO IS IRREPRESSIBLE. His Christ—gesturing with both palms displayed, one proffered and open, the other turned down—assumes yet another symbolic role, the fifth on the present agenda. Alternately supine and prone, the hands project a familiar vision, the dual form under which they appear in numberless images of the Last Judgment, one hand uplifting, one putting away (Figs. 88, 89). It

4. More complication: we have seen Christ's hands reach toward bread and wine. But as the left alights on the table, the thumb points to another wineglass; and the thumb of the hand addressing the wine points to another loaf. Thus each hand touches down midway between bread and wine. It is a matter of emphasis. We refer the left hand to the bread, the right to the wine, because we see these staples in line with the orthogonals formed by the arms.

In fact, Leonardo shows each hand flanked by the elements of the Mass.
5. Copies that omit the wineglass: Birago's engraving (Fig. 4); the San Lorenzo fresco (Fig. 143); Araldi's copy of 1516 in Parma (Fig. 148); the Ponte Capriasca and Lomazzo copies (Figs. 153, 158); the Hermitage copy (Fig. 27), and, most consequentially, the Morghen engraving (Fig. 14), on which Goethe based his interpretation of the event.

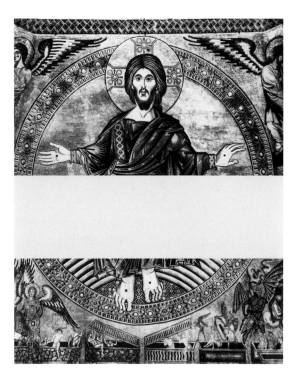

is a compelling formula, which Leonardo would have known since early childhood, when first he looked at the cupolar crown of the Florence Baptistery to see Christ part the reprobate from the elect (Fig. 28).[6]

Seeing this gesture of ultimate separation anticipated at the Last Supper—and the pronated hand directed at the first of the damned—we are led to suspect that the Christ of the Parousia, and of the concomitant Judgment, is being prefigured; as indeed he is in the rite of the Mass, wherein "Christ renders present the whole of His redemptive work.... In the Consecration He comes in Flesh and Blood, as in the days of His first coming; at the same time He...comes in the glory that will be revealed in His second coming."[7]

At the same time. This simultaneity is Leonardo's set theme, the object of the *Cenacolo*'s synthesis. Christ's motion here signifies that central sacrament which makes the salvific work ritually present, even to resurrection and judgment.

Revert now to the lost feet of Christ, whose curious cleaving, I have suggested, intimates the Crucifixion (p. 63). But there is more. Seen in whole, the figure's shaped outline from head to foot forms a perfect rhomb, lozenge, or diamond—an unlikely figure to strike in a moment of perturbation. This again is symbolic geometry, a pose not of this moment so much as eschatological, a posture ordained to invest a mandorla, Christ's typical aura in representations of the Last Judgment. As a prototype, I cited the figure in the summit of the Florence Baptistery. The relevance of this image to the *Cenacolo* becomes more apparent when its midportion is screened, as that of Leonardo's Christ is by the table (Fig. 90).

90. *Last Judgment Christ* (Fig. 28) with middle zone masked.

6. The archetypal gesture of hands turned alternately upward and down is common in Florentine art, e.g., Giotto's fresco in Padua; Maso di Banco's fresco in Santa Croce, Florence (Fig. 89); Fra Angelico's *Last Judgment* panel at San Marco, Florence. (Cf. the hands of God in Filippo Lippi's *Madonna Adoring the Child with St. John and St. Romualdo*, c. 1463, Uffizi.) That the gesture of Leonardo's Christ foreshows the ultimate Judge was observed independently by Polzer (1973/74, p. 69).

7. Pius Parsch, *The Liturgy of the Mass*, 3rd ed., London, 1957, pp. 19 and 238.

91. Plan of Santa Maria delle Grazie complex.

Of course, the Last Judgment association need not exclude other reaches of symbolism. Some may feel that the contrast of hands prone and supine is too universal to reserve for the *dies irae*. As well as damnation/salvation, the opposure may signify earth and heaven, life and death, or mortality-resurrection.[8] But Christian iconography made that dual gesture formulaic in the Judge of the Second Coming; therefore, in this modality, hardest to think away. And as Leonardo is the first (and last?) to dispose the hands of a *Last Supper* Christ in this manner, he could not have missed the connection, not with his wits about him.

THE COMPARISON OF LEONARDO'S PROTAGONIST with any Christ of the Last Judgment raises a problem. At the Judgment, the auspicious hand is always the right—in Leonardo's *Cenacolo*, it is the wrong hand that opens. Accordingly, it has been suggested (Antoniewicz, App. B, p. 208) that Leonardo reversed the actions of right and left because he himself was left-handed. This is improbable, since the picture is not a private notation. More to the point, it is not a self-contained image but part of an architectural complex, the end wall of a monastic refectory adjoined to a cloister and church. These conditions demanded respect, even from a sinistral. What checks did they impose?

When Leonardo embarked on the *Cenacolo* project, Montorfano's *Crucifixion* fresco, completed in 1495, was already in place on the opposite wall (Figs. 92, 95). And there, on the south wall of the refectory, the right side of Christ turns, as required, toward the Madonna and the Good Thief. The side of blessedness, eastward, was thus pre-established. In agreement with Christ's own inclination,

the long refectory hall was, as it were, oriented laterally, toward its pulpit on the east wall, and to what lay beyond the east wall—the graveyard and church (Fig. 91).

Could these preconditions be slighted? Some other painter, commissioned to place a *Last Supper* on the north wall of the refectory, might have ignored the site. The subject, after all, was not like a *Crucifixion* or a *Last Judgment*, subjects that automatically rank right against left. Since a *Last Supper* seats six Apostles of equal dignity on either side of their Lord, it would have been possible, even on this

8. Thomas McEvilley of Rice University kindly communicated the following (letter of February 14, 1973): "The Christ mudra represents his dual nature, the down-turned palm represents the mortal nature of Christ, the upturned, eternal life. Comparative points:... In Orphic iconography, intermingling with the Early Christian, certain figures point both upward and

downward, indicating the life/death knot. In Sufic Islam the dervishes dance with right hand palm upward, left hand palm downward, both arms outstretched. In sign language employed by the deaf, the mudra for death is: hands in front of chest, one palm upward, the other downward, then each hand turns over...."

92. Donato Montorfano,
Crucifixion, 1495.

north wall, to repeat the standard symmetrical scheme without favoring one side over the other. But the wall of Leonardo's *Cenacolo* runs (panning from left to right) west to east, parallel to the west-east axis of the adjoining church. And we have seen that Leonardo conceived his work with respect to the cardinal points, inviting into his picture the evening light from the real west windows, and infusing the composition with symbolic asymmetry, its drift to the lighted side. It was these conditions more than any sinistral quirk that must have determined the choice and direction of Christ's giving hand in the painting. Leonardo would not avert his Christ from the east.

What, then, do we make of Christ's two-handed gesture? While his pronated hand turns to the baleful side, to the Judas dish and the wine of his blood, the other—the hand of good tiding that underlies the promise of resurrection attested by Thomas' finger—opens toward the bread of life; the two hands together prefiguring the attitude of eschatological majesty.

6. TRY TO IMAGINE the *Cenacolo*'s central figure, not as its simulacrum proliferates in cheap reproductions, but as this Christ would have greeted a man entering the refectory by way of its formal entrance, the *porta antica* in the east wall. With this ingress in mind, we discover that the propitious left hand, offered across the table, extends illusionistically toward the visitant; it is aimed at the door (now walled up) that formerly opened on the Chiostro Grande, the Cloister of the Dead. For a person entering through this door, the boon of that proffered hand must have come reassuringly. Whatever meaning the visitor took from the gesture, he would have seen the open hand put forth in his direction. And not toward him alone, for the hand reached out to those who, dying in Christian hope, await Christ's call in the grave—those asleep in the Chiostro dei Morti and, directly beyond, those dead of the house of Sforza who were to rest under the dome of the church.[9]

It is hard to believe that these connections—from the depicted Christ, through the entrance, athwart the burial

9. The phrase "under the dome of the church" is loose enough to fudge on the question whether the Sforza sepulcher in Santa Maria delle Grazie was to be placed in the apse or in the tribuna, i.e., plumb under the apex of the central dome. Despite Pedretti's exhaustive research, Lodovico's first-chosen site for his tomb remains uncertain (Carlo Pedretti, "The Sforza Sepulchre" [Part I], *Gazette des Beaux-Arts*, 89 [April 1977], pp. 125–27; Part II, 91 [1978], pp. 1–20). That the Sforza duke sought to emulate the Medici of Florence is well known, and the tomb of Cosimo de' Medici in San Lorenzo, completed in 1467, lies at the foot of the high altar, directly under the dome. (See Janis Clearfield, "The Tomb of Cosimo de' Medici in San Lorenzo," *Rutgers Art Review*, 2 [January 1981], pp. 21–22.) Pedretti remarks (II, p. 7) that Santa Maria delle Grazie was for the Sforza what San Lorenzo was for the Medici, a family mausoleum. But Cosimo's tomb in San Lorenzo was in the crypt, its location in the church proper marked only by an inlaid marble slab in the floor, so that the view of the high altar remained unobstructed. Could the Sforza tomb have been designed to satisfy the requirement of centrality without blocking that axial view? Pedretti cites small Leonardo sketches for a "tall and elegant aedicula," dating "from the period of the Sforza sepulchre, c. 1495–97," which, he believes, "would have been appropriate for a funerary monument to be placed at the center of the tribune" (II, p. 7). He proceeds: "An open structure as shown in Leonardo's sketches could well have served the dual purpose of a tomb and a ciborium, framing the altar visually

along the longitudinal axis . . . as Bernini's Baldacchino frames the Cathedra Petri." Moreover, "the whole Sforza sepulchre . . . was actually completed [by December 1498] and set up in the tribune but taken down in compliance with the decrees of the Council of Trent and its parts dispersed in 1564" (I, p. 125). What survives of the dismembered monument, installed in the Certosa di Pavia, are the marble effigies of Lodovico and Beatrice, carved by Cristoforo Solari.

Pedretti's phrase "set up in the tribune" suggests that the monument's original destination was directly under the dome, i.e., not in the apse. Yet it was in the apse of the Grazie church that Lodovico's deceased wife was entombed, and Lodovico wished to be laid at her side—whether or not he regarded her apsidal resting place as final. Perhaps it was her untimely death in 1497 that necessitated the tomb's (temporary?) relocation. At any rate, in a subsequent essay, Pedretti (1983, p. 43) speaks confidently of "the Sforza Sepulcher…located in the center of Bramante's apse." And again (p. 153): "In the center of Bramante's apse, in 1497, the Sforza Sepulcher was built under the supervision of Cristoforo Solari il Gobbo, possibly to Leonardo's design." We are left undecided. As Pedretti put it in 1977 (I, p. 125): "Any information about the funerary monument as a whole in its original setting would be an invaluable contribution to our knowledge of the overall program of rebuilding Santa Maria delle Grazie since it was certainly meant as the visual and symbolic focus of the new church."

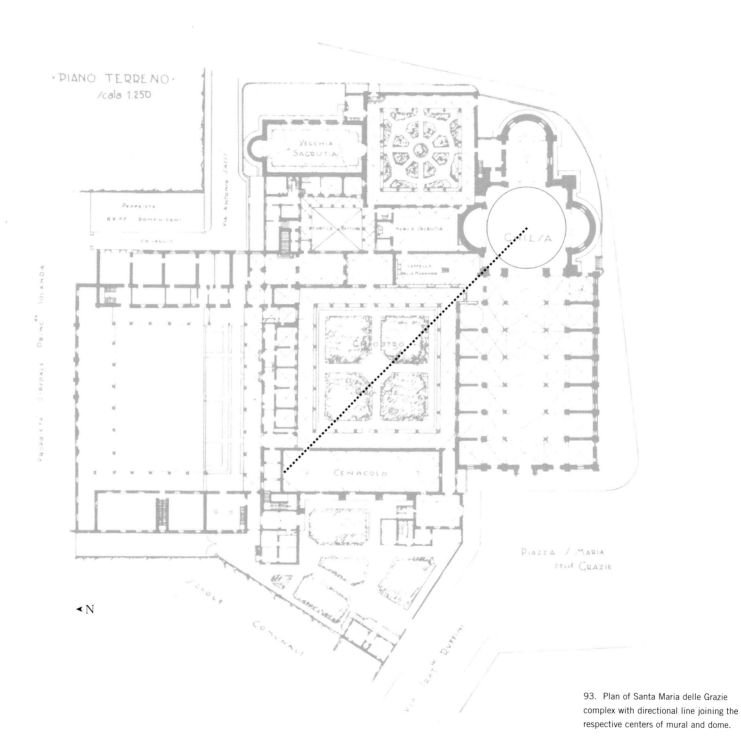

·PIANO TERRENO·
/cala 1:250

◄ N

93. Plan of Santa Maria delle Grazie complex with directional line joining the respective centers of mural and dome.

ground, and on to the church—were lost on Leonardo's patron, the Sforza duke, Lodovico il Moro. The *Last Supper* commission was part of a grandiose scheme to turn the monastery-church complex into a Sforza family mauso-leum; and there had been enough recent deaths to lend ur-gency to the project. The former duke, Gian Galeazzo, had died (October 22, 1494) shortly before the probable date of the commission. As work on the mural proceeded, Lodovico's daughter died (November 22, 1496); then, six weeks later, Beatrice d'Este, his well-beloved wife. The grief-stricken Sforza usurper continually frequented the Grazie altar and, having prayed at his wife's tomb, which he expected to share, dined Tuesdays and Saturdays at the prior's table in the refectory, facing Leonardo's image of Christ.[10] His feelings during these visits are not recorded, but try to imagine the psychic freight of his weekly itinerary: rising from prayer at the high altar, crossing a burial ground to enter the refectory by the *porta antica* in the east wall, then at once to be solaced by that candid hand, a hand aimed at the graves even as it prescribed "the medicine of immortality."[11]

A glance at the plan of the Grazie complex confirms that the topical correlations I have tried to describe were a studied effect. Begin at the *Last Supper* wall of the refectory. A line sprung from its midpoint—produced at the angle of Christ's left arm crossing the table—reveals a surprising connection: clearing the *porta antica* and traversing the Chiostro dei Morti, this rectilinear course, running south-east at 45 degrees, homes in on the midpoint of Bramante's tribuna, the church's domed crossing (Fig. 93). Or, revers-ing the sequence, the centerpoint of the dome is located to lie on one straight diagonal with the refectory entrance and

the midpoint of the *Last Supper* wall—the point whence Leonardo's Christ initiates that commanding axis by the fiat of his left hand. In other words, the direction of Christ's life-giving motion defines the dome's radius.

Carlo Pedretti has shown how closely Leonardo collab-orated with his friend Donato Bramante in replanning the church; the painter was simultaneously engaged in both pro-jects (Pedretti 1973a, pp. 30ff). No reason, then, to suppose that the precise correlation between dome and refectory mural happened by chance, or that the happening passed un-noticed. The placing of Bramante's tribuna, its exact dis-tance from the preexistent nave, had been the architects' free decision. It could have been placed further east. In fact, being calculated to correspond with the central event in Leonardo's wall painting, the dome's radius became the ex-tended outgrowth of the depicted Christ's gesture. And this gives us the sixth in the present inventory of functions which Leonardo credited to these capable hands.[12]

BUT IS IT CONCEIVABLE that the painter compressed such abundance of meaning in one pair of hands? So formulated, the question is sterile, since Leonardo's unrecorded inten-tions are not available. The question rebounds on us as we choose between probabilities. Overloading Christ's gesture with interpretations, we may well be reading in more than the painter intended. Conversely, resistance to multiple meanings may be projecting our preference for simplicity upon Leonardo. The risk of projecting attends both alter-natives, and, judged by the historical record, the *Last Supper* has been more grossly wronged by simplistic underinter-pretation than by surfeit of subtlety.

10. See Möller (1952, p. 9), citing his source in the Chronicle of P. Rove-gnatino, a resident in the monastery from 1500 to 1520.

11. "The bread which is the medicine of immortality" is the wording of St. Ignatius, Bishop of Antioch (c. 112 C.E.), quoted in H. Bettenson, ed., *Doc-uments of the Christian Church*, Oxford, 1947, p. 104.

12. This observation, first recorded in the 1973 version of the present book,

has entered the *Cenacolo* literature without meeting resistance—its geo-metric precision is too compelling. It has been repeatedly cited by Pedretti (see especially *Leonardo architetto*, Milan, 1978, p. 109), was elegantly re-dia-grammed by Monstadt (1995, p. 273), and seems persuasive even to Eichholz (1998, p. 497), despite the author's disdain of sacramental interpretations (p. 461: *eine Tendenz zur Sakramentalität kommt für mich nicht infrage*).

For myself, there is one determining consideration: that it is methodologically unsound to imagine Leonardo insensitive to the implications of his inventions. He was creating the most thought-out picture in the history of art, and we have probability on our side if we grant him awareness that the action he assigned to his Christ yields at least six intelligible connotations:

1. Christ vails his arms in token of willing surrender.
2. The gesture accuses the traitor.
3. It contours a triangular figure in sign of the Trinity.
4. The hands in concert, directed to bread and wine, announce the sacrament of Communion.
5. The open hand, launching the radius of the great dome as if founding the church, extends the promise of life to the dead.
6. The palms, alternately down- and upturned and addressed respectively to the dark and light sides of the room, prefigure the Judge of the Second Coming.

In the working of his central figure, Leonardo visualized the continuum of Christian salvation.

7. AS IF ALL THIS were not enough, Christ's gesture must still be credited with a seventh function.[13] This seventh depends again on the apparent forward thrust of Christ's arms. Photographs, being products of single-eyed cameras, tend to quash the effect, and as of the latest cleaning, the depicted bodies abdicate nearly all claim on the third dimension. And yet, standing off at some distance, one still sees that Christ's arms do more than triangulate his upper body. Branching across the table, they give the figure a projective "ground plan." The body in depth describes an open trape-zoid formed by arms diverging from the plane of the chest. The arms fan out, obliquely foreshortened, and with far-reaching consequence.

When Goethe wrote that Leonardo's *Last Supper* represents the impact of a spoken word on an assembly, he was thinking as a playwright, not as a painter. In his description, the picture illustrates the effect of a foregone auditory event, the visible sequel to a vocal stimulus which itself lies outside the scope of visualization. Thus, in the Goethean conception, the picture, wanting the voice of Christ, remains incomplete; it mutes the speech act that supposedly causes what we are seeing. This literary approach to the painter's pictorial thinking misses the plenitude of the image. It misses the thrust of a picture whose vitality is not fed by an absent stimulus—words that have died on the air—but by an ongoing process, like the beat of a heart or the emission of light.

Of course Leonardo expects us to recognize the protagonist as the speaker, the *proponitore*. But what is immediately manifest, what we are made to see as the impetus to all motion, is not a word but a gesture. That gesture is causal. Visually, choreographically, the motive force in the picture is the flare of Christ's arms, and it is to their action that the whole picture responds. As Christ's hands clear a site for themselves, his nearest neighbors roll back, make way, and fall into responsive diagonals. The redisposition of these flanking triads with respect to the table is instantaneous. On our left, parallel to the right arm of Christ, one oblique trine runs elbows-out from John to Judas. On our right, Thomas and Philip align with the startled St. James. Both trines together confirm the divergence of that central arms' spread. They absorb its momentum and relay it, further

13. Is there an eighth? Ruskin gives timely warning. A lady who had just come from a lecture on botany had been delighted to learn that "there were seven sorts of leaves." Ruskin reflects: "Now I have always a great suspicion of the number Seven; because when I wrote the *Seven Lamps of Architecture*, it required all the ingenuity I was master of to prevent them from becom-ing Eight, or even Nine, on my hands"; *Fors Clavigera* ("The White-Thorn Blossom," May 1, 1871). Just so, I prevent an eighth, disqualifying as super-numerary the effect of Christ's down- and upturned hands on the apparent descending/ascending movement of the side walls and the wall strips be-tween the windows (p. 132).

amplified, to the tapestried walls, so that the walls, too, seem to expand, fanning out in remote obedience to the charge of Christ's arms.

Once seen, the correspondence between the track of these walls and the mediating inner disciples cannot be un-seen. Seen synoptically with Christ, the depicted room in its splayed-out perspective adapts itself to the "ground plan" of Christ's action, three walls falling in line. As the cham-ber's back wall parallels the frontality of Christ's shoulders, so, by virtue of the perspectival projection, the foreshort-ened sides (along with two ceiling beams and two bands in the floor) obey the course set by his arms. The perspective becomes, as it were, the visible consequence of a visible cause. From the closest disciples to the hithermost reach of the room, the response is to one font of energy, dramatic action and geometric projection reacting together.

Walls amplifying a motion initiated in Christ. We are witness to a spectacular symbiosis of the sentient and the inanimate—and receive the shock of this visual equation: what mobility is to the body, perspective is to the walls; it is their adaptive response, their form of commotion, their way of being ensouled. Perspective and body movement alike are revealed as modes of reactivity to an impulse re-ceived from the prime mover.

Christ's spectacular influence on the spatial perspective is, I have suggested, part of Leonardo's preemptive answer to Goethe (p. 113). The poet, for all his love of the painter's art and of this painter, conceded that even Leonardo must unavoidably scant the larger of the God-man's two natures. Of a drawing for the head of Christ formerly misattributed to Leonardo, he remarks: "Here, of course, we see only the human being who does not hide his soul's sorrow; but to ex-press simultaneously, and without quenching these features, the sublimity, autonomy, strength, and power of the divine, this were a task which even the most spirited earthly brush might find hard to bring off."[14]

To say it again, Goethe's thinking here is that of a drama-tist; hence his justified doubt whether even the bravest painter (or actor) could collapse sublimity and submission in the phenomenon of a face. To Goethe, the impossibility of the task set a term to the powers of painting. And he was surely right that no human visage, whether limned or alive, conveys, all at once, the antinomies we so easily check off in speech, coupling incompatibles by recitation. Power and sorrow, omnipotence and docility—these consort well enough in phrasemaking, rarely on human faces, and the Christ of the Gospels fails on this score. His divinity goes un-recognized even by Satan and is revealed to a chosen few only on special occasions, and by dint of what theater calls "spe-cial effects"—revealed, not by facial mien or expression, but (at the Baptism) by a heavenly voice and the miraculous de-scent of a dove; or (at the Transfiguration) by the appearance of Old Testament prophets in comradely levitation.

And so Leonardo. To portray the fullness of Christ, he needs physiognomics no more than the Gospels do. His ren-dering of divinity in Christ's person relies not on visaging or histrionics, but on causations, connections, interrelations—all those "formal arrangements" that chart the impact of godly presence on men and matter.

We touch here on the most sensitive of Leonardo's paradoxes. Obviously, the tapestried walls, being the facing sides of a projected rectangular hall, must run parallel to each other (would have been built parallel to each other had this been a real, not a depicted room). It follows that these walls cannot mimic the divergence of Christ's arms in a structural sense. We resist being tricked into an erroneous reading of perspectival directions. As we observe the walls and the diagonally disposed groups of Apostles together, we may savor their rhyming as a compositional artifice. But when it comes to understanding what we are seeing, dis-cernment pries them apart. What these aroused diners and

14. The Brera drawing is reproduced in Pedretti 1983, p. 13, and full page in Brown 1983, fig. 15. For Goethe's original text, see p. 199.

their Lord do at this moment is not what inflects the walls! Reason will not allow the sides of a rectangular box to be so double-dealing as to simulate two spreading radii. Yet the paradox is no greater than that of seeing parallels meet at the horizon. Leonardo's design, for all its appeal to the intellect which decodes a one-point perspective, appeals no less to that intuition which sees what appears. In the *Cenacolo*, the path of the tapestried walls is doubly charged: one charge is rational—to define the locale of the narrative as a rectangular chamber; the other is visionary—to exhibit space in mysterious congruity with the divine influence from the center.

We are asked to share the master's profound acquiescence in the given ambivalence of perspective, an acquiescence that actually wills ambiguity. The seeming convergence of the side walls as well as their understood non-convergence—the thing seen and the thing mentally comprehended—both in parity assume significant status. They may contradict one another, but they coexist, like sight and thought in the mind.

Leonardo's depicted space, then, is not an inert shell so much as a reactive condition, informed and moved by the action onstage. We apprehend its optical movement in three possible ways. In analytical mood, we unthink the actors and study the empty set to find a chamber whose side walls in geometric projection speed to their vanishing point. Seen two-dimensionally as backdrops for the outer groups of Apostles, these same side walls participate in the general eastward drift from left to right (p. 130). But concerted with the action of Christ, the wall planes diverge, as if in response to the power released by Christ's gesture, as if launched on their oncoming paths by his will.

The result is a prospect of uncanny vitality. Through the valve-like gap formed by the inner groups of disciples, the picture pours itself out toward us. And as this effluent energy, discharged from the center, expands into the space we ourselves occupy, the perspective even of the refectory walls seems to reverse itself. The walls' spatial motion, their convergence upon a remote centric point, is perceived instead as an outcome—the hitherward propagation of a movement engendered in Christ.

The old question, whether or not the depicted chamber prolongs the refectory, is thus turned back to front. Instead of asking how Leonardo's chamber joins on (and finding a kind of malfunctioning at the joints), we discover—remembering how a nave may be built onto a choir—that the picture makes actual space contingent on the divine presence. As Christ's arms—now in their seventh function—anticipate and embrace even the real perspective, our physical ambience is subsumed in his influence. All visible space is defined in his aura, and perspective itself becomes sanctified. Christ, the submissive Lamb of the Passion, literally imparts himself to the world. He moves his hands—no more than that; and at their motion, the very order of space, the laws governing visibility, are received as an emanation.

Personal Note

Closing this chapter with a premonition of its likely reception allows me to make use of a word which I will never again have occasion to relish. The word—you will find it in any unabridged English dictionary—is *septemfluous*, i.e., flowing out in seven directions. It was Ovid who coined the term in reference to the delta of the Nile, which, in his day, fanned out into seven mouths (now, alas, down to a pair).

To revert to my premonition. Cautious colleagues will dismiss the above as "interpretative overkill." They will not specify which of the seven functions here attributed to Christ's gesture they regard as unlikely. Few will assert that this or that action is *not* being performed. But seven is a ponderous number, and that many simultaneous functions imputed to one pair of hands is exorbitant. Each observation alone may be sound. It's the septemfluity that appalls.

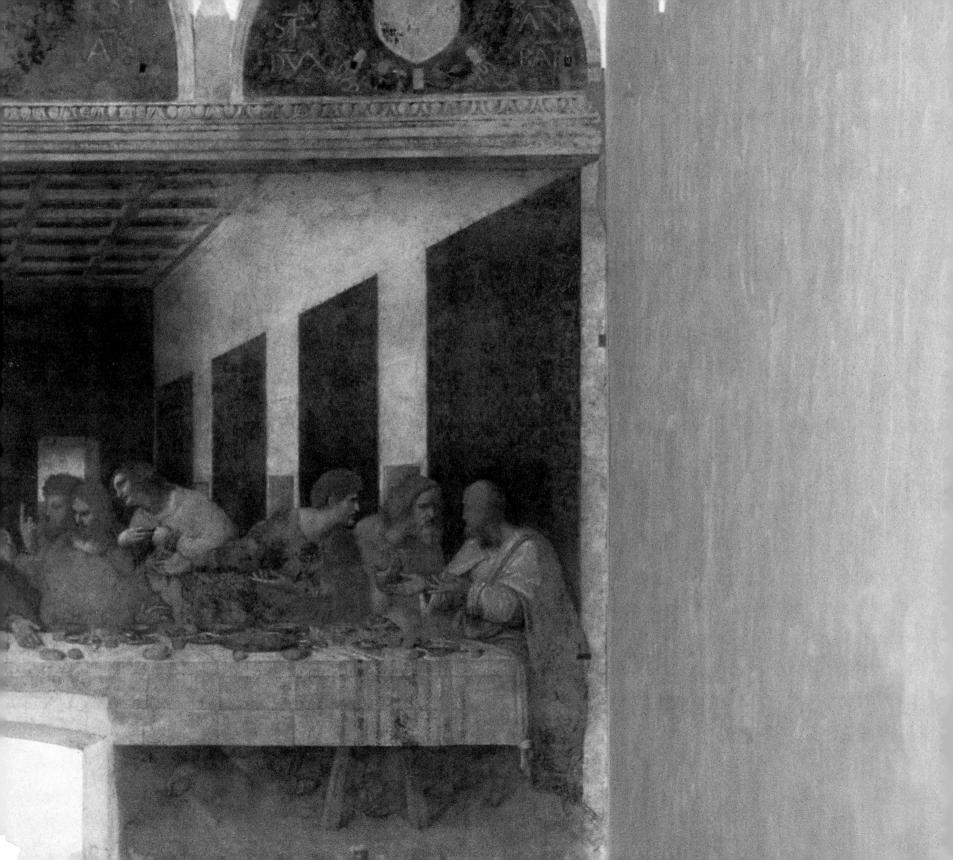

CHAPTER VIII

Marginalia

STILL UNRESOLVED is the geometry of the perspective, which was never supposed to be a problem at all. But suddenly, in the year my own essay appeared, Carlo Pedretti announced that Leonardo's spatial construction had "puzzled generations of scholars" (1973, p. 70). Perhaps it had, though few had been willing to say so; not while Leonardo was expected to be forthright and clear.

It was this expectation that faded during the 1970s. The ideally unambiguous had long lost its cachet, and a generation of younger scholars, looking close and posing new questions, inaugurated a season of unembarrassed bewilderment.

By 1980, Leonardo's *Cenacolo* could be described as "a context of . . . contradictions," with portions of it "substantially distorted" and the whole under one overarching "contradiction [that] eludes explanation."[1] A thoughtful study by Michael Kubovy, published in 1986, found the mural's perspective "not perfect" and the picture replete with "dialectical tension" and "jarring discrepancies"—"a 'difficult' work

of art, one that forces you to engage in mental work." Kubovy concluded: "There is an indefiniteness, an ambiguity, about the place, most befitting the locale of an event so critical to the spiritual life of the church."[2]

Meanwhile, Martin Kemp's analysis of the picture (1981) discovered "unexpected extremes of artifice and visual paradox." Kemp noted that Leonardo had "failed to provide a table of adequate width for all the figures"; that "the structure of the illusionistic room . . . is founded upon an illogical contrivance"; that "the relation of the table to the space is nowhere explained and on analysis can be shown to occupy so much of the width of the room that no one could be seated at its ends. [Finally] all this ambiguity is contained within a border which is itself deeply ambiguous. . . ." It reads like a grievance list, though written by a judicious admirer.[3] And as of 1996, users of the thirty-four volume *Dictionary of Art* will find a full column devoted to Leonardo's *Last Supper* (vol. 19, p. 189), written by the same Martin Kemp and including this:

94. The mural's right margin abutting the east wall of the refectory, after the latest cleaning.

1. Polzer 1980, pp. 240, 246, 247.
2. Kubovy 1986, pp. 140, 145, 149.
3. Kemp 1981, pp. 194–96. The author's remarks on Leonardo's "illogical" structure follow his similar qualms about the figures: "There is barely room for four figures on each side of Christ (who is, incidentally, depicted on a

larger scale . . .) and there are certainly no seats from which Peter and Thomas could have risen and none to which they could return." Kemp justifies these contrivances as "narrative concentration," and itemizes further "paradoxes" in the perpectival construction. In both the company and their housing, he recognizes reliance on artifice.

Leonardo created a compelling effect of perspectival space opening off the refectory, but rendered the relationship between the illusionistic and real spaces deeply ambiguous at its margins.

Deeply ambiguous. Just how this warning will slow the encyclopedic browser is hard to say, but it is surely unusual for a magisterial reference work to confess itself mystified. What now are we to make of Leonardo's perspectival construction: are we seeing a rectangular hall correctly projected from a fixed vantage? Or is the convergence we see "decelerated," or, as others surmise, "accelerated," i.e., the representation of a theatrical set that comes pre-funneled to pretend greater depth (p. 188)?

These questions may be unanswerable so long as a single system is presupposed. My own suggestion—now thirty years old, still controversial—posits a coincidence of two systems. In brief: the *Last Supper*'s perspective dives into the picture and at the same time, being transfigured, radiates out of it. To simulate a domestic interior, the perspectival construction enters the picture from a vantage point pegged at inaccessible height halfway down the refectory; it issues in altered form to the grounded viewer. Ask what would have caused the perspective to undergo such reversal, and the answer is: the encounter with a living presence which the hollow geometry, sailing forth like a ghost ship without complement of a crew, knows nothing of. But as Leonardo's linear perspective comes fully manned, so it submits to the same centered force that excites every gesture. The pictured space delivers simultaneous alternatives. We can imagine it as a chamber built before the diners arrived and bound to survive their departure. And we can see the lineaments of this same fabric unraveling from their vital node in the person of Christ, as if the structure were not preformed so much as in process of being engendered, obedient to the action onstage.

That this proposition must sound irrational is evident even to me—irrational if the depicted chamber is thought of in isolation. But in this picture nothing is usefully thought of in isolation. We do better assuming that Leonardo conceived stage and performers together. On this reasonable assumption, we will be receiving the set as the setting of an event that is both narrative and sacramental; a set which Leonardo will have erected to double-function along with his subject. The program prescribed a withholding of clues to produce functional equivocation. Strange things needed doing to service both sides of the subject.

These reflections will be developed in the next chapter. Right now, more questions come crowding in. They want instant attention, if only to demonstrate why single-minded interpretations of Leonardo's perspective no longer work.

HAVE YOU EVER TRIED to locate the base of the back wall in Leonardo's construction? On this delicate topic the picture is secretive, as it is about the running tracks of the side walls, or the scope of the ceiling, or the joining at the proximate corners, or the format of those bottomless tapestries, or the main light at the back—how far down does it go? Only the artist knows, but his knowledge he keeps to himself. In a picture so fastidious about small change, such as the count of subtabular toes, why this reluctance to divulge metric proportions?

Reticence of a different sort troubles the lateral margins, where Leonardo seems candid, for once. But this candor, this open show of the seams where the mural abuts the real refectory walls, is deceiving. Here, in one of his boldest decisions, Leonardo produced a conundrum that remained unresolved for almost five hundred years.

Consider what Leonardo at these downright margins refused to do. His forerunners in monumental wall decoration believed that a fresco must be ushered with a certain formality. The masters of Renaissance narrative painting, from Giotto in Padua to Perugino's team in the Sistine Chapel, were excellent storytellers committed to realism, yet they laid their scenes within ornamental borders—they

95. Refectory, Santa Maria delle Grazie, with Montorfano's *Crucifixion* on the south wall, 1973 photograph.

would not release a picture without the ceremony of a frame.

With the outgoing Quattrocento, decorative surrounds were gradually discarded, giving way to proscenium effects. To promote the illusion of vistas viewed as if through an arch, gateway, or loggia, painters now margined their scenes with architectural orders, freestanding piers, or engaged pilasters—signposts to mark the transition from actual into virtual space (as in Montorfano's fresco, Figs. 92, 95). The many insulating devices invented by late fifteenth-century fresco painters are ingenious and often delightful to contemplate.

Leonardo forgoes them all. His *Cenacolo* will have no exordium, no prologue, no mediation. He paints the first monumental Renaissance mural that frames itself directly— frames itself only!—in the hall it adorns. His picture overspreads the north wall of the refectory and meets the adjoining side walls at given right angles without fearing the jolt. This much, at any rate, has always been plain to see. Hence my alarm when I saw it stated by scholars of name

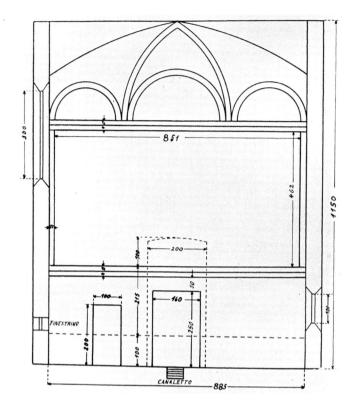

96. Diagram of north wall. Möller 1952, fig. 49.

that the mural came with a framing border (Fig. 96).[4]

A framing border? Why had it eluded me, and where in this world had they found it?

I think I now know the answer. Unfortunately, the solution depends on sharp-focus peripheral vision—one reason why Leonardo's marginal riddle was so long ignored. Moreover, until the early 1980s, the mural's edges and corners showed not a trace of original or posthumous pigment; nothing to draw one's attention.

The situation changed shortly after the recent cleaning and mending got under way. By 1984, the upper corners had received a new, hard-edge definition (Figs. 94, 100). What for lack of visual clues had long seemed unknowable has become overwhelmingly obvious. But let me, for history's sake, revert to our pre-1980 predicament, before the restorers—I think independently, and driven, as I had been, by the logic of the design—arrived at the necessary solution.

To repeat: at the margins and upper corners, the mural no longer showed any articulation whatever. And the early copies were of no help; they shirk, or invent alternative marginalia, probably for good reason. Since the copyists were translating the composition to other places, Leonardo's linkage of the mural to the actual refectory walls was not their concern (see p. 116). Nor do margins and corners distract those who dwell on Leonardo's rendering of the drama.[5] The problem arises only when a sojourner at the site wonders how exactly the depicted scene was meant to connect. Only then does the question intrude.

4. German scholars used to describe the mural as bounded by a continuous strip frame (*die das ganze Bild umrahmende Profilleiste*; Strzygowski 1896, p. 145). A framing border (*Bildrahmen*) is assumed by Hoerth (1907), whose famous diagram (his pl. XII, fig. 13) stops the picture at the edge of the first tapestry, omitting the nearest wall strips. In Möller's pre-World War I reconstruction (published 1952), these strips are interpreted as the supports of a triple arcade that involves the actual vaulting over the mural, replicating Montorfano's *Crucifixion* on the wall opposite. Heydenreich (1958, p. 12) reverts to "the painted border surrounding the picture" (*Rahmenleiste die das Bild umzieht*). Polzer (1980, p. 240 n. 9) rediscovers a "simulated picture

frame which, by its presence, would serve as a barrier between the actual and the pictorial space."

5. Cropped margins are routine mutilation in postcards as well as art books. In Frederick Hartt's *History of Italian Renaissance Art* (1969, pl. 55; 2nd ed. 1979), the double-spread color plate of the *Last Supper* stops the picture at the edges of the first tapestries. In the book's third edition (1987), a new, slightly smaller plate includes the margins but excludes the architrave. Even in the Brambilla/Marani tome (1999), the full-spread color plate of the mural is cropped at the right, denying the picture the refinement of differing margins.

It intruded on me as an intolerable disparity between what I was reading and what I could see. Accordingly, I will try to present the matter chronologically, telling it phase by phase as the experience unfolded—for me and a former student, now a scholar in his own right, whose insights, first at one critical moment, then in the outcome of a six-year inquisition, dispelled the darkest perplexity.

Phase I (c. 1970). You vaguely wonder how the mural defines its four margins. Along the top, where a simulated stone architrave pretends to support the lunettes, the definition seems clear. Since the architrave looms roughly 7 meters above the refectory floor, its underside shows, which is as it should be. But when you try to track that wall-to-wall architrave to its ends—to those upper corners where it meets the refectory walls—the wonder returns. What holds this beam up, and how would the corners have turned?

So then you search the picture's vertical margin (preferably on the right, which is somewhat better preserved). Of course you take this margin to be part of the foreshortened side wall, a wall you assume is all there to see. It is hung with four *millefleur* tapestries that are separated by interstitial wall strips diminishing in perspective. Since a last flitch of wall shows beyond the fourth hanging, you assume that a similar one precedes the first hanging to constitute the fore-edge of the depicted wall coincident with the edge of the picture. This is how the *Cenacolo*'s margins are read in the more faithful sixteenth-century replicas. And this is how they appear in the Raphael Morghen print (Fig. 14), the double-folio engraving of 1800 which, for well over a century, being continually copied and reproduced, displaced the original in most people's imagination (see App. E, no. 48).

Needless to say, the Morghen engraving makes no issue of the outer seams of the original painting. The print was intended for home decoration, for modest religious establishments, or for the cabinets of collectors. How the mural itself collided with vaulting and refectory walls was not the

engraver's business. Concerned only with the internal economy of the composition, the engraving interprets the lateral margin as simply the nearest part of the tapestried wall. (Copies of Morghen's work tend to cancel even this margin and open at the first tapestry.) Since all engraved copies omit the architrave, the upper corners too pose no problem.

But edge and corner nagged at the *Leonardisti* who, during decades of intense Leonardo research beginning around 1880, restudied the mural *in situ*. And some serious researchers declared the picture to be self-framed, whereas my own scrutiny showed no such thing. Yet these scholars must have seen something frame-like, even if none of them spelled it out, thinking, perhaps, that what is marginal should not be encouraged to matter.

Suppose it does matter. Suppose the frame-finders had panned horizontally along the architrave's underside, then turned down the nearest wall strip. That, I thought, might yield two framing elements (Fig. 97). But consider what follows. This near sliver of wall, this strip that had always registered in perspectival recession—should it now register as the membering of a flat frame? One way or another, I decided that the corner joint needed fixing. End of Phase I.

97. Articulation of the upper right corner.

Phase II. Worrying the upper joint of the mural during a plane ride—pencil in hand on the back of the menu—I suddenly realized how cleverly Leonardo had punned in that corner. As his feigned architrave meets the depicted side wall at a right angle seen in perspective, the architrave's underside cannot but terminate in a diagonal—an orthogonal stroke leading inward. And if Leonardo had left the wall bare, or had not allowed the first tapestry to be quite so forward, the corner articulation would have ended up as in our dismal Fig. 98. What Leonardo did do—terminating the architrave's underside in an oblique edge continuous with the tapestry top—becomes eloquently ambiguous (Fig. 99). Now architrave, wall strip, and tapestry corner meet in a common point, and the visual effect of their tryst is to simulate the oblique joint of a rectangular frame. But in fact, the junction here is readable either way: as a flat miter joint, or as the three-dimensional corner of a square-cut recess.

Ambiguity engineered with precision: rather than let the first tapestry start further inward, which would have removed any doubt about the inclination of that nearest wall strip, Leonardo has three distinct features converge in an infinitesimal punctuality that will not relax. The wall strip, hinged like a fin to the mural's outermost margin, swings perspectively inward, and returns to the picture plane—not in alternation, but in the perpetual motion of coincidence.

Such was the evidence taking shape under my pencil as it retrieved Leonardo's solution; and no airline menu was ever eyed with more satisfaction. If Leonardo's corner articulation had been a problem, the diagram on the menu's back was clear proof—the first that seemed utterly incontrovertible—that Leonardo could craft purposeful equivocation. And since the last restoration interprets the upper

98. Upper corner articulation without the wall tapestries.

99. Leonardo's upper corner solution.

corners in the same way (Figs. 94, 100), Leonardo's solution now appears simply given. In former times, when the mural's outskirts were terra incognita, their exploration was a high enterprise. End of Phase II.

Phase III. A classroom at Hunter College, New York, spring 1973, scene of a seminar on Leonardo's *Last Supper*. I had just finished expounding that upper corner when Francis Naumann, then a graduate student specializing in twentieth-century art with focus on Duchamp and Dada, asked: "And what did he do at the bottom?" I replied that I didn't know, and knew of no way to find out, since all original pigment below the table disappeared long ago. And again, the early copies were of no help—none of them tries to rethink, or needs to rethink, how the mural connects with the refectory walls. Leonardo's design for the lower corners seems lost forever, I said.

Whereupon Naumann—taking the first step of that six-year trek—propounded this simple wisdom: "But he must have done something."

Agreed. So I suggested we each ponder whatever treatment we could think of for those lower corners — to be checked out next week.

Next week I came up with, and chalked on the blackboard, three possibilities, one of which included a hypothetical reconstruction of Leonardo's pavement design; but none brilliant enough to illuminate that bottom corner.

Naumann again: "There's a fourth possibility"—and produced an idea never sounded before in the vast literature on the *Last Supper*. Suppose we imagine that nearest vertical margin not as part of the wall, and not as a flat framing member, but as the inward flank of a pier or corner pilaster, a fictive prop for the false architrave to rest on; a most welcome member, seeing that the architrave has no other means of support. The lower corner will then be constituted as the pier's footing seen in perspective (Figs. 51, 101).

A startling idea and a solid structural possibility. Only

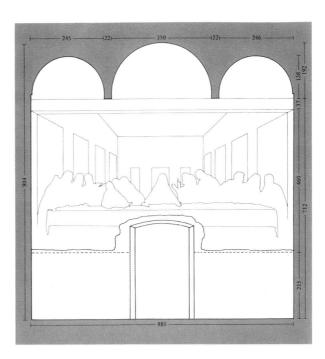

100. Diagram from Brambilla 1984, p. 4.

101. Measured drawing of the north wall of the refectory, with the mural's outer margins as corner piers. Naumann 1979, fig. 23.

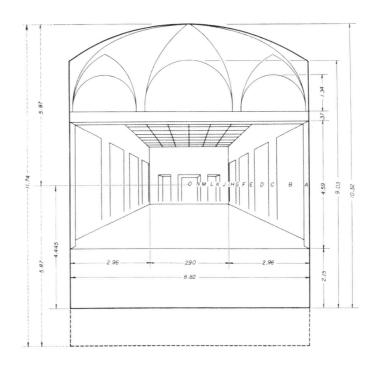

one reservation remained: pictorially, the jagged profile now formed at the lower corner struck me as dissonant. An averted pier lacking a capital and now landing squat on the pavement without base or plinth looked strangely impoverished. But then I glanced at my reconstruction of Leonardo's pavement design, which postulated a transverse band, light on dark ground, lining the length of the threshold. Such a transversal, the proximate feature of a squared pavement design, is common in turn-of-the-century pictures (Figs. 102–104). Combining this transverse band with Naumann's hypothesized pier, we suddenly saw the whole system snap into seeming necessity (Fig. 105).

Now, in a sense, the scene was indeed self-framed all around by a rectangular border: along the crest, the shadowed soffit of the architrave; down the sides, the jambs of supporting corner pilasters; across the bottom, a bright transverse stripe in the floor.

So that's what those earlier scholars had some inkling of when they talked the mural into a frame! And how fitting to find them both off and on target. For each of these marginal members may be read perspectively as a receding plane within the spatial illusion and, at the same time, as a flat border (Fig. 106).[6]

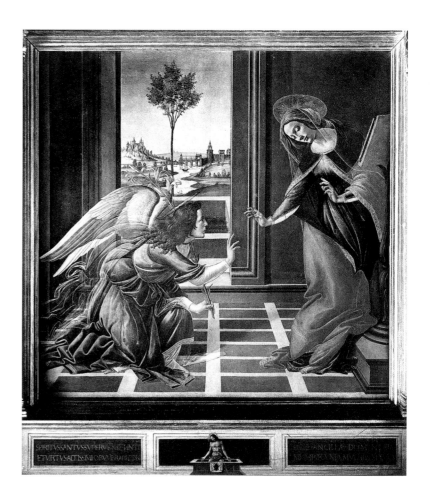

102. Sandro Botticelli, *Annunciation,* 1489–90.

6. The ambiguity of the proximate wall strips was discussed in my 1973 essay on the *Last Supper* (pp. 342–43: "The painter . . . margined his fresco with an optical pun that resists resolution," etc.). This observation has passed into common domain. Martin Kemp's 1981 monograph, addressing the vertical margins alone, summarized with exemplary brevity. The lateral margins, Kemp wrote, function "both as a flat frame and as the perspectively inclined edge of the opening in the refectory's end wall" (1981, p. 196). Recognition that such "punning" permeates Leonardo's pictorial thinking is somewhat slower in coming, but may be coming from Kemp, who continues: "Conceptually, this concealed artifice takes naturalistic painting a stage beyond Masaccio's *Trinity*. Masaccio's . . . logic is inflexible. Leonardo's *Last Supper* looks logical and he relies upon us assuming that it is indeed logical. But it is not. Its apparent reality veils a series of visual paradoxes. This system gave him a crucially greater range of expressive rhythms than is possible within a doctrinaire piece of Albertian perspective."

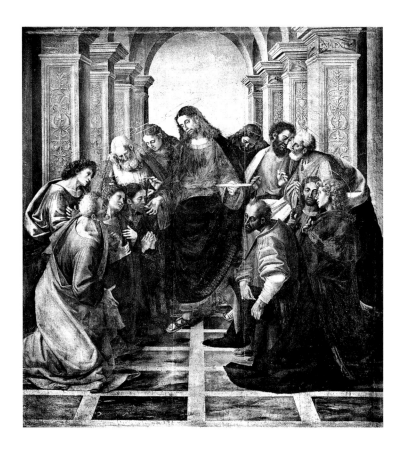

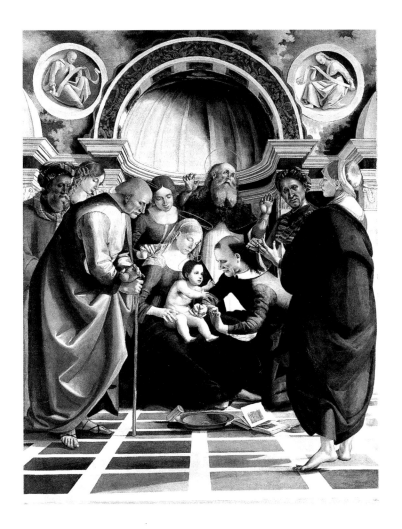

left
103. Luca Signorelli, *Circumcision*, 1491.

right
104. Luca Signorelli, *Communion of the Apostles*, 1512.

105. Hypothetical reconstruction of the interrelation of architrave, corner pier, and pavement design.

106. Reconstruction of the depicted room with projected ceiling and hypothetical corner pier.

107. Mantegna School, *Flagellation*, c. 1470 (?).

A surprising anticipation of Leonardo's transformational margins appears in Mantegna's engraving of the *Flagellation* (Fig. 107). The work is unfinished, the blank right-hand border only sketched in. But the composition articulates at the bottom exactly as in Naumann's proposal for the *Last Supper*: it shows the unadorned flank of an averted pier, whereas the upper right corner in its unfinished state allows this same member the semblance of a flat frame, again as in the *Cenacolo*. It is tempting (though not imperative) to imagine Leonardo in the mid-1490s contemplating this print as a sample of the new reproductive technology. If he laid eyes on it, he would have registered its potential for marginal ambiguity; which the *Cenacolo* complicates further by enlisting both pavement and tapestries to "frame" the design.[7]

Of course, this virtual frame is a mirage. It is a side effect conceded to whoever wants it—a courtesy Leonardo offers traditionalists who would not want a fresco introduced without the customary punctilio. The picture's deep structure, however, remains unaffected, and there is no reason to think that the flat-frame specter ever caused conscious anxiety.

It engaged me for several reasons. First, because it allayed a mildly disquieting quandary (p. 157). Second, because the revealed treatment of edge and corner furnished positive proof of the painter's duplicity—not in a matter of expression or symbolism (where alleged ambiguity might betray diplopia on the interpreter's part)—but in the artist's geometry, his techne at its most razor-sharp. Third, because that riddling "frame" seemed somehow pregnant with promise. And it did prove remarkably fertile: my classroom disquisition on the mural's upper right corner produced lasting results in Naumann's subsequent work.

Setting aside the fiction of a framing surround, we still are left with two readings of the marginal strips. We can read them naively, the way they appear (unless cropped away) in all copies, including the Morghen print, i.e., as continuous with the depicted side walls; or read them sagely according to Naumann, as the flanks of less-than-half-seen piers in the corners. From inside the depicted room, these corner piers would show in full (Fig. 108). End of phase III.

7. Deliberate ambiguity in framing devices may be commoner than we thought. Cf. the gilt embrasure in Vincenzo Foppa's *Madonna del Libro* (Castello Sforzesco, Milan). The flat frame insinuated at the upper corners turns decisively perspectival at bottom. Nor can we tell whether the Virgin's place is within it, before, or behind. Her relation to the surround is marvelously irrational, transcendental.

Phase IV. Naumann's initial insight was acknowledged in the 1973 version of the present book. His progress yielded results which, among other things, exposed two missteps of mine. The errors, though they begin very small, end up cramping the system; they produce a depicted room that cannot contain the sum of its occupants (which Kemp 1981, p. 196, still believed to be the case). Whereas Naumann's correction promotes the room's spread to sufficiency—and from approximation to certainty.

Prior to Naumann, I had concluded (reluctantly and in common with others) that the apparently given width of the room would not allow easy seating at the far ends. It was guesswork, the best one could do. Since the depicted side walls conceal their tracks, the extent of the floor wall-to-wall remains visually indeterminate. As Möller's diagram

(Fig. 8) demonstrates, Leonardo seemed to be fudging—compressing the chamber for dramatic effect, much as he serried the diners with respect to the table. But for admirers of Leonardo's exacting intelligence, the notion that he would draft a perspective unequal to its task of containment is unacceptable; it gives them no peace and keeps them determined to prove that everything in the system interconnects with measurable precision.

Among the things Naumann set himself to discover was the "running track" of the back wall, one of the arcana mentioned above. Exactly where does it fall? On the picture plane it drops out of sight, but how far down? If this is to be a rational structure, not dream-wrought or Escher-built but inhabitable, then the builder must have settled the wall at a specific depth. Where, then, shall we floor it? Suppose we

108. The Grazie refectory imagined from inside the *Last Supper* room.

109. Diagram showing the effect of locating the base of the rear wall too low.

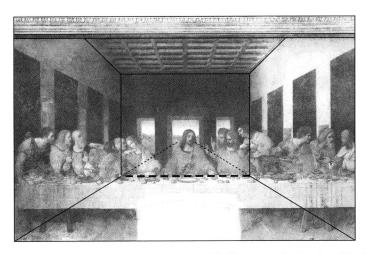

110. Diagram showing the effect of leveling the base of the rear wall with the far edge of the table.

level it with the near edge of the table (Fig. 109). Now draw the rear wall's base out both ways to where it meets the side walls, i.e., to the room's far bottom corners; then, through these corners, trace the orthogonals as they run from the centric point of the perspective (in the right temple of Christ) down to the mural's threshold. Surprise! Christ has just lost two or three of his chosen and the room, a couple of tapestries. We have tracked the side walls where they cannot possibly run; the room has narrowed so as to shut out its marginal inmates. In short, if we drop the base of the rear wall down to this tabletop level—which seems not unreasonable—the consequence is disaster. And the disaster deepens, the wide chamber shrivels, the more the rear wall is lowered.

No one wants such vexation. Let us then raise that invisible wall base a bit, down only to the *far* edge of the table, where it looks and feels right (Fig. 110). Now perform the same operation again, checking out the orthogonals to see if they allow the room enough latitude. Alas, they do not; no way for the outfields to get decent accommodation.

Well, then, how far down does the back wall descend? It cannot hover above the cleavage formed by the arms of

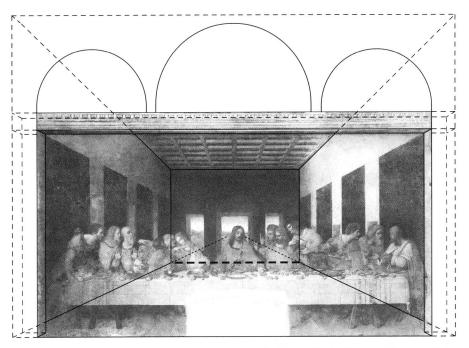

111. Diagram showing the base of the rear wall at its only possible level.

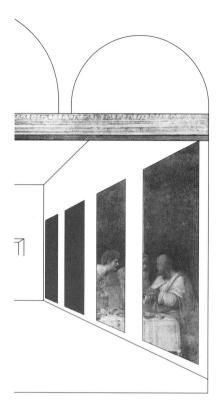

112. The effect of accepting the requisite widening of the room without interpreting the proximate wall strips as the flanks of corner piers.

113. The corner piers oblong in section.

Christ and St. John, for then we would see it. We must posit it somewhere under that cleavage; the question is, how far under, without being gulled by that tabletop. Not much ladder room here; the variable we are seeking is minimal.

My 1973 essay resorted to compromise. To allow the side window an adequate underprop between sill and floor, I suggested lowering the rear wall by "no more than two fingers' breadth" beneath the aforementioned cleavage, but such imprecision won't do. Naumann showed that each minute drop of the rear wall's base causes far-out depredation: drop it a quarter inch, and the side walls close in by the yard, ousting Apostles. To keep the full twelve on board, to keep the room wide enough to contain even their seats, the rear wall's base must be pitched at its highest permissible level—which happens to coincide precisely with the trough of the cleavage and not below by any "two fingers' breadth" (Fig. 111).

But this finding of Naumann's, this requisite grounding of the rear wall, yields a surprising result. If the perspective is assumed to be rational, then the rear wall's base—structurally its only possible base—turns out to effect a widening of the depicted chamber beyond any width previously seen or suspected. The oncoming side walls must now be imagined to spread farther out, spreading unseen behind those marginal strips, which we now rediscover to be the flanks of Naumann's corner pilasters.

Can these be dispensed with? Fig. 112 shows one visual effect of truing the spread of the chamber without at the same time interpreting the nearest wall strips as the flanks of corner piers. In Naumann's proposal, these piers perform a visually logical function by lending support to the fictive stone architrave. Forgo these supporting piers, and the architrave which, in the visible part of the picture, is already too long, keeps stretching on out of sight. The room's upper corners end up deprived; instead of Leonardo's exquisite triple convergence (Fig. 99), an unsightly misfit.

Return now to the picture's vertical margins, conceived during that spring 1973 seminar as solid architectural mem-

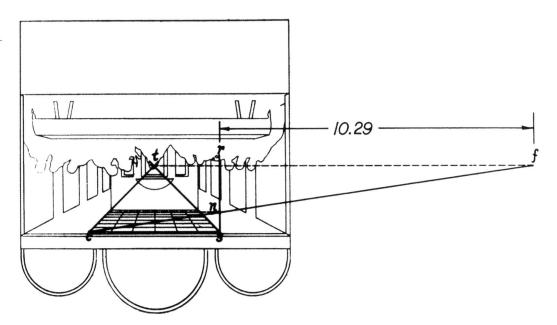

bers. I took these members to be of square section. Proceeding on this assumption, my reconstruction left the room still too tight and the housing of the outermost figures consequently irrational. Naumann's eventual findings acquitted Leonardo of irrationality. In the paper he published in 1979, he proposed that the corner pilaster (of which we see the inner flank only) might be oblong in section (Fig. 113). This allows the trackways of the side walls to stand further out, dilating the depicted room to the width required by the downward reach of the rear wall. The postulate of a corner pilaster of rectangular section—beyond which the tapestried wall keeps running on—gives the depicted room an implicit dimension considerably wider than the refectory. The next question is, how much wider?

Naumann realized early on that exact measurements could be recovered only by mastering Leonardo's own method of perspective construction and by applying it to the ceiling, which, on a diagram turned upside down, presents a calibrated Renaissance floor (Fig. 114; cf. Fig. 135). This squared "pavement," considered according to Leonardo's mode of construction, enabled Naumann to locate the distance (or station) point, i.e., the point from which the perspective was drawn. By projecting the coffers forward in accord with the viewing point that generates the perspective, Naumann found the hidden ceiling's full forward spread, upward and out to its hithermost corners (Fig. 115). Verticals dropped from these newfound corners determined the amplitude of the room, the running tracks of the side walls, and, incidentally, the rectangular section of the corner pilasters, which had been Naumann's first point of entry.[8]

8. Some of Naumann's conclusions had been anticipated by Carlo Pedretti. He too turned a reproduction of the *Cenacolo* upside down to study the ceiling as the perspectival projection of a receding pavement (1973a, p. 39, and fig. 22; based on a lecture delivered in 1970). He too projected the hidden part of the ceiling upward, dropped perpendiculars from its discovered fore- ends, and so established the greater width of the chamber. But working without Naumann's corner pilasters, Pedretti left Leonardo's architrave unsupported and the mural's margins still nondescript. Cf. Fig. 112 and Kemp (1996, p. 189): "The ceiling passes upwards behind the lunettes to an imprecisely defined point." Naumann shows the point defined with precision.

What makes Naumann's reconstruction persuasive is its demonstration of organic interconnectedness. It shows how the visible and the secret cohere; how the inmost, the hidden interior, conditions the outermost; how a single point, such as the junction of John's arm with Christ's, necessitates the lay of floor, walls, and ceiling, the fielding of marginal figures, the relation of the depicted space to the refectory. Such proof of coherence supersedes and outranks any interpretation that parses disconnected details.[9]

Not that Naumann's reconstruction has won universal acceptance.[10] But, though his work faulted me on two points, I welcome his findings, because an opinion (Kemp's, Möller's, or mine) that holds Leonardo's space-figure relation to be irrational must yield to proof of its rationality. It is easy enough to accuse Leonardo's perspective of shorting the outer Apostles. But the charge becomes irresponsible once Naumann's postulates—rectangular corner pilasters and the discoverability of the point of projection—prove the constructed space to be adequate and correct. In Naumann's reconstruction, the perspective of Leonardo's depicted chamber emerges as self-consistent, and the conundrum that had "puzzled generations of scholars" is solved. The solution ensures that the spatial construct of the *Last Supper* is rational after all—so long as we view it from a fixed distance and from opposite the protagonist some 15 feet above ground.

CASE CLOSED? No, not quite yet: because in Leonardo's *Cenacolo* one mystery cleared leads to another. What is most striking, most baffling in the Naumann solution is its eerie unfamiliarity. The order that underlies Leonardo's perspectival construction turns out to be out of this world, counter-intuitive. It will not match what one sees. The ceiling in its full forward projection—once we have mentally stripped it of the cover provided by the lunettes—swells to uncanny enormity. The hithering side walls scud past our peripheral vision; and the shape of the chamber, now confirmed by projective geometry to be a rectangular box, looks more than ever splayed out in front. The closer the system approaches mathematical reason, the more it contradicts what we see.

Was the artist aware of the dichotomy he was laying out? In chapter I of this book, after discussing the betrayal announcement as the moment presented, I argued that even the duration into which this complex "moment" expands is but half of the story told, since, in the picture, the institution of the eucharist is equally honored. It now seems to me that we must recognize the same faculty, the same mind at work in the *Cenacolo*'s perspectival projection. I suggest that the proven rationality of the structure is but half of its nature, and that the artist is accountable for both halves.

9. A classic instance of imposed disconnection is the treatment of the rear wall in Eichholz's monograph (1998, p. 89). The author declares the wall's downward reach to be unascertainable. Its siting at the meeting of the arms of John and Christ is, he writes, "occasionally assumed, e.g., by Naumann." The wording insinuates (*a*) that Naumann on this point is one among many; (*b*) that his leveling of the rear wall's base at that cleavage is an assumption; and (*c*) that the assumption is arbitrary. Here as elsewhere when he disagrees or misunderstands, Eichholz cites a colleague's conclusion without respect to the argument, thereby making the conclusion seem merely capricious.

He calls Naumann's positioning of the rear wall's base uncertain (*keineswegs sicher*), and opines that it "may well reach deeper behind the figures, even below the far edge of the table"—which demonstrates incomprehension of the connections involved. Eichholz (p. 91) believes that Leonardo's structural ambiguities were deliberately contrived to pique our curiosity, lest we get bored.

10. So far as I know, only Carlo Bertelli has understood the necessity of Naumann's rectangular corner pilasters; see his preface to Ludwig H. Heydenreich, *Invito a Leonardo: L'Ultima Cena*, Milan, 1982, p. 11.

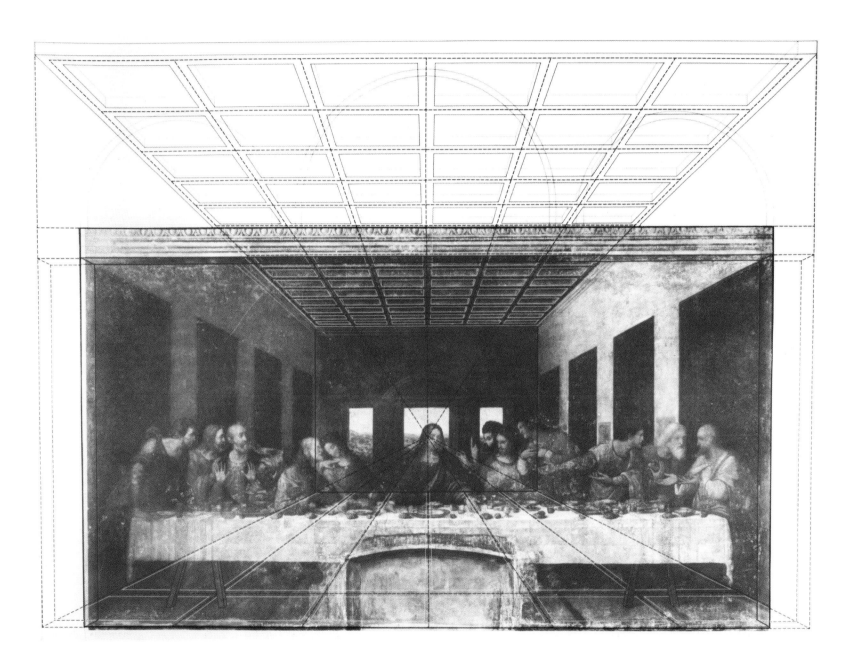

115. Naumann's final reconstruction of
the *Last Supper*. Naumann 1979, fig. 13.

CHAPTER IX

The Sanctification of Space

LEONARDO probably did not read St. Jerome. By his own account, he was thought an "unlettered man," and Latin was not his strong suit. But Jerome was the great culture hero of Renaissance humanists, and Leonardo, painting a penitent St. Jerome in 1481 (Vatican Pinacoteca), would have learned something of the saint's legend, if not of the exegete. Now, fourteen years later, commissioned to paint a *Cenacolo*, our "letterless" painter may have had the good sense to learn more, to hear—perhaps from the erudite Prior Vincenzo Bandello—how Jerome, the "Glorious Doctor," the *maximus doctor*, the very "light of the Church," conceived the place where the Last Supper was celebrated. Following is Jerome's gloss on the Gospel passage (Mark 14:13–15) that describes the meal taken in a "guest-chamber," a "large upper room [*coenaculum*] furnished." Jerome explains: "By upper room is meant the higher way; and by large and furnished is meant the amplitude of the Church." And again: "The large upper room is the great Church in which the name of the Lord is spoken."[1]

Such symbolism is not what we tend to associate with Leonardo, but I would bear it in mind—keep open the possibility that the painter envisioned the housing of the *Last Supper* in the light of its patristic interpretation, i.e., as a simple mess hall in perpetual self-transcendence.

I will proceed indirectly: recall, first, how the picture frustrates any plain reading of its spatial construction; second, how this construction departs from Leonardo's own written precepts; third, how lightly the problems which the picture poses for a thoughtful observer could have been dodged, as they were by Leonardo's less talented colleagues. All of which makes our *Cenacolo* a difficult picture, and its difficulties suggestive of some grave purpose. I am led to the conclusion—originally presented a generation ago, but still widely resisted—that the *Last Supper*'s "large upper room" was crafted to double-function: as homely setting and as mysterium.

116. Leonardo, *Self-Portrait*, c. 1512.

1. St. Jerome as quoted in St. Thomas Aquinas, *Catena aurea in Quatuor Evangelia*, ed. P. Angelici Guarienti, Turin and Rome, 1953, I, p. 541. For the meaning of *coenaculum*, see Charlton T. Lewis and Charles Short, *A Latin Dictionary*, Oxford, 1969: "originally, a dining room, usually in an upper story; hence, an upper story, an upper room."

Horst (1930–34, p. 122) was right to point out that a segment gable over a central window in Italian domestic buildings invariably characterized an upper story.

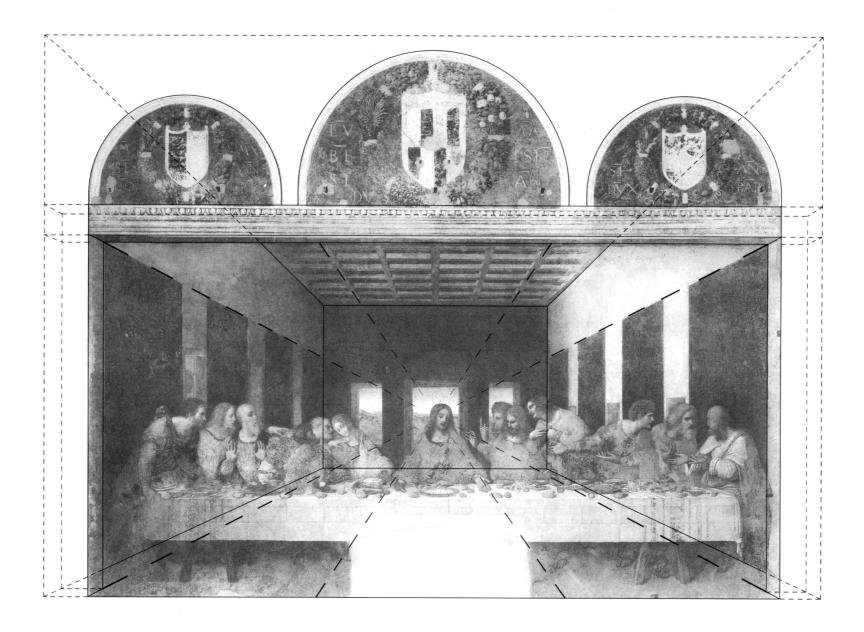

117. The three-dimensional construct of the *Last Supper* and its radiation effect on the picture plane.

Planned Obfuscations

Begin with St. Simon, the baldpate at the far right. His scruff introduces a scrawny man, yet his girth swells enormous, and his mantle—wide enough to upstage the first tapestry—dips deep enough to muffle the room's lower right corner. Unwittingly, Simon makes secret what we feel entitled to know: where the wall touches down and how far out. Meanwhile, at the opposite end, original darkness behind St. Bartholomew muffles exactly as much; crucial clues to the width and shape of the room are suppressed. Such anti-phenomena ensure the elusive character of the chamber. Much of what shows in the picture serves to occlude—overhead no less than at bottom and sides. As the table hides most of the floor, and the tracks of the side walls slip out of sight, so the architrave cuts off the better half of the ceiling. Granted that our nescience is aggravated by the picture's condition, but its ruinous state does not exculpate Leonardo. He made sure that answers to simple queries regarding the room would not spring back as optical data, but would need teasing out.

In the foregoing chapter, we saw the setting of the *Last Supper* rationalized, but with surprising results—learning, for instance, that the baseline of the rear wall must be pegged unexpectedly high, exactly where Christ's arm verges on John's (Figs. 111, 117). This finding was not arrived at by looking, but on the drawing board, plying T square and ruler. Mere looking will posit the wall base at the steadying shelf of the table. This, we now know, is an error—the effect of it is to shrink the room and cashier precious Apostles (p. 165). Yet the error remains visually appealing, especially with respect to the main aperture at the back; for it is only when the drop of that middle light hits the tabletop that it acquires the harmonious proportion of 2:1, the very ratio, 1:2, that governs the format of the whole painted field. So then the middle light, like the rear wall, sports two sets of proportions: one for analysis, another for trustful seeing. Similar double offerings, unsettling what one expects to be stable, flow from all over.

Practice vs. Precept

What exactly is the *perceived* form of the chamber? Sighted from within the refectory—which we know to be a hall of verifiable rectangularity—the depicted space plainly warps into otherness. There is no overlooking the skew where, from any available vantage, Leonardo's side walls jerk away from the abutting refectory walls, swerving inward (Figs. 1, 78, 79). This much is given. Here, for once, all agree. The question before us is whether—here we separate—whether Leonardo noticed this skewage and, having noticed, shrugged it off as unavoidable, thinking, perhaps, that no one would care. Alternatively, whether these marginalia were planned to remain forever inscrutable, compounding that overall "contradiction" which, as Polzer puts it, "eludes explanation." Or, finally, whether the artist devised his aberrant margins with a purpose that is not beyond human ken. This last position is presently held by a very small party—small, but with a potential for growth.

Assume that the artist intended what he produced. In that case, for whatever reason, Leonardo made his projection unstable, flouting a rule he himself had laid down a few years before. Several passages in the *Trattato* acknowledge the awkward truth that a perspectival construction presupposes one motionless viewer, when in fact "viewer" is plural and mostly footloose.

To cope with this nuisance, Leonardo advises painters to study their compositions—and the objects represented within them—from far off and *from every vantage*. No painter of his generation brings more concern to the plight of a well-wrought perspective falsified by peregrine feet. He even offers a remedy: keep any object drawn in perspective at a substantial remove.

> If you want to represent an object near to you which is to have the effect of nature, it is impossible that your perspective should not look wrong, with every false relation and disagreement of proportion that can be imagined in a wretched work, unless the spectator, when he looks at it, has his eye at

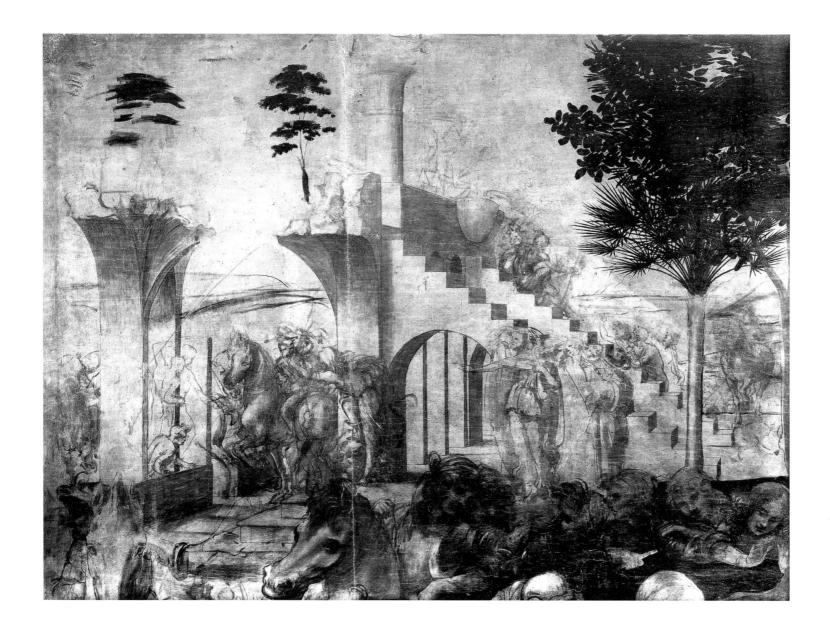

118. Leonardo, *Adoration of the Magi*,
1481–82, detail of background.

119. Maso di Banco, *St. Sylvester and the Dragon,* c. 1335–45.

120. Francesco Botticini, *Feast of Herod and Beheading of the Baptist,* 1484–91.

the very distance and height and direction where the eye or the point of sight was placed in doing this perspective…otherwise do not trouble yourself about it, unless indeed you make your view at least twenty times as far off as the greatest width or height of the objects represented, and this will satisfy any spectator placed anywhere opposite to the picture.[2]

Leonardo is warning his juniors that a viewer's mobility distorts the best-laid perspectives, and that havoc may be avoided only by keeping all perspectival planes at a safe distance.

Well, then, what about that nearest tapestry and its wall coming so touching close? Here, at the margins of the *Last Supper,* Leonardo did "represent an object near to you which

is to have the effect of nature." But instead of warding it off, he keeps it at hand, so that, given the restlessness of the viewer(s), it is "impossible that [the] perspective should not look wrong."

The safe distancing of perspectival planes is what Leonardo's own earlier work had resorted to. In the 1481 *Adoration of the Magi,* the prospect of remote piers, ruined arches, and stairs (Fig. 118) is effectively insulated from the viewer's caprice, and any professional of the day would have recognized this as the right thing to do: don't let perspectival effects come too near, at any rate, not in large frescoes. Was the painter of the *Last Supper* unaware of the risk he was taking?[3]

2. Richter 1883/1970, no. 543; see also nos. 544, 545.

3. For an example of "the right thing to do," see Maso di Banco's fresco *St. Sylvester and the Dragon* at Santa Croce, Florence (Fig. 119), where all planes in perspectival recession are safely distanced. The alternative, e.g., a massive dividing wall in perspective edged up to the picture plane, may appear in predella panels, too small to conflict with actual space, as in Botticini's *Feast of Herod* (Fig. 120). On a monumental scale, such extravaganzas were shunned.

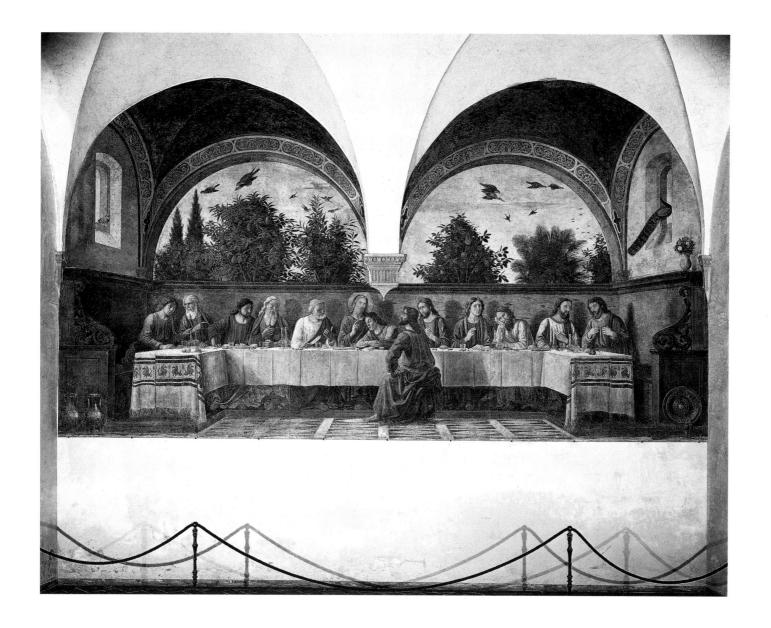

121. Domenico Ghirlandaio, *Last Supper*, 1480, Ognissanti, Florence.

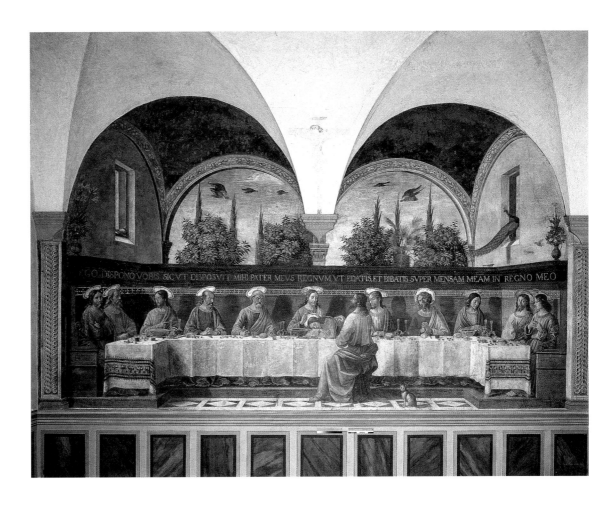

Artful Dodging

Earlier *Cenacolo* painters were good at skirting the predicament the mature Leonardo walks into. Thus Ghirlandaio in the *Last Supper* painted in 1480 for the refectory of the Ognissanti, Florence (Fig. 121). To minimize the collision of real walls with the sides of the loggia he was depicting, Ghirlandaio applied four expedients:

— inward from the pictorial threshold, a generous allowance of floor before the staging begins;
— parallel to the picture plane, outlying buffers designed to postpone the incidence of perspectival recession;

— foreshortened side walls admitted only in radical abbreviation;
— their receding planes accessoried with diverting detail, such as molded cornice, embrasured windows, a peacock, a vase of flowers, cast shadows. The depicted sides still clash with the real walls, but, being brief and fancily trimmed, not too disturbingly.

Ghirlandaio's subsequent rendering of the subject (San Marco, Florence, Fig. 122) adds other ruses. To separate real from virtual space, two outer consoles proper to the refectory's vaulting fuse into simulated pilasters down to the

standing planes that would register in recession, i.e., any plane deep enough to jar with the live perspective of the actual hall.

Arrived in the 1490s, we face at last Montorfano's *Crucifixion* fresco in the refectory of Santa Maria delle Grazie, the work opposite Leonardo's *Last Supper* (Figs. 92, 95). Here Calvary is made to loom through the triple arcade provided by the refectory's vault. The scene is wide and deep and densely peopled. But search fore- or middle ground for upright planes in perspective: the closest candidates are slender, square-sectioned piers displaying their meager flanks— too insubstantial to correlate with the convergence of the refectory walls. Montorfano understood what, by 1490, designers of monumental narrative pictures would have thought obvious: that a fresco at the end of a hall is seen from within that hall's own perspective; that the two systems had better not disagree, lest the painted one show "every false relation…that can be imagined"; that large upstanding planes in wall frescoes are therefore best kept unforeshortened; and that upright planes in recession should be either loaded with incident (Ghirlandaio), or slenderized, or, best of all, dispatched to the hinterland. Not that these artists had read Leonardo's unpublished counsels. They had no need to.

The more astonishing that Leonardo's *Cenacolo* spurns their devices. What common sense would eloign is planted up front; shifty side walls, instead of being prudently briefed, stretch huge in length; and the tapestry decoration, so far from disguising the walls' obliquity, slaps on four panes to confirm it. The result is exactly the situation Leonardo had warned would "*dis*satisfy any spectator." Yet he renounces every safeguard against what he had called "wretched work," as if determined to make his perspective "look wrong."

Writing on the *Cenacolo*, Martin Kemp (1981, p. 199) finds "intuitive adjustments which [Leonardo] made for the sake of required effects—even if these adjustments were

123. Junction of Ghirlandaio's San Marco *Last Supper* with the refectory wall.

threshold; and an inscription in large Roman majuscules runs end to end to override the foreshortening of the sides. For the mobile spectator, it still does not work (Fig. 123), but you can see how Ghirlandaio tried to evade what Leonardo embraced.

Perugino finds further means to insulate his perspective (Fig. 124). He begins by surrounding his *Cenacolo* with a thick ornamental border, behind which bench and table recede. Then, with astute foresight, he rids the picture of up-

124. Pietro Perugino, *Last Supper*
(Il Cenacolo di Foligno), c. 1495.

incompatible with the rules of scientific naturalism which he so loudly proclaimed." With respect to Leonardo's spatial projection, I would put the case differently. The rule he set down for the management of perspective and point of view was meant for beginners. In his own most pondered painting, he leaves regulation behind, transcends it in the pursuit of a goal unique to this situation, this subject.

The effect is indeed catastrophic. Never does the perspectival projection come right in experience. Wherever on the refectory floor a viewer takes up position, the depicted sides defect from the refectory walls. And the mural's bare margins, instead of veiling a regrettable discontinuity, sharpen our awareness of it. We are not to forget just how heteromorphic the two systems are.

WHY WAS THIS DONE? Those naked margins keep forcing the question whether the picture's perspective, *in conjunction with the refectory*, simulates no more than the rectangular structure which we know to have been correctly projected from its fixed altitude. But since the chamber's inward contraction appears more acute than that of the refectory walls, what else is the artist showing? Is it likely that he used the moderate convergence of the refectory walls to dramatize a departure from their rectangularity? Is it conceivable that Leonardo, with the floor-bound viewer in mind, intended that viewer to see the depicted chamber taper into a trapezoid? A rectangular box in perspective, but with loosely hinged sides to imply some concomitant otherness? If such a chimera (in place of that long-cherished

"tectonically clear and unambiguous spatial construction") seems repugnant to reason, so much the worse for reason.

When this unwelcome thought was aired in public more than three decades ago, one colleague asked: if Leonardo's guestchamber is to be registered as non-rectangular, how come it hadn't been noticed before?

Of course it had been—it's too obvious to miss. But as a subversive notion, threatening to unseat the official rectangle, it long remained unacknowledged. What the published record conveys is reluctance gradually giving way over the course of a century. In 1902, Heinrich Pudor argued that the form of the chamber approaches a triangle, with the protagonist projected upon its apex.[4] Max Raphael (1938, p. 90) saw the rear wall in tight constriction relative to the open throw of the sides. Castelfranco described Leonardo's space as a "schematically concentrated perspective" (1965, p. 41). Soon after, Carlo Pedretti diagrammed it as an "accelerated perspective." It is, he wrote, "a perspective suitable for conveying the speed with which the eye plunges to the bottom of a deep space, as if aiming at the exit of a tunnel...."[5] In fact, what I call the trapezoid has been observed (under different names) often enough. And the literature of the 1990s, though still ajangle with disagreement, takes the problematic nature of Leonardo's construction for granted.[6]

The forenamed scholars who openly questioned the rectangularity of the chamber were confessing what they were seeing: a room whose rear gets only one-third of the prospect, while the forward reach of the side walls arrogates

4. Heinrich Pudor, "Das Leonardische Abendmahl," in *Laokoon: Kunsttheoretische Essays*, Leipzig, 1902, p. 128f.

5. Pedretti 1973, pp. 71–72. Ten years later, Pedretti elaborated: "[Leonardo] adopted a kind of 'accelerated perspective' as used in the basreliefs of ciboria and as already adapted by Bramante in his feigned choir of San Satiro…. Attempts have been made to find a point in the refectory from which the four principal orthogonals of the painted space would appear as a continuation of…the refectory. But no matter where one goes, there is no

way to see an all-around correspondence, since this was obviously planned not to be there. So the painted space is inevitably to be perceived as tapering away into the distance, with an extraordinary sense of acceleration… (1983, p. 44).

6. E.g., Monstadt 1995, p. 245: "Not a schematic Quattrocentist box space, but a well-thought-out variegated construction of mutually influential spatial zones and architectural elements." I would not so confidently dismiss that "box space."

125. Leonardo, architectural studies, detail of Fig. 46.

126. Baptistery, Florence, interior view toward altar.

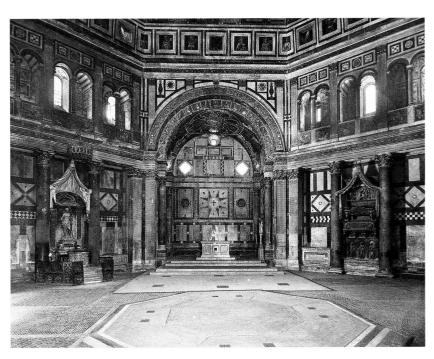

the full spread. But this effect the painter too would have noticed, just as he would have known what Naumann has proved—that the room is a correctly projected rectangle. So my argument amounts only to this: that Leonardo observed the discrepancy between the form as perspectival projection and the same form in visual experience; and that he made this discrepancy tell.

How this discrepancy intrigued Leonardo is, I believe, attested by a famous study sheet preserved at Windsor. Its main feature is a red chalk drawing for the *Last Supper*'s James Major (Fig. 46), but look at the architectural sketches in pen and ink at lower left (Fig. 125): a corner bastion with domed tempietto between walls diverging at 90 degrees. The structure is drawn twice from two distinct exterior viewpoints; then the same structure in plan, showing how the wings abut the turret at a right angle. Finally, in a sketch of the upper portion alone (bottom left), this same pile again, but viewed from within the court, so that the wings appear widely splayed. The draftsman is recording the divergence of the optical from the tectonic, noting the fact that right-angled walls may be visually experienced as a far wider angle. (This final sketch includes two parallel curves starting from the right end. They are not festive swags, but more likely a thought, a mental clamp applied to a perceived dilation, so as to identify this now widened angle as none other than the right angle shown in the plan.) It is this optical instability that elasticizes the far corners of the *Last Supper*'s perspective, wherein presumptive right angles register at 130 degrees. Visually, these corners appear as if they defined the interior angles of an octagonal structure; the chamber's three walls divaricate exactly like any three walls in a regular octagon (such as the Florence Baptistery, Fig. 126). What we don't see in the *Cenacolo*—but must presuppose— is the rectangularity of a chamber with matching ends and parallel sides. For some, only this mental construct is valid. Leonardo, I suggest, wants equal time for the evidence of the eye.

IS THIS NOTION FANTASTICAL? In rudimentary form, it must have been familiar to painters since the Trecento. Consider the oft-repeated image of the entombed Man of Sorrows exhibiting the stigmata (Figs. 102, 127, 128). He stands in an open sarcophagus of ambiguous shape—would you call it trapezoid or right-angled? Some will declare it rectangular, because that's how these stone coffins come. If the painting makes the sides seem oblique, why, that's just a perspectival illusion. Others, responding to what actually shows, find these same sides aligned with Christ's arms and, in this alignment, cooperant in triangulating the figure. While conceding the rectangularity of this as of other standard sarcophagi, they see the trapezoid form it takes in this picture as pictorially structural. Both forms coexist without displacing each other. And so they do in Leonardo's *Cenacolo*—on a scale vastly expanded and more three-dimensionally complex.

Perhaps we respond to the challenge of such coexistence according to temperament, or to satisfy our sense of what objective art history should admit. Some protest that two diverse readings of a room's shape cannot both be correct. Therefore, our duped intuition of a wedge-shaped chamber must be repressed. Such argument would be persuasive if the room in question were (*a*) real rather than visionary; (*b*) if there were no adjoining hall to contrast with; and (*c*) if the space represented were merely diagrammed, uninhabited, so that the effect of the perspectival projection would owe nothing to the presence of Christ. Since none of these conditions applies, I still see Leonardo's rectangular chamber contextualized into double function.[7]

127. Niccolò di Tommaso, *Man of Sorrows*, c. 1360–70.

128. Antonio and Bartolomeo Vivarini, *Man of Sorrows*, 1451.

Contextualized in What Ways?

First, by collocation with the refectory. Leonardo knew that his tapestried walls would sway and tack with the viewer's motion, and that the tack amplifies with the depth of the planes. Yet he deepened the chamber—needlessly in the judgment of copyists and adapters—so that the awkward jolts at the joints are intensified. No depicted interior in monumental Renaissance painting is so prone to distortion as one shuffles about.

But consider what it is that is being distorted: only the ideated rectangularity of the chamber—the form presumed to appear when seen from a still, perfectly centered vantage point 4.5 meters up in the air and exactly 10.29 meters away from the picture; only this goes awry. But let the depicted walls break at any angle soever against the refectory walls, their fickle paths maintain a morphological constancy: constant through all fluctuations is their conformity with the radial gesture of Christ. The wide flare which the depicted room, by way of the six inner Apostles, takes from Christ's open arms never ceases to magnify what these arms set in motion. Despite the waywardness at the hinges, the walls' apparent expansion in correspondence with Christ remains immune to distortion, and this is a special gift: a deep, one-point perspective that transmits a steadfast message to every point in the hall.

Assuming that the effect was foreseen and intended, Leonardo will not, after all, have ignored his own admonition to examine a painted perspective from every possible station; and that notorious break at the junction of real and fictive sides becomes purposeful. Leonardo will have structured a space whose man-made regularity appears ever changeable, but whose congruence with Christ's action (like the congruence of the sarcophagus sides in the above *Man of Sorrows*) persists. While the perspective of the rectangle fluctuates, the walls follow their steady Christ-given course—as unparallel to each other as the flare of Christ's arms.

If this alternative figuration fails to match the convergence of the refectory walls, it does not follow that we no longer receive it as an extension of real space. What we see is an extension of differing shape, a shape imparted by Christ. And if this congruence with the protagonist's gesture is willed, so must be those breaks at the margins. They surely serve to endow the depicted space with a specific optical character—continuous with, yet divergent from the refectory space. The refectory itself is measurably a normal rectangle; the virtual space of the picture is a perfect rectangular construct driven toward triangularity, *but driven to it as to another perfection*.

To see both conditions in "conjoint presence" requires synoptic vision, a way of seeing that includes our room in front of the picture and the picture itself inclusive of actors and ambience. Leonardo's spatial invention withholds its secret if one extracts from it preferentially—pares the perspectival rectangle down to a diagram without intervention of figures, or thinks of it as a stage set used by an itinerant troupe. To imagine these premises cleared—emptied of table and company the better to take the room's measure—this is not what the image demands. The *Cenacolo* is a unitive moment: in one viewing, a neat geometric contrivance, in another—received simultaneously—a theophany unfolding in a complicit space whose articulations proceed from the center like rays from a luminous body (Fig. 117). This much is, for me, both a conclusion and a continually renewed first impression.

7. My plea for the recognition of the trapezoid has been occasionally misunderstood, as if I argued that Leonardo had represented a room actually built with convergent sides. Thus in Joseph Polzer's attempt to refute (1980, p. 244): "The painted room was intended by Leonardo to be precisely what it seems to be: rectilinear [*sic*, but he must mean *rectangular*], with square coffering on the ceiling. This corresponds to the rectilinear grid so often applied in the perspectival construction of floors in Renaissance paintings. Transposed on the ceiling, Leonardo used the grid to clarify the space of his room."

Polzer's assertion that the depicted room "seems to be" rectilinear (i.e., rectangular) baffles me. So it may be *understood*, the way converging railroad tracks are understood to run parallel. But *seeing* applies to perception.

Selective Attention

Inevitably, a picture of such innate complexity invites specialized studies. No one can seriously examine, say, Leonardo's color, or delineation of character, or application of mathematics, or the dictates of his patron, without (for the nonce) putting the rest on hold. Accordingly, the historic reception of the work is a record of shuttling attention. Many sixteenth-century copyists pluck the figures from the perspectival construction, sloughing as a disposable husk almost four-fifths of the composition. Writers such as Bossi and Goethe find it expedient to suppress the picture's theology—they wish to dwell undisturbed on its rendering of emotion. Art historians commandeer previously painted *Last Suppers* in order to isolate innovations. Perspectivists screen out the narrative so as to focus on the painter's projective geometry, while cartoonists and entertainers select for satire and merriment. At this writing, the media concentrate on condition problems, all else in this bromide being too stale to make news. Given the various goals people have, these practices are inevitable and legitimate— yielding an abundant mixed crop. The picture holds matter enough to dole out to all comers, more than enough to satisfy bards, comics, and specialists; or to humor latter-day appropriation art. But since Leonardo's *Cenacolo* is the creation of an *uomo universale*, it deserves periodic attempts at reintegration.

Trying to see the work in its integrity, I find the shape of the *Last Supper*'s guestchamber doubly engendered: by geometry and by the gesture of Christ. As an inert projection, the room is a walled-in rectangle diminishing in perspective. As the visual propagation of an impulse emanating from Christ, this same room forms an open trapezoid in perpetual expansion. Not one or the other, but both. Both forms in co-presence, addressed to co-present faculties of the soul. To doubt the rectangle is unreasonable; to deny the trapezoid, unseeing.

129. Facade of Santa Maria delle Grazie, 1490s.

The Necessity of the Trapezoid

To one who is literate in perspective, the suggestion that Leonardo's guestchamber is anything but rectangular comes as an affront—as if one didn't know how to read. The trained eye interprets the waning width of the room as an illusion—not what is "really there." If the side walls seem bent on closing in behind Christ, our educated intelligence knows that such mere appearance (like that misleading convergence of railroad tracks) must be discounted.

But Leonardo's scheme will not have it discounted, for the appearance of rearward contraction is confirmed over and over by means other than perspectival. I list five of these means.

First, signaling by arithmetic. *Like the facade of the adjoining church* (Fig. 129), the foreground plane of the mural articulates into Five—four groups attending the quintessence at center. Behind this quinsome arrangement, reaching rearward, comes the fourfold membering of the side walls; finally, the fenestration. We are shown instant decrescence: from five through four and arriving at three, the trilight at the rear. Alternatively, tracking from back to front, the room expands from tripartition, by way of

quadripartitioning tapestries, to a quintuple front. Thus the proximate and the distal plane disagree even as five is perceived to be greater than three. Innocent looking receives the blessing of number.

Second: architecturally speaking, the room's rectangularity is refuted by its implausibility as an actual building. Consider the openings at the back. The combined clearance of the three windows (if that's what they are) reduces the back wall to a skeletal structure, and the remnants between the windows to "slender piers."[8] Such radical perforation can hardly be taken literally as a feature of fifteenth-century building. We accept it visually on the scale of that shrinking rear wall, but don't ever try to project its fenestration upon the frontal plane of the chamber, i.e., the north wall of the refectory. Visualize the three windows up front, and the extravagance of their proportions leaps to the eye. The gabled centerpiece alone would spread as wide as the middle lunette overhead, half as wide again as the gross Baroque doorway rammed through the wall in 1652 (cf. Fig. 96). These metric anomalies confirm our intuition. Though Leonardo's spatial illusion can be rationalized into rectangularity, the room as we see it does not yield a credible fabric unless narrowed toward the rear.

A third observation (too subjective, perhaps, to score in the present context) concerns the far-flung interdependence of floor and ceiling; they complement one another. While the ceiling emerges only from behind the lunettes—belatedly, as it were, and not until well diminished—the floor (before its ruin) displayed only its broadest forward extension. This differentiation of decks helps mold the perceived shape of the room. Since the ceiling shows no forward expansion and the floor no backward contraction; since the near and the far, contrasted as wide against narrow, dissociate so abruptly, our reasoned assumption of equivalent fore and aft is frustrated. We are further encouraged to look in as from the open end of a funnel.

Fourth: hitherto we have accepted the fictive three-dimensionality of Leonardo's construction, as if we were facing a set you could walk through from table to windows. But Leonardo's illusionism can be elastic to the point of being collapsible—as when the gable over the distant midlight (effaced in the recent cleansing) mounts an incipient nimbus for the protagonist. Throughout the picture, no matter where things are emplaced, they keep haunting the picture plane. This twin competence of all data—in perspective and on the flat—gives the trapezoid factor in the design a role more significant than any considered so far.

Look at Fig. 130, which I take from a classic paper published in 1971 by Thomas Brachert.[9] It shows the *Last Supper* squared up, overlaid by a grid. Brachert found the whole fresco surface governed by a square module—the picture is six squares high by twelve across—and found the module established by the width of the ceiling coffers where they first come into view (a width equal to the length of Matthew's right arm, or *braccio*). Across the top of the picture, the coffering marks off six modular squares, the narrow end of the ceiling tallies exactly four, while the total acreage of the ceiling, stamped on the picture plane, fills precisely five squares

8. Horst (1930–34, p. 126) calls the wall sections between the windows *sottili pilastri murali*. That Leonardo's wall-window ratio could irk is proved by sixteenth-century copies (e.g., Figs. 27, 142), where the windows are narrowed to solidify the end wall.

9. Brachert 1971. Brachert's insights are of permanent value. But in trying to see almost everything in the picture "subjected to the quadrature" of the field, the author may be overstating his case, as when he finds the centric point misplaced, "probably due to artistic license" (p. 465). More probable that Leonardo employed coincident systems, as in the case of the tapestries, where Brachert identifies two proportionate systems overlapping. So in the overall design, some crucial landmarks follow the surface grid, others, an alternative armature. One system orders deep space, another the picture plane, and the two interweave. Hence the alignment of Christ's arms with features of floor and ceiling; the positioning of the gable to orbit the (misplaced?) centric point; the coincidence of James' arms and of Judas' elbow with the diagonals defined by the tapestry tops, etc. In short, the composition respects both the modular squaring and the perspective convergence.

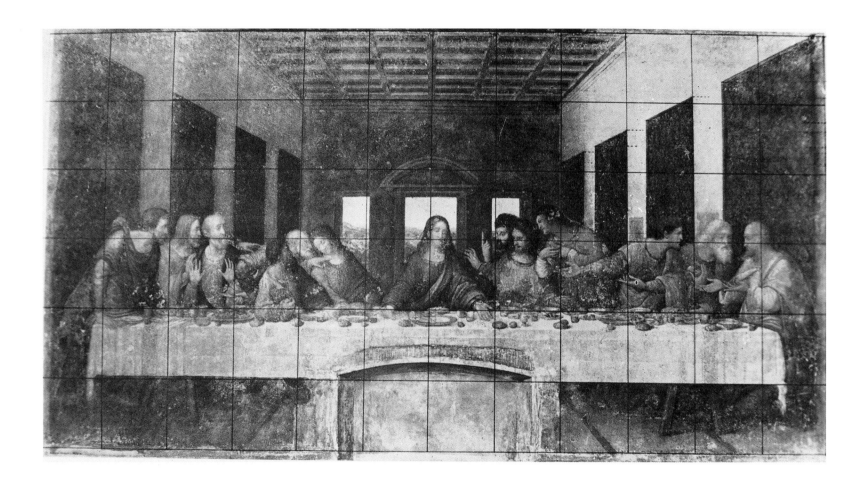

130. The *Last Supper* with modular
grid. Brachert 1971, fig. 1.

131. Diagram with abstraction of trapezoids.

(including the two at the outer ends diagonally bisected).

Contemplating Leonardo's design through Brachert's grid, one is amazed to discover that the backward march of the ceiling gains no more surface terrain than one modular unit. One sees it, consents perforce, and remains naively incredulous that a patch so small could attain quite so far. This is the kind of foreshortening Renaissance writers continually marveled at, and it looks marvelous still: profound verisimilitude—the compelling illusion of accelerating departure—sits within rigid coordinates to map a plane figure. The trapeze of the ceiling, whose six topmost coffers define the quadrature of the overall field, this circumscribed pale steadies, clarifies, and sustains the sense of a tapering chamber, a space gathered under the sign of a trapezoid.

Why under this sign and not another? Is it because perspective will have it so? Yes, and for the equally valid reason that both floor plan and ceiling conform to the shaping gesture of Christ (Fig. 131). As shown in chapter VII (p. 148), the "plan" of the protagonist's action from frontal shoulders to reach of hands traces a trapezoid, the very figure that defines as well the elevation. There is no inconsistency in seeing Christ's upper body triangulated from base to crown, and seeing, at the same time, the mastaba shape set forth by the red and blue of his dress. The shaped couple-color of Christ's tunic and mantle accords with the stereometry of his gesture. Local color and action in depth conspire in this primary emblem to prefigure the trapezoid overhead and the apparent plan of the chamber.

LET ME REITERATE what the present argument tries to do. We are not urged to imagine an edifice built on a non-rectangular plan. This *cenaculum* never was built. It was projected as sheer appearance, and I am counting the ways in which Leonardo empowered the trapezoid character of this appearance. Four of these ways have been listed. I proceed to one which is surely the subtlest, the hiddenest, the most difficult to articulate, or to accept. It needs a rubric of its own.

Fifth: Tapestries Versus Walls—
"O sides, you are too tough" (*King Lear*, II, iv, 200)

Naumann's reconstruction of Leonardo's scheme admits a single irregularity, one inconsistency in the perspectival construction (which Brachert too had observed; see Hüttel 1994, p. 119). It concerns the tapestries, whose continuity smooths over the discontinuity of floor and ceiling: four hangings in series along each side wall. But Naumann's careful replay of Leonardo's projection (Fig. 132) reveals that the tapestry series is not quite what it seems. To simulate orderly diminution at a rate satisfactory to the eye, Leonardo had to imagine these hangings as neither constant in width nor evenly separated. "The tapestries," Naumann writes, "get wider . . . as they progress towards the rear of the chamber" (1979, p. 84). Had the tapestries diminished in depth at the same rate as the ceiling coffers—i.e., at the pace required by the projection—there would have been five on each wall, with a very pinched one nearest the windows. Yet Leonardo made do with just four, contrary to his system. This poses a problem; an anomaly within the master's perspectival projection is no trivial tort.

Naumann's diagram traces the room's wall elevation and plan in their proper dimensions, as they would appear

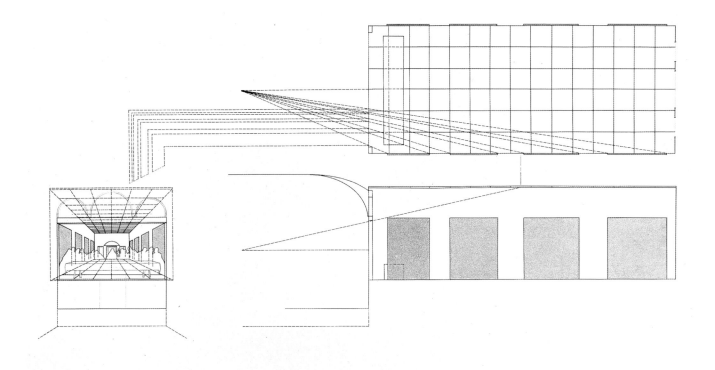

before perspectival distortion. The measurements show that the depicted chamber was conceived as potentially buildable, the tectonic structure and its projection in mutual fit—except for that single misfit. Though the painting renders the chamber correctly from a fixed distance point, the tapestries—which *seem* to define the side walls as the coffers define the ceiling—do not diminish at the requisite rate. Their diminution is slowed, so that their number per wall stops at four. Why did the painter wrongly accommodate this lesser count, as if he imagined the tapestries growing progressively broader and spaced ever wider apart?

Various answers suggest themselves. One is to deny the conclusion it took Naumann six years to reach. But until his work is done over to produce a responsible refutation, denial is without merit.

An alternative answer, accepting the evidence of Fig. 132, is to argue that unequal wall hangings hung at widening intervals were indeed what Leonardo envisioned; which would acquit the perspective of self-contradiction. But Renaissance wall decoration knows no such system, and it is counter-intuitive; not the impression conveyed.

Well, then, why not accept the suggestion that the whole schema presents a false, forced, or "accelerated" perspective? Suppose Leonardo depicting not a rectangular room, but something like a perspectival stage set, such as Palladio's Teatro Olimpico, or like Bramante's false apse at San Satiro in Milan. But then the painter would be taking a circuitous route to imitate illusionistic effects which themselves imitate painting. More to the point, the suggestion ignores the incontrovertible proof that Leonardo's one-point perspective—except for the sizing and spacing of those rebel hangings—is accurate.

132. Plan and elevation of the illusionistic chamber of the *Last Supper* with projection of the tapestries from the distance point. Naumann 1979, fig. 14.

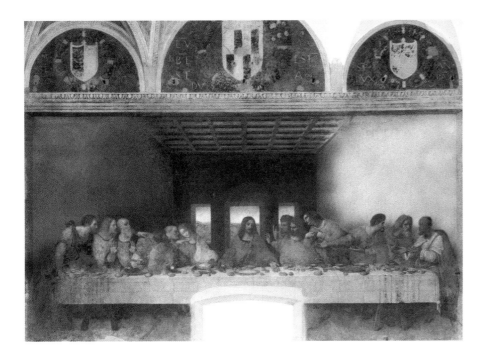

133. The *Last Supper* imagined without wall articulation.

Another approach is to apply Martin Kemp's general comment on the *Cenacolo* (p. 178 above)—that Leonardo made "intuitive adjustments," even at the cost of his own "rules of scientific naturalism." With such license in mind, one might propose that the painter simply preferred the look of four hangings on the side walls. As executed, the last of them leads in smooth transition to the rear windows, which a diminished fifth tapestry, thin as a rail, would not have done. Leonardo, then, would be faking for pictorial effect. This is a comforting fallback position, but unpleasing to admirers of the master's mathematical bent.

Try yet another approach: since the problem arises from the fact that the sides of this projected rectangular room should accommodate five equal-width (though backshortened) tapestries, whereas they show only four; and since four is the number that slots best between five and three, i.e., between the quintuple front and the trinal rear wall (see p. 184), could this arithmetical fit have been motive enough to overrule the consistency of the perspective? Perhaps; the 5–4–3 sequence is elegantly engaging. But it could not have been the main reason for marring an otherwise flawless geometry. No one will rush to ascribe such inverted priorities to Leonardo.

There is one more course to consider. Begin by admitting that the apparent slant of the walls depends crucially on the evidence of the tapestries. Had these been omitted (Fig. 133), not a soul would have taken the side walls to run on parallel tracks. It is the sprint of the tapestries that angles the walls, with each additional relay deepening the apparent recession, confirming the parallelism of the side walls, i.e., the rectangularity of the room; while every subtraction makes the space seem that much shallower, that much more trapezoid.

Suppose now that the painter had deployed the tapestries in the correct number of five: the room would have seemed longer, more plainly rectangular. By reducing the

Naumann (1979, p. 84) had glossed the progressive widening of the tapestries—or rather, their inadequate narrowing in recession—as follows: "it tends to 'slow down' the viewer's illusion of depth. The 'decelerated perspective' creates the illusion of a . . . shallower architectural space."

This is interesting. If the tapestries are given in "decelerated perspective," while the projection of floor, table, and ceiling is sound, could it be that here two distinct perspectival projections are interlinked, one for things that recede horizontally (floor, ceiling, and tabletop), another for the recession of upstanding planes? We would be getting a hybrid system, warp and woof in miscegenation, a fast-diminishing view on the chamber's longitudinal axis, a slowed-down perspective on the cross axis.[10] But no comparable instance of such 3-D cross-weaving exists, and nothing in Leonardo's recorded brooding comes close.

10. A similar intuition, though without Naumann's elegant proof, occurs in Max Raphael's 1938 essay (published 1989, pp. 89 and 108–09).

hangings to four, Leonardo intimates (visually!) that the walls are too short to enclose a rectangular space. As he ordered the tapestries, these insufficient four suggest that the side walls meet the rear wall not at 90 degrees, but at an obtuse angle of 130 degrees, the way the shorter walls of an octagon meet; which is exactly what we are given to see. The mutual relation of walls in the *Cenacolo* is made to look like the meeting of octagon-forming walls (as shown in Fig. 126). What follows? That the depicted chamber— discounting the hangings for the first half of this sentence— projects a proper rectangular room, with all orthogonals, *including the gradient of the tapestry sequence*, in consistent convergence on the vanishing point; but that Leonardo had then reduced the tapestries from five to four, as if the side walls, too short for the full count of five, inclined like the sides of an octagon. The walls—the walls themselves— are correctly projected; what contradicts is their surface articulation.

The result is to simulate once again a trapezoid space. But note that this simulation implicates no *structural* feature, such as coffers, which are constitutive of a ceiling. The in-

consistency is not incorporated; it derives entirely from these movable hangings, each one ring-hung from small hooks punctiliously rendered (Fig. 134), as if to insist that the anomaly in the perspective resides only in detachable items. It is the reduced count of the hangings that am-biguates the wall's inclination and sustains the visionary al-ternative to the rectangular plan.[11]

Thus the projection of the rectangular chamber—side walls (sans hangings) included—remains theoretically self-consistent. And since no one sees this perspective from the high station point of its projection—which would require five tapestries on each wall—no one com-plains that we are two tapestries short. If the sum of them has been docked 20 percent, the effect merely corrobo-rates what the beholder on the refectory floor has seen all along. The tapestry deficit on the side walls confirms that the housing of the *Last Supper* is receivable as other than the theoretic rectangle.

So much for my fifth proposition. It seeks to explain what the errant perspective of the tapestries actually brings about—though it seems regrettably intricate. Yet the ex-planation agrees with the data. It accords with the general argument that almost everything in this picture is pro-grammed to double-function. And it supports the conclu-sion that the appearance of this spatial construct as both so and not so, non-rectangular yet rectangular, was willed, and willed to us by Leonardo.

Run-Through
Let me sum up the case for the trapezoid. Few scholars question—and since Naumann's reprise of Leonardo's pro-cedure no one may doubt—that the *Last Supper*'s chamber is in one sense rectangular. Our problem is its alterity, the

11. The little hooks from which the tapestries hang appear in only one of the early copies (Fig. 154). By the end of the eighteenth century, they must have been overpainted. But they have resurfaced in the original mural (see Bram-

billa/Marani 1999, plates on pp. 241, 323, 338–39, 361). Bossi's copy (Fig. 26; copied in turn in the Vienna mosaic, Fig. 185) misrepresented the tapestries as sunken panels, masoned into the wall.

134. Leonardo, *Last Supper*, detail of tapestry hooks revealed on the right wall by the latest cleaning.

artist's insistence that the chamber be recognized as simultaneously trapeziform. We have seen this insistence take various forms, and I recapitulate.

— Viewed from the refectory floor, the walls of the depicted chamber close in, wrenching away from the parallel walls of the actual hall.

— Architecturally, the "skeletal" system of the rear wall denotes a contracted span.

— Arithmetically, as five exceeds three, so the articulation of the frontal plane exceeds that of the rear.

— In a boxlike interior, allowing for perspectival distortion, front and rear should seem to match. The *Cenacolo*'s sides dilate as they hither, as if the table prized them apart.

— Disparity between fore and aft is accentuated by the abrupt wide/narrow contrast of floor and ceiling.

— The tapestry shortage implies shorter walls coming in at an obtuse angle.

— The manifest trapezoid of the chamber is exemplified in the surface shape of the ceiling, epitomized in the figure of Christ, and confirmed by the visual congruence of the splayed walls with the "ground plan" of Christ's gesture.

For all the care Leonardo lavished on the projection of the rectangular chamber, he bestowed no less on its other nature, planting clue after clue lest we discount what we see.

Given these many signals, it seems ungracious to dismiss the apparent cuneiform of the chamber as the mere side effect of perspective. Though we infer the rectangle from the projection, in the picture as visual datum the trapezoid dominates in the shaped boundary of the ceiling, the felt expanse of the floor, the elevation of side walls and tapestries, the plan of the central corpus. If, as Panofsky remarked, the invention of focused perspective is the most characteristic attainment of the Renaissance, then the trapezoid—the form produced wherever orthogonals intersect

with transversals—is the most characteristic figure in fifteenth-century painting (Fig. 135). For the Quattrocento painter projecting ruled one-point perspectives as the order of space, the trapezoid is, daedally speaking, the ineluctable modality of the visible. In the *Last Supper*, it comes as the giver's gift, the sign that reconciles the phenomenal to its cause.

135. Leonardo, perspectival construction showing the determination of any point on a plane, c. 1492.

Reenter Jerome

One final suggestion, reverting to the opening of this chapter. Seen *in situ*, Leonardo's perspective shows the rudiments of an architectural figure whose closest analogy is with a familiar ecclesiastical model, the polygonal apse rising on a trapezoid plan. Regardless of where in the refectory he was seated, the monastic observer would have seen his longitudinal hall culminate in a virtual space whose apparent plan frames a sacrament.

Is this association, which St. Jerome would have welcomed, imputable to the artist?

The polygonal apse (or the polygonal chapel containing a mensa) was a common feature of late Gothic churches. Leonardo knew it well from such structures as the Cathedral of Florence. While in Milan, he drew the plan of the Duomo, a building whose exterior east end is a powerful statement of the trapezoid as the apsidal form. Santa Maria delle Grazie itself, before the building of Bramante's tribuna, climaxed in a polygonal apse.[12]

The *Cenacolo* does not, of course, imitate apses in their internal aspect. All it does is plot their foundation, foreshadow the paths of their walls. Leonardo's guestchamber looks no more like an apse than this Christ looks like a priest, the bread at his fingertips like a wafer, the glass in front of St. John like a chalice, or the table itself like an altar. But at this moment, the Church is yet to be founded, or rather, is being founded in the hallowing of these staples. Throughout the painting, the familiar converts to the sacramental—as we saw even some of the gestures do. Think of the eager hands of Philip, Thaddeus, and Simon, gesticulant under the sway of emotion and, coincidentally, finding ritual forms of eucharistic reception (pp. 79–85). Think of Christ's gesture, the full burden of it; or of Thomas' finger,

interpretable as wagged in warning, but contextualized into assurance of resurrection. Each of these gestures, members, and objects participates both in the narrative and in transfiguration. And just as two lowly floor stripes may be suddenly graced by falling in line with the Giver's arms (p. 58), so the profane, flat-roofed chamber, shaping itself to Christ's gesture, prefigures a sanctum. Perspective becomes narrative symbolism, becomes choreography, iconography, homily, riddle, and mystery. The point is that Leonardo's projective geometry undergoes irresistible sublimation.

That Leonardo intends a participant space seems to me undeniable. What may fairly be doubted is the meaning of it, or the need for a meaning. Why, asks the *advocatus diaboli*, why drag in the polygonal apse? May not the apparent relatedness of the perspective answer a craving for consonance, satisfying Leonardo's demand for "harmonic total effect"? Granted that his architectural setting collaborates with the action; granted even that the feigned trapezoid of the chamber is Christ-induced. We may still question whether this shape need be interpreted as allusively ecclesiastic.

Rightly, the devil's advocate argues that the place does not look like a chapel, that a refectory annex has no business insinuating an apse, and that monks at mealtime are not taking Communion. As one scholar put it when my suggestion was young: "It simply does not make sense iconographically to presume that . . . Leonardo would have placed his *Last Supper*, with its intense exploration of human drama, within a sanctuary" (Polzer 1980, p. 246 n. 12).

To my knowledge, the first scholar to welcome the notion that the trapezoid space we actually see in the picture might intimate a polygonal apse was Carlo Bertelli; *quasi l'effetto d'un abside*, he wrote.[13] It was Bertelli, too, who pointed me to the quotations at the head of this chapter—

12. Leonardo drew the Milan Duomo plan on fol. 55v of Codex Forster III, Victoria and Albert Museum, London. For the originally polygonal apse of

Santa Maria delle Grazie before it gave way to Bramante's tribuna, see Bruschi in Dell'Acqua 1983, p. 36, fig. 18.

St. Jerome's gloss on the Evangelist's "upper room," explained as "the amplitude of the Church." This lift to an upper floor only Leonardo respected, but he did more. To sharpen the ecclesiastic allusion, he lined the side walls of the chamber with eight *millefleur* hangings (eight perhaps for the Resurrection, the Day of the Lord.)[14] Such tapestries, common in Western Europe throughout the fifteenth century, were traditionally taken to symbolize Paradise—in Christian context, the sanctuary of the Church. In a study of the paradisal symbolism of *millefleur* tapestries, Florens Deuchler describes these implied paradise gardens as "the presentment [*dieVergegenwärtigung*] of Ecclesia," quoting supporting texts wherein "the Church is likened to Paradise."[15]

Thus the foreshadowings of Ecclesia in the *Cenacolo* multiply. They are there in the upper-floor staging as glossed by Jerome, in the apse-like path of the walls, the wall hangings, the triune fenestration, and in what no one can fail to see: that the foreground is taken up by a dining table which even now becomes the first Christian altar. Domestic on the narrative level, the table is, like the protagonist, twofold in nature. Duality here is not polarized; it is neither successive nor oscillant, but coincident. And so, too, the very chamber grows sacramental. Its double nature is thoroughgoing, engaging walls, windows, and ceiling no less than the mensa.

OR SO IT APPEARED TO ME near three decades ago when the initial version of the present essay was published. It still seems a good hunch, though obviously beyond proof. Whether or not Leonardo had the polygonal apse in mind when he guided those walls is unknowable. What we do know, because we are given to see it, is the shared reflexivity of actors and ambience. It is not the disciples alone who respond. Every orthogonal in the picture trues inward and heads out from the center—converges and emanates. *Dal centro al cerchio, e sì dal cerchio al centro* (Dante, *Paradiso*, XIV, 1). Christ himself, though in full foreground, appears nearly nimbed from afar, present at table and at an unvanishing point of convergence. Move in on the midmost of the perspective, and you are at the magnet and font of all energy, psychic, somatic, and geometric—from here and to here.

This restless synergy matches the duplexity of the subject. Of course, the *Cenacolo* represents the announcement of the betrayal, the foreshow of imminent martyrdom, Christ signing the debt of his mortal nature. But in the collapsing duration which this picture is, the subject is as fully the grant of his sacramental body. The disciples, every one of them preordained, respond in accord with their natures, their faith, their forthcoming Communion, and the apostolate they inherit. All this unfolds in a chamber whose plan the disciples would (if they cared) find as squarely normal as we do the refectory's. But to us other aspects are shown. Along with the Master's frontality and the shape of his signing—from apex down to enfutured feet—we see perspective in transfiguration, see the orthogonals of the structure educed from his summit, see space expand to the spread of his arms.

This outmost effect is revealed only to that "trustful seeing" which apprehends the chamber as trapezoid, apse-like or not. The room so perceived acquires transcendence by apostolic transmission from two outstretched hands, hands

13. Carlo Bertelli, preface to Ludwig H. Heydenreich, *Invito a Leonardo: L'Ultima Cena*, Milan, 1982, p. 17. For Bertelli's reference to St. Jerome, see his "Il Cenacolo Vinciano" in Dell'Acqua 1983, p. 194 n. 13. A brief recent acknowledgment of Leonardo's apsidal symbolism occurs in Rossi/Rovetta 1988, pp. 24–27. Eichholz, grimly secular to the last, adopts "a preferred profane interpretation of the chamber," suppresses every contrary consid-

eration, and dismisses the case (1998, pp. 118–19, 180).
14. For the resurrectional symbolism of the number eight, see Steinberg 1983/96, pp. 163–65. Eight as the number of immortality is briefly cited within Eichholz's discussion of numerological symbolism (1998, p. 121).
15. Florens Deuchler, *Der Tausendblumenteppich aus der Burgunderbeute: Ein Abbild des Paradieses*, Zurich, 1984, p. 23 and n. 37.

that consecrate as they move. In such perception, the dual nature of the manGod and the twain meaning of the event coincide with the twinned scienceArt of Leonardo's perspective. The structured rectangularity of the chamber is surely there, emplacing the human Christ; its other form issues from the prime mover, taking its shape as drapery does from the motion of limbs, as the folds of a sleeve receive theirs from the mandate of an arm. Leonardo's Christ gives himself to the world, as if the words *corpus meum* fulled space itself, as if space were the costume he wears.

SO MUCH FOR THE PAINTING. As regards Leonardo's religious beliefs during the 1490s, I come away with no firm conviction; no necessary conclusions follow from the above. That Leonardo despised superstition and mocked the pretensions of ignorant monks is well known; but many good Christians did likewise. In the end, his beliefs remain as unsearchable as his *St. John*, his *St. Annes*, his *Madonnas*. Vasari, in the first edition of his Leonardo *vita* (1550), makes the artist an unbeliever, an investigator of nature whose inquisitive mind had drawn him away from religion, even to the "heretical" notion that it was better to be a philosopher than a Christian. In Vasari's definitive second edition (1568), this doomful charge is deleted and the great Leonardo recast as a faithful son of the Church. No telling where the truth lies.

But one truth is still there to see, even in the fade-out of the *Cenacolo*'s present condition. The artist in Leonardo respected his subject, meditated center and radius, its ubiquitous midpoint and boundless periphery—and studied to make his painting commensurate. What I believe he pondered most deeply was depictability, the limits of the expressible, if such existed. It was the lure of these limits that busied his passions, whatever the cause to be visualized—muscle work or the propagation of light, turbulent water or doctrinal symbolism, or, if the painting required it, the transparency of the paradox that more and still more equals one. The task throughout was to discover what art could be made to do.

Appendices

APPENDIX A

Bossi and Goethe: Original Texts

Page numbers preceding the following paragraphs refer to their respective English translations.

p. 24 n. 8:
Goethe writes: "Das Aufregungsmittel, wodurch der Künstler die ruhig heilige Abendtafel erschüttert, sind die Worte des Meisters: Einer ist unter euch der mich verräth! Ausgesprochen sind sie, die ganze Gesellschaft kommt darüber in Unruhe; er aber neigt sein Haupt, gesenkten Blickes; die ganze Stellung, die Bewegung der Arme, der Hände, alles wiederholt mit himmlischer Ergebenheit die unglücklichen Worte, das Schweigen selbst bekräftigt: Ja es ist nicht anders! Einer ist unter euch der mich verräth" (1817, p. 55).

p. 26 n. 11:
Here Goethe banters: "Wir haben das Abendmahl mit Leidenschaft durchgedacht und durchdenkend verehrt; nun sei uns aber ein Scherz darüber erlaubt. Dreizehn Personen sitzen an einem sehr langen schmalen Tisch; es gibt eine Erschütterung unter ihnen. Wenige blieben sitzen, andere sind halb, andere ganz aufgestanden. Sie entzücken uns durch ihr sittlich leidenschaftliches Betragen, aber mögen sich die guten Leute wohl in acht nehmen, ja nicht etwa den Versuch zu machen, sich wieder niederzusetzen; zwei kommen wenigstens einander auf den Schoss, wenn auch Christus und Johannes noch so nahe zusammenrücken."

p. 31:
Bossi exults: "Il vangelo aveva narrato a tutti i pittori anteriori a Leonardo, che Cristo, radunati i suoi eletti, aveva detto che uno di loro lo tradirebbe. La conseguenza di tali terribili parole, egualmente dal vangelo descritte, presentava uno sviluppo felice di tutte quelle passioni, la cui imitazione forma il pregio principale dell'arte. E pure chi prese di mira la frazione del pane; chi la benedizione del vino; chi la distribuzione dell'uno o dell'altro, situazioni tutte egualmente consacrate dalla storia e dalla religione, ma non atte certo a destare passioni nè varie nè forti, e quindi per loro natura di effetto debole e monotono, tanto più in una scena ove, come in questa, è grande il numero degli attori principali. Il vero punto altamente degno dell'arte era ancora intatto, allorchè venne il pittore de' costumi, il vero Aristide italiano,[1] il divino Leonardo che non si accontentò, come i suoi antecessori, del tributo degli animi religiosi o degli occhi che si appagano di una seducente superficiale imitazione; ma volle a sè gli animi di tutti gli uomini capaci di sentire, di ogni tempo e di ogni religione; volle a sè tutt' i cuori cui non è ignota l'amicizia e l'orrore del tradimento. Egli ponderò colla scorta della filosofia di quanto e quale aumento tali sentimenti fossero capaci per rispetto al suo principale personaggio, cioè all'Uomo Dio; ma compose in tal modo l'opera sua, che, astraendo anche la divinità del protagonista, rimane ancora tanto d'importanza generale al soggetto, che nulla vi sagrifica l'arte alle private opinioni o alle cerimonie religiose, non eterne e non generali come i sentimenti umani" (1810, p. 78).

p. 35 n. 6:

Goethe defers: "Bis hierher haben wir von dem Werke des Ritter Bossi im Allgemeinen Nachricht, im Einzelnen Uebersetzung und Auszug gegeben, seine Darstellung nahmen wir dankbar auf, theilten seine Ueberzeugung, liessen seine Meinung gelten, und wenn wir etwas einschalteten, so war es gleichstimmig mit seinem Vortrag" (1817, p. 73).

p. 85:

Goethe describes: "Thaddäus zeigt die heftigste Ueberraschung, Zweifel und Argwohn: er hat die linke Hand offen auf den Tisch gelegt, und die rechte dergestalt erhoben, als stehe er im Begriff mit dem Rücken derselben einzuschlagen; eine Bewegung, die man wohl noch von Naturmenschen sieht, wenn sie bei unerwartetem Vorfall ausdrücken wollen: Hab' ich's nicht gesagt! Hab' ich's nicht immer vermuthet!" (1817, pp. 57–58).

p. 149:

Goethe regrets: "Hier ist freilich nur der Mensch, der ein Seelenleiden nicht verbirgt; wie aber, ohne diese Züge auszulöschen, Erhabenheit, Unabhängigkeit, Kraft, Macht der Gottheit zugleich auszudrücken wäre, ist eine Aufgabe, die auch selbst dem geistreichsten irdischen Pinsel schwer zu lösen sein möchte" (1817, p. 85).

1. Bossi's "pittore de' costumi," vaguely translatable as "painter of human ways," derives from the Ciceronian translation of the Greek ἤθη (*ethe*) as *mores*. The reference to Aristides of Thebes, contemporary of Apelles, is explained by the passage in Pliny (*Natural History*, xxxv, 98, trans. K. Jex-Blake, Chicago, 1968): "He [Aristides] was the first among all painters to paint the soul, and gave expression to the affections of man—I mean what the Greeks call ἤθη—and also the emotions." For a discussion of Pliny's passage, see Adolphe Reinach, *Recueil Milliet*, Paris, 1921, p. 272 n. 3. Bossi's description of Leonardo as "il pittore de' costumi, il vero Aristide italiano" follows Bartolommeo da Siena, *De vita et moribus beati Stephani Maconi Senensis Cartusiani…*, Siena, 1626, bk. 3, p. 137 (quoted by Bossi, p. 250 n. 34): "In quo suspicere plane libet quae et quanta fuerit Leonardi praestantia, argutaque pingendi navitas, quodque mirabile ingenium, ac divina prope mens ad vivum interiores exprimendi suis in tabulis humanos affectus per exteriora videlicet oris lineamenta, ut Aristidem insignem pictorem Thebanum in hoc superasse diceres, modo ejus in tabulas nostra aetas incidisset."

Antoniewicz on the *Last Supper* (1904):
Translation and Original Text

SINCE ANTONIEWICZ's all but forgotten paper is hard to find and to this day untranslated, I append the original German text preceded by an English translation made for the present occasion by Jacqueline E. Jung and myself. And since Antoniewicz's reading of the *Last Supper* ranks with the boldest revisions ever visited upon our discipline, I herewith add a few biographical facts, taken from the Polish dictionary of national biography, the *Polski Słownik Biograficzny*, I, Cracow, 1935, where the entry on Johann Bołoz Antoniewicz (1858–1922) runs to three columns. (Standard Western reference works—excepting one brief mention in the *Repertoire d'Art*, 1921—do not cite his name.)

In 1876, age eighteen, Antoniewicz entered the University of Cracow (then part of the Austro-Hungarian Empire) to study law, but soon switched to philology and comparative literature. Four years later, he enrolled for graduate studies in Munich, wrote his dissertation on Schiller, and proceeded to publish in German literary journals. Meanwhile, his aesthetic interests had broadened to include music theory and art history, with emphasis on Renaissance painting and Polish art—this at a time when Poland, long since partitioned among Prussia, Russia, and Austria, was not a political entity.

In 1894, Antoniewicz organized an exhibition of Polish art, 1764–1886. His monograph on the Romantic nationalist painter Artur Grottger (1836–1867) appeared in 1910, by which time he had become professor of art history at the University of Lwów (now in Ukraine).

Of his published work, I know only two short articles

(on pictures by Botticelli and Rubens) published in 1905. The *Polski Słownik* further cites a paper on Titian, another on Cracow's great treasure, Leonardo's *Lady with the Ermine*, and, following the political reconstitution of Poland, two Leonardo papers delivered in 1919 at the quincentenary celebration of Cracow University. Of the 1904 *Last Supper* paper no mention is made; nor was it ever published in full.

A word on the afterlife of that paper in professional literature. Antoniewicz gets a quick brush-off from Malaguzzi Valeri (1915, p. 521 n. 3) and fierce scathing in a footnote in Möller (1952, p. 184 n. 54). The latter's work, thanks to the date of its publication, produced unexpected results. Most of Möller's research had been done before World War I, when the Antoniewicz paper would still be recalled as a recent embarrassment. But Möller's important *Cenacolo* monograph remained unpublished until the quincentenary of Leonardo's birth, 1952, and by then the climate was beginning to change, so that the barest reference to Antoniewicz's long-forgotten interpretation might suddenly seem full of promise. In the spring of that year, Edgar Wind rediscovered the eucharistic factor in the *Cenacolo* and the significant contrast of left and right (he does not cite Antoniewicz). In 1961, Herbert von Einem, unaware of Wind's work, revived the eucharistic interpretation, mentioning Möller's footnote to Antoniewicz, but leaving unclear whether he had consulted Antoniewicz's text. As late as 1975, a monograph on Leonardo's *Last Supper* (Feddersen, p. 188) attributes the first notice of bread and wine at Christ's fingertips to von Einem. Soon after, in Hans Ost's *Leonardo-Studien* (Berlin,

1975, p. 89), Antoniewicz is mentioned and curtly dismissed. But by that time, unknown to Ost, my own publication of 1973 had honored the ostracized Pole, in whom I found a much-needed ally.

1983: When Anna Maria Brizio tried to refute my position on Leonardo's *Last Supper* (1983, p. 21), she assumed that I had been influenced not by the picture (how could that be!), but by my reading of Antoniewicz.

What follows is the abstract of Antoniewicz's presentation as it appeared in the *Proceedings of the Cracow Academy* (to which I add a few comments, both laudatory and critical).

Johann Bołoz Antoniewicz, "O wieczerzy Lionarda da Vinci (Das Abendmahl Lionardos)," *Bulletin International de l'Académie des Sciences de Cracovie (Classe de Philologie. Classe d'Histoire et de Philosophie)/Anzeiger der Akademie der Wissenschaften in Krakau (Philologische Klasse. Historisch-Philosophische Klasse)*, no. 6 (June 1904), pp. 53–66.

Translation

Interpretations of Leonardo da Vinci's *Last Supper* in the refectory of Sta. Maria delle Grazie, Milan, generally—and with only the slightest exceptions—agree that the picture represents the moment of the betrayal announcement. Insofar as they go into sufficient detail, opinions diverge only with respect to the phases of the event.

Some would have Christ speaking and the Apostles reacting to his words at the same time. Others see the picture depicting primarily the agitation that takes possession of the disciples immediately after the already delivered betrayal announcement. The first view is the older and most likely harks back to the following statement of Fra Luca Pacioli in the *Divina proportione* of 1498: "non è possibile con magiore [attentione] vivi li apostoli immaginare al suono dela voce delinfallibil verita quando disse: UNUS VESTRVM ME TRADITURUS EST."[1] In itself, this textual passage need not compel one to suppose that Christ is portrayed in the act of speaking, but further citations in Bossi's monograph[2] offer sufficient proof that Christ has typically been understood to be speaking, announcing the impending betrayal. Thus on the supposedly earliest engraving of the painting, which Bossi believed to have been produced "prima del secolo decimosesto,"[3] the following words, evidently an interpretation of the narrative, appear in abbreviations on a *cartellone* affixed to the tablecloth: *Amen dico vobis, quia unus vestrum me traditurus est.* Goethe, in Rome, sees a miniature copy of the *Last Supper* in the home of a priest (who was himself a painter), and reports to Frau von Stein on the 18th of January, 1787: "The chosen moment is that in which Christ, seated in friendly cheer with the Apostles, says: 'And yet there is one among you who betrays me.'"[4] Thirty years later, Goethe no longer sees the betrayal announcement in the picture as unfolding, but as already accomplished. In his essay "Observations on Leonardo da Vinci's Celebrated Picture of the *Last Supper*" of 1817, he substantiates this new point of view in detail, arguing that the "dire words" from Christ's lips have already fallen, continuing even now to cause the agitation that shakes the holy calm of the Supper table.[5] Whereas Christ himself, silently and with heavenly resignation, emphasizes and confirms his words through the motion of his arms and hands, the inclination of his head,

1. Fra Luca Pacioli, *Divina proportione: Die Lehre vom goldenen Schnitt*, ed., Constantin Winterberg, Vienna, 1889, Quellenschriften N.F. 2, 41. [The numbering of Antoniewicz's footnotes, which have been left unrevised, began anew on each page. The present translation and republication adopt consecutive numbering.]

2. *Del Cenacolo di Leonardo da Vinci libri quattro di Giuseppe Bossi pittore*, Milan, 1810.
3. Ibid., p. 162f.
4. *Tagebücher und Briefe Goethes aus Italien: Schriften der Goethe-Gesellschaft*, ed. E. Schmidt, Weimar, 1886, II, p. 259.
5. *Über Kunst und Altertum*, 1817, pp. 113–88; Hempel 28, 506.

and his lowered gaze. But it was not in the Milan refectory, not before the original, that Goethe revised his opinion—he had, after all, seen it but once, very briefly, thirty years earlier on his return journey from Italy; no, it was in his Weimar study, looking at Raphael Morghen's engraving, which blurs whatever is fraught with meaning [*alles Prägnante*] and indispensable to an interpretation. Yet Goethe's authority is so great, so seductive are his conclusions, that today almost everywhere only his interpretation is considered correct.

What to me seems untenable in Goethe's reading is his condemnation of Christ to utter passivity and the shift of the weight of the narrative to the disciples. In this view, Christ himself is not thought of as agent, but as merely a wagoner who lets the reins slip from his hands. What Leonardo always strives for, what he tirelessly holds up to himself and to his disciples as the chief postulate of truly artistic composition, is the distinctness, the sharp clarity, the unambiguous decisiveness of each gesture, movement, and posture.[6] Mobility, action as the outward expression of the vital individual and concerted effectiveness of each ensouled body (*animale*), is the unspoken, self-evident precondition of his art. The character to whom Leonardo applies his observations, or by whom he exemplifies his instructions, he thinks of as ever active, directly engaged; and accordingly calls him *il proponitore, il parlatore, l'operatore*, or simply *il motore*.

[Comment: In the very act of maintaining that a given action has been universally misunderstood, Antoniewicz insists that this same misunderstood action is "unambiguous." The conviction that there can be no ambiguity in Leonardo remains unshaken. Since this belief is shared by Antoniewicz's skeptical audience, his revisionist reading registers as unacceptable.]

A cursory glance at all of Leonardo's paintings and sketches, not excepting the most hastily executed and least certain, suffices to convince us that the theme of his compositions is always an action—and more specifically an action initiated by the main character of the *istoria*. Moreover, among the hundreds upon hundreds of *Last Supper* representations, from the earliest beginnings down to ecclesiastical images of the nineteenth century, we shall find not a single example that fails to present Christ in significant action, whether in a concrete-historical or a sacral-symbolic sense. Let us frankly admit it: were it not for Goethe's interpretation—which, like everything that proceeds from him, has the power to fascinate—we would have to declare a *Last Supper* representation without an actively motivating Christ to be an aesthetic absurdity.

The betrayal announcement as such is a motif of inadequate definition, a theme whose approximately correct interpretation becomes possible at best by way of emphatic facial expressions, but which could easily be read as responsive to any speech that neither derives from nor gains support from a specific action during the Last Supper scene. Thus I cannot imagine how such a complex, intimate process as Goethe sees, a moment characterized by pure passivity and mystical interiority, could have been made the starting and centric point of a powerful work with thirteen figures larger than life, nearly all passionately moved and disturbed. Furthermore, it is hard to see how the arms of Christ as they appear in the picture could accompany the just delivered announcement of the betrayal. Surely, the event Goethe supposed would require the hands and arms to rest parallel and inactive. The following remark by Leonardo, however, might at last put an end to that mistaken interpretation: "Sonno alcuni moti mentali sanz' el moto del corpo" and these "lasciano cadere le braccia, mani et ogni altra parte che mostri vitta."[7] The movement of the soul

6. Leonardo da Vinci, *Das Buch von der Malerei, Quellenschriften* 15 (I), pars. 294, 298, 325, 358, 368, 376, 409, and passim.

7. Ibid., pars. 370, 1, 368, 9: "Some emotional states are accompanied by no particular movement of the body....They cause arms and hands to sink down, and so likewise whatever shows life."

which Goethe attributes to Christ, the mute confirmation of previously spoken words, must undoubtedly be numbered among such "moti mentali" which play themselves out "sanz' el moto del corpo"—those, that is, which are not accompanied by the movement of the whole body. Its sensible expression, then, would have to be a parallel lowering of both arms and hands upon the tabletop, or perhaps their calm repose or interfolding—a movement that would mark the end of a process, not its beginning, and, moreover, one characterized by a centerward orientation. But here both arms diverge along clearly explicit lines, like two messengers dispatched in diverse directions. The left arm is moderately tensed and extended, the left palm fully opened in a distinctly demonstrative "speaking" gesture, whereas the right hand presses forward, palm down, splayed fingers open and spread apart as if preparing to grasp or take hold of some object. Christ's eyes are fixed upon an object lying in the path of his indicative left hand. Thus Christ is not the passive dead center of the picture, but its organically animating hub. In this unique picture, he is not the mute, miming reflex of his own words, but the organizing determinant of the whole—here, too, the "fount of life."

2. In contrast to this interpretation, Prof. Strzygowski —proceeding from iconographic considerations and supported by the drawings which he doubtless interpreted correctly if not exhaustively—has attempted to prove that Leonardo's mural, following the words of the Gospel of Matthew 26:23, presents the moment at which the discovery of the betrayal is manifested through the simultaneous dipping of Christ's and Judas' hands in the common bowl.

I cannot agree with this interpretation for the simple reason that then Christ's glance would, in the normal way, have to follow his right hand aimed at the bowl, whereas he clearly directs head and eyes toward his extended left hand. To say nothing of the fact (apparent in any good photograph, especially that of Ferrario) that the half-filled wineglass intervenes between Christ's right hand and the bowl. This glass is gently approached by Christ's hand, while (as has often been noticed) Judas' left hand does not press forward but rather, like his whole upper body, recoils.

[Here again an insistence on either-or weakens Antoniewicz's argument. If, in his reasoning, the dish between Judas and Christ is disqualified as an object of Christ's attention because Christ's gaze is averted, then that gaze is averted as well from the wineglass.]

Titian, too—recognizing fearful surprise in the rigid gesture of the [Judas] figure—transferred it to the right hand of the Apostle seated next to Christ in his *Emmaus* picture at the Louvre. Therefore I can concur only with the primarily negative-critical part of Strzygowski's very interesting conclusions. Some of his apposite observations on the technique and structure of the picture will be made use of below.

I proceed to the grounds of my own hypothesis.

[What follows sounds at first like conventional formal analysis. It ends up as a pioneering attempt to locate the work's meaning in its formal structure.]

3. Three features cooperate in wonderful harmony to make Christ and his action prevail amidst the multifigured, restlessly surging throng of the Apostles, to show him clear and distinct as the starting point of the whole, and to bring the primary subject convincingly into focus. These features are:

a) light and color
b) figural grouping
c) linear design

a) *Light and color.* A bright light with soft transitions flows over the snow-white tablecloth before Christ. Entering from the left, it quickens and illuminates the central third—reaching from Simon Peter to Philip—of the long-stretched table, and lightens the mid-portion of the right wall. While James Major, Christ's left-hand neighbor, catches full light like an umbrella, only some parts of the figure of Christ are fully light-struck. These, however, are the decisive ones: the right side of the face; the throat; the extended right hand with white shirt cuff; and, brightest of all, the

open left palm and the shimmering, glistening blue of the mantle pulled athwart the left shoulder and arm. In contemplating the picture, this deep-blue, brightly lit triangle formed by the table's edge and the contour of mantle and arm always attracts our gaze as the outstanding and strongest color patch, and this impression is significantly reinforced by the many parallel or long-drawn, sharply illuminated cross folds of the mantle.

[Since the recent removal of the old overpaint, such phenomena as the shimmering blue of Christ's mantle are no longer apparent in the original.]

While our very first glance is thus drawn to the play of the hands and the line along the left arm, the glow of the evening light entering from the rear through the open central door illuminates the Savior's head like an aureole, lending him a golden nimbus such as no other master conceived!

The doorjambs, which could hardly be more simply conceived, contrast effectively to encase the half-length Christ as in a dark picture frame.

This powerful effect of light and color, which gathers in the picture's mid-portion to culminate in the figure of Christ, is heightened considerably by the actual lighting conditions of the room. For the daylight that falls from the first of the high, narrow windows some five steps away from the mural coincides precisely with the depicted light. Christ thus appears as a column of light, for no other artist has seated the figure at the intersection of two powerful streams of light. What is decisive for the interpretation and meaning of Christ's action—and hence for the whole of the picture—is thus predetermined by light and color.

b) One of the most striking features of this picture's overall composition is the isolation of the figure of Christ. Precisely where one would least expect it, a caesura cuts

deep into the rhythm of the contour that had run uninterruptedly to this point from left to right, willfully sundering what tradition and artistic practice had always demanded be indivisible. The master, it is true, did preserve the privileged place at Christ's right for John, that ideal image of wordless and helplessly grieving love, thereby characterizing him, in harmony with the words of the fourth Gospel, as the beloved disciple. But the immediate contact is abrogated.

The tide of unified action from James Minor to Simon Peter and from him leaping to John, while sweeping Andrew and Judas along in the rush toward Christ, comes to a sudden halt and glides groundward at the figure of John. Just over the table's edge, in straight lines open at an angle of nearly 75 degrees, the contours of Christ and John diverge; John's head, upper body, and arms gravitate to the left; Christ in the opposing direction.

This deep-cut hiatus in the contour leaps the more strikingly to the eye because of the sharp-edged window jamb wedged between Christ and John. Like a bolt rammed into place, it seems to spread the two masses apart, thereby opening the view upon the level undulations of the *campagna*.

Furthermore, the following should be noted.

Whereas the twelve disciples show in full or three-quarter profile, overlapping or even crossing each other, Christ alone presents his whole upper body in full frontal view. Nothing that could disturb or injure the statuesque yet loose symmetry of this linear flow juts in, nor dares to infringe. As Rubens aptly remarked, Christ is seated "n'ayant personne qui le presse, ni qui soit trop près de ses côtez."[8]

So then, Christ is self-contained in statuesque isolation. This impression is further heightened by the plain segment gable over the middle door [nearly lost in the latest cleaning], which, defining Christ's spiritual sphere upward, arches

8. Cited by Bossi, p. 45, from de Piles (1635–1709); the bibliographical information is not noted, and only specified with the dates "1699–1715." Whether this indicates the *Abrégé de la vie des peintres* or the *Idée du peintre parfait*, which

likewise appeared in 1699, I cannot determine at this juncture.

[The Rubens text appears in Roger de Piles' Abrégé de la vie des peintres, Paris, 1715, pp. 161–62, translated in Heydenreich 1974, p. 18.]

over his head as a kind of architectural nimbus. Complete the here-implied circle, and we find that its centerpoint coincides with the center of the entire picture, located on the right side of Christ's brow. This circumference closes like a medallion—like the unapproachable circle of medieval saints' legends—about the figure of Christ, which overlaps no neighboring figure. Only to the left of Christ do two forceful intrusive hands break through the magic circle.

c) Linear composition.

The interior architecture of the chamber in which Leonardo's *Last Supper* takes place is surely the simplest of any among Italian pictures known to us from the fifteenth and sixteenth centuries. Aside from the aforementioned plain segment gable over the middle door, the round, curved, undulant line seems not to exist for the creator of this picture. Throughout, we find only straight lines, right angles, sharp edges, rectangles, squares, trapezoids.

Since we cannot here go into detail, let the following observations suffice. The geometric centerpoint of this picture, whose height measures exactly half its width, coincides with its visual focal point; as Strzygowski correctly recognized, the vanishing point is to be found at the right temple of Christ.

*[The ensuing run-on sentence in Antoniewicz's text refers to the floor stripes (*Bodenstreifen*), about which the author could have known only that they ran straight. As in other descriptions before and since, the openings between the wall hangings are misinterpreted as more tapestries. But what immediately follows contains some of the sharpest and most original observations in the history of formal analysis.]*

The stripes of the floor, the short sides of the table, and the upper edges of the eight larger, patterned tapestries and the six monochrome (?) smaller ones (higher on the left), which stretch across both lateral walls, all these, along with the seven beams of the ceiling, unite in a system of sharply defined perspective lines, whose striking clarity is effectively emphasized at various prominent points, such as the corners of the windows, the terminals of the trestles, and the pendant tags of the tablecloth, as well as a few particularly distinctive deployments of arms, hand gestures, and head positions.

A network of no fewer than twenty-two perspectival lines weaves its web over the picture surface. This abstract linear system invests the picture with a clarifying, ordering, concentering presence, which succeeds in producing an effective contrast to the restlessly billowing mass of disciples, setting off their excited gestures and explosive movements.

Wherever the beholder's eye, contemplating in wonder, may come to rest—from every point, from below and above, from left and right, from all corners and angles—these lines lead back to the fundamental motif, to the driving force of the picture, to its geometric, perspectival, and spiritual midpoint: to the forehead of Christ, seat of his thoughts, font of his salvific words and of his visible action. Here too—as always with Leonardo—the technically constructive transmutes into the spiritually ideal.

In this brief extract, I will pick from this network only three pairs of lines, so as to analyze their paths and their functions more closely.

They are, first and foremost, the two diagonals, whose course is marked by the upper rims of the four pairs of tapestries, the inner angles of the respective side windows, and the tips of the dangling corner tassels of the tablecloth. The diagonal on our right lies on axis with Judas' elbow-supported right forearm, while the counter-diagonal pointedly touches the fingertips of the widespread arms of James Major.

Noteworthy too are the vertical and horizontal lines that bisect respectively the width and the height of the picture. The former bisects the upper pictorial margin, the segment gable over the middle door, the door itself, and the table, including the dish in front of Christ. This is the mathematical line of the central (fourth) ceiling beam and of the dark central floor band. It is as well the ideal axis of the figure of Christ, of his erect upper body and of his forward right foot

which—as the copies (e.g., that from Castellazzo) still show—was painted with its full sole resting on the dark band.

[As will be shown in App. D, it is only the Castellazzo copy that articulated the pavement with a (light, not dark) band on the median. Antoniewicz rightly observes that Christ's foot comes to rest on this band, but he stops short of reading the observed correlation symbolically. Just so, he makes the great diagonal falling from upper right stop at Judas' elbow, failing to note the breadroll spurned by that elbow. And so (in the following paragraphs), he sees the orthogonal of Christ's left arm lead to the bread at the fingertips, without noting its continuance in the floor bands. The need for a step-by-step exploration of the picture's totality is nowhere better demonstrated than in Antoniewicz's bold advances and sudden halts.]

The horizontal bisector coincides with the pictorial horizon and with the isocephalically disposed heads of Christ and the Apostles Bartholomew and Matthew. It thus becomes the horizontal constant of the rising and dipping graph formed by the apostolic figures.

Special attention must be paid to the functions of the two perspectival lines that proceed from the axes of the second and corresponding sixth ceiling beams. They are crucial—perhaps even decisive—for a correct interpretation of the picture. Let us trace their course carefully. The line falling from upper left, having run axially along the entire length of the second beam and then passed through the centric point at Christ's forehead, continues onward as the axis of his outstretched left arm and open-palmed hand, then proceeds down to the moderately large round breadroll. Here it suddenly stops. Its unmistakable, natural, rectilinear continuation appears analogously in the axis of the sixth ceiling beam that runs through the right arm of Christ: it ends in the glass half filled with red wine, which the open right hand is just preparing to grasp.

Now, suddenly, we become aware of the geometrically constructive factor in the figure of Christ. His right forehead, as already observed, is the geometric, structural, and ideal focal point of the picture, upon which the perspective lines converge radially; his body is the pictorial median translated into organic form; his arms are two structural sight lines likewise organically translated. Thus is effected the transformation of a casual appearance of life into functional structure, the raising of the real to the ideal, of the concrete to the absolute. The variety of the Apostles' movements and gestures can hardly be exhausted with words: here we see marvels of psychophysics which only a phenomenon such as Leonardo could have brought forth. Tracking the figures from left to right we recognize one man swiftly grasping the immediate event, next to another's questioning gaze, and another's repelled, resistant astonishment; one eagerly seeking a response to his questioning, another lost in his painful thought, yet another rigid in fear. And then again an explosive expression of enthusiasm discharged in outcry, followed by the assurance of selfless devotion, next to one protesting keen disbelief; and in the last figures, youthfully ardent demand for attention, irresolute whispering, and quick, energetic reaction. All these stirrings are fluid and momentary, as if accidental. The artist's eye seems to have ambushed and caught them in an unguarded moment, not letting the living model forgo one atom of its fresh pulsating vitality during the long trail of its translation from retina through arm to paintbrush. Even the sharpest observer, the finest wordsmith, must finally fail before the immediate fullness of life of these twelve figures.

Fundamentally different is the formation of the Christ figure. Its element is a premeditated contrivance, a deliberate and cogitated structure displaying the primitive simplicity of an equilateral triangle. The axes of the two arms, which we have just recognized as the continuations of two ceiling beams, form the triangle's sides; the straight line, which we imagine traced from the surface of the left hand to the right, lays down the base; its apex lies at Christ's right temple, coincident with the center as well as the vanishing point of the picture; finally, the perpendicular that falls from this apex (i.e., the height of the triangle) coincides with the

picture's central axis, from which Christ's arms diverge at the constant angle of approximately 30 degrees.

By virtue of this structural and tectonic element which conditions it, the Christ figure separates itself decisively from the figures of the twelve disciples. Whoever pursues the constructive lines of this picture, seeking the enduring, the steadfast within the fluxion of these appearances, will find it ever again at the figure of Christ. Only by manifesting itself to us in its conditioned freedom as organic construction, as a vital, sentient, and agent tectonic form—only through this absolute form does the figure of Christ rise from the mass of concrete sensuous appearances to attain the supreme sphere of the ideal.

Thus the artist exalts the figure of Christ above all the others by means of its illumination, its singleness, and its tectonic formation, compelling the viewer's eye to proceed from that figure while always reverting to it. The perspectival lines of the arm axes put the observing eye on the track that leads to the right interpretation.

This track points us to the conclusion that what we here see depicted, beginning with the bread indicated, is the institution of the sacred supper.

If this assumption is correct, then the gestures of the Apostles must be in agreement. But from these gestures we gather with certainty only this: they all are dependent, influenced and conditioned by a "Something." These figures act not from some primary impulse; they react. And this "Something" to which they react is twofold—it is both an after-effect and another which exerts its immediate effect even now; it is something that has already occurred and something that occurs in the present.

That the first of these can only be Christ's words "Unus vestrum me traditurus est" is clear. The gestural language of Simon Peter is too obvious to admit the mere possibility of another interpretation; if we lacked the relevant textual support in the Gospel of John 13:24, we would have to invent similar words for it.

What, then, might the second motif be? Surely it is an event unfolding in this very moment, one that arouses in those who see and hear it, those closest to him, the most agitated and emphatic expressions. At Christ's left blazes the fire of a new movement: the place to which Christ's glance is directed, at this same place stares James Major, that enthusiastic choleric who cries out with arms spread wide in shuddering wonder. Toward that place, Matthew too points his parallel extended arms, and thither Bartholomew, bending forward, directs his gaze. Aside from the latter, the figures at the left half of the table are still occupied with the words previously uttered by Christ; while those on the right side become the immediate eye- and ear-witnesses of the institution of the eucharist.

We are seeing the climax of the first half of the institution. A moment later, Christ will slowly retract his left hand and turn his head to the right. Already his right hand has begun to move forward, preparing to take hold of the wineglass. One grasp, and Christ's mouth will open, and the questions and doubts about betrayal and betrayer will subside as well on this side of the board. Then John, roused from his doleful brooding, will perhaps (like James Major now) turn with fervent love toward the Savior, who will let fall the words: "Drink ye all of this. For this is my blood of the new testament, which shall be shed for many unto remission of sins" (Matt. 26:27–28).

This is my view of Leonardo's *Last Supper* in Sta. Maria delle Grazie.

One glance at Raphael Morghen's engraving suffices to shed light on the origin of Goethe's interpretation. Here Christ's eyes glance aside into the indeterminate; his left hand has lost its direction and tension and rests without strength or motivation; the bread is shifted out of that sight line which has proved to be such a reliable guide; the wineglass toward which Christ's right hand reaches in the painting is wholly absent, so that the hand which, in the original, steered consciously to its goal, retains only the stiff, senseless

grimace of an articulated puppet. Goethe, earnestly bent on analyzing the work, had before him a falsified text. This he interpreted rightly, but it was not the original text—not the *Last Supper* of Leonardo, which he had seen face-to-face only fleetingly some thirty years earlier. Rather, he dealt with the text he had before his eyes at that moment, the then much-admired Morghen engraving, which he considered to be, at least in the essentials, a faithful replica of the original; a consideration fully justified at the time.

[Antoniewicz's coda, here following, is ingenious and nobly argued, but, to my mind, misguided. A more compelling reason for the picture's leftward orientation is offered on pp. 143–45.]
Doubts about the correctness of my interpretation could well be aroused by the consideration that Christ performs or initiates the institution of the eucharist with his left hand, and in a leftward direction. Against this objection we have the established fact that Leonardo (excepting only the Louvre *Annunciation*, which dates from his earliest youth) lets the action in all his multifigured compositions proceed from the left or develop toward the left. It is with the left hand and from the left (i.e., from the standpoint of the picture) that the Christ Child receives the votive gift from the oldest king's hand in the Uffizi *Adoration*, and likewise from the left in the preparatory sketch in the Louvre. The *Madonna of the Rocks* extends her left hand in blessing over her Child's head in the Paris picture. It is toward the left that the Blessed Mother—in the world's most magnificent cartoon,

that in the London Royal Academy [now National Gallery, London]—presents her Child to the little John the Baptist who, continuing this directional flow, in turn bestows a blessing toward the left. Likewise, in the picture of the Virgin Mary with St. Anne in the Louvre (as well as in other school and academy productions dependent on the London cartoon), we see the Madonna present the Child to the lamb with arms stretched out toward the left. But the closest analogues are certainly the two hastily scribbled sketches of the Last Supper itself on the well-known Windsor sheet [Fig. 187], in which Christ—and this is particularly clear in the second, lower version—passes the dipped bread with his left hand diagonally across the table toward his left, where Judas rises abruptly from his seat in accordance with the words of the Gospel of John 13:24.

And thus, in the *Last Supper* too, the master entrusts to the left hand, that faithful and obedient executrix of his artistic thoughts and intentions, the noble task of introducing an action in a clear, vivid, and unambiguous manner. Rather than finding it a valid objection to my hypothesis, I am able to perceive in the head and glance inclined gently leftward, and in the left hand that points and reaches toward the left, nothing other than a proof, not to be underestimated, that in this picture, too, *per analogiam*, the point where the left hand reaches actively forth represents the pivot of an actual immediate event—an event which in the given case, is nothing other, and can be nothing other, than the institution of the eucharist.

Original Text

In der Erklärung des Abendmahles Lionardos da Vinci im Refektorium zu Sta. Maria delle Grazie in Mailand hat man sich—mit ganz verschwindenden Ausnahmen—dahin geeinigt, daß in dem Bilde der Moment der Verratankündigung dargestellt ist.

Die Meinungen, sofern sie überhaupt genügend präzisiert sind, gehen nur bezüglich der Phasen dieses Vorganges auseinander.

Die einen denken sich Christus sprechend und die Jünger gleichzeitig auf diese Worte reagierend, die anderen sehen in dem Bilde hauptsächlich die Darstellung der Erregung, die sich der Schüler unmittelbar nach bereits erfolgter Verratankündigung bemächtigt. Die erstere Ansicht ist die ältere, und geht wohl auf folgenden Ausspruch Fra Luca Paciolos in der Divina Proportione vom J. 1498 zurück: non è possibile con magiore [attentione] vivi li apostoli immaginare al suono dela voce delinfallibil verita quando disse: UNUS VESTRVM ME TRADITURUS EST.[1] Wenn auch aus diesen Textworten die Annahme, als sei Christus eben sprechend dargestellt, nicht mit zwingender Notwendigkeit gefolgert werden muß, so schöpfen wir aus den Citaten der Bossischen Monographie,[2] genügende Beweise, daß man sich Christus redend, den Verrat eben verkündigend dachte. So sind auf dem angeblich frühesten Stiche, den Bossi "prima del secolo decimosesto" entstanden glaubt,[3] als Interpretation der Handlung auf einem am Tischtuch befestigten *"cartellone"* in Abbreviaturen die Worte angebracht: *Amen dico vobis, quia unus vestrum me traditurus est*. Goethe sieht in Rom bei einem Geistlichen, der selbst Maler war, eine Miniaturkopie des Abendmahles und berichtet darüber am 18. Jänner 1787 an Frau von Stein: "Der Moment ist genommen, da Christus den Jüngern, mit denen er vergnügt und freundschaftlich zu Tische sitzt, sagt: Aber doch ist einer unter euch, der mich verräth."[4] Dreißig Jahre später sieht Goethe in dem Bilde nicht mehr die sich eben vollziehende, sondern die bereits vollzogene Verratankündigung. In seiner Abhandlung "Abendmahl von Leonard da Vinci" vom Jahre 1817[5] begründet er ausführlich diese Ansicht, es seien die "unglücklichen Worte" aus Christi Mund bereits gefallen und wirken jetzt als Aufregungsmittel fort, die ruhig heilige Abendtafel erschütternd, Christus selbst aber bekräftige und bestätige sie schweigend mit himmlischer Ergebenheit, durch die Bewegung der Arme und Hände, durch das Neigen des Hauptes, den gesenkten Blick. Nicht im Mailänder Refektorium, nicht vor dem Original ist Goethe zu dieser neuen Ansicht gekommen—hatte er es doch einmal nur und ganz flüchtig vor dreißig Jahren auf der Rückreise aus Italien gesehen—sondern in seinem Weimarer Arbeitszimmer, vor dem Stiche Raphael Morghens, der alles Prägnante, zur Deutung Unentbehrliche verwischt. Doch ist Goethes Autorität so groß, und seine Ausführungen selbst so bestechend, daß diese Deutung heute beinahe überall als die einzig richtige gilt.

Was mir an der Deutung Goethes unhaltbar erscheint, ist die Verurteilung Christi zu vollständiger Passivität und die Verschiebung des Schwerpunktes der Handlung auf die Schüler. Christus selbst wäre also demnach nicht handelnd gedacht, sondern lediglich ein Wagenlenker, der die Zügel aus der Hand fahren läßt. Was Leonardo stets anstrebt, was er nicht müde wird sich und seinen Jüngern als wichtigstes Postulat echt künstlerischer Komposition vor Augen zu halten, ist die Deutlichkeit, die scharfe Klarheit, die unzweideutige Bestimmtheit jeder Geste, Bewegung und Stellung.[6]

1. Fra Luca Pacioli, *Divina Proportione. Die Lehre vom goldenen Schnitt.* Neu hrsg. von Constantin Winterberg, Wien, 1889. Quellenschriften N.F. 2, 41.
2. *Del Cenacolo di Leonardo da Vinci libri quattro di Giuseppe Bossi pittore,* Milano, MDCCCX.
3. l.c. 162 sq.
4. *Tagebücher und Briefe Goethes aus Italien.* Schriften der Goethe-Gesellschaft, hrsgb. v. E. Schmidt, Weimar 1886, 2, 259.
5. *Ueber Kunst und Altertum,* 1817, S. 113-188. Hempel 28, 506.
6. Lionardo da Vinci, *Das Buch von der Malerei.* Quellenschriften 15 (I) § 294, 298, 325, 358, 368, 376, 409 und ö.

Die Bewegung, die Handlung als Äußerung des lebendigen Ein- und Zusammenwirkens der in jedem einzelnen beseelten Körper (animale) wirkenden Faktoren ist die schweigende und selbstverständliche Voraussetzung seiner Kunst. Denjenigen, an dem Leonardo seine Beobachtungen anstellt oder seine Vorschriften exemplifiziert, denkt er sich also immer handelnd, tätig eingreifend und nennt ihn deswegen auch "il proponitore, il parlatore, l'operatore," oder kurzweg "il motore."

Ein flüchtiger Blick auf alle Bilder und Skizzen Leonardos, die flüchtigsten und allerzweifelhaftesten nicht ausgenommen, genügt, um uns zu überzeugen, daß der Vorwurf seiner Komposition immer eine Handlung und zwar eine von der Hauptperson der istoria ausgehende Handlung ist; aber auch unter den Hunderten und aber Hunderten von Abendmahldarstellungen von den frühesten Anfängen bis auf die Kirchenbilder des XIX Jahrhunderts werden wir keine einzige finden, in der Christus nicht in bedeutender Handlung, sei es in real-historischem, sei es in symbolisch-sakralem Sinne vorgeführt wäre. Gestehen wir es offen: hätten wir nicht Goethes Ausführungen, die ja wie alles, was von ihm ausgeht, faszinierend wirken, wir müßten eine Abendmahldarstellung ohne tätig eingreifenden Christus für ein ästhetisches Unding erklären.

Ist die Verratankündigung an und für sich schon ein Motiv von zu schwacher Prägnanz, das höchstens durch ein forciertes Mienenspiel eine annähernd richtige Deutung ermöglichen, sonst aber leicht eine Verwechslung mit irgend einer anderen von einer bestimmten Handlung nicht ausgehenden oder unterstützten Ansprache während der Abendmahlscene herbeiführen könnte, so kann ich mir gar nicht denken, wie ein so kompliziert intimer Vorgang von rein passivem Typus und mystischer Innerlichkeit, wie ihn Goethe sieht, zum Ausgangs- und Mittelpunkte eines mächtigen Werkes mit dreizehn überlebensgroßen, beinahe sämmtlich leidenschaftlich erregten und bewegten Gestalten gemacht werden könnte. Ferner ist schwer einzusehen, wie die Arme Christi, so wie wir sie auf dem Bilde sehen, die Begleiter der eben erfolgten Verratankündigung sein können. Der von Goethe vermutete Vorgang setzt doch eine parallele, untätig ruhende Lage beider Hände und Arme voraus. Folgende Bemerkung Lionardos dürfte jedoch dieser irrigen Deutung endlich ein Ende machen:[7] "Sonno alcuni moti mentali sanz' el moto del corpo" und diese "lasciano cadere le braccia, mani et ogni altra parte che mostri vitta." Die von Goethe bei Christus angenommene Seelenbewegung, die schweigende Bekräftigung der vorhin ausgesprochenen Worte ist doch unzweifelhaft solchen "moti mentali" beizuzählen, die "sanz' el moto del corpo" sich abspielen, von der Bewegung des ganzen Körpers somit nicht begleitet werden. Ihr sinnlicher Ausdruck müßte demnach ein paralleles Herabsinken beider Arme und Hände auf die Tischfläche, oder deren ruhiges Aufliegen oder Falten sein, eine endende und keine beginnende Bewegung, und zwar von konzentrischer, der Mitte zustrebender Richtung. Inzwischen divergieren beide Arme in scharf ausgesprochenen Linien auseinander, wie zwei in verschiedenen Richtungen ausgesandte Boten, der linke Arm ist mäßig gespannt und vorgestreckt, die Linke öffnet die volle Handfläche mit ausgesprochen weisender "sprechender" Bewegung, die Rechte dagegen schiebt sich vor, mit der Handfläche nach unten, mit spinnenförmig geöffneten und gespreizten Fingern, bereit, irgend einen Gegenstand zu greifen oder zu fassen. Die Augen fixieren einen in der Richtung der weisenden Linken liegenden Gegenstand. Christus ist somit nicht der tote und passive, sondern der organisch belebende, der springende Punkt des ganzen Bildes. Er ist auf diesem einzigen Bilde nicht der schweigende mimische Reflex der

7. a.a.O. § 370. 1, 368/9: "Einige Gemütsbewegungen sind von keiner Bewegung des Körpers begleitet....Die ersteren bewirken, daß Arme und Hände herabsinken, und so alles, was Leben zeigt."

eigenen Worte, sondern der bestimmende Organisator des Ganzen, auch hier "der Quell des Lebens."

2. Dem gegenüber hat es Prof. Strzygowski doch versucht, von ikonographischen Erwägungen ausgehend und gestützt auf das von ihm unzweifelhaft richtig gedeutete, wenn auch nicht erschöpfte Zeichnungenmaterial nachzuweisen, Lionardos Wandbild bringe im Anschluß an die Worte des Evangeliums Matthäi 26.23 den Moment, wo die Entdeckung des Verrates durch das gleichzeitige Eintauchen der Hände Christi und des Judas in die gemeinsame Schüssel herbeigeführt wird.

Dieser Deutung kann ich schon aus dem Grunde nicht beistimmen, weil Christus natürlicherweise mit den Augen der der Schüssel zusteuernden rechten Hand folgen müßte, während er doch ganz deutlich Kopf und Augen in der Richtung der vorgeschobenen Linken gerichtet und gesenkt hält, ganz abgesehen davon, daß, was aus jeder guten Photographie, besonders aber aus der Ferrarios ersichtlich, zwischen der Schüssel und der Rechten Christi das halbgefüllte Weinglas steht, dem sie sich leise nähert, Judas' Linke dagegen, wie schon häufig bemerkt, nicht vorwärts, sondern folgerichtig mit dem ganzen Oberkörper rückwärts fährt. Auch Tizian sah an ihr die erstarrende Gebärde erschrockener Verwunderung und übertrug sie so in die Rechte des zur Rechten Christi sitzenden Jüngers auf seinem Emmaus-Bilde im Louvre. So kann ich denn mit dem hauptsächlich nur im negativ-kritischen Teile von Strzygowskis sehr interessanten Ausführungen übereinstimmen. Einige seiner treffenden Bemerkungen über die Technik und Tektonik des Bildes benutze ich unten.

Ich gehe jetzt zur Begründung meiner Hypothese über.

3. Drei Motive wirken in wunderbarer Harmonie zusammen, um Christus und seiner Aktion inmitten der vielgestaltigen, unruhig wogenden Schar seiner Jünger Geltung zu verschaffen, ihn als den Ausgangspunkt des Ganzen klar und deutlich vorzuführen und das Hauptmotiv zur überzeugenden Anschauung zu bringen. Es sind dies:

a) Licht und Farbe,
b) die figurale Komposition,
c) die Linearkomposition.

a) *Licht und Farbe.* Ein helles Licht mit sanften Uebergängen ergießt sich über das schneeweiße Tischtuch vor Christus; von links her einfallend, belebt und beleuchtet es das von Petrus Simon bis Philipp reichende mittlere Drittel des langgestreckten Tisches und erhellt die Mittelpartie der rechten Wand. Während Jacobus major, Christi Nachbar zur Linken, einem Schirme gleich das volle Licht auffängt, werden nur einige Partieen der Gestalt Christi von diesem voll getroffen; es sind dies aber die entscheidenden: die rechte Gesichtsseite, der Hals, die vorgestreckte Rechte mit dem weißen Hemdstreifen, am hellsten aber die linke offene Handfläche und die schimmernd blaue, leuchtende Fläche des quer über die linke Schulter und den linken Arm gezogenen Mantels. Dies tiefblaue, hell beleuchtete, von dem Tischrande, dem Mantel- und Armumriß gebildete Dreieck drängt sich immer bei Betrachtung des Bildes als vornehmster und stärkster Farbenfleck unseren Augen auf, dieser Eindruck wird noch durch die vielen parallelen oder in langgezogene Schlitze sich öffnenden, scharf beleuchteten Querfalten bedeutend verstärkt. Während so unsere Augen gleich beim ersten Anblick auf das Spiel der Hände und auf die linke Armlinie gelenkt werden, umleuchtet der Glanz des durch die offene Mitteltüre von hinten einfallenden Abendlichtes einer Aureole gleich das Haupt des Heilands und schafft ihm einen goldenen Nimbus, wie ihn kein zweiter Meister ersonnen!

Der Türpfosten, den man sich wohl nicht einfacher denken kann, fängt einem dunkeln Bilderrahmen gleich das Brustbild wirksam kontrastierend auf.

Diese mächtige, in der Mittelpartie des Bildes, folglich in Christi Gestalt sich summierende Licht- und Farbenwirkung wird noch durch die faktische und tatsächliche Beleuchtung wesentlich gesteigert, da ja das durch das erste,

etwa fünf Schritte von der Bildwand entfernte, hohe und schmale Wandfenster einfallende Tageslicht sich mit dem gemalten vollkommen deckt.

So erscheint die Gestalt Christi gleich einer Lichtsäule, denn der Künstler hat ihr als Sitz den Kreuzungspunkt zweier mächtiger Lichtströme angewiesen. Was für die Deutung und Bedeutung der Handlung Christi und somit des ganzen Bildes bestimmend ist, ist also schon durch Licht und Farbe besonders hervorgehoben.

b) Eines der augenfälligsten Merkmale der Gesammt-komposition dieses Bildes ist die Isolierung der Gestalt Christi. Gerade an einem Punkte, wo man es am wenigsten erwarten dürfte, schneidet eine tiefe Caesur in die Rhytmik der bis nun von links nach rechts ohne Unterbrechung fließenden Umrißlinie tief ein und trennt eigenmächtig, was bis dahin der Tradition und Kunstübung als unzertrennlich gegolten.

Wohl hat der Meister dem Johannes, diesem Idealbilde sprach- und ratlos trauernder Liebe, seinen bevorzugten Platz (hier zur Rechten des Herrn) bewahrt und ihn so im Einklange mit den Worten des vierten Evangeliums als den Lieblingsschüler charakterisiert, aber der unmittelbare Kontakt ist aufgehoben.

Der Strom einheitlicher Handlung, von Jacobus minor auf Petrus Simon, von diesem auf Johannes überspringend, Andreas und Judas mitreißend und bedingend und auf Christus zuschnellend, staut sich jetzt plötzlich und gleitet an Johannis Gestalt zu Boden. Gleich über der Tischkante streben nämlich unter einem Winkel von beinahe 75° in geraden Linien die Konturen Christi und Johannis auseinander, Johannes gravitiert mit Haupt, Oberkörper und Armen nach links, Christus in der entgegengesetzten Richtung.

Dieser tief einschneidende Hiatus der Umrißlinie springt umsomehr in die Augen, als sich zwischen Christus und Johannes der scharfkantige Fensterpfeiler einschiebt,

der, einem eingerammten Pfahle gleich, beide Massen auseinander zu treiben scheint und so beiderseits den Ausblick auf die wagerechten Wellenlinien der Campagna öffnet.

Ferner ist noch folgendes zu bemerken.

Während die zwölf Jünger sich in vollem oder Dreiviertel-Profil zeigen, sich gegenseitig überschneiden oder gar kreuzen, zeigt Christus allein den ganzen Oberkörper und zwar in voller Vorderansicht. Nichts ragt noch wagt sich herein, das die statuarische und doch freie Symmetrie des Linienflusses stören oder verletzen könnte. Treffend bemerkt Rubens: Christus sitze da "n'ayant personne qui le presse, ni qui soit trop près de ses côtez."[8]

Christus ist also isoliert, in statuarischer Abgeschlossenheit. Dieser Eindruck wird noch erhöht durch den schlichten Rundgiebel oberhalb der Mitteltüre, das Christi geistige Sphäre nach oben abgrenzend, sich über seinem Haupte als eine Art von tektonischem Nimbus wölbt. Ziehen wir die hier angedeutete Kreislinie fertig, so gewahren wir, daß ihr Mittelpunkt mit dem in der rechten Stirnseite Christi liegenden Augpunkte des ganzen Bildes sich deckt. Sie umschließt medaillonartig, gleich dem unnahbaren Kreise der mittelalterlichen Heiligenlegende, Christi Gestalt, ohne irgend eine der Nachbargestalten zu überschneiden: nur zur Linken Christi durchbrechen zwei Hände, gewaltsam eindringend, den magischen Kreis.

c) *Die Linearkomposition.*

Die Innenarchitektur des Gemaches, in dem Lionardos Abendmahl sich abspielt, ist wohl die einfachste unter allen, die wir auf italienischen Bildern des XV. und XVI. Jahrhunderts gewahren. Abgesehen von dem erwähnten primitiv-schlichten Rundgiebel über der Mitteltüre, scheint die runde, gebogene, geschwungene Linie für den Schöpfer dieses Bildes nicht zu existieren: überall gewahren wir nur gerade Linien, rechte Winkel, scharfe Kanten, Rechtecke, Quadrate, Trapeze.

8. Citiert bei Bossi S. 45 aus De Piles (1635–1709); das Werk ist nicht angegeben und nur mit den Jahreszahlen "1699–1715" bezeichnet. Ob damit

das "Abrégé de la vie des peintres" oder die ebenfalls 1699 erschienene "Idée du peintre parfait" gemeint ist, vermag ich augenblicklich nicht anzugeben.

Ohne hier auf einzelnes eingehen zu können, genügt zu bemerken: der geometrische Mittelpunkt dieses Bildes, dessen Höhe genau die halbe Breite mißt, fällt mit dem Augpunkte zusammen, der Verschwindungspunkt, was Strzygowski schon richtig erkannt, ist in der rechten Stirnseite Christi zu suchen; die Bodenstreifen, die kurzen Tischkanten, die oberen Ränder der acht größeren, gemusterten, und der sechs kleineren (linkerseits höheren), einfarbigen (?), an den beiden Seitenwänden ausgespannten Teppiche und die sieben Deckenbalken vereinigen sich zu einem System scharf ausgeprägter, perspektivischer Linien, deren augenfällige Deutlichkeit von verschiedenen hervorstechenden Punkten, so z. B. den Fensterwinkeln, den Endpunkten der Tischblöcke und den herabhängenden Tischtuchzipfeln, sowie von einigen besonders markanten Armlagen, Handbewegungen und Kopfstellungen auf das wirksamste unterstützt wird.

Ein Spinnengewebe von nicht weniger als zweiundzwanzig perspektivischen Linien überzieht netzartig die Bildwand. Dies abstrakt lineare System bringt in das Bild ein klärendes, ordnendes, konzentrierendes Element und schafft so aufs glücklichste einen wirksamen Gegensatz zu der unruhig wogenden Schar der Jünger, zu ihren erregten Gebärden und explosiven Bewegungen.

Wo immer das Auge des Zuschauers sinnend und staunend ruhen mag, von überall her, von unten und oben, von links- und rechtsher, aus allen Ecken und Winkeln wird es von diesen Linien zurückgeführt zu dem Grundmotive, *zum treibenden agens des Bildes, zu dessen geometrischem, perspektivischem und geistigem Mittelpunkte: zur Stirne Christi,* dem Sitze seiner Gedanken, dem Quell seiner heilverkündenden Worte und seiner wahrnehmbaren Handlung. Technisch Konstruktives setzt sich somit auch hier, wie immer bei Lionardo, in geistig Ideales um.

Aus dieser Masse will ich in diesem kurzen Auszuge nur drei Linienpaare herausgreifen, um ihren Lauf und ihre Funktionen näher zu analysieren.

Es sind dies vor allem die beiden Diagonalen, deren Lauf der obere Rand der vier Teppichpaare, die Innenwinkel der bezüglichen Seitenfenster und die Endpunkte der herabhängenden Tischtuchzipfel hervorheben; die rechtsseitige ist zugleich die Achse des rechten mit dem Ellbogen aufruhenden Vorderarmes des Judas, während die Gegenlinie in bezeichnender Weise die Fingerspitzen der beiden sich weit öffnenden Arme Jacobi des Älteren berührt.

Ferner sind zu beachten die senkrechte und die wagerechte Linie, welche das Bild der Breite, bezw. der Höhe nach halbieren. Erstere halbiert die obere Bildleiste, den Rundgiebel über der Mitteltüre und diese selbst, den Tisch sammt der vor Christus stehenden Schüssel, sie ist die mathematische Linie des mittleren (vierten) Deckenbalkens, sowie des dunkeln mittleren Bodenstreifens, sie ist aber zugleich auch die ideale Achse der Figur Christi, seines aufgerichteten Oberkörpers und des vorgeschobenen rechten Fußes, der, wie aus den Kopien (z. B. der aus Castellazzo) heute noch ersichtlich, als mit der ganzen Sohle auf dem dunkeln Streifen ruhend gemalt war. Die wagerechte Halbierungslinie fällt mit dem Horizonte des Bildes und den isokephal geordneten Köpfen Christi und der Jünger Bartholomäus und Matthäus zusammen und wird so zur horizontalen Norm der auf- und niederwogenden Wellenlinie der Apostelgestalten.

Ganz besondere Aufmerksamkeit beanspruchen aber die Funktionen der beiden perspektivischen Linien, die von den Achsen des zweiten und des diesem entsprechenden sechsten Deckenbalkens ausgehen. Sie sind für die richtige Deutung des Bildes sehr wichtig, vielleicht sogar entscheidend. Folgen wir ihnen genau. Erstere setzt sich, nachdem sie als Achse den zweiten Balken seiner ganzen Länge nach durchlaufen und den in der Stirne Christi liegenden Augpunkt passiert hat, also Achse seines vorgestreckten linken Armes und der mit der offenen Handfläche nach oben aufliegenden Linken fort und läuft bis zu dem runden mäßig großen Brodlaibe. Hier bricht sie plötzlich ab. Ihre natürliche,

geradelinige, ebenfalls nicht zu verkennende Fortsetzung findet die Achse des sechsten Deckenbalkens dagegen in ganz analoger Weise im rechten Arme Christi; sie endet in dem zur Hälfte mit rotem Weine gefüllten Glase, das zu ergreifen die geöffnete Rechte sich eben anschickt.

Nun werden wir plötzlich das geometrisch konstruktive Element in der Gestalt Christi gewahr. Seine Stirne ist, wie schon bemerkt worden, der geometrische, konstruktive und ideelle Brennpunkt des Bildes, in welchem die perspektivischen Linien strahlenförmig zusammenschießen, sein Körper ist die ins Organische umgesetzte Mittelachse des Bildes, seine beiden Arme sind zwei ins Organische umgesetzte konstruktive Augenlinien. So vollzieht sich die Umwandlung der absichtslos lebendigen Erscheinung in konstruktive Zweckmäßigkeit, die Steigerung des Realen zum Idealen, des Konkreten zum Absoluten. Die Mannigfaltigkeit der Bewegungen und Gebärden der Jünger läßt sich mit Worten wohl kaum erschöpfen, wir schauen hier Wunderdinge der Psychophysik, wie sie einzig und allein eine Phänomen, wie Lionardo erschaffen konnte. Wir sehen, den Gestalten von links nach rechts folgend, rasches Erfassen des unmittelbaren Vorganges neben fragendem Schauen und unwillig abwehrendem Erstaunen, heftig auf Antwort dringendes Befragen, schmerzerfüllte Gedankenabwesenheit und banges Erstarren; und dann wieder den explosiven Ausdruck des Enthusiasmus, der sich in einem Aufschrei entladet und die Versicherung selbstlosester Hingabe, neben zudringlich fragender Einwendung, endlich jugendlich-leidenschaftlich aufforderndes Hinweisen, unentschlossenes Zuraunen und rasche energische Gegenäußerung. Aber alle diese Bewegungen sind flüssig, momentan, wie zufällig, das Auge des Künstlers scheint sie in einem unbewachten Augenblicke erlauert und erhascht zu haben, ohne daß das Urbild bei dieser Uebertragung auf dem weiten Wege von der Netzhaut durch den Arm zum Pinsel auch nur ein Atom von seiner frisch pulsierenden Vitalität eingebüßt hätte. Selbst der schärfste Beobachter, der feinste

Sprachkünstler müßte es sich schließlich versagen, der unmittelbaren Lebensfülle dieser zwölf Gestalten mit Worten beizukommen. Grundverschieden ist die Bildung der Gestalt Christi. Ihr Element ist eine vorbedachte Konstruktion, eine beabsichtigte und wohlüberlegte Tektonik von der primitiven Einfachheit des gleichschenkligen Dreiecks. Die beiden Armachsen, die wir soeben als Fortsetzungen der zwei Balkenachsen erkannt haben, bilden die Schenkel, die Gerade, die wir uns von der linken Handfläche zur rechten gezogen denken, bildet die Basis dieses Dreieckes; sein Scheitel liegt in der rechten Stirnseite Christi und deckt sich somit mit dem Mittel- und zugleich dem Verschwindungspunkte des Bildes; die von diesem Scheitel gefällte Senkrechte (die Höhe des Dreieckes) deckt sich mit der Mittelachse des Bildes, von der die beiden Arme unter dem gleichen Winkel von ungefähr 30° abstehen.

Durch dies konstruktive und tektonische Element unterscheidet sich die von diesem durchaus bedingte Gestalt Christi aufs allerentschiedenste von den zwölf Gestalten der Jünger. Wer die konstruktiven Linien dieses Bildes, das Bleibende und Feste in dieser Erscheinungen Flucht verfolgt, der muß sie auch in der Gestalt Christi wiederfinden. Erst dadurch, daß uns auf diese Weise Christi Gestalt in der gebundenen Freiheit, als organische Konstruktion, als lebendige, fühlende, agierende Tektonik sich äußert, hebt sie sich aus der Masse der konkret sinnlichen Erscheinungen durch die absolute Form zur höchsten, idealen Sphäre empor.

So erhebt denn der Künstler die Gestalt Christi durch deren Beleuchtung, Isolierung und tektonische Bildung über alle anderen und zwingt das Auge, von ihr in der Betrachtung des Bildes auszugehen, zu ihr stets zurückzukehren; die perspektivischen Linien der Armachsen bringen es auf die zur Deutung führende, richtige Spur.

Diese Spur führt uns also zur Annahme, daß wir hier die Darstellung der mit Hinweis auf das Brot beginnenden Einsetzung des heiligen Abendmahles vor uns haben.

Ist diese Annahme richtig, so müssen die Gebärden der

Jünger dazu stimmen. Aus diesen entnehmen wir aber vor allem eines mit voller Sicherheit: sie alle sind abhängig, beeinflußt, bedingt von einem "Etwas," sie handeln nicht aus primären Impulsen: sie reagieren. Und dieses "Etwas," auf das sie reagieren, ist ein zweifaches, eines, das noch stark *nachwirkt*, und ein zweites, das unmittelbar *einwirkt*, ein bereits *Geschehenes* und ein *Gegenwärtiges*.

Daß ersteres nur die Worte Christi "Unus vestrum me traditurus est" sein können, ist klar. Ist ja die Gebärdensprache Simonis Petri doch zu deutlich, um nur die Möglichkeit irgend einer anderen Deutung zuzulassen; hätten wir auch nicht die betreffende Textunterlage im Johannesevangelium 13, 24, so müßten wir uns selbst ähnliche Worte hinzudichten.

Was mag aber wohl das zweite Motiv sein? Sicherlich ein unmittelbar eben jetzt sich abspielender Vorgang, ein Ereignis, das die Nächsten, die es sehen und hören, zu den erregtesten und heftigsten Äußerungen hinreißt. Zur Linken Christi lodert das Feuer einer neuen Bewegung: ebendahin, wo Christus hinblickt, starrt auch Jacobus major, der enthusiastische Choleriker, aufschreiend und seine Arme in erschauernder Bewunderung weit ausbreitend, dahin weisen auch Matthäi parallel ausgestreckte Arme und dahin richtet Bartholomäus, sich vorbeugend, seine Blicke. Von Letzterem abgesehen, ist die linke Tischhälfte noch mit den vorhin ausgesprochenen Worten Christi beschäftigt, während die rechte Seite zur unmittelbaren Augen- und Ohrenzeugin der Einsetzung des Abendmahles wird.

Wir sehen den Höhepunkt der ersten Hälfte der Einsetzung. Im nächsten Augenblick wird Christus langsam die Linke zurückziehen, den Kopf rechtshin wenden: denn schon schiebt sich die rechte Hand vor und bereitet sich zum Ergreifen des Weinglases. Ein Griff, und Christi Mund wird sich öffnen und verstummen werden auch auf dieser Seite der Tafel die Fragen und Zweifel über Verrat und Verräter, und Johannes wird sich vielleicht, erwacht aus schmerzerfülltem Brüten, ähnlich wie jetzt Jacobus major,

in inbrünstiger Liebe dem Heilande zuwenden, während dieser die Worte wird vernehmen lassen: "Trinket alle daraus. Das ist mein Blut des neuen Testamentes, welches vergossen wird für viele zur Vergebung der Sünden."

Dies ist meine Anschauung über das Abendmahl Lionardos in Sta. Maria delle Grazie.

Ein Blick auf den Stich Raffael Morghens genügt, um uns über den Ursprung von Goethes Deutung aufzuklären: Christi Augen blicken abwärts ins Unbestimmte, die Linke hat ihre Richtung und Anspannung verloren und liegt kraft- und bedeutungslos da, das Brod ist aus der Augenlinie, die uns ein verläßlicher Wegweiser war, gerückt; das Weinglas, nach dem auf dem Bilde die Rechte greift, fehlt gänzlich, so daß aus der bewußt auf ihr Ziel lossteuernden Hand nur die starr sinnlose Grimasse der Gliederpuppe geblieben ist. So hat nun Goethe, als er ernstlich an die Analyse des Werkes ging, ein gefälschter Text vorgelegen; er selbst hat ganz richtig gedeutet, aber nicht den Urtext, nicht das Abendmahl Lionardos, das er nur flüchtig dreißig Jahre vorher von Angesicht zu Angesicht geschaut, sondern den Text, den er eben vor Augen hatte, den damals vielbewunderten Stich Morghens, den er doch für eine wenigstens in allem Wesentlichen treue Wiedergabe des Originals hielt und zu halten voll berechtigt war.

Zweifel an der Richtigkeit meiner Deutung könnte aber wohl der Umstand wecken, daß Christus die Einsetzung des Abendmahles mit der linken Hand und in der Richtung nach links vornimmt, bezw. beginnt. Dem gegenüber läßt sich die Tatsache feststellen, daß Leonardo (mit Ausnahme der aus seiner allerfrühesten Jugend stammenden Verkündigung im Louvre) in allen Gruppenbildern die Handlung von der Linken ausgehen, oder in der Richtung nach links sich entwickeln läßt: mit der Linken und von links her (vom Standpunkte des Bildes aus) empfängt der Christusknabe das Weihgeschenk aus den Händen des greisen Königs auf der

Anbetung in den Uffizien, nach linkshin nach diesem schon auf der vorbereitenden Skizze im Louvre, die Linke streckt segnend die Grotten-Madonna über das Haupt ihres Kindes auf dem Pariser Bilde, nach links hält die göttliche Mutter auf dem herrlichsten Karton der Welt, dem der Londoner Royal Academy, das Kind dem Johannesknaben entgegen, welches, diese Richtung fortsetzend, wieder nach linkshin segnet;—ebenso sehen wir auf dem Bilde der Muttergottes selbdritt im Louvre (und ähnlich auch auf den anderen von dem Londoner Karton abhängigen Schul- und Atelier-bildern) die Madonna mit beiden in ihrer ganzen Länge nach links gestreckten Armen das Kind dem Lamm entgegen-halten. Das nächstliegende Analogon sind aber sicher die beiden auf dem bekannten Windsorer Blatt mit rascher Hand hingeworfenen Skizzen zum Abendmahl selbst, auf denen Christus—besonders deutlich ist dies auf der zweiten tiefer unten angebrachten zu sehen—quer über den Tisch mit der Linken und nach links hin dem rasch von seinem Stocksitze sich erhebenden Judas (im Anschluß an die Worte des Evangeliums Joh. 13, 24) den eingetauchten Bissen reicht.

Und so hat nun der Meister auch diesmal der linken Hand, der vertrauten und folgsamen Vollstreckerin seiner künstlerischen Absichten und Gedanken die hehre Aufgabe anvertraut, in klarer, anschaulicher, unzweideutiger Weise die Handlung einzuleiten. Statt also eines gegen meine Hypothese sprechenden Umstandes vermag ich in dem leise nach links gewendeten Haupte und Blicke, in der linken und nach links hin sich streckenden und weisenden Hand nichts anderes zu erblicken, als einen nicht zu unterschätzenden Beweis, daß per analogiam auch hier in diesem Bilde, an dem Punkte, wo die Linke tätig eingreift, der Herd eines tatsächlichen, unmittelbaren Geschehens zu suchen ist, eines Geschehens, daß im gegebenen Falle eben nichts anderes ist noch sein kann, als die Einsetzung des Abendmahles.

APPENDIX C

The Identification of the Apostles

THE SEQUENCE OF APOSTOLIC NAMES which Bossi found lettered on a fresco copy of Leonardo's *Cenacolo* in the parish church at Ponte Capriasca near Lake Lugano (App. E, no. 14) established the now familiar nomenclature. Reading from left to right according to seating arrangement: Bartholomew, James Minor, and Andrew; Peter, Judas, and John; then, on Christ's left, James Major, Thomas, and Philip; finally, Matthew, Thaddeus (alias Jude), and Simon.

But, *pace* Bossi and Goethe, what authority attaches to Ponte Capriasca? Bossi discovered the date 1567 on one of the interior arches of the church and reasoned that it must refer to the consummation of some major project, such as the fresco. Subsequently, a Swiss scholar claimed to have read the date "1547" inscribed on the painting itself, and this earlier date was accepted by Möller as the more probable, even though, with the fresco's deterioration, the inscription could never be found again. Meanwhile, a local tradition ascribed the fresco to a young painter on a visit from Milan in the 1520s, and this was the date accepted by Gustavo Frizzoni (1890, pp. 187–91), who attributed the work to Leonardo's pupil Giampietrino. Earlier authors had given it to Pietro Luini, son of the better-known Bernardino Luini.

Whoever this unknown turns out to have been, the question remains whether he was following a vital, authentic tradition, or doling the names out at random. Long years of study (1965–73) convinced me that the Ponte Capriasca designations are sound, that Bossi and Goethe were right to accept them, and that modern attempts to reshuffle (as by Möller, Heydenreich, and others) are misguided.

The proposed changes focus on two pairs of Apostles—Philip and Bartholomew, and the two Jameses. Möller (1952, pp. 54–55) argued that it is not St. Bartholomew but St. Philip who stands at the left end of the table. The argument had been made long before by the Abbé Guillon (1811) on the following grounds: at the Feeding of the Multitude (John 6:5), it is to Philip that Christ puts the question, "Whence shall we buy bread that these may eat?" It follows that *Philippe fut en quelque sort le pourvoyeur de la table de Jésus-Christ*. Möller concurs and appoints Philip to the role of steward (*Schaffner*). He observes that the bearded man at far left seems to be dressed in a sort of apron (actually a paludamentum or pallium), designed, he says, to leave the right arm free for serving, while his right hand holds a napkin (visible in some early copies but not in others), which "probably served to clean the table and sweep up the crumbs since the meal was already finished" (p. 55). Thus the attentive watcher at the far left must be hosting the supper, and this role can be assigned to none other than Philip. "A man of Leonardo's practical turn of mind" (*der praktisch denkende Leonardo*), says Möller, "would not have let slip such an opportunity to characterize a disciple."

Möller forgot that Jesus had sent two other disciples to town to procure the provisions for the forthcoming Passover meal (Mark 14:13–16, Luke 22:8–12). Moreover, the notion of sweeping up crumbs from a mensa on which bread had been consecrated seems somewhat lame. But, then, Möller subscribed to that former majority view which denied Leonardo's *Last Supper* any association with the sacrament.

Möller's corollary argument for denying the ardent youth, fourth from the right, the identity of St. Philip is even less persuasive. The very prominence Leonardo gives to this figure confirms the Capriasca identification. In the Gospel account, it is Philip whose question at the Last Supper elicits Christ's declaration: "He that sees me has seen the Father...." Philip, furthermore, is a Florentine patron saint, and the relic of his left arm, brought to Florence in 1190, was venerated in the Baptistery. (See Francesco Albertini's paralipsis in his *Memoriale...di Florentia*, Rome, 1510: *Non fo mentione del braccio di sancto Philippo & altre reliquie di Sancti riccamente adornate.*) The arm bone inhabits a fifteenth-century reliquary surmounted by a Donatellesque statuette (preserved at the Museo dell'Opera del Duomo). The statuette (Fig. 37), along with Nanni di Banco's earlier statue at Or San Michele (Fig. 36), suggests that the young Philip's physiognomic type had become something of a tradition in fifteenth-century Florence (see p. 76). Bossi adduced other arguments to show that the Leonardo figure is fully in character. Finally, left in place, Philip joins James Major and Thomas in a group of three Florentine patron saints next to Christ. Thus the identification of Philip as given at Ponte Capriasca remains satisfactory and has not been bettered.

The attempt to unseat James Major is equally ill advised. It rests on the notion that Leonardo would always have paired sharers of a common feast day. Now it is true that Thaddeus and Simon, the old comrades at the far right, share October 28 as their saint's day; but as we have seen (p. 79), they share more than that. Hence their coupling cannot be taken as proof that calendric coincidence was Leonardo's overriding consideration in seating them side by side.

The other pair with a common feast day (May 1) are Philip and James the Less. Familiar as that feast used to be ("...his child is a year and a quarter old, come Philip and Jacob," says Mistress Overdone in *Measure for Measure*), we need evidence to persuade us that Leonardo grouped his Apostles according to their place in the calendar rather than by their personalities, destinies, and ties of blood.

The joining of James Minor and Philip can be effected in one of two ways, and both have been tried: either by identifying Philip with the terminal figure at left—so that he neighbors our James Minor; or else by assigning James Minor's identity to the Apostle who sits first on Christ's left. In this infelicitous shuffle, the heroic figure with outflung arms becomes the meek James the Less, adjoining a beardless Philip whose designation stays fixed.

But the stalwart Apostle with the spread arms conforms better to the militant personality of James Major. As one of Christ's favorite disciples (the others being Peter and John), James' proximity to Christ is appropriate. And if Leonardo respected brotherhood—as he did in associating Thaddeus and Simon and again Andrew and Peter—then there is perfect aptness in his seating James Major and John, the sons of Zebedee, on either side of their Lord. Bossi (1810, p. 101) was right to observe that they are seated here as their mother (possibly Mary Salome, the Virgin's sister and her comforter at the Crucifixion) had prayed: "Grant that these my two sons may sit, the one on thy right hand, and the other on the left, in thy kingdom" (Matt. 20:21).

Let this suffice to plead for the soundness of the Ponte Capriasca identifications.

WHEN THE ABOVE WAS WRITTEN three decades ago, some of the apostolic identities were still in dispute. Since then, the Ponte Capriasca nomenclature has settled in, and the matter seems closed.

The Castellazzo Fresco
and the Certosa Canvas at Odds

A DIRGE for the Castellazzo fresco (Fig. 136), destroyed during the three-night bombing of Milan in August 1943.

The work measured about three-quarters the size of the original mural (338 x 674 cm). It was painted for the refectory of the Hieronymite monastery just outside Milan, and it is the only early copy of monumental scale whose dating rests on more than stylistic grounds: on the exterior wall of the refectory, Bossi (1810, p. 135) found an inscription that recorded the completion of its renovation in 1514. Bossi surmised that the renovation would have included the refectory's fresco, which, accordingly, must have been painted during Leonardo's second Milanese period (intermittently from June 1506 to July 1508, thereafter continuously until September 1513).

Shortly before 1790, the Castellazzo monastery was suppressed and the fresco made accessible to the public—including Bossi, Teodoro Matteini (whose *Cenacolo* drawing Raphael Morghen engraved), and Stendhal, who admired the work for its high quality and freshness of preservation. In 1832, before the monastery was razed, the fresco was taken off its wall in three parts, damaged in the process,

patched up, and deposited in the Brera. In 1891, Giuseppe Bertini, then the Brera's director, had it transferred to canvas, "restored to its original aspect," and transported to the Grazie refectory.[1] A photograph taken of the refectory in c. 1900 shows the Castellazzo copy hung on the east wall, at right angles to the Leonardo (Fig. 137).

Since the origin of this unsigned work is undocumented, its authorship remains conjectural. One assumes that the commission would have been entrusted to one of the master's pupils or to a capable follower. Which one? The name of Leonardo's disciple Marco d'Oggiono had long been loosely attached to this fresco, as to several other copies, but by c. 1890 critical scholars hoped to do better. Bertini assigned the work to the Milanese Andrea Solario (c. 1465–1524), an artist not otherwise known as a fresco painter, but the attribution has stuck.[2]

For twenty-five years, the Castellazzo copy graced the Grazie refectory, enjoying the high reputation for authenticity which, a hundred years earlier, had made it serve the reconstructions of Dutertre, Matteini-Morghen, and Bossi (Figs. 14, 26, 180).[3] Following World War I, it was removed

1. See Gustavo Frizzoni in *Archivio Storico dell'Arte*, 7 (1894), p. 41; idem, *L'Arte*, 2 (1899), p. 158; Möller 1952, p. 150.
2. Bertini's attribution of the Castellazzo fresco to Andrea Solario was seconded by Frizzoni (1894), accepted by Kurt Badt (*Andrea Solario*, Leipzig, 1914), Berenson (1932 Lists, s.v. Solario), Horst (1930–34), and Fernanda Wittgens (as on p. 220 n. 4). But Luca Beltrami had ascribed the work to Cesare da Sesto; Möller gave it to Giampietrino (again, not known to have painted in fresco). The Solario monograph by Luisa Cogliati Arano (1966)

questions the attribution but seeks no alternative, a lack supplied in Alberici/De Biasi (1984, p. 72, no. 63), where the Castellazzo copy is flatly called "opera di Marco d'Oggiono." David Alan Brown (*Andrea Solario*, Milan, 1987, p. 153) makes an interesting case for upholding the generally preferred Solario attribution.
3. For the dependence of Bossi's "reconstruction" on Castellazzo, see his p. 169: *Disegnai in appresso diligentemente le teste tutte, molte mani, alcuni panneggiamenti e tutto il di sotto della mensa della copia di Castellazzo.*

to the monastery library, and there, stored with the copy by Paolo Lomazzo (Fig. 158), it perished in 1943, leaving behind only one black-and-white photo.[4]

The Castellazzo fresco—the only large early copy whose date falls securely within Leonardo's lifetime—is one of several in competition for top fidelity status. It has lately been losing out to two candidates that have the advantage of material presence: the full-size canvas in the Abbey at Tongerlo (now in its Da Vinci-Museum), near Antwerp (Fig. 154), and the similarly scaled topless canvas from the Certosa di Pavia owned by the Royal Academy, London (Fig. 145). But the latter's origin is obscure; at Pavia it is not recorded until well past 1600. (The Tongerlo copy is first documented in 1545.)

My present concern is the design of the pavement: I want to know whether Leonardo had centered Christ's feet on a central, axial stem, or floated them over blank ground. In the Castellazzo photograph, the floor articulation is only faintly discernible, but it is unmistakable in Bossi's description (1810, p. 135): "The pavement is of a vivid red, interrupted from top down by five green stripes" (*Il pavimento è di un rosso vivace interrotto d'alto in basso da cinque strisce verdi*). In other words, the floor design matched the membering of the ceiling, showing one band on the median, two more on each side. The alternative pattern, with a total of six parallel bands converging about a blank center, is represented by the rivals in London and Tongerlo.[5]

While the detached Castellazzo fresco hung in the Grazie refectory, a generation of scholars and amateurs, viewing the original and its derivative side by side, pronounced Castellazzo the truest of all known copies. For Gustavo Frizzoni in 1894, it was "the most admirable and closest to the original." Hoerth (1907, p. 236) wrote: "everything in this copy testifies to great care in striving to do justice to every detail of the model." Two years later, the Munich painter Friedrich Schüz—after repeated discussions with Prof. Cavenaghi, who had just completed a once-famous restoration of Leonardo's mural—reported: "Leonardo admirers will be happy to hear that the meddlesome copies [the pre-1908 photograph of the refectory, Fig. 137, shows half a dozen of them scattered about] have been removed to be housed in a separate exhibition space.... Only Andrea Solari's [*sic*] copy from the monastery at Castellazzo, recognized as the most faithful, is to remain."[6]

So then, while Castellazzo had a physical presence which daily passed the test of comparison with the original, it was highly esteemed. Now that its image lingers only in a dismal old black-and-white, its standing as a clue to Leonardo's lost labors has plummeted. Where the Castellazzo pavement design differs from the Certosa-Royal Academy copy (recently cleaned in Milan by Brambilla), the vote of confidence goes to the latter.

Not that the Certosa copy has been spared its own ups

4. In 1954, when Mauro Pellicioli completed his post-World War II restoration of Leonardo's mural, Castellazzo received one last plaudit. Cleaning the landscape background, Pellicioli discovered traces of a river's blue water. These, he thought, confirmed Castellazzo's fidelity. Fernanda Wittgens, the art historian who oversaw the 1950s restoration, agreed: *Questo particolare ritrovato ha confermato la diligenza della copia [di Castellazzo]....Tale copia di vastissime dimensione, conservata da decenni nella Biblioteca dei Frati, avrebbe potuto costituire l'elemento fondamentale per 'fare il punto' nelle polemiche riguardanti la conservazione del Cenacolo; essa, infatti, confrontata con l'originale dopo il restauro, poteva servire da supremo collaudo del miracolo compiuto da Mauro Pellicioli* (Fernanda Wittgens, "Restauro del Cenacolo," *Leonardo: Saggi e Ricerche*, Rome, 1954, p. 10).

The relic of Leonardo's own landscape background as revealed in the

most recent restoration does not support the above; it suggests that deviant panoramas were freely invented by every one of the copyists, no two of whom invent alike.

5. The lowermost zone of the mural must have gone blank before the mid-sixteenth century. Accordingly, all early copies, including the most respected, such as the signed Cesare Magni panel (Fig. 150), make free with the floor design. The Dutertre drawing of 1789–94 in Oxford, which Heydenreich published in 1965 (App. E, no. 47), claiming it to be the most accurate of *all* copies known, invents a network of squares, with one central stripe flanked by five more on each side.

6. *Münchner kunsttechnische Blätter*, May 11, 1909, p. 68. For Schüz's own copy of the *Last Supper*, 1908, see Hüttel 1994, p. 26 and fig. 23. The work also appears in Marani 1999, p. 44, but mislabeled as the Castellazzo copy.

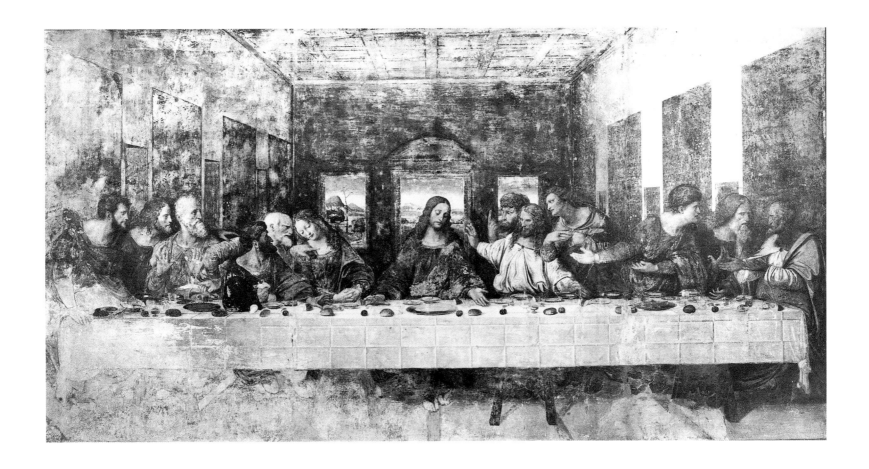

136. Andrea Solario (attrib.), c. 1510,
from the monastery at Castellazzo.

and downs. We don't know where it came from. On stylistic grounds, the picture is now dated around 1520. But despite its hugeness and quality, no sixteenth-century description of the Certosa's art treasures mentions it—the work is first documented in 1626. Sometime before that late date, the canvas was brought, perhaps from a lesser Carthusian foundation, to the glorious Charterhouse of Pavia, where, according to testimonies gathered by the Abbé Guillon (1811; quoted in Hoerth 1907, p. 191 n. 110), it was exuberantly admired. *Bella quanto l'originale*, writes a guidebook of 1671. The Carthusians prided themselves on possessing a jewel equal to the original owned by the Dominicans in Milan. After 1784, following the wholesale suppression of monastic establishments under the enlightened Emperor Joseph II, the picture was auctioned off. The purchaser was a Milanese citizen, who let it be hung in the new Accademia di Belle Arti (Palazzo di Brera), from 1801 under the energetic directorship of Giuseppe Bossi.

It was then that the fidelity contest between the Castellazzo fresco and the Certosa canvas was joined. The dilemma became inescapable: which of these two early copies—both at hand in Milan, and both by old misattribution ascribed to Marco d'Oggiono—deserved the more trust? Since they displayed radically different floors for Christ's footing, only one could be faithful to Leonardo, unless both betrayed him. To this quandary there was no ready answer, none forthcoming from the wretched state of the mural.

We need not suppose that the uncertainty about how the picture touched bottom worried more than a handful of sticklers. But the timing is crucial. The crisis came at a moment when the technique of reproductive engraving had reached new heights of precision. What Goethe had ardently craved when he wrote in his Roman diary, December 2, 1786—"If only there were some means of fixing such images firmly in one's memory!"[7]—was about to be realized. No matter how murky the condition of a given Old Master painting, there would soon be prints that rendered every dimness in it decisive and clear. One brave attempt at a reliable multiple record of the *Cenacolo* had just come to nought—Dutertre's preparatory drawing of 1789–94 (App. E, no. 47) never did reach the copperplate. Almost immediately after, two champions came forward to deliver the prize: Raphael Morghen in Florence and the Swiss G.G. Frey, domiciled in Milan. Their definitive work, it was hoped, would perpetuate Leonardo's design.

And so it did—for much of the nineteenth century, without, however, resolving the aforementioned quandary. In fact, the engravings of Morghen and Frey (respectively 1800 and 1803), institutionalized the Castellazzo-Certosa divergence. Since the lower center of the original mural had long before given way to a large Baroque door (1652), and since no vestige of Leonardo's pavement survived to 1800, the engravers had no choice but to follow this or that copy. Morghen, basing his famous engraving on a (lost?) drawing by Teodoro Matteini, relied indirectly on the fresco copy then still *in situ* at Castellazzo. Frey's engraving conformed to the canvas from the Certosa.[8] The effect of this double boon, regarding the pavement alone, was the promulgation of alternative systems—one with a floor that mirrored the ceiling and a centerline leading up to Christ's feet, the other without.

For the next hundred years or so, the Castellazzo model prevailed, thanks in part to the wild success of the Morghen engraving, in part to the detached fresco's privileged situation in the Grazie refectory. Whereas the Certosa copy, by 1818, was packed off to England for sale. There, in 1821, it

7. Goethe, after admiring the Sistine Ceiling, *Italian Journey*, trans. W.H. Auden and Elizabeth Mayer, New York, 1968, p. 134.

8. A drawing in the British Museum (Fig. 184) has been plausibly identified as Frey's work, preparatory for the print (partially reproduced in Hoerth 1907, pl. XXII).

was bought for the Royal Academy—"rescued from a random pilgrimage by the courage and vigilance of our President, and by the Academy made our own," as Henry Fuseli put it in 1830 in a public lecture on Leonardo's *Last Supper*.[9]

The Academy's copy had of course been purchased as a Marco d'Oggiono. Half a century later, Jean-Paul Richter demurred: "The author of this valuable picture is far more likely to have been Gian Pietrini, a very clever pupil of Leonardo's."[10] Both candidacies were squelched when Möller decreed: "There cannot be the least doubt that it is the work of Beltraffio" (1952, p. 138).[11] Recent research vindicates Richter: the Certosa copy is now positively a Giampietrino (see App. E, no. 6).

The Royal Academy never had the facilities for a decent display of the picture. Around 1970, when I requested to see it, the canvas had to be hauled out of storage, a dusty sight. Since then, it has come up in the world, up at the eminence of a seesaw, opposite Castellazzo. Following Brambilla's lustration, it was not reinterred, but bestowed in a five-year (extendable) loan upon Magdalen College, Oxford (1993). The world—or the portion of it that attends to such matters—now takes its veracity as a given. Where Eichholz's *Cenacolo* monograph refers to the two variant pavement designs (1998, p. 153), the blank-center alternative is declared to be that of the Certosa-Royal Academy copy *and of the original*. That Leonardo's solution might still be moot is not allowed.

Reverting to the original mural. At my last visit to the Grazie refectory (May 1998), Pinin Brambilla and Pietro Marani, the art historian in charge, assured me that the Castellazzo-Morghen midline under Christ's feet must be dismissed as fallacious—Leonardo's own floor stripes must have converged about a blank middle, the way they do in the Certosa, Tongerlo, Magni, and Hermitage copies. Over the mural's threshold, at lower right, the removal of overpaint had uncovered two pairs of incised orthogonals, and these were to settle the issue. Marani produced a string with which we measured the distance between the two pairs of incisions. That distance applied toward the center did not reach the median, confirming the Certosa-Tongerlo solution. But, though I tremble to disagree with friends who have long lived so close to the work, is there sufficient reason to attribute those crude partial incisions—which do not recur on the left side of the mural—to Leonardo? Could these incisions be the trace of an early restorer following the Certosa model as he tried to return a semblance of receding floor to the void he was facing? And if it was indeed Leonardo who incised these converging floor lines, could they not—like most of the other incisions uncovered by the restoration—point to an early phase of the project which the master rejected? (cf. Brambilla/Marani 1999, pp. 359, 369).

In *Leonardo: L'Ultima Cena*, Marani (1999, p. 92 n. 47) refers to Leonardo's original pavement design as no longer a problem—except for the minor nuisance of allaying my personal qualms. He recalls that he showed me the evidence of the newfound incisions at lower right, and explains what might have caused me to misconstruct Leonardo's pavement with a midline under Christ's feet. I had been, he suggests, "led astray by the Morghen engraving" (*Lo Steinberg . . . è stato tratto in inganno dall'incisione del Morghen*—the sentence does not appear in the English edition, Chicago, 2001, p. 78). But this trivializes the issue. The thing that urgently needs explanation is not an alleged misstep of mine, but what would have led Morghen in the late 1790s astray.

Here the answer is known: Raphael Morghen, penned in his Florentine shop, engraved after a meticulous drawing

9. Henry Fuseli, "On the Prevailing Method of Treating the History of Painting, with Observations on Lionardo's 'Last Supper'" (Lecture XI), in John Knowles, *The Life and Writings of Henry Fuseli*, London, 1836, III, p. 8.

10. J.P. Richter, *Leonardo* (1880), 2nd ed., London, 1884, p. 26.
11. In academic prose, the words "doubtless," "undoubtedly," "not the least doubt" invariably introduce a debatable proposition.

produced in Milan by the excellent Teodoro Matteini. So then we restate the question. What was it that led Matteini (and ten years later Giuseppe Bossi) astray? Again we know. It was their reliance on the fresco at Castellazzo, an answer which at last deposits us at the critical question: what, in 1510, led Solario, the presumed Castellazzo painter, astray? On what sort of impulse, by what license, under what prompting, would Solario have altered Leonardo's design, before the copies that displayed the alternative pattern existed, and when his charge was to make his simulation precise?

To recall what is at stake. The copies under consideration, preeminently Castellazzo versus Certosa, represent two major projects, probably executed about ten years apart, one now attributed to Solario, the other to Giampietrino, both followers of Leonardo. The Milanese Andrea Solario was an independent master, some dozen years younger than Leonardo and in his unfolding career increasingly under the senior's spell. The phases of his development are plotted in David Alan Brown's *Solario* monograph (Milan, 1987). Brown points out that Leonardo (after two years of inconstant shuttling) was resettled in Milan by the summer of 1508, i.e., during the period preceding Solario's move to France, and while both men were employed by the same high-ranking French patrons. "It is to be presumed," he writes, "that Andrea had access to the works that were in progress in Leonardo's studio" (p. 97). If so, Leonardo presumably knew what Solario was just then doing at Castellazzo.

As for the still somewhat mysterious Giampietrino—presently the unchallenged author of the Certosa copy—he had apparently been a live-in disciple during Leonardo's first Milanese period. Thus both painters, Solario and Giampietrino, knew or had personally known Leonardo when they received their commissions to replicate the *Last Supper*. But one of them altered the master's design. Was it Solario in c. 1509–10, doing it while Leonardo was on the scene, or Giampietrino in a subsequent decade after Leonardo's departure for France?

The alterations which one or the other inflicted are not insignificant. If, in accord with the present majority view, we take Giampietrino, the Certosa painter, to have rendered the blank-center pavement correctly, then it was Solario at Castellazzo who altered the system, tampering with the nadir to incur consequences such as the following: *(a)* a thoroughgoing vertical axis; *(b)* exact correspondence in the respective articulations of floor and ceiling; *(c)* Christ's arms, already aligned with two ceiling beams, now further aligned with two flanking floor bands down to the threshold (p. 58); *(d)* in the conjunction of Christ's feet with the median floor band an intensified intimation of feet destined to crucifixion; *(e)* that same floor band now a rich triple pun—a palpable perpendicular that reads as horizontal recession and re-erects symbolically into the stem of the cross (p. 66).

I see these "consequences" as structural and as compressors of meaning. Was it Solario at Castellazzo who introduced them—inadvertently or by design; whereas Leonardo in the Grazie refectory had used a less knotted system?

Let me venture a conciliatory fantasy. Suppose Leonardo himself had weighed both alternatives, had, in the 1490s, opted for the blank center solution, and was now, fifteen years later, coaxing Solario to give the unused variant a try. Leonardo would, in effect, have it both ways, creating a situation not unlike that posed by the two versions of the *Madonna of the Rocks*. Only this much is certain: if, in respect to the feet and the pavement, the Castellazzo fresco departed from the original, then its ominous midline must have been either contrarious or approved by the master.

Suppose Solario changed the original system with Leonardo's blessing, or at Leonardo's behest. Not a seductive scenario—no evidence for it whatsoever. But what are our choices? If we maintain that Leonardo had composed his *Cenacolo* according to the Certosa blank-center version, must we suppose that he did not know, or perhaps care, that Castellazzo was altering it? Should we suspect that the master and the devoted Solario were not on speaking terms in

1510? (Such fallings-out do occur, but Solario's known output does not suggest resistance to Leonardo, and the rest of the Castellazzo copy indicates total respect.) Or shall we take the minority view that Solario faithfully reproduced what he saw in still fair condition in the Grazie refectory, and that Giampietrino at some subsequent date, with the mural deteriorating and Leonardo no longer around, produced the Certosa variant? The question that remains unaddressed by those who pronounce the Certosa solution authentic is this: what would have led the Castellazzo painter to burden a given narrative picture with more geometric rigor, more symbolism? What led Solario astray?

The collusion scenario may well be whimsical. I indulge it here because I dislike even more the alternative: to treat the matter as if no wills were involved; as if the departure from the original system, whether at Castellazzo or in the Certosa copy, had come about by mutation; as if that midline had been casually repositioned like a stick shift; as if the decision one way or the other involved no human relations.

MY VOTE IN FAVOR of the authenticity of the Castellazzo solution rests on this further consideration. All copies of the *Cenacolo* show the protagonist at midpoint. But Leonardo made the figure limber enough for the upper body to lean slightly off-axis. Whereas the body's mid-portion sits centered with respect to the centered rear window, head and shoulders sway to one side. And the feet? Would they have held their place on axis under the figure's seat—or swung sideways to follow the tilt of the head? Here again our copies diverge. Compare Figs. 144 and 145 for the difference it makes. At Castellazzo, the median floor band that attracted the feet kept them centered, securing the stability of the pose. Not so in the Certosa (and the Tongerlo) version, where both feet dodge the center, deflect like a pendulum. The copyist, having no median to steady the nadir, sidles the feet to fall plumb with the tilted head—nosetip and foremost toe lined up like a bowstring, so that the sitter's body warps on the picture plane into an arc. This sidelong lurch of close-cleaving limbs becomes here a feckless waver. The footing of the Certosa Christ is a surface adjustment, not felt as a body in action. Let the reader ponder p. 234, then perform the Certosa pose for the feel of it, as Giampietrino did not. The observation confirms my belief that the Certosa painter and his unknown (Northern?) colleague at Tongerlo are the less likely to have preserved Leonardo's solution. My preference, though presently not in good standing, is the position taken at Castellazzo: a midline under Christ's feet.

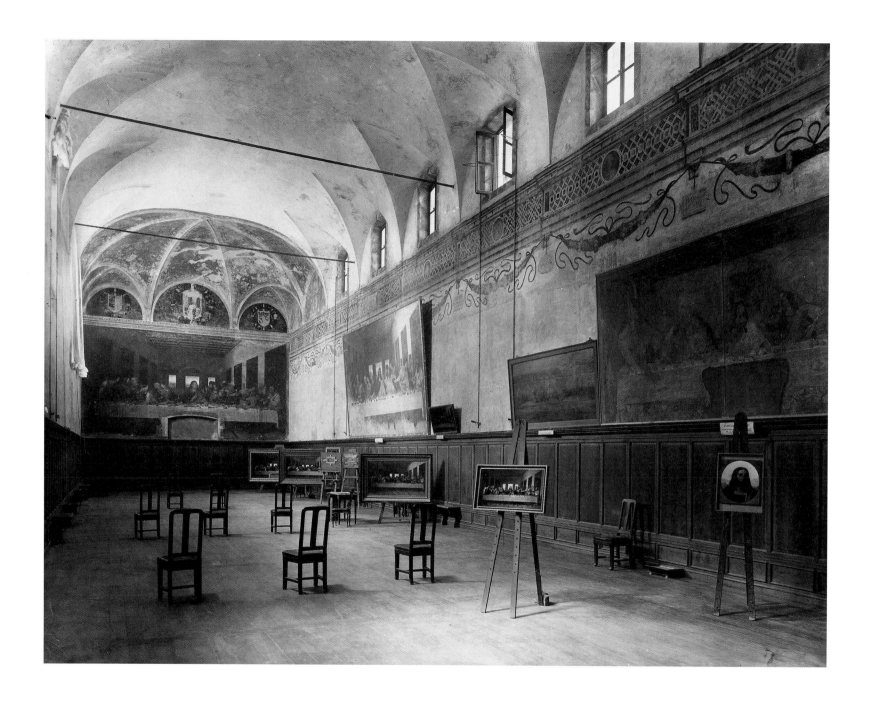

Copies and Adaptations

THE INDUSTRY OF CATALOGUING COPIES of Leonardo's *Last Supper* began two hundred years ago and now has a substantial history of its own. First in the field was a prior of Santa Maria delle Grazie, Domenico Pino. He, in 1796, examined nine copies. His purpose: to determine whether the unsheathed knife in St. Peter's right hand was authentic (Pino 1796, pp. 84–86). He concluded it was, since the best early copies render it the same way. It's the sort of cross-checking we still engage in to authenticate a particular Leonardo motif. Respecting that naked blade, I once asked myself whether Leonardo had emphasized its ominous character by making it—despite the witness of sliced bread, fish, and orange—the only cutting edge at the table. Not quite: under Simon's left hand, the Certosa and Tongerlo copies (Figs. 145, 154, nos. 6, 15) admit a slender fruit knife, to which Peter's weapon compares as cutlass to cutlery. (As of the latest restoration, Simon's little knife has resurfaced in the original mural, its recovery helped along by the evidence of the copies.) So then, in this regard, Pino had pioneered the right methodological track.

Soon after that earliest monograph on the *Last Supper*, a new edition of Leonardo's *Trattato* (Milan, 1804; its introduction reused in the London, 1835 ed.) offered "the most authentic list of ancient copies still extant," raising the total from Pino's nine to a dozen.

Then came Bossi's work of 1810, with its conscientious description of no fewer than twenty-six copies, not counting *varie altre copie minori* and excluding prints and "imita-

tions" (p. 168). The procession climaxed in Bossi's own full-scale "reconstruction" (no. 49, then owned by the viceroy of Italy; destroyed in World War II).

For most of the nineteenth century, Bossi's list remained a plateau. When Erich Frantz in 1885 devoted the final chapter of his *Last Supper* monograph to a survey of the copies, he could only comment on the Bossi collection. But by then, more searching questions were being asked. Provenance, patronage, authorship had come under scrutiny, and the ways in which the copies copied each other rather than the original ruin. There was growing awareness that some copies may even have influenced those well-intentioned or impious hacks who, intermittently for three hundred years, overpainted the self-effacing original. The actual mural as a point of reference and guide to the master's solutions was recognized as unstable, and the cumulative evidence of the best copies, even if contradictory, became increasingly indispensable.

The work of ferreting out, researching, and publishing further copies was resumed in the first decade of the twentieth century. It was then that a dozen *Cenacoli* were hung or poised on easels in the Grazie refectory (Fig. 137). Following the completion of Luigi Cavenaghi's five-year restoration of the original in 1908, the smaller ones were removed, leaving only the detached Castellazzo fresco and Lomazzo's huge canvas of 1561 (respectively, left and right in Fig. 138) to face each other on the long walls. Critical lists reappeared in the literature:

137. The Grazie refectory in a pre-1908 photograph displaying small copies on easels, the Castellazzo and three smaller-sized copies on the east wall.

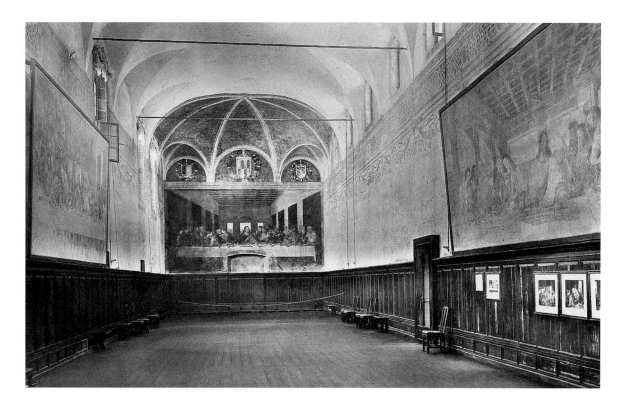

138. The Grazie refectory in a pre-World War I photograph showing the Castellazzo copy on the west wall, the Lomazzo copy opposite.

Hoerth 1907, pp. 17ff. and 235ff.

Seidlitz 1909, pp. 425–27 n. 23, listing twenty-one painted copies before proceeding to reliefs, prints, and drawings

Malaguzzi Valeri 1915, pp. 534–57, forty copies listed, fourteen illustrated, exclusive of drawings

Horst 1930–34

Möller 1952, pp. 109ff., compiled mostly before World War I

Each of these worthy catalogues adds to the heap, correcting where necessary and incorporating new finds, until even *Leonardisti* fatigued—unfortunately before adequate photographic records were made. Meanwhile, down on the ground, the situation kept changing. Some catalogued copies darkened unseen in provincial foundations (e.g., the late sixteenth-century fresco in Revello near Saluzzo, Piedmont). Some had perished in World War II; others donned new attributions or might be identical with copies long since translocated. One was aiming at moving targets.

By the time I joined the force around 1970, interest in the copies had waned. Few were displayed, unless in unvisited sacristies. Those owned by museums which I was granted to see (Louvre, Royal Academy) had to be hauled sorry-state out of storage. The one at the Soprintendenza, Milan (no. 16), showed marks of destructive neglect, paint blistering off.

It was then (1973) that I compiled yet another inventory of copies. It included primarily works from the sixteenth and early seventeenth centuries, plus a handful of relief sculptures, drawings, and prints of consequence. My list ran to forty-three items—no quantum leap here. But since recent literature keeps referring to this 1973 compilation, let

it at least be available in book form—updated, amplified, illustrated, and commented on.

The 1980s brought a new wave. In 1984, the Castello Sforzesco museum, Milan, mounted an exhibition on the subject of *Leonardo e l'incisione*. In the accompanying catalogue, an abundance of prints after the *Last Supper* (though not the requisite superabundance) was reproduced, documented, discussed (see Alberici/De Biasi 1984).

In 1988, Marco Rossi's chapter "L'interpretazione del *Cenacolo* attraverso le copie cinquecentesche" discussed painted sixteenth-century copies (Rossi/Rovetta 1988, pp. 76–95; Eichholz 1998, p. 103, mistakenly sets Rossi's total at seventy-six). Yet, as Rossi rightly remarked, even his roster was incomplete, since copies of Leonardo's *Cenacolo* are still coming to light.

In 1994, Richard Hüttel published a valuable survey of the fortunes of the *Last Supper* in nineteenth- and twentieth-century word and image, *Spiegelungen einer Ruine (Reflections of a Ruin)*. The introductory chapter surveys the early stages of the copying industry, followed by the tide of twentieth-century modernizations: parodies, movie stills, funnies, and blasphemies, as well as 3-D installations at airport chapels and otherwise. But whether the purpose is worship, merchandising or cachinnation, nearly all these sub-Suppers submit to one operational principle: discarding Leonardo's architectural setting, they confine themselves, as Goethe had done, to the thirteen figures at table. I reproduce a rare exception that allows energy to the setting (Fig. 139). Also reproduced is the earliest diversion of Leonardo's *Cenacolo* to the politics of the moment (1832; Fig. 140). It shows the French cabinet dining with La Liberté, who has just announced that one of the party will betray her. We gather that every one of them will (see also Hüttel 1994, p. 71).

Georg Eichholz's mammoth monograph (1998) considers any number of copies, as well as close and remote adaptations (see especially his pp. 103–06). The copies proper receive yet another updated catalogue—excluding

139. *Friday? Good!* Anonymous lampoon of the *Last Supper*, c. 1970.

140. A. Bouquet, *Dernier soupé de la liberté avec ses apôtres/ Le 29 Juillet 1830*, 1832.

drawings and prints—in Marani 1999, pp. 69–80. All these efforts of the last fifteen years adduce new photography, some in color, often of works never before reproduced. Meanwhile, a good number of deserving copies have been dusted off, restored, and put on display, notably those at the Royal Academy (no. 6), Tongerlo (no. 15), Écouen (no. 12), Ponte Capriasca (no. 14), the Brera's small Cesare Magni panel (no. 11), and the Ambrosiana's Vespino (no. 39).

IN THE FOLLOWING INVENTORY, the restriction chiefly to copies produced before c. 1640 has been largely retained. In most cases, the present roster includes illustrations or refers to accessible reproductions. Comments are added where I thought I had something to say. The information given is summary, and the list far from complete. But it includes every copy whose testimony is of interest, either because of its accuracy, early date, prestigious location, or critical attitude toward the original—as when a copy, generally respectful of Leonardo, alters his color scheme, changes the set, resolves ambiguities, or insists on separating Christ's feet.

Among the criteria for including this or that item, I have mentioned "its early date." This entails more than respect for seniority. In the immediate demand for copies, and in the promptness with which the demand was met, the case of Leonardo's *Last Supper* is first of its kind. Of course, there had been earlier images—icons of the Madonna believed to bring healing or victory—that were multiplied because coveted for their hoped-for effect. But what sort of boon was expected from a copy of the *Last Supper*? The many replicas we have notice of, produced or commissioned within a decade of the picture's unveiling, suggest other analogies—not with thaumaturgic icons so much as with sacred texts or official decrees, things you need your own copy of. Hence the historic importance of the fact, recently brought to light, that the admirable Bramantino was commissioned as early as 1503 to reproduce Leonardo's *Last Supper* (see

Marani 1999, p. 74, no. 1). But Bramantino is not on my list, because his copy does not exist and, I suspect, never did. As Melville's Ishmael puts it in bypassing an elusive item in his classification of whales: "Let him go. I know little more of him, nor does anybody else" (*Moby Dick*, chap. 32, "Cetology").

In promoting the art of reproductive engraving, the *Cenacolo*'s role may have been crucial. We take the availability of reproductions of paintings for granted, assume as a matter of course that a painter's invention, like a writer's, may be printed (or pirated) in any number of copies. But the decisive impulse to institutionalize what would soon become common practice came from Leonardo's *Last Supper*, from the need instantly felt far and wide to have a version of this picture always at hand. Within a year or two of the mural's completion, its design was engraved.

Excluded from this roster are the innumerable *Last Supper* representations that recall Leonardo's paradigm only because the figures on the far side of the table rehearse a few memorized gestures. This open category comprehends the Raphael-Marcantonio engraving (Fig. 7); Bernardino Luini's fresco of c. 1530 (no. 13, here adduced as a cautionary counter-example). Also excluded are sculptural tableaux, preeminently the monumental staging by Andrea da Milano and Alberto da Lodi in Saronno (Marani 1999, p. 79, no. 46). The life-size figures sit about a three-sided, or horseshoe, table. Two or three gestures are lifted from Leonardo—the arms' spread of James Major, Thomas' hoisted finger, the extended hands of Simon at extreme right. Discounting these sparse quotations, the work is in no sense a copy.

Among later works that show indebtedness to Leonardo's model without qualifying as copies are Rubens' *Last Supper* studies at the Getty and Chatsworth; the mid-nineteenth-century relief over the Altar of the Sacrament in the left transept of San Giovanni Laterano, Rome (see no. 29); the famous still from Buñuel's film *Viridiana*; and thousands more. They're still arriving.

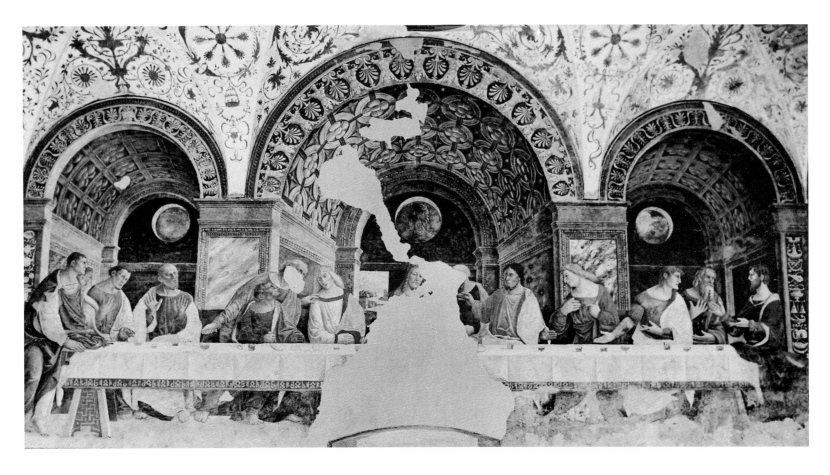

I. SIXTEENTH-CENTURY PAINTINGS

1. Antonio da Gessate, 1506. Detached fresco from the **Ospedale Maggiore, Milan**. Described by Bossi in 1810 (pp. 131f.); subsequently covered with whitewash. Retrieved in 1890 (*Archivio Storico dell'Arte* 3 [1890], p. 410); the dimensions then given as 2.7 x 6 m. Documents for attribution and dating discovered by Luca Beltrami. Displayed until c. 1915 in the refectory of Santa Maria delle Grazie (Malaguzzi Valeri 1915, p. 534 n. 2). Destroyed in 1943. No photographs known, but discussed, with description of background architecture, by Hoerth 1907, p. 235. Recent references: Marani 1999, p. 74, no. 3.

2. Giovan Pietro da Cemmo, 1507 (Fig. 141). Sant' Agostino, Crema, refectory. Detached fresco, now in lamentable condition. The arcuated setting totally reinvented, but interesting for its effect on the grouping of figures— seven under the central arch flanked by lateral triads (cf. the later Garofalo adaptation, 1544, Ferrara, Pinacoteca Nazionale). The figures themselves, though more loosely spaced, follow Leonardo's original. Note especially the two-handed gesture of Thaddeus, second from right. See Bertelli in Dell'Acqua 1983, pp. 188–89; Rossi/Rovetta 1988, p. 86 and fig. 54; Marani 1999, p. 70.

141. Giovan Pietro da Cemmo, 1507.

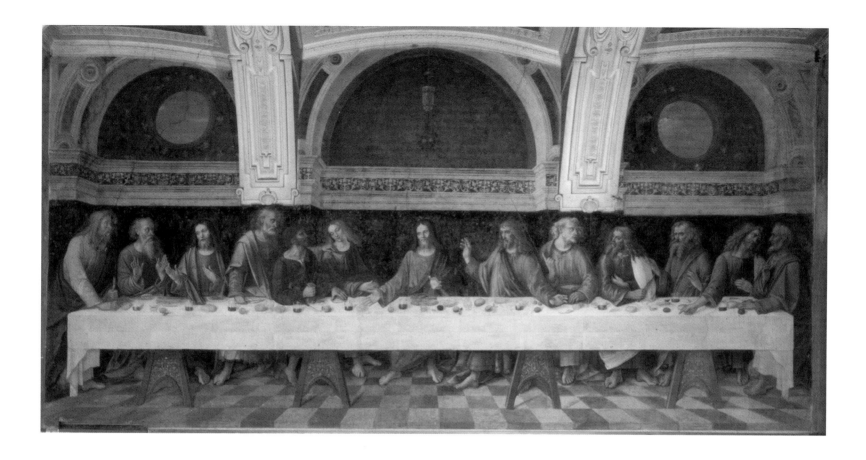

142. Tommaso Aleni,
called Il Fadino, 1508.

3. Tommaso Aleni, called Il Fadino, 1508 (Fig. 142). San Sigismondo, Cremona. Fresco. Reprod. in Vertova 1965, fig. 26. Recent references: L. Bandera, "Tommaso Aleni," in *I Campi*, exh. cat., Milan, 1985, p. 64; Rossi/Rovetta 1988, p. 84 and fig. 53 (color); Eichholz 1998, pls. 99, 125 (details); Marani 1999, p. 74, no. 4.

Aleni's paintings in the Museo Civico, Cremona, give a fair idea of his limited competence. His free adaptation of Leonardo's figural composition interests me for the changes he made (as in the hands and feet of the central figure).

Thanks are due to the *custode* at San Sigismondo, who likes to point out, with the air of one letting you in on a secret, that James Minor, here third from the left, is the spitting image of Christ.

Special thanks to the Correggio scholar Carolyn Smyth for her hospitality in Cremona, for her valiant research, and for trying to track down the still unexplained meaning of Aleni's nickname.

143. Anonymous, early sixteenth century, San Lorenzo, Milan.

tration by enlarging the central door; invented a pavement distinct enough from the design of the ceiling; recessed Judas' figure instead of letting him throw his weight across three-fourths of the board; eliminated the wine and bread at Christ's fingertips; put Christ's feet out of sight by interposing a central trestle; made Bartholomew sit and uncross his ankles; equipped each Apostle with a substantive halo; and put the whole thing in a frame. Since the copyist must have noticed what he chose to amend, we can credit him with a degree of close observation not reached in literary descriptions until some three hundred years later.

5. Andrea Solario (attrib.), c. 1510 (Fig. 144). Detached fresco from **Castellazzo**. Destroyed in 1943. A key monument discussed at length in App. D.

6. Giampietrino (?), c. 1520 (Fig. 145). Oil on canvas, from the **Certosa di Pavia**, acquired in 1821 for the Royal Academy, London. Present dimensions 298 x 770 cm. The upper third of the picture, if it ever existed, was cut away—no one knows when. The rivalry between the Certosa copy and that from Castellazzo is discussed in App. D.

Provenance: Möller (1952, p. 139) argued, I think convincingly, that this enormous canvas (nearly the width of the original mural) could not have been in the Certosa di Pavia before the seventeenth century. First mentioned there in 1626 (see App. D), it could not have escaped earlier notice. Nothing is known of its origin, its commissioning patron, date of execution, or first destination perhaps at a lesser Carthusian foundation.

Date: Attempts at dating the work rest on style alone. Jacques Franck (1997, p. 170) dates it "between 1520 and 1560." Marani writes "c. 1515–20."

Attribution: Ascribed since the late seventeenth century to Marco d'Oggiono. In 1880, J.P. Richter suggested a "far more likely" attribution to "Gian Pietrino." The case for this still shadowy Giampietrino, now generally accepted, is fully

4. Anonymous, early sixteenth century (Fig. 143). **San Lorenzo, Milan**. Fresco. Discovered under whitewash, probably during the restoration of San Lorenzo in 1911. Malaguzzi Valeri 1915, p. 546. Recent references: Rossi/Rovetta 1988, p. 80; Marani 1999, p. 74, no. 6.

This small fresco was painted by an unknown naïf. Of the circumstances of the commission nothing is known, but the very existence of such a work in the ambulatory of one of the great churches of Early Christianity—in the city that housed the original—indicates the canonic status Leonardo's *Cenacolo* had achieved within ten years of its creation: you needed a copy of it, as you needed a Gospel book. At some unknown date, probably during the extensive restoration of the building (1574–88), the work was whitewashed over, its surface pocked to make the whitewash adhere.

The work is of interest chiefly for its implicit criticism of the original. Every change made by the copyist tells us what in the Grazie mural struck him as disturbingly new and unnecessary. He widened the rear wall and curtailed the depth of the chamber; removed the ambiguity of the fenes-

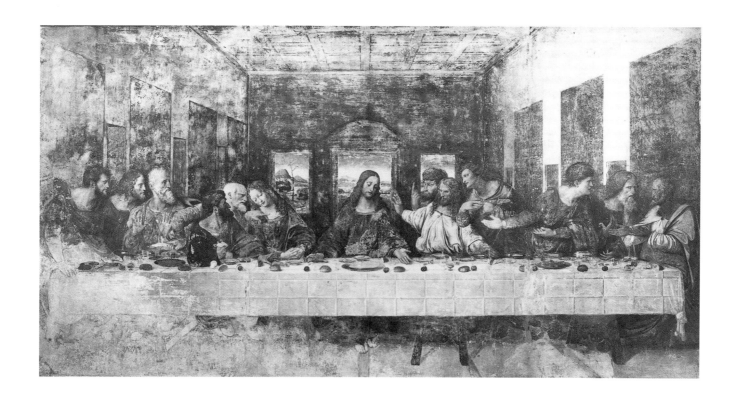

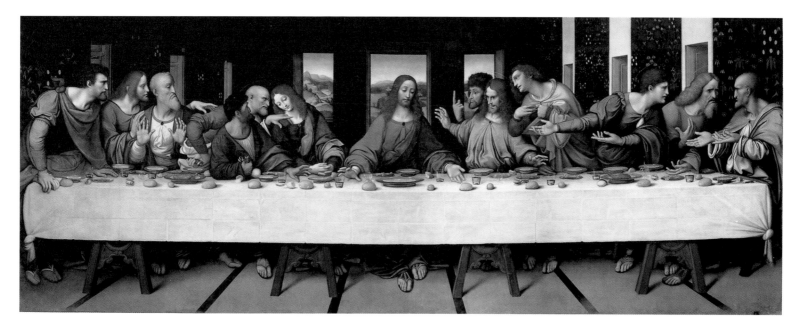

144. Andrea Solario (attrib.), c. 1510, from the monastery at Castellazzo.

145. Giampietrino (?), c. 1520, from the Certosa di Pavia.

and fairly presented by Janice Shell, in Shell/Brown/Brambilla 1988. (See App. D for Richter's brief text and for Möller's alternative attribution, "without the least doubt," to Boltraffio.) Recent references: Rossi/Rovetta 1988, fig. 46 (color), as Giampietrino; likewise Eichholz 1998, color pls. XL–XLVI; Marani 1999, p. 74, no. 9, as Giampietrino. Marani suggests, without further elaboration, that the drawings of heads after Leonardo's *Cenacolo* in Strasbourg (Fig. 52; see G. Dehio, "Zu den Kopien nach Lionardos Abendmahl," *Jahrbuch der königlich-preussischen Kunstsammlungen*, 17 [1896], pp. 181–85) were drawn, not from the original mural, but from the Certosa copy.

Condition: In the mid-1980s, the Certosa copy was sent to Milan to be brilliantly cleaned by Brambilla. Her careful account of the restoration (Shell/Brown/Brambilla 1988, pp. 41–59) records pervasive injury to the paint surface, lacerations in the canvas support, and old overpainting. We learn for the first time that the canvas joins three horizontal strips sewn together, reaching upward only as far as the tops of the windows. A fourth strip of a different fabric, 34.5 cm high, was added at some subsequent date.

It is unlikely that the picture's proportions were planned for their present state—with so much floor and so little headroom. Nor would the canvas have been cut down after arriving at the Certosa di Pavia, whose refectory is high enough to accommodate the format of the Grazie mural. But if the truncation occurred before 1600, there are three possible motives for it.

(a) The picture's original housing may have had an exceptionally low ceiling. In view of fifteenth-century architectural practice, this seems improbable.

(b) Patron or painter may have so disliked Leonardo's deep-space illusion that he (or they) cropped the picture to produce a radical flattening—which again seems less than likely.

(c) The upper half of the picture may have suffered severe damage before the saved remnant was transferred to Pavia.

All these are conjectures; the truth may never be known.

Returned to London, the Certosa copy once again embarrassed the Royal Academy, which never had proper room to display it. (In his *Last Supper* monograph [1885, p. 71], Erich Frantz reports: "The Royal Academy in London possesses a copy ascribed to Marco d'Oggiono, well executed in oils, scaled to the original, under glass, but in its unfavorable quarters hard to see as a whole." He adds that the narrowness of the Diploma Gallery's space makes it impossible to photograph the work.)

Happily, the picture was presented in a five-year (but apparently renewable) loan to Magdalen College, Oxford, where, in March 1993, it was installed in the ante-chamber of the chapel. There it still hangs (January 2000)—rather too high and rarely enjoyed. Its arrival at Magdalen was honored with a lecture by Sir Ernst Gombrich (see Gombrich 1993). The speaker commented on the original only, declared *en passant* that Leonardo's *Last Supper* makes "no visual allusion" to the eucharist (p. 10), and spent the last third of his brief talk reading from Goethe's text.

7. Battista da Vaprio (attrib.), c. 1510. Seminario Vescovile, Savona. Oil on canvas. Rossi/Rovetta 1988, fig. 48 and p. 76 (among *le copie più fideli*); Eichholz 1998, pl. 9; Marani 1999, p. 75, no. 13, with further literature.

8. Fra Girolamo Bonsignori, c. 1513–14 (Figs. 146, 147). Commissioned for the convent of San Benedetto Po, near Mantua, now in the abbey of the Vangadizza at Badia Polesine. Oil on canvas, 234 x 737 cm (originally inserted into a frescoed ensemble attributed to Correggio). Bossi 1810, pp. 140–41; Frantz 1885, p. 73; Malaguzzi Valeri 1915, p. 542; Möller 1952, p. 154. Recent references: Eichholz 1998, p. 381; Marani 1999, p. 75, nos. 11, 12.

The copy by Bonsignori (c. 1460–1519; sometimes written as Monsignori) aroused Vasari's enthusiasm (*ritratto, dico, tanto bene, che io ne stupii*; 1568, VI, p. 491, in the *vite* of

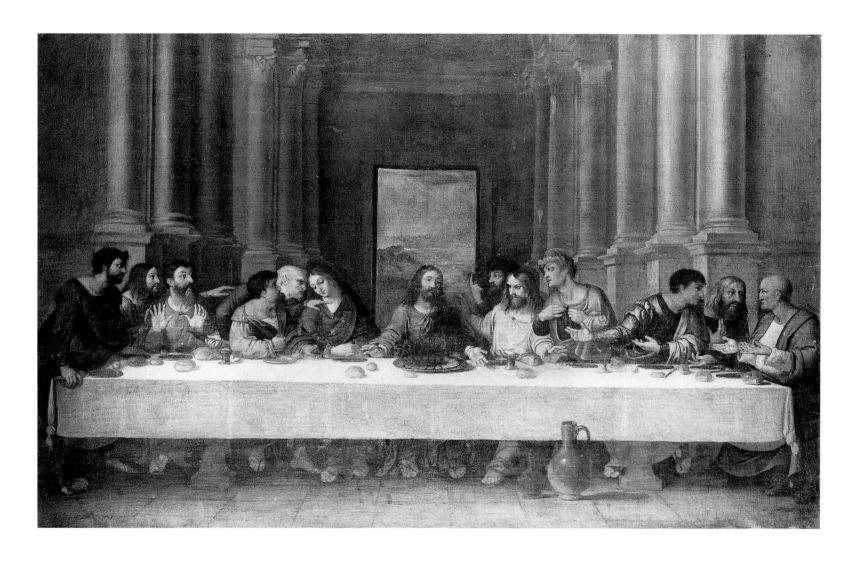

146. Anonymous seventeenth-century
replica of Bonsignori's copy.

147. Lodovico Dondo
after Bonsignori, 1598.

Garofalo, Girolamo da Carpi, et al.). The picture was itself repeatedly copied. The young Rubens may have drawn it (see no. 42); a seventeenth-century replica formerly ascribed to Poussin is in Munich (Fig. 146); another, by Lodovico Dondo, dated 1598, is curated in Budapest (Fig. 147; published in Edit Pogány-Balás, "Remarques sur une peinture de Lodovico Dondo: Replique de La Cène de Léonard de Vinci," *Bulletin du Musée Hongrois des Beaux-Arts*, nos. 56–57 [1981], pp. 65–84).

Marani (1999, pp. 75–76) mentions and reproduces a fine drawing in a Roman private collection by or after Bonsignori. One of its striking features is the immense broadening of Christ's shoulders—an effect which Bossi, too, would achieve in his copy and explain in his text (see p. 139 n. 1). (The gain in manliness is undeniable; what is lost is that triangular shaping by which manliness is surpassed.)

The complex history of Bonsignori's copy is the subject of much recent sleuthing and ongoing debate. The picture, reproducing Leonardo's table and figures against a new-invented surround, was, at the end of the eighteenth century, removed from its frescoed setting and lost sight of. Following the suppression of the convent, it was probably sold hugger-mugger, so that Bossi was unable to trace it. There is, however, a record of a Bonsignori *Last Supper* being sold to a Paris collector in the 1820s, and a fragment of a Bonsignori *Last Supper* does survive in a Paris private collection (reprod. in Malaguzzi Valeri 1915, p. 542, fig. 596). I suspect a confusion of at least two distinct versions. The canvas that migrated to France and was there fragmented cannot be identical with the complete canvas recently rediscovered in the Badia Polesine—where it was severely damaged by fire in 1981 and soon after restored. The scholar who has studied the matter most closely admits in distress: "It is not easy to say exactly when the canvas emigrated to Paris, nor when it returned to Italy" (Paolo Piva, p. 37; see below). For extensive discussion, further references, and full illustration, see Piva, "Correggio e Bonsignori: La scoperta di un episodio di collaborazione artistica del primo Cinquecento," *Quaderni di Palazzo Te*, 2, no. 4 (January-June 1986), pp. 36–60, esp. pp. 43–45; and idem, *Correggio giovane e l'affresco ritrovato di San Benedetto in Polirone*, Turin, 1988, pp. 37–38. Piva believes that the thematic emphasis in the Bonsignori copy is eucharistic, but his argument is not compelling.

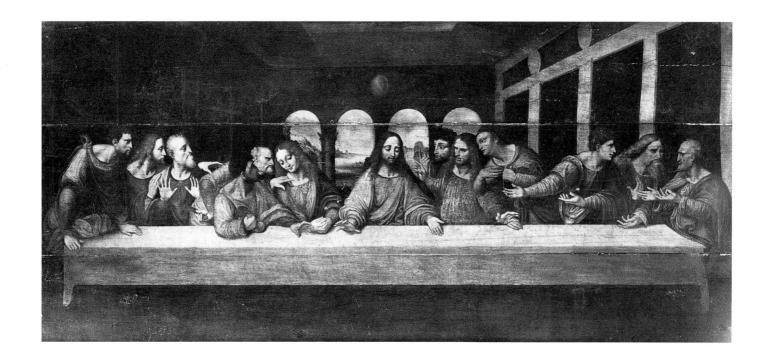

9. Alessandro Araldi, 1516 (Fig. 148). Camera dell'Araldi, San Paolo, Parma. See Corrado Ricci, "La copia del '*Cenacolo*' fatta da Alessandro Araldi," *RaccoltaVinciana*, 2 (1906), p. 72 and facing plate; Malaguzzi Valeri 1915, p. 536 and fig. 594. Recent references: Marani 1999, p. 74, no. 10.

Given its early date, Araldi's truncated copy is useful evidence for such oft-questioned items as Thomas' left hand, Judas' upset saltcellar, the blatancy of the feet. Why James Minor (second from left) was totally reinvented to deny him his likeness to Christ is incomprehensible. Puzzling too is the enormity of the Christ figure and the artist's obsession with the sternomastoid muscle. For the rest, we are intrigued to learn that in 1505 a patroness in provincial Parma urged poor Araldi to go study the Grazie mural as a sort of academy (see Marzio Dall'Acqua, ed., *Il monastero di S. Paolo*, Parma, 1990, p. 28).

10. Anonymous, c. 1520 (Fig. 149). From **San Barnaba, Milan**, now in the Brera, inv. Reg. Cron. 460. Oil on panel, 121 x 268 cm. Traditionally attributed to the omniferous Marco d'Oggiono. The panel is described by Bossi 1810, pp. 132f.; Hoerth 1907, pp. 237f.; reprod. in Malaguzzi Valeri 1915, fig. 595, Horst 1930–34, fig. 29, and Möller 1952, fig. 98. Recent references: Rossi/Rovetta 1988, fig. 45; Marani 1999, p. 74, no. 7, with further literature.

11. Cesare Magni, c. 1520–30 (Fig. 150). Pinacoteca di Brera, Milan. Oil on panel (signed), 64 x 138 cm. Purchased by the Brera in 1890 (*Archivio Storico dell'Arte* 3 [1890], p. 410) and thereafter displayed in the Grazie refectory and admired for its perfect condition. In 1973, I reported that the panel, then at the Soprintendenza ai Monumenti, Milan, was "in a perilous state of decay,…the elegant inscription in Roman majuscules—*Cesare Magni fecit*—almost obliterated" (Fig. 150A). The panel has since been ably restored.

See Strzygowski 1896, pp. 139–40; Seidlitz 1909, p. 426, no. 9; Hoerth 1907, pl. V, fig. 3; Horst 1930–34, fig. 26;

Malaguzzi Valeri 1915, p. 363. Recent references: Eichholz 1998, color pl. XLVIII; Marani 1999, p. 75, no. 16, with further literature, reprod. p. 76.

A striking feature of the Cesare Magni panel is the sheer drop at the threshold, which occurs as well in the Aleni *Last Supper* (no. 3; and in Signorelli's *Circumcision*, Fig. 103) Brambilla and Marani believe that the drop records an authentic feature of the original (oral communication, May 1998).

But Cesare's copy, though punctilious about the figures, makes free with their setting. The ceiling divides into eight files of coffers instead of the original six; the doors between the tapestries on the right-hand wall are made to match the height of those on the left; the floor stripes have multiplied, and the lower reach of Christ's body is cruelly stunted. As an index to the original, the panel's lower zone does not seem reliable.

12. Marco d'Oggiono (attrib.) (Figs. 151,56). **Château d'Écouen**. Oil on canvas, 260 x 549 cm. Transferred to the Louvre in 1807 under Napoleon. Recently restored and, since 1980, reinstalled at Écouen.

An important work of high fidelity and good quality. Since Gustavo Frizzoni (*L'Arte,* 1906, p. 412), it has been generally ascribed to Marco d'Oggiono. See Seidlitz 1909, p. 425; Horst 1930–34, pp. 126ff.; Möller 1952, fig. 99 and n. 129, with suggested date, 1530. More recent authors agree. David Alan Brown (Shell/Brown/Brambilla 1988, p. 22) cites the work as attributable to Marco d'Oggiono "with certainty." In Domenico Sedini's Marco d'Oggiono monograph (Milan, 1989, pp. 68–71) the attribution of the Écouen canvas is sustained. (About the half dozen other copies traditionally ascribed to Marco, Sedini is noncommittal). See also Rossi/Rovetta 1988, fig. 44 (color) and p. 78 n. 5 (with further literature); Eichholz 1998, color pl. XLVII; Marani 1999, p. 74, no. 8.

Yet some questions remain unresolved. It has long been known that the Connétable de Montmorency commissioned

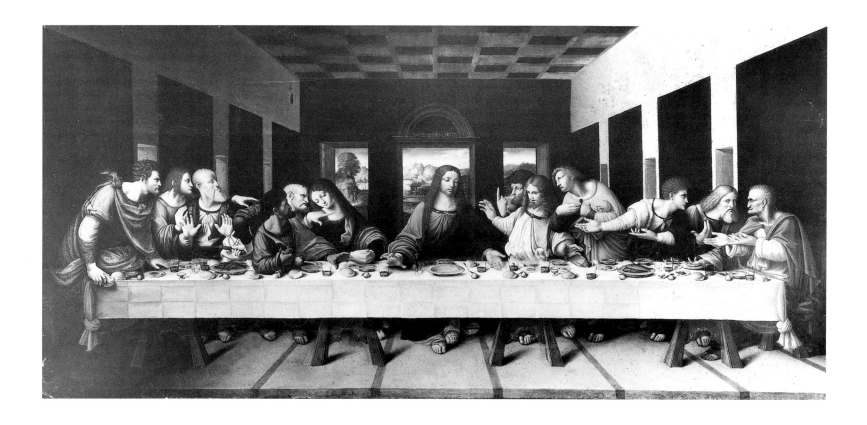

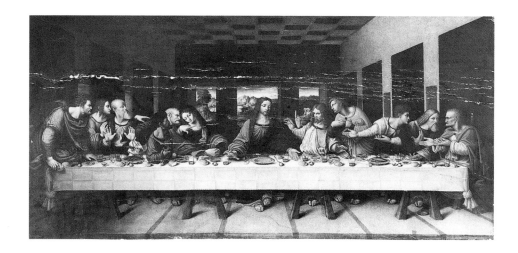

150. Cesare Magni, c. 1520–30, after restoration.

150A. Cesare Magni, before restoration.

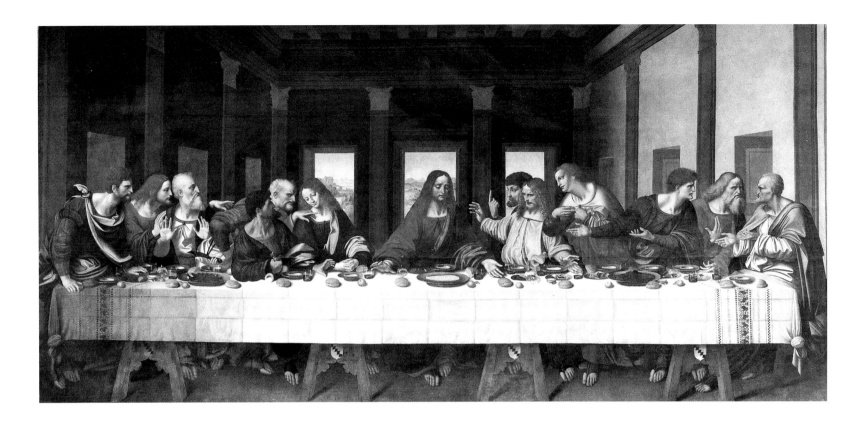

151. Marco d'Oggiono (attrib.), Château d'Écouen.

a copy of Leonardo's *Cenacolo* for his chapel at Écouen, built 1540–47. Accordingly, the present canvas is traditionally identified with a 1540s commission. *Opus posthumus?* Marco d'Oggiono, the work's presumptive author, died in 1524.

The copyist has radically flattened Leonardo's perspective and, among other changes, has denied Christ's feet their distinction by making most of the other feet drop as low. The remarkable rendering of Judas' neck—the closest among all the copies to the Leonardo drawing at Windsor (Fig. 50) is discussed on p. 95.

13. Bernardino Luini, c. 1530 (Fig. 152). Refectory of Santa Maria degli Angeli, Lugano. Fresco, detached before 1910 and separated into three parts, measuring 167 x 134,

167 x 235, and 167 x 145 cm (see Angela Ottino della Chiesa, *Bernardino Luini*, Novara, 1956, no. 97). Present state first reproduced by Luca Beltrami, *Bernardino Luini e l'opera sua a Lugano*, Lugano, 1910, pl. 11; original state, with two columns trisecting the picture, reprod. in Horst 1930–34, fig. 51, and Malaguzzi Valeri 1915, fig. 615. Recent references: Heydenreich 1974, p. 104 (mistakenly as "later sixteenth century"); Rossi/Rovetta 1988, p. 90; Eichholz 1998, pl. 29 (center only).

The moment selected seems to be eucharistic. A bowl at center hosts the lamb, flanked by a half-loaf and goblet. Yet Christ's gesturing remains without direct object, intransitive. And his feet are again spread apart. The work is the free reinvention of a master who pays homage to Leonardo's

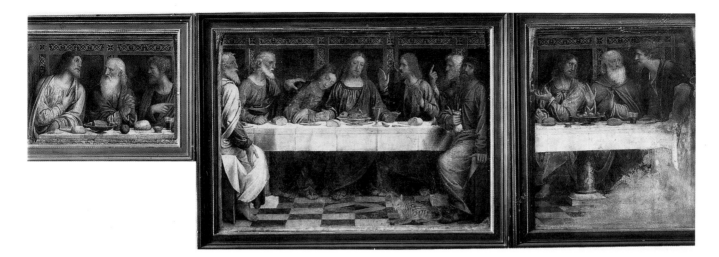

152. Bernardino Luini, c. 1530.

Cenacolo by quoting three or four apostolic gestures. But each recognizably Vincian motif quotes out of context. Like the hands of Christ, Thomas' uplifted index has nothing to indicate, and Peter's hand on John's shoulder lands without focus or urgency. Note the retention in Peter's right hand of a knife—but of a knife domesticated and placed near a cut loaf, as if to relieve Peter's instrument of its menace.

14. Anonymous (Fig. 153). Sant'Ambrogio, **Ponte Capriasca** (Lugano). Fresco. Uncertainly dated between c. 1530 and the 1560s. Mentioned by Lomazzo with attribution to Pietro Luini, son of Bernardino (see Möller 1952, n. 131). Familiar to Leonardo scholars since Bossi 1810, pp. 146–50; revisited by Frizzoni 1890, pp. 187–91. Recent references: Pedretti 1983, figs. 6, 7 (color); Rossi/Rovetta 1988, pp. 87–89, fig. 57 (color); Marani 1999, p. 77, no. 25, reprod. Photographs of the work *in situ* (Pedretti 1983, fig. 7) show how wisely Leonardo's architectural setting (side walls and ceiling) was altered to adapt the figure compositions to the new site. After four centuries of neglect, the lately cleaned fresco has become a hyped tourist attraction, (cropped) postcards and all.

As for the date, certain details—an improbable foot at far right, the absence of Thomas' left hand, the omission of Christ's wineglass, of the bread at Judas' elbow, etc.—suggest that the copy was made after mid-century, when much of Leonardo's original surface was no longer intelligible, as indeed Vasari attested in 1568.

The importance of the fresco to Leonardo's iconography is discussed in App. C.

15. Anonymous, c. 1540 (Figs. 3, 6, 154). **Abbey of Tongerlo** (near Antwerp). Oil on canvas, 418 x 794 cm, i.e., matching the scale of the mural. Documented at the Tongerlo Abbey since 1545. Severely damaged by fire in 1929; restored 1932–33 and again in the late 1990s. Color reproductions in Eichholz 1998, pls. XXIII–XXXVIII.

On Möller's authority, the work was for a while attributed to Andrea Solario, hence datable before 1510 (Möller 1952, pp. 117ff. and pl. II; thus Gantner 1962 and Luisa Vertova in her revised edition of Berenson's *Italian Pictures of the Renaissance*, 1968, I, p. 411, there dated 1506–07). Möller had reasoned as follows: from 1507 to 1509, Solario is documented as working in the Amboise palace at Gaillon, Normandy. An inventory of pictures at Gaillon taken in 1540 records a "*Last Supper*." According to Möller, this entry

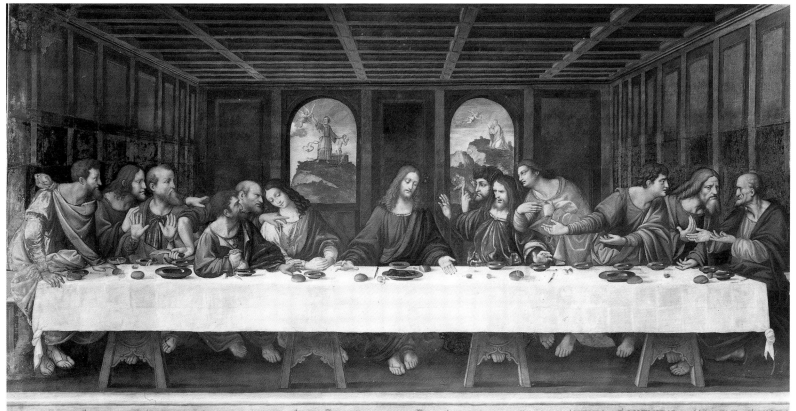

153. Anonymous, Ponte Capriasca (Lugano).

does not reappear in the subsequent Gaillon inventory of 1550. He inferred that the picture acquired by the Tongerlo Abbey in 1545 must be identical with the work inventoried at Gaillon in 1540. Though that "*Last Supper*" entry names no painter and claims no connection to Leonardo's *Cenacolo*, Möller concluded that it must refer to a work which Solario would have painted (from undocumented cartoons?) at Gaillon in c. 1507. The argument collapsed when it was shown that the "*Last Supper*" entry in the Gaillon inventory of 1540 does in fact carry over to the inventory of 1550 (see R.H. Marijnissen, *Het da Vinci-Doek van de Abdij van Tongerlo,* Abdij Tongerlo, 1959, p. 13). Meanwhile, the Tongerlo copy had been purchased from a private collection in Antwerp.

With the Solario attribution out of the way, there is no further reason to date the Tongerlo copy in Leonardo's lifetime, or to attribute it to an immediate follower. Eichholz's reference to the work as "probably from the circle of Leonardo's pupils" (1998, p. 103) is groundless. Marani attributes the picture to an "anonymous Fleming" (1999, p. 75, no. 18). Who this Northerner was—just when he was active, and whether he worked from the original or from a copy, painted or drawn, or from cartoons which may also have served other copyists—all this is unknown.

The Tongerlo and Certosa canvases (no. 6) are now said to be our most accurate copies. They do indeed have much in common, which could mean either that both accurately record the original, or that the cartoons they were painted from were identical or interdependent. There is close agreement in the rendering of the figures, the draperies, the furnished table, the placement of the sixteen visible feet, the stripping of the rear wall of its gable, the design of the floor—six thin dark stripes converging about a blank center. Jacques Franck (1997, p. 170 n. 21) describes the Tongerlo colors as "strikingly close to those of the Giampietrino copy [no. 6] and of the copy at the Hermitage [no. 21]." Yet the Certosa canvas shows a rose-colored pavement, whereas the Tongerlo painter, who may never have seen the original,

makes the floor green. And whereas the side doors between the tapestries are leveled in the Certosa version, they appear correctly at unequal height at Tongerlo (as at Castellazzo). The landscape beyond the windows is freely and variously invented in both canvases, as also in the Castellazzo fresco. Finally, in spacing the figures relative to their backdrops, all three copies take liberties. Since the copyists reassembled the composition by splicing sectional drawings, such variations would have been almost impossible to avoid.

Cleaned in the 1990s, the Tongerlo canvas was installed at its abbey in a separate area now called the Da Vinci-Museum. The abbey's website, www.tongerlo.org/da_vinci, promotes the canvas as "the most faithful and the most beautiful replica," and invites travelers who "want to admire the *Last Supper* of da Vinci in its original beauty . . . [to] pay a visit to our museum." It would be churlish to cavil: given its size, its high quality, and general accuracy, the Tongerlo copy ranks with the finest surviving testimonies to the near-lost Leonardo.

Much of the credit for the present status of the Tongerlo copy must go to Möller, who first recognized its importance, had it splendidly photographed, and, in his enthusiasm, mistook author and date. Two of his asides are worth mentioning. Möller thought that the Vatican arazzo (no. 38) derived directly from the Tongerlo copy, because both show the identical telltale details: two pairs of loops to secure Judas' purse and, under Matthew's extended right arm, a tiny leaf still adhering to the stem of an apple. On first reading this, I gave it a silent bravo!—but soon noticed that both loops and leaf occur in same shape and place in the copies from Castellazzo (no. 5) and San Barnaba (no. 10), and in the Cesare Magni panel (no. 11).

One more item of consequence: according to Möller (p. 165), an entry in the Tongerlo archives records that Rubens visited the refectory and made a drawing of its *Last Supper* (see no. 41).

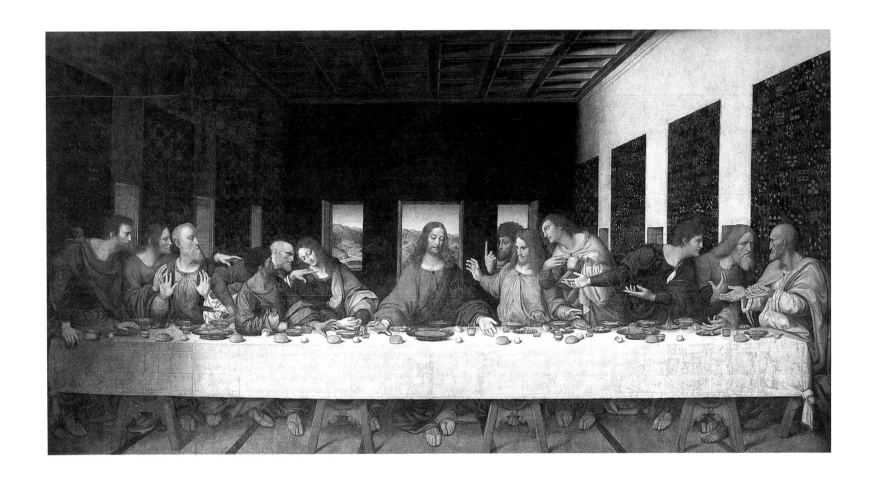

154. Anonymous, c. 1540, Abbey of Tongerlo.

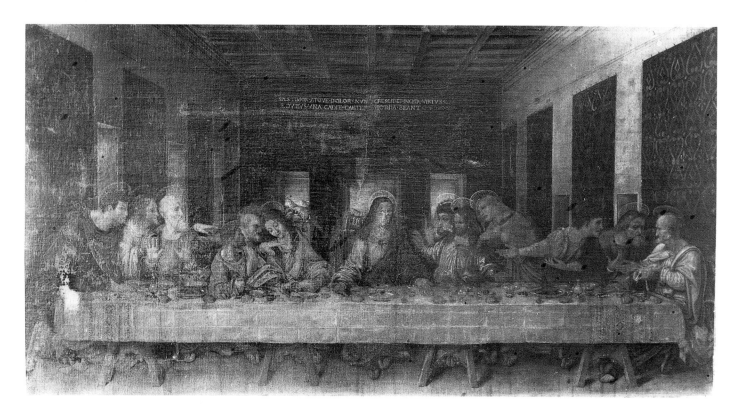

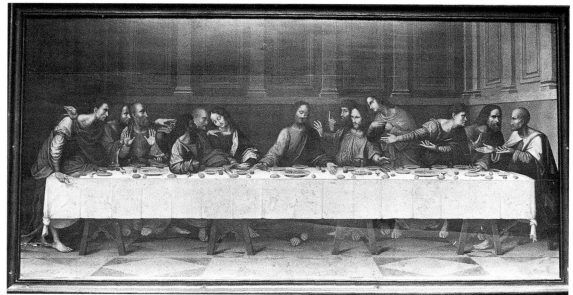

155. Anonymous, Soprintendenza, Milan.

156. Anonymous, sixteenth century, overpainted in the 1830s, St. Germain l'Auxerrois, Paris.

16. Anonymous (Fig. 155). Soprintendenza ai Beni Ambientali e Architettonici, Milan, acquired c. 1900. An exceptionally fine small oil on canvas, 30 x 65 cm, unfortunately badly darkened and in ruinous state. When I saw it at the Palazzo Reale, Milan, in April 1973, I was told by *architetto* Zamboni that the picture had been damaged in a World War II fire. This may not be the case, since the picture is probably identical with no. 10 in von Seidlitz's list of copies (1909, p. 426), where it is cited among the small replicas then on view in the Grazie refectory and described as follows: "A small much darkened anonymous copy. It gives the impression of great fidelity, though arbitrary in color."

The picture is indeed (except for the omission of a floor pattern) amazingly faithful to the original mural. (The halos and perhaps the inscription on the rear wall seemed to me to be later additions.) But in the accuracy of the side doors between the tapestries—high on the left, low on the right—only the Tongerlo copy and the Castellazzo fresco match this little canvas, which seems unique in displaying correctly even the little hooks that hold the tapestries up.

Recent references: Marani 1999, p. 77, no. 19, reprod., with further literature.

17. Anonymous, c. 1540 (?). A small copy in oil from the monastery at Castellazzo. Present whereabouts unknown. Described by Bossi 1810, p. 143, as in the Castellazzo monastery and as *senza dubbio copia della copia a fresco di Marco [d'Oggiono] in Castellazzo*. Although Bossi acknowledges differences between the fresco and the small oil with its fanciful pavement, he finds enough points of comparison to declare the latter copied from the large fresco. If this is correct, we have learned that, by c. 1540 (Bossi's date), a painter or patron who wanted his own record of Leonardo's *Cenacolo* would prefer to have the work modeled on a good copy rather than on the deteriorating original. Recent references: Marani 1999, p. 77, no. 21.

18. Anonymous (Fig. 156). **St. Germain l'Auxerrois**, Paris, sacristy. Oil on panel, dimensions unpublished, and the work presently inaccessible. First mentioned by Raphael du Fresne in his introduction to the *editio princeps* of Leonardo's *Trattato*, Paris, 1651, fol. 13r (published in simultaneous French and Italian editions). After attributing to Francis I (rather than Louis XII) the vain wish to have Leonardo's mural transported to France, du Fresne suggests that the king may have ordered a copy, perhaps the very one now at St. Germain. Du Fresne's suggestion—often repeated, e.g., by Mariette—that the work may have been a royal commission of c. 1517, when Francis I was in Milan, is unverifiable.

The St. Germain copy, now installed in the sacristy, was severely damaged in the pillaging of the church on February 13, 1831. Within the decade, it was heavily overpainted, especially in the area of the table and figures (see F. Villot, *Notice des tableaux exposés…au Louvre, Paris*, 1849, p. 109: *cette copie entièrement usée est repeinte maintenant de la manière la plus maladroite*; and Möller 1952, p. 153.) Two graffiti in the lower right corner, both in eighteenth-century script, indicate that the present panel is indeed the original sixteenth-century work, its middle zone, including the furnishings of the table, wholly repainted, but top and bottom intact, so that its unique figured pavement and wall paneling are preserved. The design is recorded in a sixteenth-century drawing at Windsor (Fig. 21) and in the engraving made after this drawing by W. W. Ryland in 1768 (Fig. 22). It was Malaguzzi Valeri (1915, p. 552) who recognized the connection between the Paris panel and the Windsor drawing, dating the latter *assai vicino, per tempo, all'originale*.

The Windsor drawing, which displays only a loaf and chalice on the table, was made, as Möller observed, to show the dimensions of a projected new frame for the St. Germain copy. But it is unlikely that a major iconographic change such as the substitution of the eucharistic species for the original table setting would be introduced in a working

drawing for a new frame. More probably, the iconography of the drawing records the state of the St. Germain panel before its nineteenth-century overpainting. Cf. pp. 43–44.

The St. Germain copy is briefly mentioned in M.-J.F. Lépicié, *Catalogue raisonné des tableaux du roy*, Paris, 1752, I, p. 5. Recent references (reproducing the present state of the panel): Rossi/Rovetta 1988, fig. 43 and p. 84; Marani 1999, p. 77, no. 20, with further literature, reprod. p. 76.

19. Giovan Paolo Lomazzo, 1561 (Fig. 158). Fresco painted when the artist was twenty-three for the refectory of Santa Maria della Pace, Milan, 311 x 877 cm. Detached in the 1880s, transferred to canvas (Frizzoni 1890, p. 191); hung in the Grazie refectory before World War I (Fig. 138, right); destroyed in 1943. Malaguzzi Valeri 1915, fig. 604; Möller 1952, fig. 103. Recent references: Marani 1999, p. 77, no. 24, with further literature.

20. School of Paris Bordone (attrib.) (Fig. 157). Musée des Beaux-Arts, Strasbourg. Oil on panel, 27 x 74 cm. The attribution was ventured by Horst 1930–34, p. 146 and fig. 32, and has not been contested. Recent references: Marani 1999, p. 77, no. 23.

Considering how earnestly the painter strove to preserve the character of the Twelve, his departures from the original betray unspoken complaints, probably more than personal to the artist. The Strasbourg picture is a modest aside to the history of *Cenacolo* criticism, but it shows what no sixteenth-century critic had spleen enough to articulate: that Leonardo's deep space might be an unnecessary distraction, that the protagonist's contours are too geometric, his shoulders too skimpy, his feet too primly pointed. And what would have caused Judas' upset saltcellar to migrate to his elbow—here as in no. 31?

21. Anonymous, dated early to mid- to late sixteenth century (Fig. 27). The State **Hermitage** Museum, St. Petersburg. Oil on panel, transferred to canvas, 77 x 132 cm. Acquired 1845 from a St. Petersburg private collection; no earlier provenance known. Reprod. in Malaguzzi Valeri 1915, pl. XI; Horst 1930–34, fig. 24. Recent references: Marani 1999, p. 77, no. 22, with further literature. The 1916 Hermitage catalogue attributed the work to Marco d'Oggiono (d. 1524). In the 1958 Hermitage catalogue, I, no. 2036, it appeared as anonymous, late sixteenth century. It is now reascribed (like the San Barnaba and Écouen copies, nos. 10 and 12) to Marco d'Oggiono; see Tatiana Kustodieva, "I Leonardeschi all'Ermitage," in *Achademia Leonardi Vinci: Journal of Leonardo Studies*, 4 (1991), pp. 57–71.

A respectable work. The wine at Christ's right hand is omitted, his left foot hardly retracted. The most striking departure from the original is the emphatic widening of the rear wall.

22. Giovanni Battista Tarillo, 1581 (Fig. 159). Abbey of San Donato, Sesto Calende. Fresco, 632 cm wide. Condition ruinous. Malaguzzi Valeri 1915, p. 550 and fig. 609; Horst 1930–34, fig. 28. Recent references: Marani 1999, p. 77, no. 27.

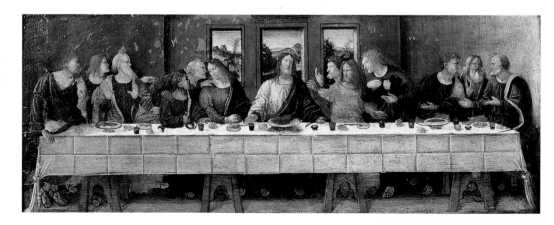

157. School of Paris Bordone (attrib.), Strasbourg.

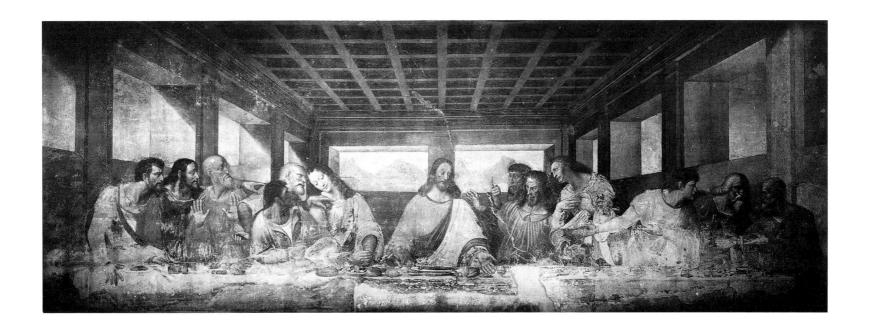

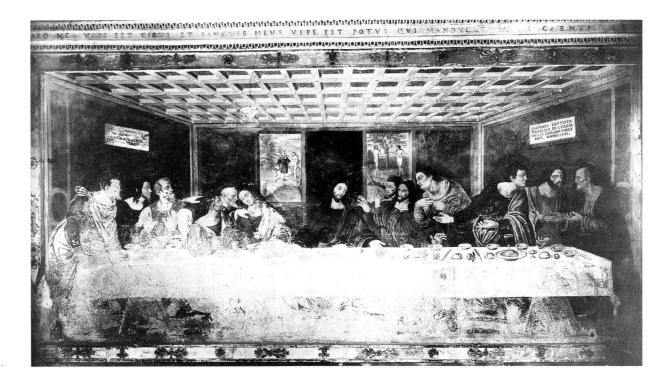

158. Giovan Paolo Lomazzo, 1561, from the refectory of Santa Maria della Pace, Milan.

159. Giovanni Battista Tarillo, 1581.

Nos. 23–26 are known to me only in reproductions or from the references cited below.

23. Anonymous, late sixteenth century. San Siro, Lanzo d'Intelvi (Como). Malaguzzi Valeri 1915, p. 550: *A Lanzo d'Intelvi, nella parrocchiale, v'è pure una vecchia copia, abbastanza fidele, ma piuttosto ritoccata e in parte rifatta in tempi non lontani.* Recent references: Rossi/Rovetta 1988, fig. 49 and p. 80, with further literature; Marani 1999, p. 78, no. 28.

24. Anonymous, sixteenth century. Oratorio, Novazzano (Ticino). Fresco. Rossi/Rovetta 1988, fig. 51 and p. 80, with further literature; Marani 1999, no. 29.

25. Anonymous, sixteenth century. Castello Sforzesco, Milan, inv. 703. Oil on panel, 160 x 260 cm. Marani 1999, p. 75, no. 14, with further literature.

26. Franco-Flemish, sixteenth century. Castello Sforzesco, Milan, inv. 704. Tempera on canvas, 40 x 202 cm. Marani 1999, p. 75, no. 15, with further literature.

II. SIXTEENTH-CENTURY RELIEFS

27. Circle of Tullio Lombardo, c. 1510 (Fig. 160). Ca' d'Oro, Venice. A fragmentary, unfinished marble relief, 85 x 189 x 11 cm. Discovered in 1880 in Santa Maria dei Miracoli, Venice; formerly immured in the passage to the sacristy; see Gustavo Frizzoni in *Archivio Storico dell'Arte*, 2 (1889), p. 134; Seidlitz 1909, p. 427, no. 24; Malaguzzi Valeri 1915, fig. 623; L. Planiscig, *Venezianische Bildhauer der Renaissance*, Vienna, 1921, p. 234 and fig. 241. Recent references: Rossi/Rovetta 1988, fig. 47; Marani 1999, p. 79, no. 43, with further literature.

The sculptor may have worked from an unidentified drawing or combination of sources. The right arm of James Major—straight up from the elbow instead of backshortened—suggests that his sources included the Birago engraving (no. 30). Abandoned, perhaps because the sculptor mismatched the relative proportions of upper and lower bodies, most noticeable in the main figure and the stander at the far left. The relief is of interest chiefly as a pioneering attempt to translate Leonardo's design into sculpture.

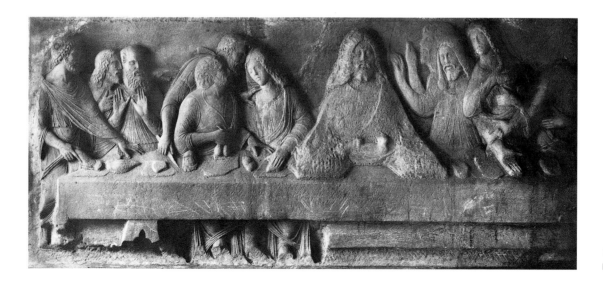

160. Circle of Tullio Lombardo, c. 1510.

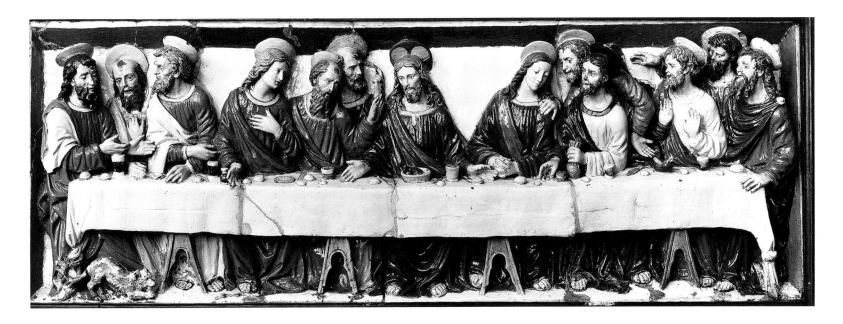

161. Giovanni della Robbia, c. 1510–20.

28. Giovanni della Robbia, c. 1510–20 (Fig. 161). Victoria and Albert Museum, London. Polychrome enameled terracotta, 55.9 x 162.6 cm; composition reversed. Recent references: Lambert 1987, no. 218; Rossi/Rovetta 1988, fig. 61; Marani 1999, p. 79, no. 44.

The spaniel at lower left and various other details show the sculptor, like Rembrandt more than a century later (see nos. 44–46), relying on the Birago engraving (no. 30). (This indirect relation to Leonardo's *Cenacolo* has not always been recognized. Thus Pope-Hennessy in the *Catalogue of the Italian Sculpture in the Victoria and Albert Museum*, London, 1964, no. 238 and pl. 245: "It is not related . . . to any known fresco or panel painting.") The debt to the Birago engraving involves more than the spaniel (at right in the print): there is the repositioning of Christ's parted feet, and, most tellingly, the raised hand of James Major. In Leonardo's mural, James' right arm recedes on an oblique course. Birago, unable to render the resultant foreshortening, produced a comical gesture, the forearm straight up, as if waving bye-bye. Apparently, each of the three sculptors adduced in this section (nos. 27–29) followed the Birago engraving (or one of its many derivatives) in part or in whole, without interference from the original in Milan.

29. Biagio da Vairone (d. 1514). A small marble panel to the left over the high altar in the church of the Certosa di Pavia. Reprod. in Malaguzzi Valeri 1915, fig. 622. Recent references: Rossi/Rovetta 1988, p. 84 and fig. 56, there dated 1513; Marani 1999, p. 79, no. 45.

Biagio's little panel was a forerunner to what became common practice in Italian churches: the use of relief panels of Leonardo's *Cenacolo* on altar fronts or high over the mensa. For the large precious-metal relief with life-size figures over the Altar of the Sacrament in the left transept of San Giovanni Laterano, Rome, see Jack Freiberg, *The Lateran in 1600*, London, 1995, pp. 307–09. The original silver relief of 1598–1600 (not, perhaps, strictly Leonardesque; Freiberg, figs. 35 and 117) was "reduced to coinage in 1798, during the French occupation of Rome. . . . In the 1860s a new relief modeled on Leonardo da Vinci's *Last Supper* was installed. . . ."

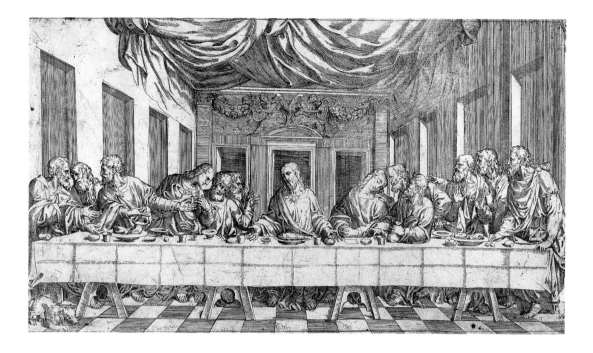

III. SIXTEENTH-CENTURY PRINTS

Not that I mean to belabor the early history of reproductive engraving, but this much may be repeated (see p.230): the very notion of reproducing new paintings and giving them widest publicity received its historic impetus from the Grazie refectory. We know of no earlier instance where the design of one monumental painting, locked in its proper place, was almost immediately disseminated on paper. It is this consideration which makes no. 30 in the present inventory a vital hinge in the history of the reception of art.

30. Giovanni Pietro da Birago (?), c. 1500 (Fig. 4). *The Last Supper with a Spaniel.* Engraving, Bartsch XIII, 83, 28. When first catalogued almost two hundred years ago by Adam von Bartsch, this pioneering print was described as "anonymous, manner of Nicoletto da Modena." Since then, and to this day, the attribution vacillates between hypothesis and conjecture. Paul Kristeller (1913) ascribed the work to Fra Antonio da Monza; A.M. Hind (1948) to the Master of the Sforza Book of Hours; von Einem (1961) to Zoan Andrea; Konrad Oberhuber (1966) to Birago, a priest from Brescia, documented as an illuminator attached to the Sforza court. (See Kristeller, *Die lombardische Graphik der Renaissance*, Berlin, 1913, p. 3, no. 1; Hind, *Early Italian Engraving*, London, 1948, V, p. 88, no. 9; Oberhuber, *Kunst der Graphik III, Renaissance in Italien*, Vienna, Albertina, 1966, no. 28). The Birago attribution is retained in *The Illustrated Bartsch*, XXIV, part 1, New York, 1980, p. 41.

For the full bibliography on Birago, see *Early Italian Engravings from the National Gallery of Art*, exh. cat., Washington, D.C., National Gallery of Art, 1973, pp. 272–73. Some more recent literature reverts to "Anonymous" (Alberici/ De Biasi 1984, no. 38; Lambert 1987, no. 215). Meanwhile, Suzanne Boorsch of the Metropolitan Museum of Art has found cogent reason (as yet unpublished) to identify the

162. Anonymous after the Birago engraving (Fig. 4), c. 1550.

engraver of our attribution-proof print with Giovanni Antonio da Brescia. The present work accepts "Birago" only for the convenient brevity of the name.

The conjectural date of the print within two years of the completion of the original mural is based on style alone. Nor do we know whether it was an artist, patron, or entrepreneur who first conceived the idea of transmitting the composition of a brand-new wall painting in a multiplied paper edition.

The appeal of Birago's print is attested by three early engraved copies, all North Italian; Hind, nos. 9a, 10, 11 (Bartsch mistakenly listing the original engraving as a second copy of no. 10); Alberici/De Biasi 1984, nos. 37, 39, 40; Lambert 1987, nos. 216, 217 (Hind, nos. 10, 11). I have suggested that one of these prints, rather than the mural itself, served the sculptors discussed in the foregoing section (see no. 28). That Rembrandt's first acquaintance with Leonardo's design came by way of Birago's bespanieled version everyone knows (see no. 44).

The Birago engraving and its offshoots give a fairly clear indication of what it was that held the attention of Leonardo's contemporaries: the variety of expressive gestures and the versatile grouping. Whereas the architectural set might be profitably suppressed or changed for the better. In Birago's print, the ceiling divides into eight instead of six bays; the new pavement articulation dissociates it from the ceiling; and the interposition of a dog gnawing his bone helps to distance the table from the stage apron. Two of the Birago derivatives reject Leonardo's deep space as unnecessary and disturbing. One of them widens the rear wall to flatten the space, evens the fenestration, inserts lateral roundels representing the angelic salutation, and puts the whole in an ornamental surround. Another tables the company before a broad, open loggia, which may have inspired the arcuated background of the famous Brussels-made Vatican tapestry of c. 1530 (no. 38). A later anonymous engraving of c. 1550 (Fig. 162) retains the field's three-wall tripartition, but banters with floor and ceiling.

And bear this in mind: that the prevailing dependence of sixteenth-century copyists on black-and-white prints (or drawings) encouraged disregard of Leonardo's original color. The free color choice often observed in painted copies (such as Van Dyck's, no. 43) suggests that painters, too, relied on available prints.

One final reflection concerns Birago's small pet. It may be no more than a genre element with repoussoir function. But in the context of the *Last Supper*, it could allude to Christ's words, "Do not give that which is holy unto the dogs" (Matt. 7:6), an injunction which, since Early Christian times, was understood to refer to the unworthy reception of the eucharist.

IV. SIXTEENTH-CENTURY DRAWINGS

Surprisingly few sixteenth-century drawings of the *Cenacolo* survive—generally in wretched condition. The copyists, painters no less than engravers, used drawings to work from, and discarded them when their purpose was served. But hundreds must have been made. Studious beginners probably copied the mural as part of their training, the way young artists in Florence, from 1505 on, drew from Michelangelo's *Cascina* cartoon. Cf. the entry on the Parmesan Alessandro Araldi (no. 9).

The following section lists a handful of sixteenth-century drawings.

31. Louvre, inv. 2551 (Fig. 163). Pen, brown ink, and wash, 21.5 x 33 cm. Malaguzzi Valeri (1915, p. 550 and fig. 612) attributes the drawing (for no apparent reason) to a Leonardo pupil. It must, however, be of the period, if only because Thomas' left hand still shows. In most respects, the drawing is remarkably faithful, but certain features in it are puzzling: the draftsman's omission of the floor pattern, his reluctance to bring the feet of Christ down below those of

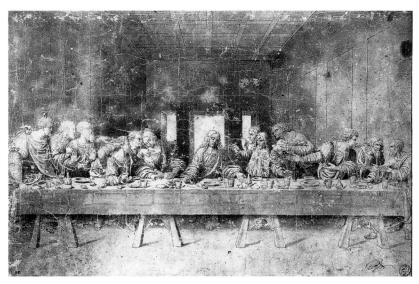

163. Anonymous, Louvre 2551.

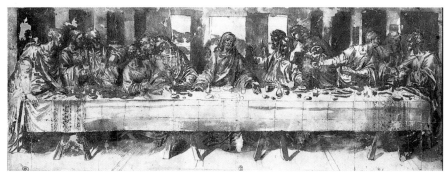

164. Anonymous, Louvre 2552.

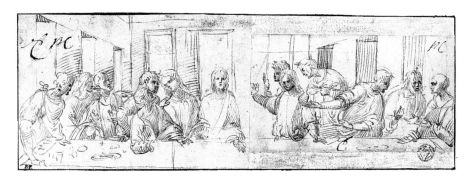

165. Anonymous, Louvre 2553.

the Apostles, the transfer of Judas' capsized saltcellar from forearm to elbow (cf. no. 20).

32. Louvre, inv. 2552 (Fig. 164). Ink and wash, 14.3 x 37.7 cm. Published by Malaguzzi Valeri (1915, fig. 613), who dated it to the mid-sixteenth century, and described it as "evidently a record made from the original." Not so; format, truncation, and the flattening of the three walls indicate that it was drawn from the Certosa version (no. 6). One small detail gives it away: the precise relation of the two innermost trestle legs to the innermost floor bands (the leg on the left is half on and half off).

The drawing was apparently meant to be painted from: colors, designated by their initials, are inscribed on garments and hair. Philip's right sleeve was to be blue—A for *azzurro*; James Major's hair was to be red—RS for *rosso*, etc. (Without a loupe, these letters may be impossible to make out in reproduction.)

33. Louvre, inv. 2553 (Fig. 165). Pen and brown ink, on two sheets of unequal size, laid down, 8.7 x 26.1 cm. Published by Malaguzzi Valeri (1915, fig. 611) with the comment (p. 550): *sembra opera fiorentina abbastanza delicata della prima metà del 1500*. A naive but appealing sketch, drawn in a Quattrocento manner by an artist who had not undergone Leonardo's tuition.

34. Louvre, inv. 2554 (Fig. 166). Pen and wash heightened with white, 20.4 x 27.8 cm. Signed on the tablecloth: "PALM:F." A copy of the right half of the Vatican Arazzo (no. 38). Malaguzzi Valeri 1915, fig. 610.

35. Anonymous (Fig. 167). The Armand Hammer Center for Leonardo Studies, University of California, Los Angeles (incorporating the Elmer Belt Library of Vinciana). Chalk, 13 x 19.5 cm. The setting derives from the Vatican Arazzo (no. 38; see Carlo Pedretti, *Leonardo da Vinci: Exhibition*

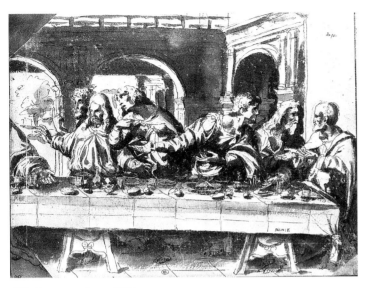

166. Anonymous, Louvre 2554.

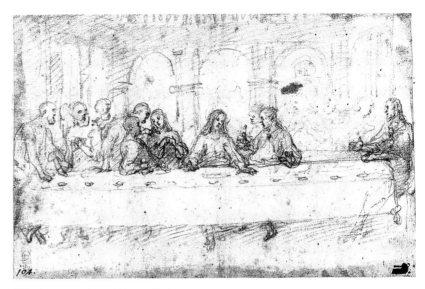

167. Anonymous, Armand Hammer Center.

in Honor of Elmer Belt, University of California, Los Angeles, 1973, no. 3). The figures are intelligently reimagined; several gestures and postures are expressively altered.

36. A superb drawing, present whereabouts unknown, in a perilous state of water damage and advanced mutilation (Fig. 168). I quote from a personal letter received January 6, 1968, from Kate T. Steinitz, then curator of the Elmer Belt Library of Vinciana at the University of California, Los Angeles: "I send you a photograph of a *Last Supper* which was offered to us a long time ago, 1952. It was in a terrible condition; therefore the offer was turned down. It belonged to Mme. Maudiet of Paris and was offered to us by Mrs. Christopher Gray … of Baltimore, Md. Now that these little copies are coming into the limelight, I'm sorry we refused it. Panofsky, visiting us recently, was quite enthusiastic about Carlo Pedretti's attribution to the illustrator of Cod. Huygens, whoever he may be. I am not convinced, much as I respect and love Panofsky—I feel he sees more with his iconological mind than with his eyes."

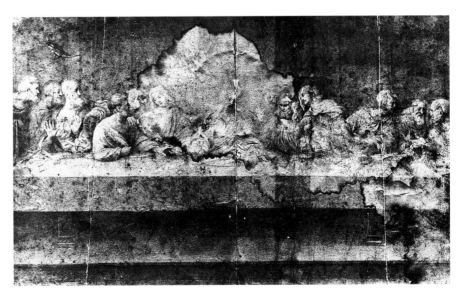

168. Anonymous, whereabouts unknown.

169. Flemish or Fontainebleau
School, c. 1530, Vatican.

170. Flemish (?), presumably
based on cartoons after Fig. 169.

V. SIXTEENTH CENTURY: OTHER MEDIA

37. **Simon Bening**, Hennessy Hours, c. 1525–30 (Fig. 20). Bibliothèque Royale, Brussels. Predella to the miniature of the *Agony in the Garden*; see Joseph Destrée, *Les Heures de Notre-Dame dites de Hennessy*, Brussels, 1923, p. 76 and pl. xxxiii; Malaguzzi Valeri 1915, p. 557 and fig. 620. The iconographic significance of this illumination is discussed on p. 43.

38. **Vatican Arazzo, Flemish or Fontainebleau School**, woven in Flanders; designer unknown, c. 1530 (Fig. 169). Vatican Apartments. Tapestry, 500 x 905 cm. Discussed in Möller 1952, fig. 90 and pp. 129–34. Contextualized in Janet Cox-Rearick, *The Collection of Francis I: Royal Treasures*, New York, 1995, pp. 79–81, 135, 363–66, and p. 468 n. 14 for further literature. Other recent references: Rossi/Rovetta 1988, fig. 58; Marani 1999, p. 79, no. 49, with date "1530."

The tapestry was a royal gift from Francis I to Pope Clement VII on the occasion of their meeting in Marseilles, October 1533, to celebrate the marriage of His Holiness' niece Catherine de' Medici to the king's son, Henri d'Orléans, the future Henri II. Thirty years later, the occasion, including the exchange of gifts, would be commemorated in a drawing by Antoine Caron, with accompanying sonnet (see Cox-Rearick, p. 79 and fig. 104). But Caron's drawing, one of a series of twenty-eight, executed in 1560–74, unaccountably shows the unveiled tapestry representing a *Last Supper* other than Leonardo's. (Cox-Rearick's repeated state-ment, pp. 135, 366, that the Vatican tapestry had been commissioned and produced for Francis I even before he became king in 1515 remains unverifiable and difficult to accept.)

Of another Vatican tapestry, I reproduce a photograph sent to me (August 10, 1974) by Deoclecio Redig de Campos, then director of the Vatican Museums (Fig. 170). He called the work "the San Michele tapestry . . . in the Vatican Floreria."

The first Vatican arazzo and yet another are mentioned in Giulio Mancini, *Considerazioni sulla pittura* (1614–21), ed. Rome, 1956, I, p. 76: *di questi tempi ancor sono gl'arazzi pontificij, parte di disegno di Raffaello e parte di Leonardo da Vinci.... Vi è una copia della Cena degli arazzi del Vinci fatta in quei tempi e forsi ricavata da esso et si ritrova in Perugia appresso un gentil-huomo di casa Baldeschi.* Of this latter work I have no further notice.

Nos. 34 and 35 above both depend on the Vatican tapestry.

VI. SEVENTEENTH-CENTURY COPIES

39. **Andrea Bianchi, called Il Vespino**, 1616 (Figs. 12, 33, 171). Pinacoteca Ambrosiana, Milan. Oil on canvas, 118 x 835 cm. A partial copy that admits only the upper bodies above a bare tabletop. Commissioned by Cardinal Federigo Borromeo in 1612, ostensibly to conserve what was fast fading from the original mural, as indicated in the inscription at upper left: RELIQVIAE COENACVLI FVGIENTES HAC TABVLA

171. Andrea Bianchi, called Il Vespino, 1616.

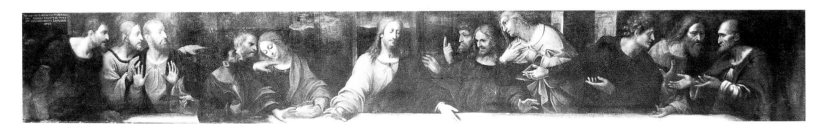

EXCEPTAE SVNT VT CONSERVARETVR LEONARDI OPVS. The work was reluctantly undertaken and finished in 1616, by which time the copy now at the Royal Academy, London (no. 6), may have entered the Certosa di Pavia, where it is first documented in 1626. Strangely enough, the cardinal neglects to mention this early sixteenth-century copy and the fresco at Castellazzo (no. 5). The existence of these superior works surely obviated the need for Vespino's endeavor. See Horst 1930–34, fig. 36; Möller 1952, figs. 105–06.

In 1973, when I saw the huge canvas in an attic storeroom of the Ambrosiana, it was in poor state. Cleaning in 1978–79 restored the picture to a condition fair enough to display under the ceiling of the museum's bookshop and ticket sale area, and to permit decent reproduction in color; see Marco Rossi and Alessandro Rovetta, *La Pinacoteca Ambrosiana*, Milan, 1997, p. 38 (with full bibliography), and Rossi/Rovetta 1988, p. 80 and fig. 8. Two black-and-white details appear in Marani 1999, p. 78, no. 30.

40. Rubens School (Fig. 41). Musée du Louvre, Paris, inv. 20.191. Leonardo's Christ and St. Simon alone. Black and red chalk, ink, bister and watercolor washes; on two sheets pasted together, 31.7 x 48.6 cm. See Frits Lugt, *Inventaire général des dessins des écoles du Nord. École flamand*, Paris, 1949, II, no. 1200: *La figure du Christ et celle de l'Apôtre Simon, tirée de la Cène. D'après Léonard de Vinci . . . Dessin mou, dans lequel nous ne pouvons pas retrouver la main du maître. Mais il a sans doute été exécuté sous sa direction.* The iconographic significance of this Lord's Supper epitome is discussed on p. 82.

41. Pieter Soutman (c. 1580–1657). Etching, datable c. 1620 (Fig. 17). Double folio, 29.4 x 98.8 cm, printed from two plates, based on a lost or still unidentified drawing by Rubens; familiar to Rubens admirers ever since C.G. Schneevogt's *Catalogue d'estampes d'après Rubens*, Haarlem, 1873, no. 231.

Dispensing once again with Leonardo's perspective, the etching presents the frieze of figures against a central baldachin, flanked by dark neutral ground. The scene is reversed and the table cleared of all but a chalice and breadloaf placed before Christ. In the inscription space, passages relating to the eucharist from Matthew 26, Mark 14, and I Corinthians 11:23. Bottom line: *Lionardo da Vinci Pinxit; P.P. Rub. Delin.; Cum Priuilegio; La caena stupenda di Leonardo d'Auinci chi moriua nelle braccie di Re di francia.*

(Translation: "Painted by Leonardo, drawn by Rubens and copyrighted by royal privilege—the stupendous Supper of the painter who died in the arms of the King of France." That final trim is, of course, mythic; when Leonardo died at Amboise in 1519, Francis I was campaigning elsewhere. But the legend stuck. In the 1780s, Giuseppe Cades etched the exalted death scene *alla gloria della pittura* [Alberici/De Biasi 1984, no. 173]. Ingres made a painting of it, engraved by Richomme [Fig. 172]. Beyond all Leonardo's other achievements, it was the manner of his dying that proclaimed his uniqueness. What other painter died in the arms of a king!)

Soutman's graphic manner is coarse. As Nagler wrote long ago, "For him, beauty and grace mattered less than a strong pictorial effect" (G.K. Nagler, *Neues allgemeines Künstler-Lexicon*, Munich, 1847, XVII, p. 98). But the fluent drawing is spirited, and the tonal contrasts are bold enough to give Soutman's unusually large plates what is now called "wall power"—which explains why Rubens enrolled this former pupil among his collaborators. (Soutman produced no fewer than seventeen large etchings after the master's designs.) Yet we know little about him. As Julius S. Held observed forty years ago, "Soutman had worked in Rubens' studio. [His] role as collaborator and as imitator of Rubens is in need of further clarification"; Held, *Rubens: Selected Drawings*, London, 1959, I, p. 145.

A drawing of Leonardo's *Last Supper* preserved at Dijon and traditionally ascribed to Rubens (no. 42) has been pro-

posed as the template for Soutman's print. But its dimensions don't fit, and the Rubens attribution is moot. (Two further drawings of the *Last Supper*, both in British collections and said to be Rubens' work, are cited in Möller 1952, p. 194 n. 137; they are unknown to me and absent from subsequent Leonardo-Rubens literature.) Closely related to Soutman's print is a drawing in his own hand for the (unreversed) left half of the composition (Chatsworth; reprod. in Brown 1983, p. 31). The sheet is not squared for transfer and the dimensions do not quite coincide, but it is clearly preparatory for the etched plate.

The Rubens drawing which Soutman acknowledged in the etching's inscription need not have been done in Milan. More probably, it was drawn from the full-scale copy at the Tongerlo Abbey (no. 15). According to Möller (p. 165), Rubens visited Tongerlo and drew its *Cenacolo*, "as recorded in the archives of the abbey"—which I here take on trust. The visit would have occurred during 1618–19, when Rubens, commissioned by the Fishermen's Guild of Mechelen (Malines, less than twenty miles from Tongerlo), was creating his great triptych, *The Miraculous Draught of the Fishes*, for their cathedral. His drawing of the *Last Supper* at Tongerlo may have provided the occasion for Soutman's print—but all this is conjecture.

The print was a resounding success. It was reissued five times by a succession of publishers, and at least three printmakers copied it. According to Möller (p. 164), Soutman was one of four artists—the others being Rymsdyck, Vermeulen, and F. de Witt—who based their Leonardo *Last Supper* prints on the same lost Rubens drawing, but this is an evident error (though repeated verbatim in Alberici/De Biasi 1984, p. 50). The etching by Andreas van Rymsdyck (act. London, c. 1767–84; Fig. 173) is clearly a (re-reversed) copy of Soutman's work. So is the mezzotint by Hermann Heinrich Quiter (c. 1628–1708; Fig. 174), unmentioned by Möller. And so probably is the *Last Supper* engraving (unknown to me) by the prolific Cornelius Martinus Vermeulen

172. Joseph-Théodore Richomme after J.A.D. Ingres, *The Death of Leonardo*. Note the mourner at right, gesturing in emulation of Leonardo's St. Matthew.

The STUPENDOUS PERFORMANCE of Leonardo da Vinci, WHO EXPIRED IN THE ARMS of Francis I. KING of FRANCE.

173. Andreas van Rymsdyck after the Soutman-Rubens engraving.

174. Hermann Heinrich Quiter after the Soutman-Rubens engraving.

(Antwerp, c. 1644–c. 1709), who worked repeatedly after Rubens and, on occasion, made copies of other prints. Finally, Möller's "F. de Witt" must be one of the three generations of engraver-publishers of that name whose enterprise was founded in Amsterdam in 1648 and flourished until the death of the founder's grandson in 1712. Known chiefly for their excellent maps, the de Wits also bought up old copperplates for retouching and republication. Accordingly, the address "F. de Wit" appears on the fourth state of the Soutman etching; it was not pulled from a different plate. Möller had failed to note that his three supposed co-dependents on Rubens' drawing are younger men, postdating Soutman by one or more generations. Unlikely that any of them would have had access to Rubens' drawing. What they republished or copied was the work of Rubens' pupil-collaborator.

The best remembered of artists indebted to Soutman's *Last Supper* is Rembrandt, as will be shown under nos. 44–46.

42. Rubens (?) (Fig. 175). Musée des Beaux-Arts, Dijon. Ink and brown wash, touched with white oil, 22 x 68 cm. Rubens' authorship was doubted by Max Rooses (see below), by Ludwig Burchard, and by Gantner (1962, p. 180), who writes "Rubens (?)."

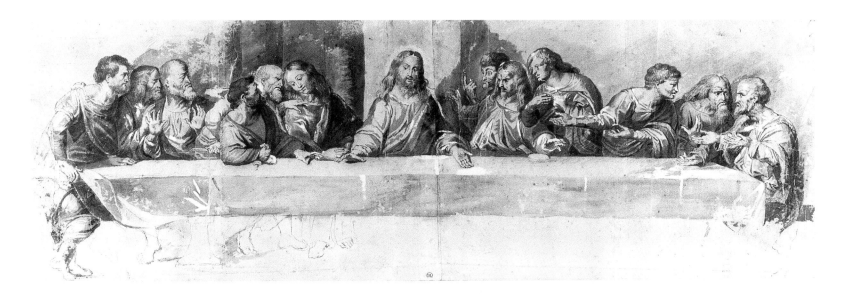

175. Rubens (?), Dijon.

It was Michael Jaffé who confidently attributed the Dijon drawing to Rubens (*Van Dyck's Antwerp Sketchbook*, London, 1966, I, pp. 32–33, and pl. XX). Jaffé presents the matter as follows: "The copy of the *Last Supper* in the refectory of S. Maria delle Grazie, which Rubens must have drawn there on a bold scale within a year or so of his coming to Italy, was also used by Soutman as the basis for the *modelletto*, which he himself drew in red and black chalks in preparation for the etching [Jaffé's n. 37 adds that "the left half of Soutman's modelletto survives at Chatsworth, No. 677"; see p. 259 above]; and for the second state of this very large and important print its maker replaced '*P. Soutman effigiavit et exud.*' with '*Rubens delin.*' Rubens' original drawing from the fresco, in pen and wash, came to the Musée de Dijon from the His de la Salle collection in 1862–65, having been quite possibly in France for a century or more." Jaffé adds casually that Max Rooses, author of *L'Oeuvre de P.P. Rubens*, 5 vols., Antwerp, 1886–92, "wrongly doubts the attribution to Rubens of the Dijon drawing." Jaffé's opinion was seconded in *Maîtres flamands. . .* , 1975, p. 76 (see no. 43).

Not all were persuaded. In a private communication, dated February 21, 1974, Julius S. Held commented: "I have grave doubts about Jaffé's attribution to Rubens; I do not know any [Rubens] drawing that falls so badly apart as does this one. Maybe it was done by young Deodat del Monte, who accompanied Rubens in Italy. . . . Are the feet an original effort? Though poorly integrated with the bodies above, they are not badly drawn; could it be a slight sketch by Rubens that was later worked up in detail, and with elaborate washes, by someone else? (Soutman?)" Three years later, Didier Bodart declared flatly that the Dijon drawing *non è di Rubens* (*Rubens e l'incisione*, exh. cat., Rome, Villa della Farnesina, 1977, p. 29).

A new insight into the Dijon drawing came in 1981, when Edit Pogány-Balás pointed out that its table supports exactly copy the two squat stone pillars that prop up the board in the Bonsignori copy formerly at San Benedetto Po near Mantua (see no. 8 for Pogány-Balás, pp. 79–80). The drawing, then, would not transcribe Leonardo's original, where the table rests on four wooden trestles, but the Bonsignori copy of c. 1513–14. If its author was the young Rubens during his Mantuan period (1600–08), he would

have made the drawing before ever laying eyes on the Grazie mural. And the color notes inscribed in Flemish on the verso and cited in Jaffé's n. 37 as being in Rubens' hand, would record not Leonardo's color, but Bonsignori's.

Unfortunately, Pogány-Balás' valuable observation is not compelling, since the Dijon drawing is not all of a piece. To my eye, nothing below the tablecloth—and that includes the table's pillar supports—is part of the original drawing. A later hand, possibly as late as the eighteenth century, undertook to complete the image by bringing the presentation down to floor level. The latecomer relied on the Bonsignori copy as a guide for the feet and the pillar supports, but he neglected to notice that the Dijon drawing sharply curtails the depth of the table and the drop of the tablecloth. The effect of his graft is to make the anatomic proportions at lower left seem absurdly stunted. Held rightly questioned whether the feet were "an original effort"; and he observed that they fail to integrate with the upper bodies—which is why the drawing "falls so badly apart." I would add that the leftmost character, St. Bartholomew, has suffered the adjunction of backside and legs, whereby the figure is turned into travesty. To judge the Dijon drawing, let the Bartholomew figure end at right elbow and hand (of which more under no. 43), and let the whole be mentally cropped above the hem of the tablecloth—as it is in the Soutman etching.

Soutman's print shows at least two further features which the Dijon drawing anticipates. His asymmetrical curtain at center is shaped like the drawing's dark central background. And whereas Leonardo's Christ keeps his relaxed shoulders parallel to the picture plane, the Dijon drawing introduces a shoulder rotation and tilt of the torso's main axis. The result is an energetic revision of the protagonist's posture, which, in the Soutman print, becomes athletic, vigorous, and commanding; not submissive, but initiatory. This reinterpretation of the *Cenacolo*'s central action suggests Rubens' vision, whether or not the Dijon drawing is his.

43. Antony Van Dyck, c. 1618 (Fig. 176). Private collection. Oil on panel, 108 x 190 cm. Inscribed at lower left: *Pedro Pablo Rubens inventor, Antonio Vanding F.* See *Maîtres flamands du dix-septième siècle du Prado et des collections privées espagnoles*, exh. cat., Brussels, Musées Royaux des Beaux-Arts, 1975, no. 13 (as in the collection of José Luis Alvarez, Madrid); reprod. in color, with citation of further literature and a history of the painting from its first mention in an Antwerp collection in 1653 to its reappearance in 1766 in a Madrid convent. It was probably after arriving in Spain that the picture acquired the Spanish inscription crediting Rubens as the "inventor." Recent references: Hüttel 1994, p. 15 and fig. 11; Marani 1999, p. 78, no. 32 (misplaced to Dijon).

The published reproductions indicate a work of high quality, probably based on a drawing, since the color scheme is freely invented. The foreground accommodates still- and animal life, whereby the table, unlike Leonardo's, is well recessed. Center background displays the sweep of a red Baroque curtain, not exactly like Pieter Soutman's (no. 41), but sufficiently similar to betray dependence on a common source.

The feet throughout are kept in deep shadow, barely discernable—except for the conspicuous foot at far left, which allows Bartholomew no crossed ankles. But Bartholomew's right hand is given a novel role: it ruffles the tablecloth which now bunches back on the table. This motif occurs in only one other instance—the Dijon drawing (no. 42), which, before being spoiled by Bartholomew's undercarriage and the rest of the footwork, may well have served as Van Dyck's model.

The furnishings of the table are minimal (no personal plate to eat from). But isolated at center, bread and chalice receive Christ's undivided attention. As in all Rubens School renderings of Leonardo's subject, the interpretation is unequivocally eucharistic.

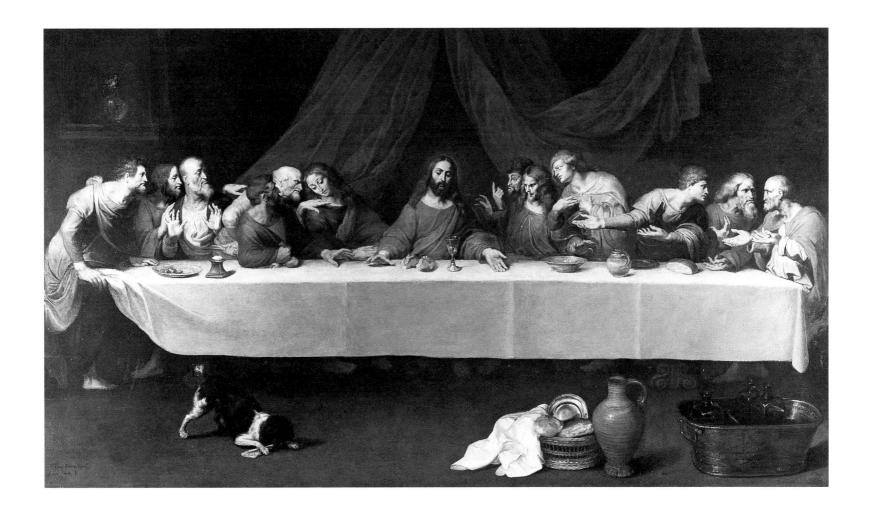

176. Van Dyck, c. 1618.

177. Rembrandt, c. 1634–35, London.

178. Rembrandt, 1635, Berlin.

44–46. Rembrandt, three drawings.

44. c. 1634–35 (Fig. 16). The Metropolitan Museum of Art, New York, Lehman Collection. Red chalk, 36.4 x 47.3 cm.

45. c. 1634–35 (Fig. 177). British Museum, London. Red chalk, 12.4 x 21.9 cm.

46. 1635 (Fig. 178). Kupferstichkabinett, Berlin. Ink, wash, and gouache, 12.8 x 38.5 cm.

Of the three, only the Lehman drawing (the largest of Rembrandt's known drawings) merits the title of "copy"—the small dog, lower right, is obviously lifted from Birago's *Last Supper with a Spaniel* (Fig. 4). But it has long been observed that no. 44 is a palimpsest. Whatever the date of the lightly drawn initial version, on some later impulse, possibly in the 1650s, Rembrandt overlaid the drawing with robust corrections, presumably after encountering some other copy that gave better insight into the original (see George Szabo, *Seventeenth-Century Dutch and Flemish Drawings from the Robert Lehman Collection*, New York, 1979, no. 23; E. Haverkamp-Begemann, *Creative Copies: Interpretative Drawings*

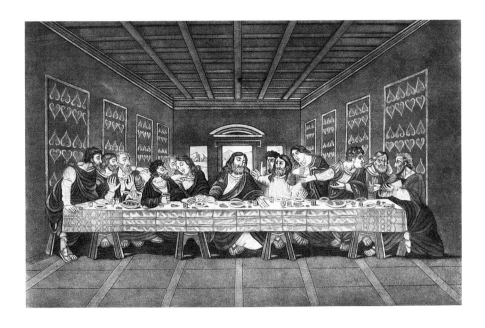

179. Anonymous Dutch, c. 1800 (?).

I pass over the copies produced in the eighteenth century, among them, a surprising number of mezzotints. Of these, some are serious, others inadvertently comical though well-intentioned. I reproduce, because it is unpublished, a Dutch mezzotint of which I fondly own an impression (Fig. 179). For the burgeoning literature on the recycling of Leonardo's *Last Supper* in the eighteenth, nineteenth, and twentieth centuries, see Alberici/De Biasi 1984; Lambert 1987, chap. 7; and Hüttel 1994.

47. André Dutertre, 1789–94 (Fig. 180). Ashmolean Museum, Oxford; drawing acquired in 1956 from a British private collection. Chalk, tempera, and wash heightened with white, 55.5 x 107 cm. The acquisition was announced by K.T. Parker (in *Ashmolean Museum: Report of the Visitor, 1958*, Oxford, 1958, pp. 65f.) and became the subject of a detailed study by Heydenreich (1965). In his English-language monograph (1974, p. 101 and fig. 63), Heydenreich declared the Dutertre drawing to be, of all known copies, "the best and most valuable." Hüttel, who had charted the flow of *Last Supper* reproductions down to Dutertre's moment, made this further claim: "Dutertre's drawing marks a turning point in the history of the reproduction of the *Last Supper* . . . an unprecedented intensity in the study of sixteenth-century copies necessarily led [Dutertre] to a new level of authenticity" (1994, p. 39; see also pp. 18–19 and fig. 15). Further references: Brown 1983, no. 21; Eichholz 1998, pl. 7; Marani 1999, pp. 40–41, 86 n. 37, with additional literature.

The story, as Heydenreich tells it, is of great interest. Briefly summarized: early in 1789, the year of the Revolution, King Louis XVI commissioned André Dutertre (1753–1842), a draftsman highly respected for his reproductive skills, to create an accurate record of Leonardo's *Last Supper*, with a view to having it engraved and published under royal

from Michelangelo to Picasso, exh. cat., The Drawing Center, New York, 1988, no. 31, pp. 115–17; Brown 1983, nos. 15, 17; E. Haverkamp-Begemann et al., *The Robert Lehman Collection, VII. Fifteenth- to Eighteenth-Century Drawings in the Robert Lehman Collection: Central Europe, The Netherlands, France, England*, Princeton, 1999, no. 66 and especially n. 16). As the source of Rembrandt's further insight, Gantner (1962) suggested the copy at Tongerlo (no. 15), but how would the stay-at-home Amsterdamer have seen it? His source is more likely to have been the Soutman-Rubens etching (Fig. 17), or an unreversed drawing for it. Here, among other things, Rembrandt would have seen James Major's right arm backshortened, and would have recognized how misled he had been by Birago's naiveté (see no. 28).

Nos. 45 and 46 offer striking evidence of Rembrandt's engagement with Leonardo's *Cenacolo*, a subject widely discussed in the Rembrandt literature. To the subject of "copies," the London and Berlin drawings are increasingly marginal.

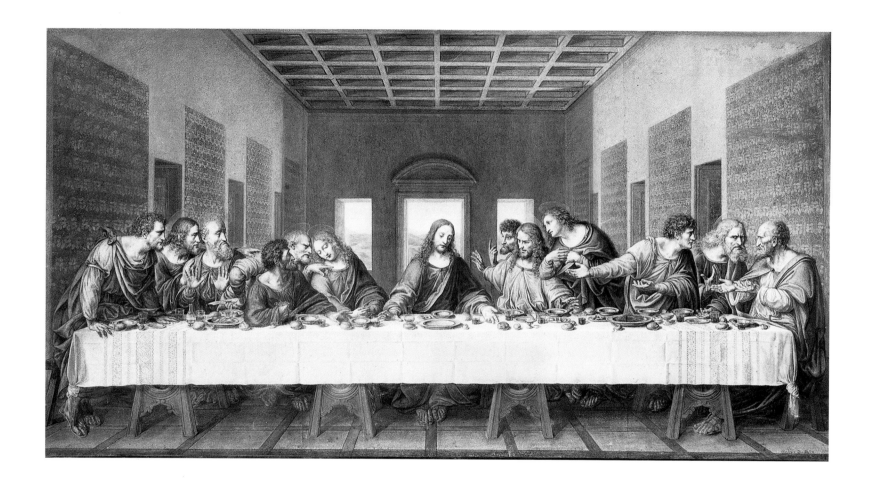

180. André Dutertre, 1789–94.

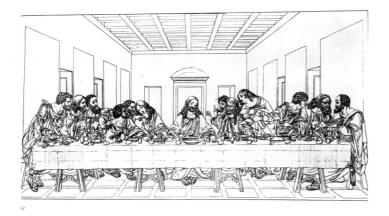

patronage. For five years, Dutertre worked on the drawing, making close comparative studies of the best copies, that at Castellazzo and the one then still at the Certosa di Pavia (nos. 5 and 6). The artist chosen to deliver the final product was Italy's foremost reproductive engraver, Raphael Morghen, who accepted the charge with enthusiasm. But the projected collaboration never materialized, probably for political reasons (see no. 48). Dutertre returned to Paris, where his *Last Supper* drawing was exhibited in 1794 and 1796 with prizewinning *éclat*.

In 1798, Dutertre was appointed to the commission of scholars and artists attending Napoleon's Egyptian campaign, and he contributed significantly to the monumental publication on Egyptian antiquities that appeared from 1808 to 1822. At last, he became a professor and died poor in 1842. But his labors over Leonardo's *Cenacolo* were not to be wholly forgotten. In 1808, Dutertre had a team of engravers make folio-size prints after his drawings of the thirteen heads in the *Last Supper* (Figs. 182, 183). They were published as *Collection des têtes du célèbre tableau de la Cène, par Léonard de Vinci. . . .* These heads were accompanied by a crudely simplified, small-scale line engraving of the ensemble (Fig. 181). Heydenreich (1965, p. 221) finds it "strange" that Dutertre left unpublished his main effort, the large

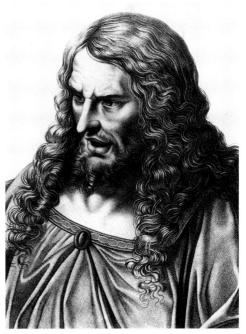

drawing that had occupied him for five years. I surmise that the artist withheld its publication, seeing that no engraved reproduction of it would equal the quality achieved by Morghen's engraving after a rival drawing by Teodoro Matteini, published in 1800 (no. 48).

Heydenreich is aware that the Dutertre drawing departs here and there from the original. (The pavement, though it includes an axial floor band, is freely invented, as is the patterning of the tapestries; the side doors between the tapestries rise right and left to the same height; and the hard-edge vertical shadows that terminate the side walls are misunderstood.) Yet Heydenreich supports his claim for Dutertre's superior accuracy by pointing out that the drawing was made just before the French occupation of Milan (1796), during which the Grazie refectory was used as a stable, and soldiers took potshots at the Apostles. It is implied that Dutertre saw the mural in better state than would be available ever after. Heydenreich failed to consider that Matteini too must have worked on his *Cenacolo* drawing before 1796 (see p. 269), and that Dutertre himself, working from 1789 to 1794, had seen the mural only as repainted in whole by Michelangelo Bellotti in 1726, and in part by Giuseppe Mazza in 1770. In the Grazie refectory, Dutertre was facing a repainted ruin, forcing him to resort, as did his successors, to the evidence of the Castellazzo and the Certosa copies, even where their evidence was inconclusive or contradictory. The most recent restoration of Leonardo's *Cenacolo* found little to learn from Dutertre.

48. Raphael Morghen, 1800 (Figs. 14, 43, 57). Engraving, 52.4 x 93.5 cm.

Recent references: Brown 1983, no. 21; Alberici/De Biasi 1984, no. 44 and pp. 51–52; Lambert 1987, no. 221; Hüttel 1994, pp. 18–22.

This showpiece of the engraver's craft became crucial to the afterlife of Leonardo's *Last Supper*, but its origins (for which see especially Alberici/De Biasi 1984, pp. 51–52 and

no. 44) remain largely obscure. Summarizing as best I can:

1. 1794. Morghen (1758–1833) is shown the Dutertre drawing (no. 47), which had been commissioned by Louis XVI in 1789 and had taken five years to complete. Moved to tears by its beauty, Morghen is enthusiastic about the project of perpetuating it in an engraving.

2. Later that year, the project aborts. Dutertre, though falsely dubbed "Swiss" to dissemble his Frenchness, returns to Paris; the precious drawing safe in his luggage. It was Heydenreich (1965) who tentatively ascribed the abandonment of the Dutertre-Morghen collaboration to politics. The feelings on the Italian side would have run something like this: only a year before, the French had murdered their king. If the *Cenacolo*, the glory of the foremost Florentine painter, was to be engraved for all time, why use a regicidal foreigner's work? But this is a guess.

3. Still in 1794 or very soon after, a delegation of Florentine artists solicits the Habsburg Grand Duke of Tuscany, Ferdinand III, to commission R. Morghen to engrave Leonardo's *Cenacolo*. His Highness is game, whereupon the admirable Teodoro Matteini (a Tuscan, born 1754, in Pistoia) is charged to repair to Milan to produce the requisite substitute for Dutertre's absconded drawing.

4. A document published by Aurora Scotti in 1980 (see Alberici/De Biasi 1984, p. 51 n. 8) records Matteini's request to the monastery of Castellazzo for permission to draw its copy of Leonardo's *Cenacolo*; given the dismal state of the original, a reasonable request. But it is less than fair to describe Matteini's drawing of the *Last Supper* as simply a copy of the Castellazzo fresco (as was done by Hoerth 1907, pp. 25–26, and often thereafter). Since Matteini's commission was to create an authentic, durable record of Leonardo's *Cenacolo*, it is unlikely that he snubbed the original. Like Dutertre shortly before, like G.G. Frey shortly after in 1803 (Fig. 184) and Bossi in 1807 (no. 49), he must have compared the available evidence to produce an interpretation—no different in this respect from what scholars have done ever since.

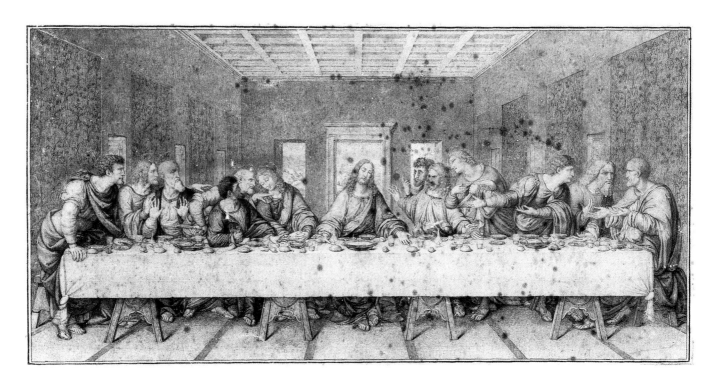

184. Giovanni
Giacomo Frey, 1803.

5. What became of Matteini's drawing? Alberici/De Biasi (1984, p. 51 and n. 9) cites an entry by Pietro Zani in the *Enciclopedia metodica critico-ragionata delle Belle Arte* (1821), wherein Zani claims to have seen Matteini's *Cenacolo* drawing "in Milan," observing that the work was greatly praised by artists and amateurs. One wonders how that drawing would have got back to Milan, after being used up by Morghen in Florence. I know of no further notice of such a drawing surviving.

6. When would Matteini have executed his drawing? Obviously before 1797, when Morghen started translating it to his copperplates. How long before? On May 16, 1796, the French captured Milan from the Austrian Habsburgs and, in contravention of Bonaparte's last-minute order, converted the Grazie refectory into a stable. The execution of Matteini's large, detailed drawing must predate that conversion. Indeed, Hoerth (p. 25) dates the drawing to 1795.

But this robs Dutertre's work (no. 47) of the distinction claimed for it by Heydenreich: both Dutertre's drawing and the one Morghen would eventually work from were done before Leonardo's mural suffered the injuries of the French. There is thus no chronological reason to regard the Morghen engraving as less authoritative than the Dutertre drawing in Oxford. Where the two differ, they differ in interpreting the same evidence.

The twentieth century has not looked kindly on Matteini and Morghen. We malign the engraving as Neoclassic, Romantic, inaccurate, mechanical, sentimental. Hind found unendurable "the monotonous regularity of hatching, cross-hatching, dot and flick, rarely relieved by any spark of real life" (A.M. Hind, *A History of Engraving and Etching* [1923], New York, 1963, p. 209). All of which is correct; the work, like most work, betrays period style.

But Morghen's print in its proper sphere is a master-

piece, and it ought to be seen as intended, i.e., in one's own home. Thus Goethe in 1817, as he embarks on his famous description: "We now come to the real object of our endeavor, painted on a wall of the monastery alle Grazie; may our readers place before them Morghen's engraving, which suffices to instruct us about the whole and its particulars." Goethe takes it for granted that every decently furnished home would have its own Morghen. (Mine does. Provenance: Portobello Road, London's flea market, purchased September 1966 for the sterling equivalent of $6.) More than 3 feet wide, it is an impressive thing. No wonder that well over forty engraved copies of it in various sizes proliferated before the mid-nineteenth century (see Hüttel 1994, p. 22).

In the Leonardo *vita* attached to the fourth English edition of the *Trattato* (London, 1835, p. l), we are told: "Any description of [the *Last Supper*] would be superfluous after the beautiful engraving made from it by the Chevalier Raphael Morghen." Proust mentions the print in three places. In the "Overture" to *À la Recherche...*, young Marcel tells of his grandmother's aversion to the mechanical nature of camera reproduction. To ensure the elevation of Marcel's blossoming spirit, she wanted his room hung with "old engravings...such, for example, as show us a masterpiece in a state in which we can no longer see it today, as Morghen's print of the 'Cenacolo' of Leonardo before it was spoiled by restoration." The remark is repeated in "Combray," and reappears, in Proust's own voice, in his preface to Jacques-Émile Blanche, *Propos de peinture: De David à Degas*, 1919.

Proust apparently thought the mural unharmed until 1800, though Armenini in the mid-sixteenth century described it as half destroyed (see p. 16 n. 2) and Vasari in 1568 called it *una macchia abbagliata*—nothing but a blurred stain. (Vasari's comment comes in his discussion of Bonsignori's copy, no. 8, not in the Leonardo *vita*.)

An Italian lithograph of 1864 (reprod. in Alberici/De Biasi 1984, no. 185) depicts Raphael Morghen, a smocked smirking gnome of a man, in the act of laboring over his *Last Supper* plates—evidently a historic moment.

49. Giuseppe Bossi, 1807 (Fig. 26). Oil on canvas, 438 x 892 cm. Bossi's "reconstruction" is fully described in his monograph on the *Cenacolo* (1810, pp. 168ff., "Della Copia del Vicere d'Italia"). Long housed in the Castello Sforzesco, Milan, it was destroyed in World War II.

See Malaguzzi Valeri 1915, p. 557; G. Galbiati, *Il Cenacolo di Leonardo da Vinci del pittore Giuseppe Bossi nei giudizi d'illustri contemporanei*, Milan and Rome, 1920; Möller 1952, p. 172. Recent references: Alberici/De Biasi 1984, pp. 53–54; Hüttel 1994, pp. 28–30 and figs. 26, 27; Marani 1999, pp. 43–44, 78, no. 40 (with further literature).

A mosaic copy of Bossi's painting, executed by Giacomo Raffaelli, was sent to Vienna in 1819 and installed in the Church of the Minorites. The original installation was a signal example of Viennese *bondieuserie* (Fig. 185). The work was recently relocated on the north wall of the church. Seen from a distance across the aisle, it makes a fair impression. Not so at close range, when you can't help seeing the faces.

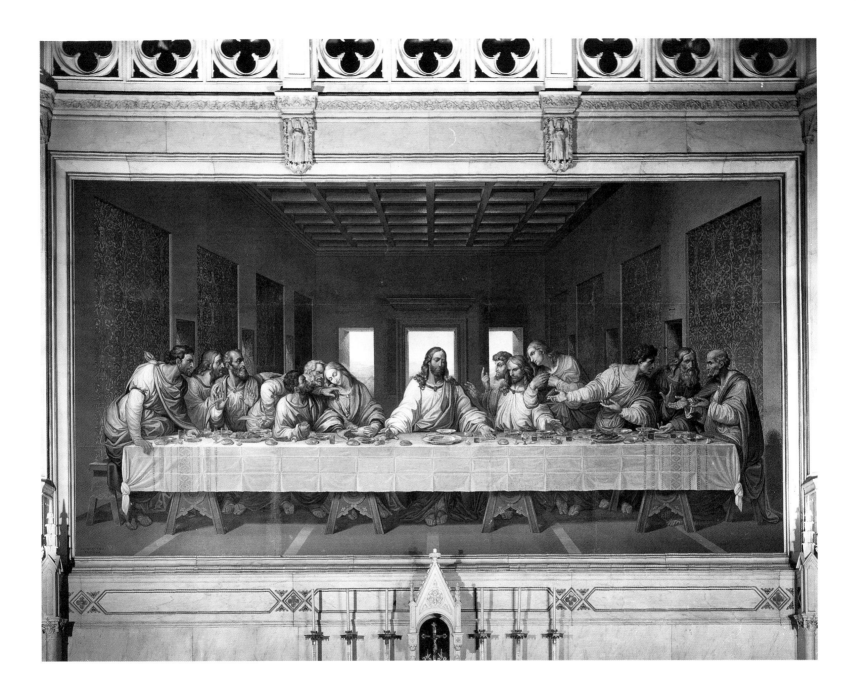

185. Giacomo Raffaelli, mosaic, completed
in 1814, after Bossi's destroyed copy.

Rethinking Two or Three Drawings
and One Meddling Text

NOT EVERYTHING LEONARDO CONFIDES to his notebooks records original thinking: it has long been recognized that he made notes on his reading. I suspect, by analogy, that some among Leonardo's sketches may be comments on what he had seen in other art.

Consider the early study sheet at the Louvre (Fig. 186), datable to 1481, i.e., before Leonardo was out of his twenties and before he moved to Milan. The sheet (some 8 inches across) is put to full use. In chief, slightly off-axis, hangs a disk nailed to the paper wall, a hygrometer, or instrument for weighing air. Resumed to serve other ends, the paper turns multistoried, airy, and populous. The artist's pen—held in the left hand and dispensing left-handedness all around—levies eleven nude figures, some alone, some companioned, but every one of them alert and engaged. The middle register pairs a creaky old man with a youth, the senior suffering the other's discourse. Then, five men at table, including two elders harangued by a talker not yet out of his twenties. Surely no study for a *Cenacolo*; a Christ to the right of these figures would not have them so indifferent to his presence. But the scene sets off a *Last Supper* association that wants instant embodiment. And so the nearest leftover corner expands for a speaker who cannot but represent a *Last Supper* Christ, a figure not cornered but broadly spaced. We are shown how to make a man alone appear middlemost. He gestures to his right, turns to his left, points back to center.

This lithe little sketch is of such charm, so ensouled—one hates to stalk it with a critical eye. But what shall we make of the gesture? It seems to illustrate a specific text: "He that dips his hand with me in the dish, the same shall betray me" (Matt. 26:23). Hence the speaker's left hand indicating the dish, while the right reverts to himself, as if to mime the "me" in "betray me." Such primitive miming of a speech act (try acting it out), literalness at this level, seems at odds with Leonardo's pictorial imagination; it's what we'd expect in a children's charade. Is this, then, Leonardo's own thought about a *Cenacolo* Christ, or is he recording a remembered motif? I am not sure, but the question nags on.

MORE PRESSING is the problem of Windsor 12542 recto (Fig. 187), a sheet of studies to which the literature assigns first place in the genesis of the *Cenacolo*. This, we are told, is where Leonardo's thinking about the commissioned fresco began.[1]

The sheet accommodates a wide range of Leonardo's preoccupations: didactic writing (eight lines that explain how to generate a regular octagon); an accompanying geometric figure; one calculation (possibly household expenses); four small architectural studies for arches and octagonal floor and ceiling; finally, across the top, two spirited sketches for a *Last Supper*. No other autograph compositional studies relatable to the Grazie project survive.

186. Leonardo, figure and composition studies, 1481, Louvre 2258.

1. For the latest summary of the literature, see Eichholz 1998, pp. 487-93. Eichholz's rigor in analyzing Windsor 12542r surpasses all previous attempts, but he follows custom in crediting the drawing with Leonardo's initial intentions.

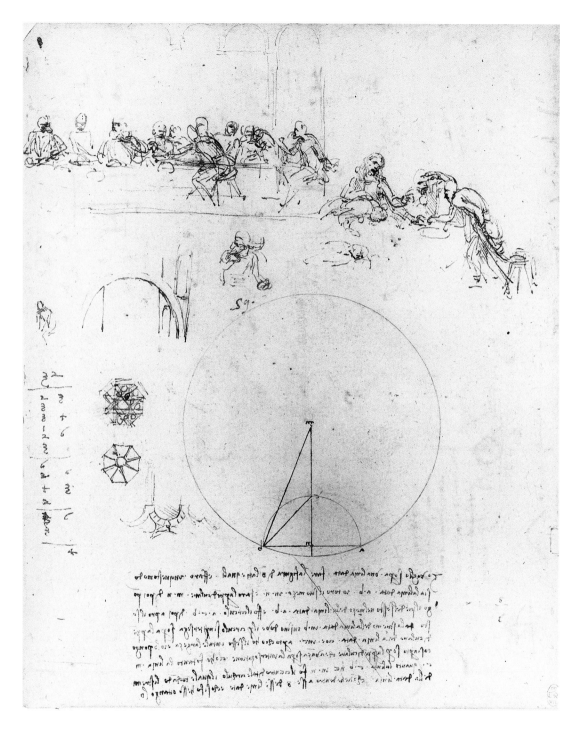

187. Leonardo, study sheet with sketches for a *Last Supper*, Windsor 12542r.

The long, left-hand sketch presents a familiar arrangement: all but one of the diners seated behind the board. Needless to say, the distinction of Judas on the near side is a commonplace. Uncommon, perhaps unique in this drawing, is the undistinction of a de-centered Christ. Present he has to be, but where in this file? Is he the one being spoken to, fourth from the left, the one within reach of Judas' elastic left arm? Some discover him in the next sitter, the round-bearded convive "third from the left" (Pedretti 1983, p. 64), a hearty toastmaster unlike any Jesus known to Christian or infidel. Others find him in the wraith second from left (Eichholz 1998, p. 490)—in both readings, badly off center, so that one wonders who in this lineup is the man of the hour: the one lost in the shuffle, or the one singled out? Judas shows only his back (so does the Resurrected in Mantegna's *Descent into Limbo*). But his prodigious stretch upstages three mere Apostles, allowing him to preponderate without competition from anonymity. There's an argument here, a sort of caution: watch out, lest your nimble betrayer—one salient actor in stark isolation near center foreground—tilt the narrative balance against the protagonist.

The drawing assembles roughly ten figures. We project two more off the page, just as the lightly sketched background arcade will produce two more bays for a total of eight. Eight arches on slender shafts to provide a locale.

Pedretti (1983, pp. 44 and 71) has pointed out that "this is [Leonardo's] only *Last Supper* study to hint at the architectural setting of the scene." Since he takes Windsor 12542r to preserve "the first sketches for the *Last Supper*, as convincingly shown by Clark, Heydenreich, and others"; and since the eight arches implied in the sketch comply with the eight lunettes over the refectory's sides, Pedretti conjectures that "Leonardo may at first have considered painting on one of the longer sides of the refectory" (p. 44). He grants that in such an arrangement "the figures would have been colossal in size," but he keeps silent about the ensuing enormity of the whole, four times as wide as the mural we know.

188. Detail of Fig. 187.

Since this is improbable, Pedretti suggests that the background proposed in the Windsor drawing—"like the space of a portico or a loggia"—"could well have been applied to the composition as painted on the end wall of the refectory." But surely not an eightfold arcade under the three lunettes of the actual vaulting. Why not rather see these eight arches as proof that this sketch was never intended for execution? Though I would rather not disagree with Pedretti, I find his present hypothesis—"a traditional scheme is being followed here as would be expected of an initial phase in Leonardo's conception of the theme" (p. 67)—unacceptable.

THE SECOND LAST SUPPER SKETCH on Windsor 12542r isolates the main four-figure group—larger in scale and with clarified action (Fig. 188). Scanning from left to right, we recognize John leaning over, face down; Christ resting one arm on John's back as he turns toward Judas; then an intervening figure, certainly Peter, who peers at the hunchbacked betrayer; and finally Judas, up from his three-legged

189. Anselmo da Campione, *Last Supper*, 1200–25.

stool to steal the show (cf. John 12:6). The Christ-Judas encounter is drawn in two variants. At first, both dip hand-to-hand in the dish; a robust pentimento has Judas reach out to receive Christ's uplifted sop.

Christ's dual action involving both John and Judas is normal. The motif of the arm on the back of the drowsing favorite occurs in Romanesque relief sculpture and persists through Fra Angelico, Bonifacio Bembo and Perugino to Titian, as well as throughout Northern art from Strasbourg Cathedral to Lucas Cranach. No less common is the "Communion of Judas," which Kenneth Clark (1958, p. 54), referring to the Windsor drawing, calls "the almost unbearably dramatic subject of Our Lord giving the sop to Judas." But what Clark found almost unbearable, Christendom had stoutly endured for over five hundred years. Clark's phrase makes Leonardo's use of the motif sound bold and inventive. Did he not know that the sop handed to Judas—or stuffed as an outsize bolt down his gullet (Fig. 189)—was standard fare? By the 1490s, especially in Milan and throughout Lombard territory, this feeding, actual or imminent, was what one expected to see. The wonder is not that Leonardo evoked an "almost unbearably dramatic" moment, but that the banality of the motif did not stop him.[2]

After about 1500, the sop-feeding motif gradually falls out of favor—undoubtedly for more than one reason, but let me cite a consideration which seems especially relevant

2. The subject of Judas receiving the sop (John 13:26)—which Eichholz (1998, p. 512) rightly calls "popular"—had been familiar since Carolingian times (see Schiller 1972, figs. 79, 81). In Romanesque art, as still in fourteenth- and fifteenth-century painting, it was the normal means of activating a *Last Supper* scene. Leonardo would have found the motif especially common in Milanese art. (Examples: Bonifacio Bembo's fresco of c. 1457, reprod. in Rossi/Rovetta 1988, fig. 24; the stained-glass *Cenacolo* window, 1476, in Milan Cathedral, Fig. 191; and the Sforza Book of Hours of c. 1490, Fig. 190). For the prevalence of the motif in the North, see Eichholz 1998, pls. 47, 48, 51, 59, 60. Cf. also the Wolgemut School drawing, Fig. 74, above. Examples by Schongauer and the Monogrammist A.G. (Fig. 198) are discussed below.

to the Leonardo drawing Windsor 12542r. The problem is the staging of the event in a rational space.

When the persons at a *Last Supper*, Judas included, line up behind the table in single file (as in the stone relief on the medieval rood screen of the Cathedral of Modena, Fig. 189, and occasionally thereafter), Christ's active arm levels sideways, parallel to the picture plane. When a lone Judas takes this side of the board, or joins a round table, the donor arm reaches diagonally across to a foregrounded Judas seen in three-quarter backview. And it is here that Renaissance artists ran into difficulty. The familiar Christ-Judas axis proved to be ill-adapted to naturalistic terrain— it could not survive the rationalization of space under perspectival controls. Given the normal depth of the table and the requisite shunting of Judas to preserve a clear view of Christ, the system no longer worked. What made it unmanageable was the distance Christ's hand must traverse to reach Judas'

mouth, when that mouth was patently out of reach.

Older masters, whose *Last Suppers* were innocent of a calibrated perspective—from Duccio to Schongauer to the Master of the Sforza Hours (Fig. 190)—saw little reason to care; they were telling a story, not counting paces. Even where the betrayer, facing twelve sitters, was made to stand and bend over, the anomaly of spurious access remained unresolved, probably without being noticed. But bring a Renaissance eye to these pictures. Look at Duccio's *Last Supper* of 1308–11, or at Schongauer's of c. 1475, or at the *Last Supper* window in Milan Cathedral (Fig. 191), or at the *Cenacolo* page in the Sforza Hours (or at the inexcusably archaized Cranach School version of 1565, where twelve Protestant chiefs impersonate the circumtabulated Apostles; reprod. in Schiller 1972, fig. 115): in all these, as in hundreds more,

left
190. Milanese illuminator, *Last Supper*, c. 1490, Sforza Book of Hours.

191. Antonio da Pandino (?), *Last Supper*, 1476, Milan Cathedral.

192. Pietro Perugino, detail of Fig. 124.

the far cry from this hand to that mouth is collapsed as if space had no berth to distend in—exactly the sort of impossibleness that Leonardo abhors. Accordingly, in Windsor 12542r, Judas is kept two arms' lengths away, and the action paced at measured intervals on a space lane that dips from the giver's head to the getter's seat. Leonardo is not only staging the narrative; he is correcting. Whether this correction was jotted down with an eye to his own *Cenacolo* project remains to be seen.

Much as I admire this three-inch four-figure grouping—and how deftly it wraps about the compass-drawn circle below—I take note of the following. First, that not one of its features entered the design of the mural; this sketch bears no relation to what Leonardo would paint in the Grazie

refectory. Second, that all its motifs derive from other *Last Suppers*, most of which Leonardo would have scorned. The drawing looks to me like a critique.

TURN NOW TO THE ST. JOHN—"leaning on Jesus' bosom," or "lying on Jesus' breast," according to the Johannine Gospel (13:23 and 25).[3] For these words, exactly interpreted, a few artists, notably Giotto at Padua, had found convincing visual expression. The commoner practice, in Italy as in the North, was to leave Jesus' breast unencumbered, and to depict John doubled over the table like one asleep, resting his head on his arms (Fig. 192). By the late Quattrocento, in presentations of the *Last Supper*, the defining trait of the disciple "whom Jesus loved" was his ill-timed slumber. Only where the subject was plainly eucharistic, as in Cosimo Rosselli's *Last Supper* of 1482 in the Sistine Chapel, must John stay awake. John would not doze through the institution of the sacrament.

But his sleeping posture—like the sop-feeding motif after 1500—came to be more generally resisted. Renaissance painters found John's somnolence at the drama's climactic moment ever harder to justify. Henceforth John's upper body erects into near-wakefulness (Sforza Book of Hours [Fig. 190]; Raphael [Fig. 7]; Sodoma [Monstadt 1995, fig. 116]; Andrea del Sarto, Luini, etc.). This is no time to nod.

A BAVARIAN POSTCARD received from a globetrotting friend reproduces Tilman Riemenschneider's famous Rothenburg altar—John, as usual, napping through the Last Supper (Figs. 193, 194). My friend's gloss on the verso reads: "Out cold; too much Moselwein." Let him not take it amiss, but I've heard this diagnosis before. Leonardo, too, would

3. Gombrich explains (1993, p. 9): "It is well known that the description of that text of the apostle St. John 'leaning on Jesus' bosom' is explained by the ancient habit of lying on couches during meals, though this had largely been forgotten and the apostles were usually represented sitting at table. But tradition still had St. John leaning against Christ, and the only rapid

sketch we have by Leonardo for this composition [Windsor 12542r] indicates that he originally meant to adopt this tradition...."

The mystic motif of John symbolizing the human soul is not relevant here; see Hans Wentzel, *Die Christus-Johannes-Gruppen des 14. Jahrhunderts,* Stuttgart, 1960.

have heard it from facetious hipsters back home, commenting perhaps on old Gaddi's fresco at Santa Croce (Fig. 30; or on the recent one at Sant' Andrea a Cercina, near Florence). And yet, in the Windsor sketch, Leonardo not only repeats the motif but goes it two better. Renouncing the comfort of cushioning arms—the right far adrift—he makes John's head land nose first on the table and levels the trunk even to its rear end, bottoms up, as if in prostration before the oncoming Judas. Preposterous, is it not? But this is what appears when these two figures are seen together. And seen together they should be, because, whatever in a Leonardo design is not seen together is delinquently overlooked. Leonardo is at all times aware how any two characters in his compositions relate to each other. In a tight four-figure group such as the one before us, the coupling of the two outermost cannot be inadvertent. Then let skeptical readers—if they can get a friend to impersonate Judas—act out John's posture: the shunted arm and the undermost nose, and the prone body from hips to head aligned with the betrayer's approach. Experiencing how it feels helps to see how it looks. (Objectors are asked to submit, along with their qualms, photographic evidence that they have conscientiously reenacted John's table manners. Absent such proof, their demurrals are vain.)

Are we to view the St. John in Windsor 12542r with a solemn art historical eye? I think it more likely that Leonardo is mocking a common gaffe, scoffing what's wrong with it, demonstrating why the old snooze motif must be dropped. He is not pondering how to depict a *Last Supper*, but telling you what to avoid.

Similar taunts punctuate the *Trattato*. Where, for example, Leonardo dislikes the stacked superposition of scenes in fresco cycles—"with different horizons on the same wall" (standard practice from Giotto to Ghirlandaio), he sneers that "the painting seems to portray a shop with merchandise for sale in rectangular drawers" (McMahon 1956, p. 155). Worse still when he derides an angel's inappropriate bearing:

193. Tilman Riemenschneider, *Last Supper*, 1499–1504. St. John (dis)appears between Christ and Judas.

194. St. John, detail of Fig. 193.

He should not be represented with such audacity and presumption that the effect appears one of desperation, or of command—as I saw, some days since, in the picture of an angel who, while he was making the Annunciation, appeared to be chasing Our Lady out of her room, with movements which displayed such offensiveness as one might show to a most vile enemy, and Our Lady seemed as if she, in despair, would throw herself from a window. Bear it in mind, not to fall into any such defects (McMahon 1956, p. 58, fol. 33).

The purveyor of the above defects has not been identified. A small Signorelli *Annunciation* (c. 1500; Philadelphia Museum of Art, Johnson Collection) shows a startled Mary in such extremity of recoil that the picture, though it lacks facilities for defenestration, might qualify. But even here, Gabriel's onrush seems unoffending. Surely Leonardo's description exaggerates for rhetoric effect. Should we assume that this strain in him—to mock by exaggeration—expressed itself only in words, written or spoken? Leonardo is, after all, the inventor of caricature. Let us allow that his derision might, on occasion, take the form of a drawing.

AND WHAT OF ST. PETER? I understand him to be putting a visor hand to his brow, as lookers do to keep out the sun. But not at suppertime, and they don't do it indoors. Here the gesture seems out of place (Eichholz 1998, p. 488, calls it *deplaziert*)—the more displaced since the object of Peter's telescopy is not two feet away. (Cf. the penultimate item in Leonardo's listing of gestures, p. 284; there, too, otiose. Cf. also the figure at upper right on the verso of the Louvre sheet, Fig. 186, reproduced in Popham 1945, p. 43.)

But then, the action is no mere genre motif. It rehearses a stand-by formula for amazement, a stance of enrapt beholding for which a Greek word, *aposkopein*, is available—a gesture invariably performed at the sight of a supernatural visitation. In Italian art, it is common enough to have furnished the subject of a good book—Ines Jucker's *Der Gestus des Aposkopein* (Zurich, 1956). Jucker shows how post-Antique art uses the gesture routinely in scenes of the Annunciation to the Shepherds, the Adoration of the Magi, the Transfiguration, Resurrection, Ascension, Assumption, the Conversion of Saul, and, finally, the Stigmatization of St. Francis, where Francis' *confrère*, Brother Leo, shades his eyes to keep a seraphic vision in focus.

Applied to a Peter looking at Judas, the *aposkopein* in Windsor 12542r is, on more than one count, inappropriate. Consider its effect on the subject. We know, knowing the story, that Judas is being summoned. And now it is he who draws all attention. Imagine the composition replete at the ends, four more diners each side: we would have twelve chair-bound figures, half-length, watching one full-length arriver in motion, and the Prince of Apostles giving the cue—all eyes on Judas. Leonardo cannot have been wholly serious in making this momentary diversion the gist of the Lord's Supper.

The questions keep coming. Was the figure of Peter gravely intended? Is Peter peering so hard because incredulous that any of the Master's disciples would sink into treachery? Perhaps so; yet, given the usual address of the *aposkopein*, its transposition to the sighting of a close mess-mate is more likely ironic. I suspect the irony to be pointed at the uncertain seating of Judas. He must have been sitting at table. But his oblique stride (watch his hindmost heel) shows him dragging a lengthy step, and Peter espies him as one coming up from afar—or, more likely, as one coming in out of art. This three-quarter backview of a Judas leaving his tripod seat to arrive at the table does seem familiar, if only because we recall Franciabigio's fresco of 1514 at San Giovanni della Calza in Florence (Figs. 195, 197). Here, too, Judas in three-quarter backview—his grasping right hand extended, lowered left at the purse—rises from a three-legged (capsizing) stool.

How comes it that this subsequent Florentine mural presents such a similar Judas? Franciabigio would not have seen Windsor 12542r. Were there intermediary drawings, now lost, leaking from Leonardo's Milanese workshop?

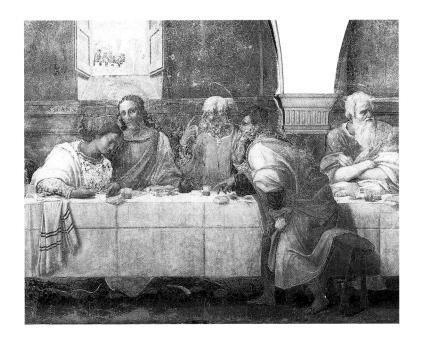

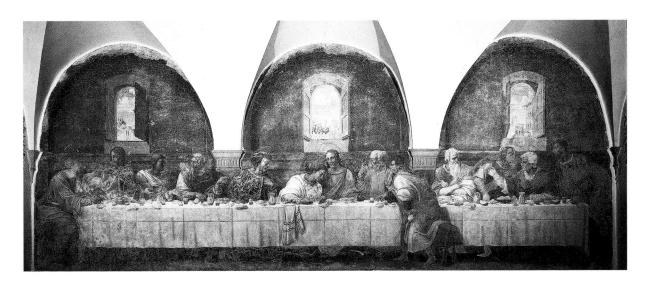

above left
195. Detail of Fig. 197.

above right
196. Detail of Fig. 187.

197. Franciabigio, *Last Supper*, 1514.

Perhaps we had better conjecture a common source. It could be a print deriving from Schongauer, such as the *Last Supper* engraving by the Monogrammist A.G., datable c. 1480–90 (Fig. 198). Here again is the tottery milking stool from which Judas has risen.[4] Here too is the three-quarter backview of one up on his feet and the needless stride that transports the man from his seat at the table to the table he's sitting at. And here too is the face-down St. John, and St. Peter midway. But if Leonardo had seen this print (or the copy of it by the Monogrammist W.H., Fig. 199, where the folded hands between John's nose and the tabletop are, as in Leonardo's drawing, omitted), then its topical cancellations of space—the squeeze of the tripod, the fabulous contiguities, and the measureless hand-to-mouth leap—must have been disapproved.

Disapproved only in solitude? I can imagine a candle-lit Leonardo brooding in nightly vigils while his acolytes sleep. By day, he would have been well attended. And we know him to have been, among other things, an irrepressible teacher. The pedagogue in him sounds off and resounds throughout the *Trattato*. That endearing propensity must have been daily endured by his disciples, some of them very young, to whom Leonardo would explain, as the *Trattato* does, what to do, what to shun. The lessons would some-times spill into didactic drawings, scribbled down perhaps as the pupils looked on. Windsor 12542r is my candidate for such demonstrative status, a hypothesis I find more attractive than the canonic alternative: to deduce from these sketches that Leonardo's thinking about the *Last Supper* commission began in banality, to be gradually worked up into an image wherein everything innovates.[5]

THE WINDSOR DRAWING (handsomely done, by the way) was, I suggest, intended to demonstrate that the ouster of Judas, unless self-imposed, will not do; that his prearranged separation from the rest of the party accords him a privilege proper only to the protagonist; that Judas rising, pacing, approaching—no matter how humbled by shaky stool and poor posture—gives him undue enlargement, and to the subject, the narrowest anecdotal interpretation. I see no reason to impute this ridiculed staging of the event to Leonardo in any stretch of the enterprise. These Windsor *Last Supper* sketches "follow a traditional scheme" only to kill it off. Leonardo is showing that the scheme is not viable, not with the beloved disciple's untimely nap and misdirected kowtow. At which point the master slides into farce and—still scathing with hand and tongue—repeats the prostrate St. John lower down, just for emphasis.

4. What should Judas during the sacred supper be perched on, and was the matter ever discussed? Some Tuscan *Last Suppers* put only the villain on a three-legged stool, others allow him no such distinction. Ghirlandaio seems to make an issue of it: in the first of his three *Cenacoli* (1476, Badia at Passignano; see Monstadt 1995, pp. 213-19 and pls. 73, 76-78), Judas squats on a tripod; in Ghirlandaio's two later *Cenacoli*, Judas' floor-length mantle conceals his seat (Figs. 121, 122).

Northern artists tend to reserve a (demeaning?) three-legged stool for Judas, but again inconsistently. Where one of Leonardo's sketches and Franciabigio's fresco show Judas' tripod prop tipping over, symbolism may be intended. Riemenschneider's Rothenburg Altar (Fig. 193) has the excluded Judas stand in mid-foreground and no place to sit.

In Italian Quattrocento *Last Suppers*, Judas is seated. His stand is a Northern invention. It occurs by 1475 in Schongauer's *Last Supper* panel from the high altar of the Dominikaner-Kirche (Colmar, Musée d'Unterlinden), a de-sign soon disseminated in engraved adaptations. (Prints by Schongauer and his school were widely marketed south of the Alps, especially in Lombard territory.) Leonardo's *Cenacolo* sketches on Windsor 12542r mock successively the native tradition and the imported novelty.

5. The conventionality of the Windsor drawing, as against the vast innovations displayed in the mural, led von Einem (1961, p. 57) to marvel at the late date at which all the significant features of the actual painting would have occurred to the master: "only now and so late! (—*und so spät!*)." The puzzle in the supposed sequence is left unresolved.

Unacknowledged, too, is John's ludicrous posture in Windsor 12542r—nose asquat, arse aloft. Inconceivable within the gravity of the subject, the pose is never described. Rather than face what Leonardo actually drew, scholars quote Scripture to interpose what he should have drawn. Von Einem (1961, p. 52) has the St. John in the drawing "at the breast of Christ"; Heydenreich (1974, p. 41) "leaning against the breast of the Lord."

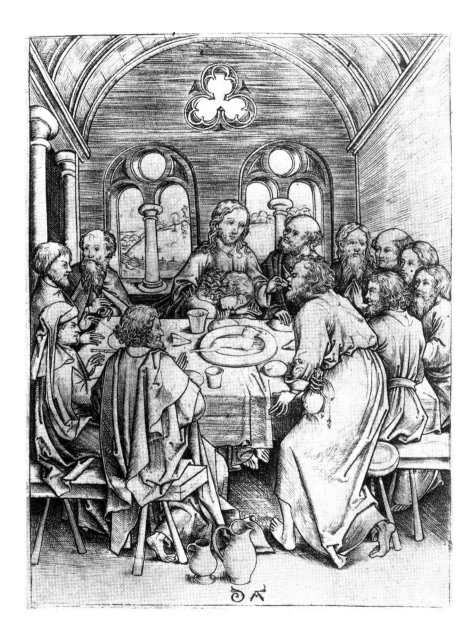

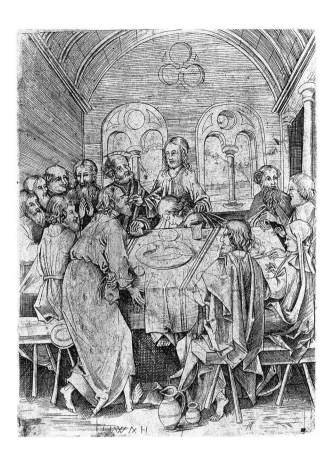

198. Monogrammist A.G., *Last Supper* (reproduced in reverse).

199. Monogrammist W.H., *Last Supper*, copy of Fig. 198.

ONE OTHER DOCUMENT from Leonardo's hand is universally taken to preserve his early thoughts for the *Last Supper*. It is a listing of postures and gestures suitable to the *dramatis personae*, a list jotted down in a tiny notebook at the Victoria and Albert Museum, London—the artist's only extant writing pertinent to the *Cenacolo*. I adduce the text in its entirety, each translated entry (here numbered) followed by the Italian original.

(1) One who was drinking and has left the glass in its place and turned his head toward the speaker.

[*Vno che beveua e lasciò la zaina nel suo sito e volse la testa inverso il proponitore;*]

(2) Another, twisting the fingers of his hands together, turns with stern brows to his companion.

[*Vn altro tesse le dita delle sue mani insieme e cō rigide ciglia si uolta al cōpagnio,*]

(3) Another with his hands spread open shows the palms, and shrugs his shoulders up to his ears, making a mouth of astonishment.

[*L'altro colle mani aperte mostra le palme di quelle e alza le spalli inverso li orechi e fa la bocca della maraviglia;*]

(4) Another speaks into his neighbor's ear and he, as he listens to him, turns towards him to lend an ear, while he holds a knife in one hand, and in the other the loaf cut through by the knife.

[*Vn altro parla nell' orechio all' altro, e quello chel'ascolta si torcie inverso lui e gli porgie le orechi, tenendo vn coltello nel' una mano e nell' altra il pane mezzo diuiso da tal coltello;*]

(5) Another, in turning around, while holding a knife in his hand, upsets with his hand a glass on the table.

[*l'altro nel uoltarsi tenendo vn coltello in mano versa con tal mano vna zaina sopra della tavola.*]

(6) Another lays his hand on the table and is looking.

[*L'altro posa le mani sopra della tavola e guarda,*]

(7) Another blows his mouthful.

[*l'altro soffia nel boccone,*]

(8) Another leans forward to see the speaker shading his eyes with his hand.

[*l'altro si china per uedere il proponitore e fassi ōbra colla mano alli ochi,*]

(9) Another draws back behind the one who leans forward, and sees the speaker between the wall and the man who is leaning.

[*l'altro si tira inderieto a quel che si china e vede il proponitore infra 'l muro e 'l chinato.*][6]

The urgent question to ask of this text is why it became a text, why it was written down. No one imagines a younger Leonardo in 1481, before setting his brush to the *Adoration* (Uffizi), itemizing its actors and recording how they were to behave; nor an older Leonardo in 1503, listing

6. Codex Forster II, fols. 62v, 63r, Victoria and Albert Museum, London; published in Richter 1883/1970, nos. 665–666.

The nine attitudes itemized in the Codex Forster notation are usually taken to record early ideas for *Cenacolo* figures, based on direct observation. But half of them refer more directly to postures found in earlier pictures, such as Duccio's *Last Supper* panel in the *Maestà* or the *Cenacoli* of Gaddi, Castagno, Ghirlandaio, and Perugino to be seen in or near Florence.

A few brief suggestions concerning the items as numbered.

(1) If the phrase "glass in its place" is interpreted to mean its place *on the table*, we would not know that the glass had just been in use. If "in its place" were interpreted as *still held in midair*, Leonardo would be recording what he had seen several Apostles do in, say, Duccio's *Last Supper* (or in those of his followers, such as Ugolino da Siena), or in Ghirlandaio's *Cenacoli*.

(2) The posture recalls a figure in Castagno's Sant'Apollonia fresco (Fig. 86, fourth from the right); more closely, the fifth from the right in Ghirlandaio's fresco in the Ognissanti refectory (Fig. 121); or even (except for "stern brow") the second from the right in Perugino's *Cenacolo* (Fig. 124).

(3) The raised open palms are common—they occur more than once in the Castagno. With shrugged shoulders and open mouth, the combination may be Leonardo's complexification. This item is discussed at some length on pp. 97–100.

(4) The half-cut loaf (or fruit) is a popular motif in Tuscan *Cenacoli* (e.g., Duccio; the Ugolino panel in the Lehman Collection, The Metropolitan Museum of Art, New York; Perugino, Fig. 124; Luini's St. Peter, Fig. 152, etc.).

(5) Discussed pp. 91–92.

At no. 6, Leonardo moves from fol. 62v to 63r, and, after one bland opening item for which we have ample precedents, gives his imagination free play.

200. Detail of Fig. 187.

the warriors to be mobilized for the *Battle of Anghiari*. Surely no worded program preceded the stress of these figures. Pedretti once said to me: no one before Leonardo had pointed out that images carry more information than words. Why, then, compose such a shortfall, why settle for the scrimp of description when you can draw?

The longer one ponders this esteemed text, the more unaccountable its existence. For the painter's own use, quick sketching would have served better. Compare the sitter in Windsor 12542r (Fig. 200; at 11 o'clock over the compass-drawn circle) with no. 6 in the text: "Another lays his hand on the table and is looking." The sketch, taking no

longer to execute, is more appealing and far more informative: it gives you the shape of the man, his trim stomach and state of alertness, his look's direction, and the defensive start of his other hand, amputated in the description. And so it occurs to me that we may have overvalued the above document. Considered as early ideas for apostolic demeanor at a *Last Supper*, that blown mouthful, that half-cut loaf, and that *zaina nel suo sito* (no.1) seem incongruously barren.

But this same roll-call of banqueters would make excellent sense as an exercise for young pupils—to keep the lads occupied, have them practice to visualize, or to remember what they had seen and record without copying. Draw this: one who was drinking turns his head to the speaker; another speaks into his neighbor's ear. Then, to dramatize the act of looking, draw a man leaning forward and shading his eyes, the better to see the emcee. Finally, in a contrapuntal vein and somewhat harder to do, a scrimmage of figures, but against a flat wall, which simplifies the assignment and proves how considerate of beginners our kindly master could be.

THIS INTRODUCES the left-handed red-chalk *Last Supper* study in the Venice Accademia (Fig. 201), a vexing document widely regarded as either Leonardo's own handiwork (in a weak moment), or as his sketch overworked and disfigured, or as a ham-fisted copy, or as a misattribution, or as a fake. But a surprising number of specialists declare it autograph and labor to place it in Leonardo's evolving creation.[7]

In my view, the Venice sketch is no grown-up's performance. An adult with no more talent than this would long before have found other employment. But that this sheet

7. It would take too long to survey once again the critical fortunes of this "perplexing document" (Pedretti 1983, p. 33), this "most puzzling of all Leonardesque relics" (Clark 1958, p. 94), this "strange, ugly drawing" (Clayton, quoted in Eichholz 1998, p. 482). For summaries of contending opinions, see *Disegni di Leonardo...alle Gallerie dell'Accademia*, exh. cat., Venice, 1966, pp. 30–31; Eichholz 1998, pp. 480–82). In his *Leonardo da Vinci*, 1939,

Kenneth Clark wrote of the drawing: "I am forced to accept it"—words deleted from the revised edition of 1958. Since then, the work's autograph status has been further debated, and no consensus in sight.

The provenance of the Venice drawing is of no help. Bossi acquired it in 1812 from unknown sources, and there the trail stops.

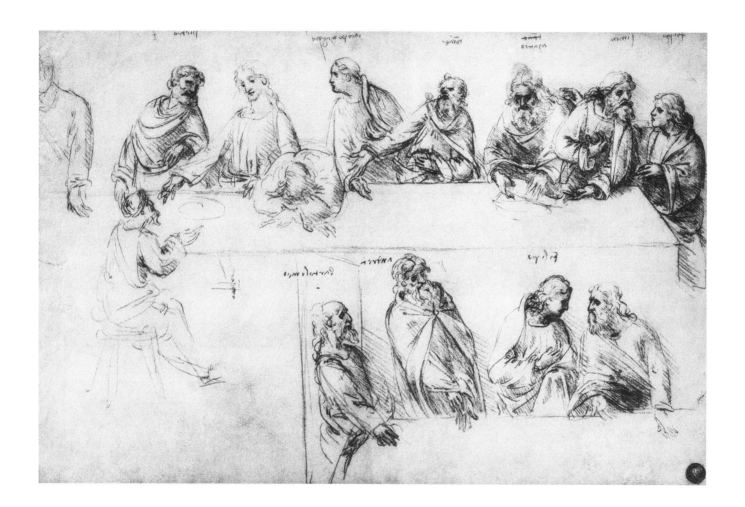

201. Leonardo School, *Last Supper*, Accademia, Venice.

emerged from the master's shop is attested by the super-scribed apostolic names; they are Leonardo's hand. And it is these floating names, mirror-written, which persuade many scholars that he who did the writing must have done the drawing as well. How could it be otherwise?

Other ways do come to mind. Imagine an adolescent boy in the household. It's early 1495, and the place is abuzz with excitement over the big task ahead. The boy has his master's affection, is eager to emulate and eager to try his southpaw at arranging the *Last Supper*'s sitters.[8] Two of the master's early ideas (Thaddeus' two-handed gesture and James Minor's out-flanking reach) he gleans from Leonardo's ongoing studies, the rest he invents or recycles from available models.[9] But the dear boy can't remember that dozen names, or their peck-ing order, whereupon Leonardo scribbles them in, never sus-pecting that after-ages might accuse him of the drawing. This my fantasy seems to me less fantastic than the attribution of the Accademia sheet to the genius of draftsmanship. Fur-thermore, my proposed reattribution brings with it a clear moral gain: it effects a benign turnabout in my critical stance. Now, instead of wincing at the incompetence of the drawing, the thought of a youngster trying to help finds me smiling at his enthusiasm and promise. Let skill come by-and-by, mean-while, I say, this *giovanaccio* draws with pizzazz.

Suppose the conjecture without further merit: it at least adds a small increment to the world's sum of goodwill.

AMONG THE MARVELS of this world are four autograph drawings at Windsor that speak directly to details of the *Cenacolo*: the folded hands of St. John (Fig. 23), the face of St. Philip (Fig. 34), head and shoulders of St. James Major (Fig. 46), and the head of Judas (Fig. 50). This last needs in-tercession, having been often maligned as a work spoiled by intrusive hands. I have done what I could for its vindication (pp. 93–96).

Looking today at what is left of the figures on that re-fectory wall in Milan, one does best to keep these drawings in mind, while unthinking what now fills their places.

End of Appendix F. Plans for further appendices were aban-doned for fear of exhausting the alphabet. Plenty more con-cerning this incessant picture remains to be seen. I haven't yet … I was going to … There's still that matter of …

Excuse me, the telephone!

"Hello," she says, "how are you?"—and adds at once, not wanting to interrupt what (she thinks) might be impor-tant work: "Are you in the middle of something?"

I told her I was in the middle of my eightieth year.

8. That Leonardo's pupils sometimes mimicked his left-handed manner is remarked by Pedretti 1983, p. 106. Of a Windsor drawing generally ac-cepted as autograph, he writes: "It is shaded from left to right, but so are some of the pupils' copies done about 1510."

9. The Christ-Judas connection in the Accademia drawing follows the Duomo's *Cenacolo* window (Fig. 191) and is surprisingly close to a model used as well in the Sforza Hours (Fig. 190). The slumping St. John, fore-shortened head first, is a common German motif, found, for instance, in the

Last Supper woodcut in the *Schatzbehalter*, Nuremberg, 1491, p. 93r.

I suspect a weightier message in the carefully worked two-hand gesture given to the figure in the upper register, second from right (here labeled "Simone"—Thaddeus in the mural). Of all the hands at this table, this pair is the best realized, their action the most complex, and closest to what we see in the mural. Evidently, the young draftsman was copying an early study by Leonardo. The likely consequence of this observation is suggested on p. 86 n. 21.

Diagram:

Last Supper with Identification of the Apostles

Gatefold:

Color Plate of the *Last Supper*

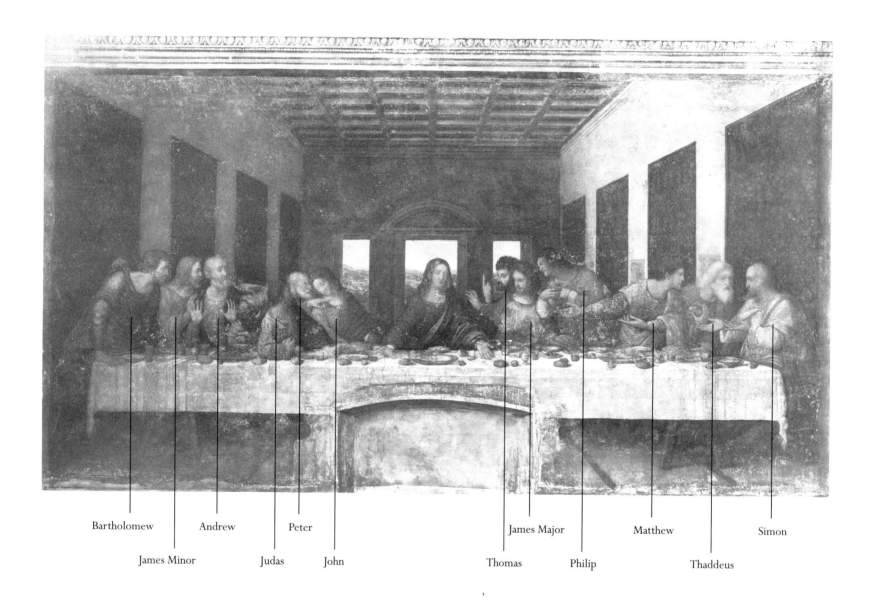

Bartholomew Andrew Peter James Major Matthew Simon

James Minor Judas John Thomas Philip Thaddeus

Last Supper with identification of the Apostles.

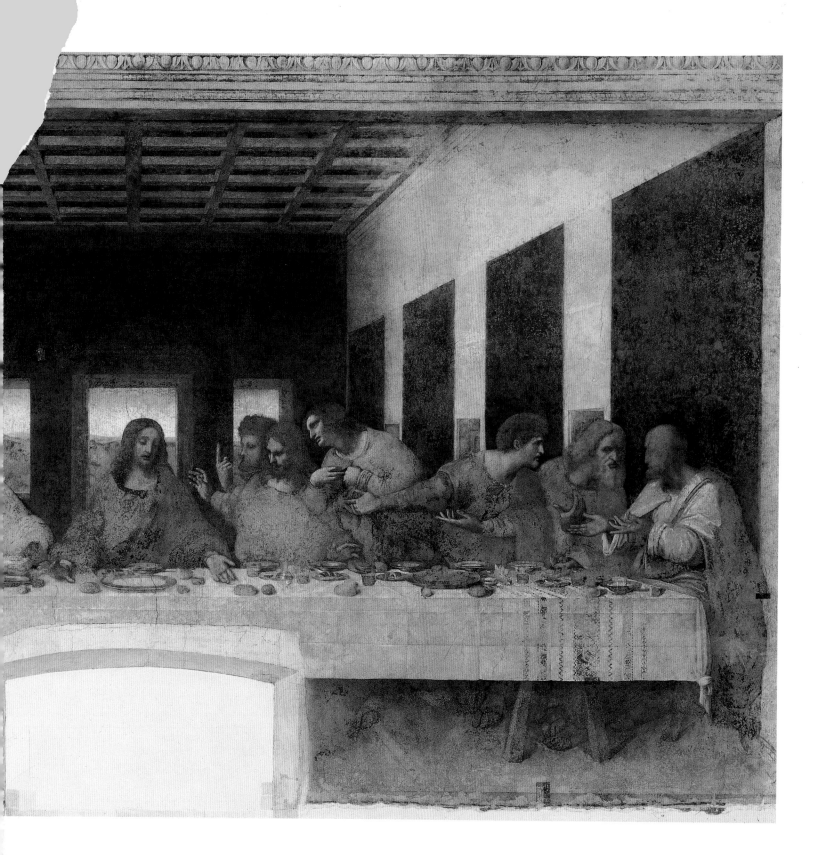

Last Supper after latest cleaning.

Bibliographical References

ALBERICI/DE BIASI 1984
Alberici, Clelia, and Mariateresa Chirico De Biasi, *Leonardo e l'incisione: Stampe derivate da Leonardo e Bramante dal XV al XIX secolo*, exh. cat., Milan, Castello Sforzesco, 1984.

ANTONIEWICZ 1904
Antoniewicz, Johann Bołoz, "Das Abendmahl Lionardos." See App. B for the original German text and an English translation. Page references in the book indicate the translation.

BOSSI 1810
Bossi, Giuseppe, *Del Cenacolo di Leonardo da Vinci*, Milan, 1810.

BRACHERT 1971
Brachert, Thomas, "A Musical Canon of Proportion in Leonardo da Vinci's *Last Supper*," *The Art Bulletin*, 53 (December 1971), pp. 461–66.

BRAMBILLA 1984
Brambilla Barcilon, Pinin, *Il Cenacolo di Leonardo in Santa Maria delle Grazie: Storia, condizioni, problemi* (Quaderni del Restauro 2), Milan, 1984.

BRAMBILLA/MARANI 1999
Brambilla Barcilon, Pinin, and Pietro Marani, *Leonardo: L'Ultima Cena*, Milan, 1999. English edition: Chicago, 2001.

BRIZIO 1983
Brizio, Anna Maria, *Leonardo da Vinci: Il Cenacolo*, Florence, 1983.

BROWN 1972
Brown, Roy H., "Leonardo's *Last Supper*: A Demonstration of Divine Necessity," unpublished paper delivered at the College Art Association conference, San Francisco, 1972.

BROWN 1983
Brown, David Alan, *Leonardo's Last Supper: Precedents and Reflections*, exh. cat., Washington, D.C., National Gallery of Art, 1983.

BURCKHARDT 1855
Burckhardt, Jacob, *Der Cicerone* (1855), 5th ed., Leipzig, 1884, part II.

CASTELFRANCO 1965
Castelfranco, Giorgio, *The Paintings of Leonardo da Vinci*, New York, 1965.

CLARK 1958
Clark, Kenneth, *Leonardo da Vinci*, Harmondsworth, 1958.

CLARK 1966
Clark, Kenneth, *Rembrandt and the Italian Renaissance*, New York, 1966.

CLARK-PEDRETTI 1969
Clark, Kenneth, *The Drawings of Leonardo da Vinci ... at Windsor Castle*, 2nd ed., revised with the assistance of Carlo Pedretti, London, 1969.

DELL'ACQUA 1983
Dell'Acqua, Gian Alberto, Carlo Bertelli, et al., *Santa Maria delle Grazie in Milano*, Milan, 1983.

DVORAK 1927
Dvorak, Max, *Geschichte der italienischen Kunst im Zeitalter der Renaissance*, Munich, 1927 (based on lectures delivered in 1918–19).

EICHHOLZ 1998
Eichholz, Georg, *Das Abendmahl Leonardo da Vincis: Eine Systematische Bildmonographie*, Munich, 1998.

EINEM 1961
Einem, Herbert von, "Das Abendmahl des Leonardo da Vinci," *Arbeitsgemeinschaft für Forschung des Landes Nordrhein-Westfalen*, 99 (1961), pp. 15–68.

ESCHER 1913
Escher, Konrad, "Zu Lionardos Abendmahl," *Monatshefte für Kunstwissenschaft*, 6 (1913), Heft 4, pp. 137–44.

FEDDERSEN 1975
Feddersen, Hans, *Leonardo da Vincis Abendmahl*, Stuttgart, 1975.

FRANCK 1997
Franck, Jacques, "The *Last Supper*, 1497–1997: The Moment of Truth," *Achademia Leonardi Vinci: Journal of Leonardo Studies*, 10 (1997), pp. 165–82.

FRANTZ 1885
Frantz, Erich, *Das Heilige Abendmahl des Leonardo da Vinci*, Freiburg im Breisgau, 1885.

FRIZZONI 1890
Frizzoni, Gustavo, "L'Affresco del Cenacolo da Ponte Capriasca," *Archivio Storico dell'Arte*, 3 (1890), pp. 187–91.

GANTNER 1962
Gantner, Joseph, "Rembrandt und das Abendmahl des Leonardo," in *Festschrift Friedrich Gerke*, Baden-Baden, 1962, pp. 179–85.

GILBERT 1974
Gilbert, Creighton E., "Last Suppers and Their Refectories," in Charles Trinkaus and Heiko A. Oberman, eds., *The Pursuit of Holiness in Late Medieval and Renaissance Religion*, Leiden, 1974, pp. 371–402.

GOETHE 1817
Goethe, Johann Wolfgang von, "Joseph Bossi über Leonardo da Vincis Abendmahl zu Mailand," in *Über Kunst und Altertum*, I, 1817, pp. 113–58. References here are to *Goethes Sämmtliche Werke*, vol. 31, Stuttgart-Tübingen, 1840, pp. 50ff.

GOMBRICH 1993
Gombrich, Ernst, *Papers Given on the Occasion of the Dedication of "The Last Supper" (after Leonardo), Magdalen College, Oxford, 10 March 1993*, Oxford, 1993.

GUILLON 1811
Guillon de Montléon, Aimé, *Le Cénacle de Léonard de Vinci rendu aux amis des beaux-arts*, Paris, 1811.

HARTT 1969
Hartt, Frederick, *History of Italian Renaissance Art*, 1st ed., New York, 1969.

HEYDENREICH 1943
Heydenreich, Ludwig H., *Leonardo*, Berlin, 1943 (English ed., London and Basel, 1954).

HEYDENREICH 1958
Heydenreich, Ludwig H., *Leonardo da Vinci: Das Abendmahl*, Stuttgart, 1958.

HEYDENREICH 1965
Heydenreich, Ludwig H., "André Dutertre's Kopie des Abendmahls von Leonardo da Vinci," *Münchner Jahrbuch der bildenden Kunst*, 16 (1965), pp. 217–28.

HEYDENREICH 1974
Heydenreich, Ludwig H., *Leonardo: The Last Supper*, New York, 1974.

HOERTH 1907
Hoerth, Otto, *Das Abendmahl des Leonardo da Vinci*, Leipzig, 1907.

HORST 1930–34
Horst, C., "L'Ultima Cena di Leonardo nel riflesso delle copie e delle imitazioni," *Raccolta Vinciana* (1930–34), pp. 118–200.

HÜTTEL 1994
Hüttel, Richard, *Spiegelungen einer Ruine: Leonardos Abendmahl im 19. und 20. Jahrhundert*, Marburg, 1994.

JANSON 1962
Janson, H.W., *History of Art*, 1st ed., New York, 1962.

JUNGMANN 1951
Jungmann, Joseph A., S.J., *The Mass of the Roman Rite: Its Origins and Development*, New York, 1951.

KEMP 1981
Kemp, Martin, *Leonardo da Vinci: The Marvellous Works of Nature and Man*, London, 1981.

KEMP 1996
Kemp, Martin, "Leonardo da Vinci," *The Dictionary of Art*, London and New York, 1996, vol. 19, pp. 180–199.

KUBOVY 1986
Kubovy, Michael, *The Psychology of Perspective and Renaissance Art*, London and New York, 1986.

LAMBERT 1987
Lambert, Susan, *The Image Multiplied: Five Centuries of Printed Reproductions of Paintings and Drawings*, exh. cat., London, Victoria and Albert Museum, 1987.

MALAGUZZI VALERI 1915
Malaguzzi Valeri, Francesco, *La Corte di Lodovico il Moro*, Milan, 1915, vol. II.

MARANI 1999
Marani, Pietro, "Il Cenacolo di Leonardo," in Brambilla/Marani 1999, pp. 15–95.

MCMAHON 1956
McMahon, A. Philip, transl. *Leonardo da Vinci: Treatise on Painting* (*Codex Urbinas Latinas 1270*), Princeton, 1956.

MÖLLER 1952
Möller, Emil, *Das Abendmahl des Lionardo da Vinci*, Baden–Baden, 1952 (compiled before World War I).

MONSTADT 1995
Monstadt, Brigitte, *Judas beim Abendmahl: Figurenkonstellation und Bedeutung in Darstellungen von Giotto bis Andrea del Sarto*, Munich, 1995.

MÜLLER 1932
Müller, Werner, "Neues zu Leonardos Abendmahl," *Das Werk*, 19 (1932), pp. 376–77.

NAUMANN 1979
Naumann, Francis, "The 'Costruzione Legittima' in the Reconstruction of Leonardo's 'Last Supper,'" *Arte Lombarda*, 52 (1979), pp. 63–89.

PATER 1869
Pater, Walter, "Leonardo da Vinci" (1869), in *The Renaissance*, New York, Modern Library edition, n.d., pp. 81–106.

PEDRETTI 1973
Pedretti, Carlo, *Leonardo da Vinci*, Berkeley and Los Angeles, 1973.

PEDRETTI 1973a
Pedretti, Carlo, "The Original Project for Santa Maria delle Grazie," *Journal of the Society of Architectural Historians*, 32 (March 1973), pp. 30–42.

PEDRETTI 1983
Pedretti, Carlo, *Leonardo: Studies for the Last Supper from the Royal Library at Windsor Castle*, exh. cat., Washington, D.C., National Gallery of Art, 1983.

PINO 1796
Pino, Domenico, *Storia genuina del Cenacolo insigne di Leonardo da Vinci*, Milan, 1796.

POLZER 1973–74
Polzer, Joseph, "Leonardo's *Last Supper*," in Dennis G. Donovan and A. Leigh Deneef, eds., *Renaissance Papers 1973*, Durham, North Carolina, 1974, pp. 37–74.

POLZER 1980
Polzer, Joseph, "The Perspective of Leonardo Considered as a Painter," in Marisa Dalai Emiliani, ed., *La prospettiva rinascimentale: Codificazioni e trasgressioni*, Florence, 1980, I, pp. 233–47.

POPHAM 1945
Popham, A.E., *The Drawings of Leonardo da Vinci*, New York, 1945.

RAPHAEL 1938
Raphael, Max, "Eine Anmerkung zum Abendmahl Lionardos" (1938), published posthumously under the title "Fläche und Raum im Abendmahl Leonardos," in his collected works, vol. 7, *Bild-Beschreibung: Natur, Raum und Geschichte in der Kunst*, Frankfurt, 1989, pp. 84–96.

RICHTER 1883/1970
Richter, J.P., *The Literary Works of Leonardo da Vinci*, London, 1883; 2nd ed., Oxford, 1939; 3rd ed., London, 1970 (all citations are to this latter, not to the Dover Press reprint of the 1883 ed., *The Notebooks of Leonardo da Vinci*, New York, 1970).

ROSSI/ROVETTA 1988
Rossi, Marco, and Alessandro Rovetta, *Il Cenacolo di Leonardo: Cultura domenicana, iconografia eucaristica e tradizione lombarda* (Quaderni del Restauro 5), Milan, 1988.

SCHÄFER 1965
Schäfer, Karl Th., "Das Abendmahl des Leonardo da Vinci," in Gert von der Osten, ed., *Festschrift für Herbert von Einem*, Berlin, 1965, pp. 212–21.

SCHAPIRO 1954
Schapiro, Meyer, "Leonardo and Freud: An Art Historical Study" (1954), in P. Kristeller and P. Wiener, eds., *Renaissance Essays*, New York, 1968, pp. 303–36.

SCHILLER 1972
Schiller, Gertrud, *Iconography of Christian Art*, Greenwich, Connecticut, 1972, vol. II.

SEIDLITZ 1909
Seidlitz, Woldemar von, *Leonardo da Vinci: Der Wendepunkt der Renaissance*, Berlin, 1909.

SHELL/BROWN/BRAMBILLA 1988
Janice Shell, David Alan Brown, and Pinin Brambilla Barcilon, *Giampietrino e una copia cinquecentesca dell'Ultima Cena di Leonardo* (Quaderni del Restauro 4), Milan, 1988.

SIMMEL 1905
Simmel, Georg, "Das Abendmahl Lionardo da Vincis" (1905), in *Zur Philosophie der Kunst*, Potsdam, 1922, pp. 55–60.

SOLMI 1900
Solmi, Edmondo, *Leonardo da Vinci*, Florence, 1900.

STEADMAN 1983
Steadman, Ralph, *I Leonardo*, New York, 1983. Not a work of academic weight, but the better for it; a book written and drawn *con amore*. I list it here so that the pleasure it has given me may be more widely shared.

STEINBERG 1973
Steinberg, Leo, "Leonardo's *Last Supper*," *The Art Quarterly*, 36, no. 4 (1973), pp. 297–410 (superseded).

STEINBERG 1983/96
Steinberg, Leo, *The Sexuality of Christ in Renaissance Art and in Modern Oblivion*, 2nd ed., enlarged, Chicago, 1996.

STENDHAL 1816
Stendhal, *Histoire de la peinture en Italie* (1816), ed. Paul Arbelet, Paris, 1924, vol. I.

STRZYGOWSKI 1896
Strzygowski, Josef, "Leonardos Abendmahl und Goethes Deutung," *Goethe-Jahrbuch*, 17 (1896), pp. 138–56.

TIKKANEN 1913
Tikkanen, J. J., *Zwei Gebärden mit dem Zeigefinger*, *Acta Societatis Scientiarum Fennicae*, 43, no. 2 (1913), pp. 1–107.

VASARI 1568
Vasari, Giorgio, *Le vite de' più eccellenti pittori, scultori ed architettori...* (1568), ed. Gaetano Milanesi, Florence, 1906, vol. IV.

VERTOVA 1965
Vertova, Luisa, *I cenacoli fiorentini*, Turin, 1965.

VLOBERG 1946
Vloberg, Maurice, *L'eucharistie dans l'art*, Grenoble-Paris, 1946.

WASSERMAN 1975/84
Wasserman, Jack, *Leonardo da Vinci*, New York, 1975; concise ed., New York, 1984.

WASSERMAN 1983
Wasserman, Jack, "Reflections on the *Last Supper* of Leonardo da Vinci," *Arte Lombarda*, 66, no. 3 (1983), pp. 15–34.

WIND 1952
Wind, Edgar, "The Last Supper," *The Listener*, 47 (May 8, 1952), pp. 747–48.

WÖLFFLIN 1898
Wölfflin, Heinrich, *Die Klassische Kunst* (1898), 7th ed., Munich, 1924, with notes by Konrad Escher.

List of Illustrations

Dimensions are in centimeters; height precedes width. The diagrams, Figs. 25, 35, 51, 97–99, 105–106, 108–113, and 117 were executed by Marcello Arosio.

Pages 11, 292: *Last Supper* with identification of the Apostles.

Gatefold, pages 293–94: Color plate of the *Last Supper*, 1494–98, refectory, Santa Maria delle Grazie, Milan, after latest cleaning.

INTRODUCTION

1. Refectory, Santa Maria delle Grazie, Milan, with the *Last Supper*.

2. Billboard with the *Last Supper*, Route 3, New Jersey, 1967.

CHAPTER I

3. Detail of Fig. 154.

4. Giovanni Pietro da Birago (?), *Last Supper with a Spaniel*, c. 1500. Engraving, 21.9 x 43.9. The Metropolitan Museum of Art, New York, 1998.195.

5. Leonardo, *Last Supper*, pre-World War I photograph.

6. Detail of Fig. 154.

7. Marcantonio Raimondi after Raphael, *Last Supper*, c. 1515–16. Engraving, 29.7 x 43.8.

8. Diagram of the *Last Supper*. Möller 1952, fig. 50.

CHAPTER II

9. Detail of Fig. 17.

10. Giuseppe Bossi, *Self-Portrait*, c. 1810. Oil on panel, 30 x 38. Pinacoteca di Brera, Milan.

11. Camillo Pacetti, *Giuseppe Bossi*, 1817. Marble. Palazzo di Brera, Milan.

12. Detail of Fig. 171, before cleaning.

13. Maerten van Heemskerck, *Last Supper*, 1551, retouched by Rubens. Pen and wash, 27.3 x 42. Museo del Prado, Madrid.

14. Raphael Morghen, 1800. Engraving, 52.4 x 93.5 (App. E, no. 48).

15. Leonardo, *Last Supper*, detail of Christ, before latest cleaning.

16. Rembrandt, c. 1634–35. Red chalk, 36.4 x 47.3. The Metropolitan Museum of Art, New York; Robert Lehman Collection (App. E, no. 44).

17. Pieter Soutman after a lost Rubens drawing, c. 1620. Etching, 29.4 x 98.8 (App. E, no. 41).

18. Ercole de' Roberti (attrib.), *Last Supper*. Oil on panel, 30 x 21. National Gallery, London.

19. Rubens, *Communion of the Apostles*, 1620. Oil on canvas, 43.5 x 43.8. Seattle Art Museum; Samuel H. Kress Collection.

20. Simon Bening, from the Hennessy Hours, c. 1525–30. Bibliothèque Royale, Brussels, Ms. II 158, fol. 26v (App. E, no. 37).

21. Anonymous after the copy at St. Germain l'Auxerrois, Paris, sixteenth century. Black chalk, 25.7 x 40.1. Windsor Castle, Royal Library, 12541 (see App. E, no. 18).

22. W. W. Ryland, engraving after Fig. 21, 1768 (see App. E, no. 18).

CHAPTER III

23. Leonardo, study for the hands of St. John. Black chalk, 11.7 x 15.2. Windsor Castle, Royal Library, 12543.

24. Leonardo, *Last Supper*, detail, pre-World War I photograph.

25. Christ's hands as the intersections of orthogonal and transversal directives.

26. Giuseppe Bossi, 1807. Oil on canvas, 438 x 892. Formerly Castello Sforzesco, Milan. Destroyed in 1943 (App. E, no. 49).

27. Anonymous, mid-sixteenth century. Oil on panel transferred to canvas, 77 x 132. The State Hermitage Museum, St. Petersburg (App. E, no. 21).

28. School of Coppo di Marcovaldo, *Last Judgment Christ*, c. 1270–75. Mosaic. Cupola, Florence Baptistery.

29. Milanese, *Crucified Christ*. Cover of Gospel Book of Archbishop Aribert, 1018–45. Cathedral Treasury, Milan.

30. Taddeo Gaddi, *Last Supper* and *Tree of Life*, c. 1335. Refectory, Santa Croce, Florence.

31. Leonardo, *Last Supper*, left hand of Christ, right hands of James Major and Thomas, after latest cleaning.

32. *Savonarola Preaching*, woodcut from Savonarola's *Compendio di rivelazione*, 1496.

33. Detail of Fig. 171, before cleaning.

CHAPTER IV

34. Leonardo, study for St. Philip. Black chalk, 19 x 15. Windsor Castle, Royal Library, 12551.

35. Thomas' head, hands, and left foot, composite from Figs. 49 and 154.

36. Nanni di Banco, *St. Philip*, c. 1410. Marble. Or San Michele, Florence.

37. Statuette of St. Philip surmounting the Florentine reliquary of Philip's arm bone, late fifteenth century. Museo dell'Opera del Duomo, Florence.

38. Leonardo, *Last Supper*, detail, before latest cleaning.

39. Posthumous sixteenth-century portrait, *Vincenzo Bandello, Prior of Santa Maria delle Grazie*.

40. Leonardo, *Last Supper*, detail, after latest cleaning.

41. Rubens School after Leonardo, *Christ and Simon*. Black and red chalk, ink, bister and watercolor washes, 31.7 x 48.6. Musée du Louvre, Paris (App. E, no. 40).

42. Byzantine, *Communion of the Apostles*, after 1354. Fresco. Church of St. John, Zemen, Bulgaria. Left: Christ dispensing the bread; right: dispensing the wine.

43. Detail of Fig. 14.

44. Byzantine, *Communion of the Apostles*, c. 1415. Fresco. Church of the Holy Trinity, Reseva, former Yugoslavia.

45. Andrea del Castagno, *The Vision of St. Jerome*, 1454–55, detail. Fresco, 300 x 179. Santissima Annunziata, Florence.

46. Leonardo, study for St. James Major. Red chalk, 25.2 x 17.2. Windsor Castle, Royal Library, 12552.

47. Andrea di Bartolo, *Communion of the Apostles*, historiated initial from a Gradual, c. 1420. Biblioteca Comunale degli Intronati, Siena, cod. G.I.14, fol. 88v.

48. Fra Angelico Shop, *Communion of the Apostles*, c. 1445–50, detail. Fresco. Museo di San Marco, Florence, cell no. 35.

49. After Leonardo, left hand of St. Thomas. Red chalk, 13.3 x 14.5. Windsor Castle, Royal Library, 12545.

50. Leonardo, study for Judas. Red chalk, 18 x 15. Windsor Castle, Royal Library, 12547.

51. Diagram showing the diagonal that targets Judas' elbow.

52. Leonardo follower, Judas, c. 1515–20. Tempera (?) and colored chalks, c. 57 x 44. Musée des Beaux-Arts, Strasbourg.

53. Anonymous copyist, subsequent to Fig. 52, Judas and Peter, from the set of heads formerly at Weimar. Chalk and crayon, 61.6 x 50.8. The Ackland Art Museum, Chapel Hill, North Carolina; Ackland Fund.

54. Leonardo School, Judas and St. Peter, c. 1510–20. Red chalk, 10.8 x 9.3. Biblioteca Ambrosiana, Milan F.274 inf., no. 5.

145. Giampietrino (?), c. 1520, from the Certosa di Pavia. Oil on canvas, 298 x 770. Royal Academy of Arts, London; on loan to Magdalen College, Oxford (App. E, no. 6).

146. Anonymous seventeenth-century replica of Girolamo Bonsignori's copy. Oil on canvas, 76 x 122. Bayerische Staatsgemäldesammlungen, Munich (App. E, no. 8).

147. Lodovico Dondo after Girolamo Bonsignori's copy, 1598. Oil on canvas, 88 x 196. Széművészeti Múzeum, Budapest (App. E, no. 8).

148. Alessandro Araldi, 1516. Fresco. Camera dell'Araldi, San Paolo, Parma (App. E, no. 9).

149. Anonymous, c. 1520, from San Barnaba, Milan. Oil on panel, 121 x 268. Pinacoteca di Brera, Milan (App. E, no. 10).

150. Cesare Magni, c. 1520–30 (after restoration). Oil on panel, 64 x 138. Pinacoteca di Brera, Milan (App. E, no. 11).

150A. Cesare Magni (before restoration).

151. Marco d'Oggiono (attrib.). Oil on canvas, 260 x 549. Château d'Écouen (App. E, no. 12).

152. Bernardino Luini, c. 1530. Detached fresco, now in three parts. Refectory, Santa Maria degli Angeli, Lugano (App. E, no. 13).

153. Anonymous. Fresco. Sant'Ambrogio, Ponte Capriasca (Lugano) (App. E, no. 14).

154. Anonymous, c. 1540. Oil on canvas, 418 x 794. Da Vinci-Museum, Abbey of Tongerlo, Belgium (App. E, no. 15).

155. Anonymous. Oil on canvas, 30 x 65. Soprintendenza ai Beni Ambientali e Architettonici, Milan (App. E, no. 16).

156. Anonymous, sixteenth century, overpainted in the 1830s. Oil on panel. St. Germain l'Auxerrois, Paris (App. E, no. 18).

157. School of Paris Bordone (attrib.). Oil on panel, 27 x 74. Musée des Beaux-Arts, Strasbourg (App. E, no. 20).

158. Giovan Paolo Lomazzo, from the refectory of Santa Maria della Pace, Milan, 1561. Fresco transferred to canvas, 311 x 877. Destroyed in World War II (App. E, no. 19).

159. Giovanni Battista Tarillo, 1581. Fresco, 632 wide. Abbey of San Donato, Sesto Calende (App. E, no. 22).

160. Circle of Tullio Lombardo, from Santa Maria dei Miracoli, Venice, c. 1510. Marble, 85 x 189 x 11. Ca' d'Oro, Venice (App. E, no. 27).

161. Giovanni della Robbia, c. 1510–20. Polychrome enameled terracotta, 55.9 x 162.6. Victoria and Albert Museum, London.

162. Anonymous after the Birago (?) engraving (Fig. 4), c. 1550. Engraving. The British Museum, London (see App. E, no. 30).

163. Anonymous. Pen, brown ink, and wash, 21.5 x 33. Musée du Louvre, Paris, 2551 (App. E, no. 31).

164. Anonymous. Ink and wash, 14.3 x 37.7. Musée du Louvre, Paris, 2552 (App. E, no. 32).

165. Anonymous. Pen and brown ink, 8.7 x 26.1. Musée du Louvre, Paris, 2553 (App. E, no. 33).

166. Anonymous. Pen and wash heightened with white, 20.4 x 27.8. Musée du Louvre, Paris, 2554 (App. E, no. 34).

167. Anonymous. Chalk, 13 x 19.5. The Armand Hammer Center for Leonardo Studies, University of California, Los Angeles (App. E, no. 35).

168. Anonymous after the Last Supper. Whereabouts unknown (App. E, no. 36).

169. Flemish or Fontainebleau School, c. 1530. Tapestry, 500 x 905. Vatican Apartments (App. E, no. 38).

170. Flemish (?), presumably based on cartoons after Fig. 169. Tapestry. Vatican Apartments (see App. E, no. 38).

171. Andrea Bianchi, called Il Vespino, 1616. Oil on canvas, 118 x 835. Pinacoteca Ambrosiana, Milan (App. E, no. 39).

172. Joseph-Théodore Richomme after J.A.D. Ingres, The Death of Leonardo. Etching and engraving. The Metropolitan Museum of Art, New York; Gift of Leo Steinberg.

173. Andreas van Rymsdyck (act. c. 1767–84) after the Soutman-Rubens engraving (Fig. 17). Etching (see App. E, no. 41).

174. Hermann Heinrich Quiter (c. 1628–1708) after the Soutman-Rubens engraving (Fig. 17). Mezzotint (see App. E, no. 41).

175. Rubens (?) after the Last Supper. Ink and brown wash, touched with white oil, 22 x 68. Musée des Beaux-Arts, Dijon (App. E, no. 42).

Acknowledgments

A favorable constellation cheered the making of this book:

Carlo Bertelli Susan Bielstein Jonathan Bober

Suzanne Boorsch Prudence Crowther

Reinhold Hohl Carlo Pedretti Helen Vendler

Follows a galaxy of lucky stars:

Leila Whittemore Carolyn Smyth David Sylvester

Johanna Pitblado Alexander Perrig Alexandra Onuf Evelyn Nunlee

Manuela B. Mena Marqués Pietro Marani Frederick Ilchman

Nancy Goldring Meighan Gale Elizabeth Frizzell Jack Flam

Robert Dance Mercedes Royo-Villanova de Álvarez

Don Quaintance more than designed the book. We were three fellow players—
deft Sheila, daedal Don and I colluding, *mutatis mutandis*,
like the trio at the right end of the *Cenacolo* table.

—L.S.

Index of Names

PHOTOGRAPHY CREDITS

Numbers refer to the illustrations.

10. By permission of the Ministero per i Beni e le Attività Culturali.

21. The Royal Collection © Her Majesty Queen Elizabeth II.

23. The Royal Collection © Her Majesty Queen Elizabeth II.

29. La Photothèque/UDF, Paris.

30. Alinari/Art Resource, New York.

34. The Royal Collection © Her Majesty Queen Elizabeth II.

41. Reunion des Musées Nationaux, Paris.

46. The Royal Collection © Her Majesty Queen Elizabeth II.

47. Foto Testi, Siena.

49. The Royal Collection © Her Majesty Queen Elizabeth II.

50. The Royal Collection © Her Majesty Queen Elizabeth II.

51. The Royal Collection © Her Majesty Queen Elizabeth II.

54. Property of Biblioteca Ambrosiana, Milan. Reproduction forbidden. All Rights Reserved.

58. Alinari/Art Resource, New York.

62. © Elke Walford, Hamburg.

67. Reunion des Musées Nationaux, Paris.

76. Scala/Art Resource, New York.

88. Scala/Art Resource, New York.

107. Jorg P. Anders.

120. Alinari/Art Resource, New York.

121. Scala/Art Resource, New York.

141. By permission of the Museo Civico, Crema.

142. By permission of the Museo Civico "Ala Ponzone," Cremona.

149. By permission of the Ministero per i Beni e le Attività Culturali.

150. By permission of the Ministero per i Beni e le Attività Culturali.

152. Alinari/Art Resource, New York.

171. Property of Biblioteca Ambrosiana. Reproduction forbidden. All Rights Reserved.

185. Foto Bundesdenkmalamt, Vienna.

186. Reunion des Musées Nationaux, Paris.

187. The Royal Collection © Her Majesty Queen Elizabeth II.

197. Alinari/Art Resource, New York.

199. Jorg P. Anders.

Designed by Don Quaintance, Public Address Design
with the production assistance of Elizabeth Frizzell
Typography composed in Perpetua and Trade Gothic
Printed by Bowne of Toronto
using Frostbrite acid-free paper
Case bound by Acme Bookbinders, Charlestown, Massachusetts